High art lite

British art in the 1990s

Julian Stallabrass

VERSO

London • New York

First published by Verso 1999
© Julian Stallabrass 1999
All rights reserved

The moral rights of the author have been asserted

Financial assistance from the Courtauld Institute of Art
Research Fund is gratefully acknowledged

Verso
UK: 6 Meard Street, London W1V 3HR
US: 180 Varick Street, New York, NY 10014–4606

Verso is the imprint of New Left Books

ISBN 1–85984–721–8

Designed and typeset by Newton Harris and
The Running Head Limited, www.therunninghead.com
Printed in the U.K.

Contents

List of illustrations/picture credits

Acknowledgements

Baudelaire says that the impartial critic should have no friends and no enemies. While being aware of the danger of acquiring too many friends, and keeping a little distance from the scene I have taken as my subject, I have found a few, and all have been important to the development of my views, though none is in any way responsible for them.

I would particularly like to thank Sebastian Budgen, Malcolm Bull, Kitty Hauser and Chin-tao Wu, who all read a draft and made detailed comments that have helped me to improve the book. Furthermore, I have benefited from conversations about the British art scene with many people, especially Matthew Arnatt, Lise Autogena, David Crawforth, Robert Garnett, Ella Gibbs, Tony Halliday, Mick James, Hayley Newman, Naomi Siderfin, Jessica Wyman and Carey Young. I have also had many stimulating exchanges of views with my colleagues at *New Left Review*, the Courtauld Institute of Art and the Ruskin School of Drawing and Fine Art. I would also like to thank my BA and MA students at the Courtauld and the Ruskin, from whom I have learned much during seminars and gallery visits. In addition, Bank and Rut Blees Luxemburg kindly provided material about their activities. I am also very grateful to the Courtauld Institute for providing a grant towards the cost of reproducing images in colour.

Some of the text in this book has appeared previously in the form of articles and reviews, though all of it has been considerably modified for inclusion here. Chapters which contain this material are as follows: chapter 2: 'In and Out of Love with Damien Hirst', *New Left Review*, no. 216, March–April 1996; chapter 3: 'On the Margins', *Art Monthly*, no. 182, December 1994–January 1995; 'Artist-Curators and the New British Art', *Art & Design*, vol. 12, nos.

1–2, January–February 1997; and review of Tomoko Takahashi, Beaconsfield, London, *AN Visual Arts*, February 1998; chapter 4: 'Phoney War', *Art Monthly*, no. 206, May 1997; chapter 7: 'High Art Lite at the Royal Academy', *Third Text*, no. 42, Spring 1998; chapter 9: 'The Decline and Fall of Art Criticism', *Magazyn Sztuki* (Gdansk), no. 18, 1998; chapter 10: catalogue essay to Beaconsfield/*AMPCOM, Between the Devil and the Deep (Blue) Sea*, London/Helsinki 1997.

Finally a note by way of 'anti-acknowledgement'. Anthony Reynolds, who represents Richard Billingham, Steve McQueen and Mark Wallinger, insisted on seeing passages from the book before deciding whether to grant permission to reproduce these artists' work. Not liking what he read, he denied permission to reproduce the illustrations needed to illustrate the text. The pictures I had chosen appear as blank rectangles along with their captions, and readers interested in seeing them can consult Billingham's *Ray's a Laugh*, McQueen's Institute of Contemporary Arts catalogue and Wallinger's Ikon Gallery catalogue, all listed in the references. This attempt to control the context in which artists' work is seen well illustrates the points made about the influence of commerce over criticism in chapter 9.

1 **Introduction**

Once upon a time, not so long ago, some of us involved in the art world thought that all would be well with contemporary art if only it were less elitist, if a little air could be admitted into the tight circle of our enthusiasm, if the public could be persuaded that the products of this world were not some con, dedicated to providing assorted posh types with an easy and entertaining living. For, aside from this one glaring fault, some of the art seemed worthy of people's attention, being radical, serious, surprising, and having the potential to change those who saw it and thought about it. At the same time, especially in Britain, that opening up of art to a wide public seemed extremely difficult to achieve. The separation between the sophisticated, not to say abstruse, art with its small cosmopolitan audience, and the philistine, materially driven masses seemed absolute. An interest in contemporary art was something that many people felt that they ought to cultivate, that seemed frightfully worthy if a little disconnected from life, and for which, in the end, there was never enough time.

In the 1990s, by contrast, this earnest minority pursuit has come to shine with some of the reflected glory of the fashion, film and music industries – a bright if distant and minor satellite in the firmament of mass culture. Johnnie Shand Kydd, a relative of Princess Diana, has produced a book of photographs of artists idling on the scene, drinking and falling about.[1] Pictures of high but also at the same time low society, taken by an aristo slumming it in bohemia, as so many have before him. The very fact that this book of banal and poorly taken photographs was published, and by a major art publisher at that, is a register of the extent to which the artists themselves have become a focus for curiosity as personalities, as stars. Yet now that contemporary British art has

become quite popular – it's hard to open a newspaper or magazine without running into the art and its attendant personalities – the cultural utopia that some had hoped would unfold with wider participation has not come about. Even so, the growth in the audience for art appears to have wrought a deep change on the art itself.

This book sets out to look at how contemporary art in Britain successfully remade itself. It will be a critical account of what forged this new art, how it is different from what went before, its relation to its audience and the mass media, its contradictions and how they may affect its trajectory in the future. It asks whether or not the change will be long-lasting, and whether this art's popularity has been purchased at the price of triviality.

Those artists who have come to public prominence, and the tendency they appear to form, have gone under a number of names: the 'new British art', or simply the 'new art', 'Brit art', or even the 'New Boomers', though the term that has stuck is 'young British artists' (often abbreviated to yBas). While there is obviously an advantage in keeping to the accepted term, it is not one that I will use here, at least not without irony. It comes from the exhibitions held at the Saatchi Gallery from 1992 onwards, and is the advertiser's most successful (if inadvertent) attempt to name an art movement. Aside from its origin, the term is inaccurate: as Matthew Arnatt put it, the yBas are young only in the same way as the Monkees are young (that is, they are no longer as young as they were, and their youth was only ever for show).[2] Moreover, while they live in Britain, not all of them are British (Jordan Baseman, Tomoko Takahashi and Rut Blees Luxemburg spring to mind as fairly prominent examples of those who are not). The other terms replicate the problems of 'yBa', 'new' being a poor substitute for 'young', suffering as it does from the same deficiency. My term, 'high art lite', has the virtue of being descriptive: I hope that it captures the idea of what I will describe, an art that looks like but is not quite art, that acts as a substitute for art. It also suggests that the phenomenon is not confined to Britain, though the particular form that it has taken here will be the focus of this book.

Naming a tendency is easy. Showing that it deserves a name, is coherent and distinctive enough to need a category to contain it, is another matter. Perhaps 'yBa' is no more than a media confection, a useful logo under which to pub-

licise the productions of an otherwise disparate generation of artists. As Liam Gillick put it in an article warning about the retrospective coherence that would be wished upon a group that was not really a group, 'What artists have learnt from more sophisticated forms of popular culture is that the creation of an aura of activity can be everything.'[3] Yet there is coherence to the tendency that goes beyond the branding of diverse work, in terms not only of age but of institutions and the social scene. Many of these artists, as we shall see briefly in this chapter, went to the same art schools, showed in the same do-it-yourself exhibitions, were represented by the same dealers, came to the public's attention at about the same time, live in the same part of London and socialise together.[4] In itself, this does not mean that the art has a common set of characteristics but, if it does, these circumstances may go some way to explaining them.

So what are the obvious defining characteristics of high art lite? The exhibition *Material Culture* held at the Hayward Gallery in 1997 spanned British art of the 1980s and 1990s, wanting to show continuities between the two decades, perhaps (in a reverse of the usual device) to validate the old in the light of the new. Reviewing this exhibition, Carl Freedman, one of the curators active in the inception of high art lite, insisted on the distinctive character of the new art, and did so in a symptomatic manner, expressing commonly held views: the work of the 1990s had a matter-of-fact air when compared to the heavy reliance on metaphor and allusion in the output of the older generation. He singled out the Lebanese-born artist Mona Hatoum for condemnation, saying that her work (for example, colanders with their holes blocked by bolts to refer to the containment faced by Palestinians in Israel) was 'sterile, laboured and burdened by its political message.'[5] It is true that much of the work that followed would be free of any such explicit burden. Furthermore, continued Freedman, while the younger artists combined Dadaist humour, the literal qualities of minimalist art and Situationist strategies to question the very status of art, the older lot 'engage with essences and metaphysics and, conservative in their compliance with the institution of art, depend on it to validate their illusionism and mystification.'[6] There is a good deal of truth to this view which characterises the newer art in terms of temperament and tactics, rather than style or medium.

There is certainly no common programme to this art: there are no manifestos, no group statements, no shared style. Yet there are distinguishing characteristics, aside from the general outlook that Freedman describes. First, the overtly contemporary flavour of the art, apparently breaking with the provincial air of much previous British work, or at least adding sufficient inflection to that character to allow it to appeal to an international market. This change has led some commentators to predict that British art will become the dominant global art, at last managing to compete successfully against US and continental European rivals.[7] Second, the artists have a new and distinctive relation to the mass media and frequently use material drawn from mass culture. Third, they present conceptual work in visually accessible and spectacular form. There are less obvious characteristics, too, that will be explored throughout the book. Since these artists form an identifiable tendency that reacts against the concerns of the previous generation, they look a little like an avant garde. The appearance may be deceptive, but it plays well in the press, both for those liberals who want to believe that high art lite represents something radical, and for those conservatives who are afraid that it does.

These various elements were put together in a remarkably accessible package, so that viewers could enjoy the resulting product without necessarily having to know the full details of the origin and previous use of each component. If contemporary British art is popular, it is because it looks a lot friendlier to the general public than it once did, and because it talks a little less about itself, or does so a little less openly. It allows those without specialist knowledge of art a way into itself by airing material from the mass media that most people cannot help but know about – television programmes, films, tabloid newspapers, and the major and minor obsessions of these popular organs: drugs, sex, violence, music, celebrity, UFOs and wildlife. So even in painting, a staid medium some might think, there have appeared pictures that take poses from pornographic magazines, or paste fragments of them onto the canvas, or are named after recreational drugs.

This change was not simply caused by artists deciding that they wanted their work to be more popular. High art lite was formed as the once confident and affluent private art market went into hibernation during the recession that began in 1989. The art market had been buoyed by the long and steep rise in

stocks, which its own prices closely reflected, and was also dependent, in its expectation of a continued upward path, on the increasing number of buyers from East Asia. While most of this money was not spent on the latest contemporary art, the continual rise in prices and profits bred a sense of security about investment in untried areas of the market. When recession came, the stock market plunged and the Japanese Bubble Economy burst. The art market, froth on the froth of speculation, suffered a catastrophic collapse.[8] Galleries closed or sharply scaled down their activities, while a few began to turn away from the work of highly expensive international stars to young, home-grown and much cheaper talent.

In the years immediately following, many artists found themselves with large stocks of unsaleable objects and nowhere to show them. Some ceased making permanent objects – there was a revival of performance work and of transient installations – and others made less conventional ones. If the materials to put together a work of art could be taken from a skip, so much the better. Artists also became their own curators, making shows for themselves and their acquaintances in the numerous industrial spaces emptied out by the recession. But, most of all, there was a turning away from the inward-looking concerns of the art world to new subjects, especially to those which might appeal to the mass media.

The recession, as we shall see in more detail later, was linked with two other changes that greatly assisted in the development of high art lite. The first was that financial troubles led Charles Saatchi to dispose of his collection of blue-chip British, US and European art.[9] He focused instead upon collecting the latest products of young British artists. The second was a change in the orientation of the Tate Gallery's Turner Prize towards work by younger artists, caused in part by the bankruptcy of its sponsor.[10] All this took place in the period 1989–91 and formed the basis for a shift in the character of the British art scene.

The consequences of these events unfolded slowly. There was quite a long period after the recession began when 'young British artists' were hardly shown by established galleries, public or private: one of the most prominent private galleries, the Lisson, only made a group show of the tendency in 1993, and did not follow that until 1995.[11] So those few galleries that were prepared

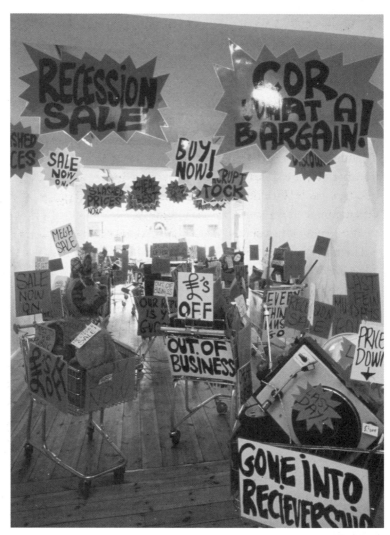

1 Michael Landy, *Closing Down Sale*, 1992, installation view

to show these artists – Interim Art, Karsten Schubert, the Saatchi Gallery, White Cube – and the exhibitions that the artists curated themselves, became very important.[12] This was the time, between 1989 and around 1995, when high art lite had to draw upon resources other than those of the conventional art world, and it was the moment that formed its particular characteristics.

Only rarely does contemporary art take money or the market as its subject matter, and few of the artists commented upon the conditions of their own creation. A striking exception was Michael Landy who, pursuing his interest in the mechanisms by which things are sold, made an exhibition at Karsten Schubert called *Closing Down Sale* in 1992. The gallery was filled with shopping trolleys and day-glo sale signs with their desperate messages exhorting the viewer to buy with tales of economic woe ('Gone Into Receivership', 'Meltdown Madness Sale' and so on). Private galleries tend to play down the fact that they are shops but Landy had made his show look exactly like what it in fact was.[13] With the country still in recession, and the art market in deep retrenchment, it was a gesture that cut deep.

While it is often assumed that artists drive themselves to change, sometimes – reluctant innovators blown before the gales of modernisation – they themselves are driven from their once-comfortable working practices. The effect of recession on the British art scene was to act as a force of creative destruction and modernisation, though, as with the successive recessions that tore up British manufacturing industry and led to the rise of service-oriented businesses, how deep that modernisation went is a matter open to question.

While the recession forced artists from old practices, it could not entirely determine what they would take up instead. The story of high art lite's triumphal development has been recounted in numerous exhibition catalogues, particularly those devoted to educating foreigners or the uninitiated masses in the virtues of the new art. It is a tale of tough entrepreneurs braving the harsh circumstances of the recession to produce an art fit for the bracing climate of the untrammelled free market, and capable of holding its own against the spectacular productions of mass culture. Much of the book that follows will attempt to undermine that neat story, but first I will briefly relate the narrative.

A remarkable number of the artists who were to find success in this tendency came from the fine art course at Goldsmiths College, part of the University of London. There, the divisions between different media (painting, sculpture, printmaking and so on) had been abolished and students were encouraged to make specific interventions in an art scene of which they were to acquire extensive and detailed knowledge. There was a productive tension

between the different outlooks of the two teachers most influential over the students: Jon Thompson – romantic and humanist, his interests centred on European art – and Michael Craig-Martin – conceptual, concerned with direct expression and mundane objects, and more interested in art made in the United States.[14]

It was at the end of the 1980s that some of the Goldsmiths students, including Damien Hirst, began to put on exhibitions in vacant office and industrial buildings. These exhibitions (examined in more detail in chapter 3) were very successful in showcasing ambitious and attention-seeking work. The first of them, *Freeze*, was to acquire near-mythical status as the origin of 'young British art', and it certainly proved a very efficient device for gaining its participants contracts with private galleries.

Also important to the development of high art lite was Charles Saatchi and his gallery in St. John's Wood, then an exclusive space that through the 1980s showed much US and European art rarely seen in Britain. These exhibitions were to have a large influence over the new generation; particularly important was the two-part *New York Art Now* exhibition that ran between September 1987 and April 1988 and included work by Ashley Bickerton, Robert Gober and Jeff Koons.[15] In the 1990s, the Saatchi Gallery mounted a series of exhibitions displaying Saatchi's acquisitions of recent British art. The first exhibition in the series 'Young British Artists' in 1992 marked the debut of Hirst's shark (fig. 4) to a good deal of media attention. Of the thirty-five artists featured in the book of Saatchi's collection of British art of the 1990s, *Shark Infested Waters*, thirteen are Goldsmiths graduates.[16] High art lite was also dependent on the few dealers prepared to support it, particularly Karsten Schubert who, following *Freeze* and the 1988 Goldsmiths MA Degree show, showed Ian Davenport, Gary Hume and, as we have seen, Michael Landy; and then later Glenn Brown, Mat Collishaw, Keith Coventry, Abigail Lane and Rachel Whiteread.[17]

As against the earnest art beloved by the establishment, work by the new tendency was irreverent and accessible. It seemed not to worry about many of the issues that had tied art up in knots and to engage instead with the broad and urgent concerns of everyday life. George of Gilbert and George, the artist-duo who have been influential over this new art in a number of ways, has commented about their use of photography:

It doesn't look like eccentric, freaky twentieth-century art, which is what we dislike so much. There's this big tradition where everything has to look (makes a retching sound) strange – it's something that infuriates the lower classes.[18]

To court a wider audience, high art lite took on an accessible veneer, building in references and forms that people without specialist knowledge would understand – and even sometimes, in its use of mass culture, incorporating material that those with specialist knowledge would generally *not* understand, having been too busy with their art-historical monographs and too snobbish to have allowed themselves an interest in pop music or soap opera. In this way, the new art set out to appeal to the media and to enrage conservatives, generating the publicity on which it was coming to rely.

A transitional example of the fuss that this visually spectacular art could cause is Rachel Whiteread's *House* (1993). For a time, it made Whiteread the most famous artist in the country, receiving much press attention, especially in

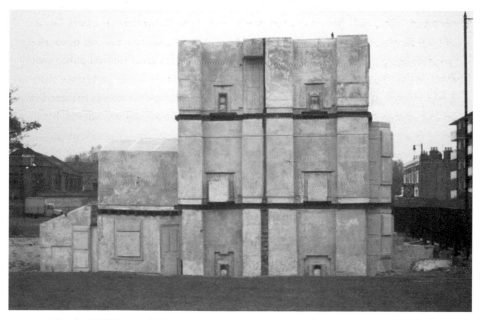

2 Rachel Whiteread, *House*, 1993

the *Independent*, and causing questions to be asked in the House of Commons.[19] The controversy this work engendered was a surprise, however, and that surprise came about because of the mismatch between the logic of the artist's practice and the unforeseen consequences of its expansion.[20]

Whiteread had been making casts of the spaces that household objects delineated (for instance, the space between the legs of a chair), of pieces of furniture or baths that took on a funereal form and once, with *Ghost* (1990), of an entire room. Although *Ghost* was large, it was still suited for gallery display. The next step, to make a cast of the interior of an entire house, was plainly not, and the result (one terraced house of a condemned row cast in concrete, and left standing against a patch of ground in the east of London) had a resonance that went far beyond the usual readings of Whiteread's work, which had centred on absence, death, the domestic and its relation to the uncanny. *House* was on public display in an impoverished area of London, and became the subject of quite hot local debate, reflected in local newspapers.[21] Borough councillors demanded its immediate demolition, while at the same time Whiteread was awarded the Turner Prize on the merit of the work. In a country where housing policy had become a central political issue (under the Conservative governments there had been a marked rise in homelessness and in properties standing empty, council houses had been sold to their occupants and a very high level of owner-occupancy had been encouraged), Whiteread's work came to take on new and explicitly political meanings. Controversy centred around its cost (£50,000) that some thought could have been better spent on real homes, and on its demolition, always planned but nonetheless protested against by art lovers.

It is notable, however, that with this work by an artist who has only one foot in the high art lite camp, the press coverage was greatest in the broadsheets and in the local press, the story being ignored by the national tabloids. This was certainly not to be the case with a later controversy: that over Marcus Harvey's painting *Myra* (see chapter 7).

Whiteread, along with Damien Hirst, still commands the highest prices of those of her generation, even if others have leapfrogged over her in terms of fame. While high art lite began by being displayed in do-it-yourself exhibitions in semi-derelict buildings, its success came astonishingly fast, given the

controversy that it proved capable of generating. In 1997 Saatchi's collection of British art of the 1990s was seen by hundreds of thousands of people at the Royal Academy in an exhibition called *Sensation*. The British Council has been successfully exhibiting high art lite all over the world, and at the time of writing the Tate Gallery is showing installations by Michael Landy and Damien Hirst, not in their 'Art Now' space but in the main galleries. This is an art that has been drawn into the establishment at speed.

Perhaps that very success will cause problems for a tendency whose greatest strength was its opposition to the practices of the established art world. Matthew Collings captured the fashion in which high art lite's most positive moment was negative:

> When you think about the older artists going around in their suits and being in biennales and giving the same interviews all the time about their concerns and being a bit gratingly half-intellectual, you feel refreshed by this frankly abject juvenile style, even if it's only for a moment.[22]

As the art market revived and success beckoned, the new art became more evidently two-faced, looking still to the mass media and a broad audience but also to the particular concerns of the narrow world of art-buyers and dealers. To please both was not an easy task. Could the artists face both ways at once, and take both sets of viewers seriously? That split in attention, I shall argue, led to a wide public being successfully courted but not seriously addressed. It has left a large audience for high art lite intrigued but unsatisfied, puzzled at the work's meaning and wanting explanations that are never vouchsafed: the aim of this book is to suggest the direction some of those answers might take, and to do so in a style that is as accessible as the art it examines.[23]

Eddie Chambers, in a review of a book of essays about British art of the 1990s, has argued that 'young British art' simply does not merit serious attention, and that it would be falsely dignified by any attempt to turn critical thought to its explanation.[24] Whatever its inherent qualities, however, high art lite has brought about a transformation of the British art world. While it is not the only interesting art that is being produced in Britain today, its success is no accident, for it does embody and respond to problems that are at the heart of

the crisis in high art and its relation to a public. This book will analyse the rise of high art lite as a phenomenon, and will also look more broadly at the social and economic landscape from which it emerged.

Given this approach to the subject, my choice of artists and of works to discuss is governed by the demands of an argument that has developed from a study of the scene. This book is not a survey and some significant work is neglected. Contemporary British art as a whole is a much richer, more complex and diverse landscape than the popular heights of high art lite would imply, but the task of this book is to show why this tendency is so dominant, rather than to cast light upon unjustly neglected work.[25]

Artists may complain that I have sometimes not explored the full complexity of their individual projects but have plucked works from them to illustrate a thesis, and sometimes they would be right; but there are phenomena that I hope can be grasped within this broad framework, whatever violence it does to proper monographic study, for an artist's work cannot be taken, and does not have an effect, only on its own terms.

The book falls into three main sections and, while this is far from being a strictly chronological account, there is a development implied in that organisation. The first section looks at the emergence and character of the new form of art on the British scene. The second considers the long period during which it seemed to coast along, slowly becoming established. The last looks at the art's destination, limits and contradictions.

Finally, a word on source material, particularly artists' and critics' statements: if, as I argue in the next chapter, the identities of artists are media constructs, how should this material be handled? Artists' statements should at best be treated with caution, for artists are not always honest (indeed, they often have an interest in lying), and, even when they are, they are not necessarily those who have the greatest understanding of what they are doing. With high art lite must be added a large measure of media savvy and manipulation on the part of artists, dealers, journalists and PR people.

Are artists' statements, then, useful in understanding the work? First, we must distinguish between published and private statements: all the material I deal with here is in the public realm and, as such, has a status because it affects and even becomes a part of the work. Second, if the artist is considered not so

much as a person but as a complex of works, exhibitions and pronouncements (and all this is not the output of one person but also of curators, supportive critics, dealers), then that complex will have a certain internal sense, a logic that relates to other similar complexes and to the culture as a whole.[26] Within that logic, statements may be judged to be more or less useful or illuminating, sometimes in revealing that logic, sometimes in promoting an artists' project – and often one cannot be done without the other. Statements cannot be judged in advance but must take their place within a broader understanding. Whether or not I have been successful in my use of them, it must naturally be left to the reader to judge.

Part I
Rising from recession

2 Famous for being famous

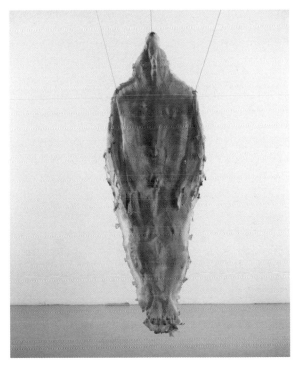

3 Marc Quinn, *You Take My Breath Away*, 1992

In a work by Marc Quinn called *You Take My Breath Away* (1992), a mould has been taken of the artist's body in ghastly yellow rubber. This full-length figure hangs limply from the ceiling, torn in places, encrusted in others – and smelling faintly. It is a ghostly prophylactic, translucent and insubstantial, a sacrificial figure, all too obviously a metaphor for deflated masculinity but also

perhaps for the fate of the artist, and certainly for the fate of the artist–hero. The body's boundaries, once mapped and clung to by this filmy material, are now torn, a blow-up artist ruined by some excess.

There is a paradox at the centre of much contemporary art: while the means by which that art is pursued are steadily less expressive of the artist's personality, more reliant on conventional ideas than feelings, more the assemblage of ready-made elements than the creation of organic compositions, the personality of the artist, far from shrinking, has greatly expanded, sometimes overshadowing the work. Furthermore, the very fact that artists do rather little to their material but nevertheless garner huge rewards leads to a fascination with the artist as an individual.[1] Far from artists (or authors for that matter) dying, they appear to be in rude, if artificially inflated, health.[2] Yet perhaps in this development the type of personality with which the artist is endowed has changed.

I will begin by looking at the work of four artists – Damien Hirst, Gary Hume, Tracey Emin and Gavin Turk – and at the particular form that their celebrity has taken. Since they are representative of a general trend, this celebrity has been quite different from that enjoyed by British artists in the past, although there have been isolated previous examples, both in Britain and in the United States. Looking at the artists' personae and the way that they are conveyed through their work will reveal something about the character of this new art. The existence of these new artistic identities – and often this is a deliberate strategy on the part of the artists – mounts a series of challenges to conventional academic thinking about the artist, the work of art and the relations of both to the mass media and to the audience for art. The account of Hirst will be the most extensive, and not solely focused upon the issue of his identity (though, as we shall see, work and identity are not strictly separable), since he is the pioneer of this tendency and still its most prominent exponent. In his development can be seen a microcosm of the tendency as a whole.

Damien Hirst

Every weekend, one autumn at the Tate Gallery, long queues of pretty young, pretty cool people would form before two tall glass cases, arranged to

form either side of a narrow corridor. Each case contained one half of a cow that had been split lengthways along its body, and the queue was for the privilege of walking between the two of them to examine the innards. This, and a calf similarly treated, which formed the work, *Mother and Child, Divided* (1993, fig. 62), was Damien Hirst's contribution to the 1995 Turner Prize exhibition – as it had been to the Venice Biennale two years earlier. If one point of the work was to make people behave in this way, then it would have been a good joke; but there are reasons to think that it was intended to be rather more earnest than this.

Bringing animal corpses into the gallery has made Hirst famous: his best-known work is simply the body of a shark displayed in a large tank of formaldehyde, coupled with the title, *The Physical Impossibility of Death in the Mind of Someone Living* (1991). Various ruminants have received the same treatment. Grandiose claims are made about this body of work, both by Hirst himself, who never ceases talking about life and death, and by its promoters. For

4 Damien Hirst, *The Physical Impossibility of Death in the Mind of Someone Living*, 1991

Virginia Button, one of the Tate Gallery's curators, 'brutally honest and confrontational, he draws attention to the paranoiac denial of death that permeates our culture', and the Prize jury, too, praised the 'thoughtfulness of his approach' and noted that his work continued the long tradition of art which 'deals with the issues of life and death'.[3] But, aside from these expected puffs and unusually for a contemporary artist, Hirst has received a great deal of attention from the mass media – and not for the usual reason that contemporary art gathered column inches in the past, that public money has been 'wasted' on the work. Hirst is as much or more known for his lifestyle as for his art, and he takes care to ensure that the two are thoroughly entangled. In a feature in the *Tate Magazine*, for instance, a full page illustration was devoted, not to any work of art, but to an iconic image of the artist with shaven head, sucking on a fag.[4] It was on the basis of this accessible blending of art with personality that feature articles about Hirst, and later about others of his generation, began to appear in newspapers, not just in liberal broadsheets, as one might have anticipated, but also in conservative papers and even in the tabloid press. Given the deep-seated indifference that such popular organs had previously shown towards contemporary art, this was a surprising development.

Like Hirst's image, his work is spectacular and attention-seeking. In one of his most striking pieces, canvases were hung with chrysalises in a closed room; the butterflies, hatched, fed off sugared water, flew, bred and died – some inadvertently squashed by art lovers. In a separate room, their bodies were painted into the bright colours of other canvases. The installation was called *In and Out of Love* (1991) and it was symptomatic of various recent developments on the British art scene. Non-art objects, or beings, are brought into contact with traditional fine-art materials and modes of display – the gallery and the private view. Titles are flip, often borrowed from films or songs. Such works are both easily affecting and coolly ironic.

This courting of publicity was cloaked with an all-knowing irony. The new generation of artists had good formal education, having been put through sophisticated fine-art courses which informed them about high 'theory' and the history of the avant garde. They also learned about the debilitating situation of high art in this country, besieged by philistine opinion and constantly having to restate its most fundamental tenets in the face of incredulity – not

that any of this had mattered when it was a world unto itself, awash with money. A facile postmodernism, the basis for a ubiquitous irony, was the foundation of this new art, one which took no principle terribly seriously, which pretended not to separate high from mass culture and which, given this relativism, accepted the system just as it was, and sought only to work within it. The new art would be quite as dreadful as the philistines said it was – obscene, trivial, soiled with bodily fluids, and exhibiting a fuck-you attitude – but this time deliberately so: it would use the philistines' energy and power in the mass media against them.

Yet the new British art was not generally seen like this, certainly not at first. Indeed, if it was to be effective, it could not be. So the defenders of traditional art played their role, fulminating against this shocking, publicly supported non-art. The most infamous of these is Brian Sewell, the critic of the *Evening Standard* who enlivens the homeward journey of London's commuters with tales of those crazy art-world folk. One anthology of his reviews, *An Alphabet of Villains*, bears a mock-up of Sewell's severed bust immersed in a Hirst-style tank.[5]

At the other extreme, the defenders of radical contemporary art were earnest in the new wave's support. Their claims were often quite as ridiculous as those of the conservatives. Of their voluminous writing, we may take a few symptomatic examples: Andrew Graham-Dixon asked of the new art:

> What if – a radical suggestion, in its own way – the point of making art is, simply, to address themes and preoccupations that can be addressed in no other way? … what this new English art speaks of is a faith, of belief in the continuing fruitfulness of certain strands of modern art. That, and a certain tolerance of spirit: a willingness to recognise that artists should be free to choose their own languages, in accordance with their own expressive needs, whatever the fashion of the time.[6]

To look at the work like this is to take it at face value – and there is a certain point to doing so. It is to look in from the outside, as someone new to high art, or someone not much immersed in the minutiae of the art world, and to see a forthright art that speaks of death or sex or drugs or junk culture. Such work is liberating for the new audience for contemporary art, for finally here is an

art that speaks to everyday concerns in recognisable voices. But when such a statement comes from a critic thoroughly immersed in this world, familiar with the in-fighting, the incessant paranoia about putting a foot wrong, the parade of fashion victims, it is merely an ideological inversion of actual circumstances.

Likewise, Stuart Morgan (one of the most influential affirmative critics in the country, quite as capable of using an all-embracing irony in his own defence as the artists), in reviewing the work of various artists who use organic matter – 'Isn't every remnant of life potentially talismanic?', he asks, quaintly – promises us nothing less than an art which will become an alternative to religion, where 'the sacred and the profane, pollution and the holy, may coincide from time to time, and the result may be an ability to change our lives.'[7] If some of these defenders are as implausible, as mystical or as defensive as ever, this is an indication that what the new scene has wrought is less a permanent change in the structure of the contemporary art world than a fragile shift in fashion. The fear is still there among artists, curators and gallery owners that

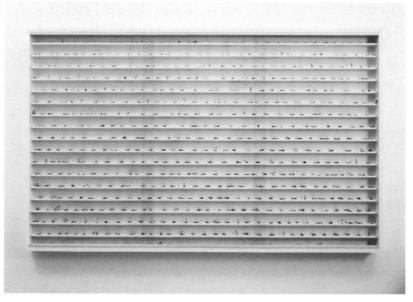

5 Damien Hirst, *Dead Ends Died Out, Explored*, 1993

they will awaken suddenly to find that all the advances have vanished, and that art is being received once again with hostile scepticism.

In a published conversation, Will Self and Hirst spent a good deal of time disingenuously laying into art critics, being agreed on their entire uselessness. Self wrote:

> The art critics who contemplate Hirst's work are like clever children playing with one of those stereoscopic postcards: they flick it this way and that, to show the Emperor alternately naked and adorned. Thus they get their kicks.[8]

Despite their contempt, the combination of these critical views whether praising and earnest, or populist and damning – form a very effective promotional machine: for it to function, the art at which it is directed must at least pretend to make big statements, and it must actually be entertaining and engage with issues that concern people. Given this, Hirst is a most convenient figure. Just as the best Mills and Boon writers are not cynical money-spinners but true romantics, Hirst in a naive, sincere way does appear to be caught up with the big themes of the human condition. In Hirst's installations, says Iwona Blazwick: 'he attempts to encapsulate the dialectical oppositions and tensions of social relations; of mind and body; of reproductive cycles and death throes; of being in and out of love.'[9] Of the cigarettes that have become as much of a trademark for the artist as animal corpses, Hirst himself explains:

> The whole smoking thing is like a mini life cycle. For me the cigarette can stand for life. The packet with its possible cigarettes stands for birth. The lighter can signify God, who'd give life to the whole situation. The ashtray represents death, but as soon as you read it like that you feel ridiculous. Because being metaphorical is ridiculous but it's unavoidable.[10]

Ridiculous or not, the giant ashtrays, the cigarette butts arrayed on shelves are meant to be read as *memento mori*.

Another Hirst installation involving insects was called *A Thousand Years* (1990): within its glass frame, flies breed and feed; as they buzz between its two sections they may enjoy a rotting cow's head, or be fried by a fly-zapper. Jerry

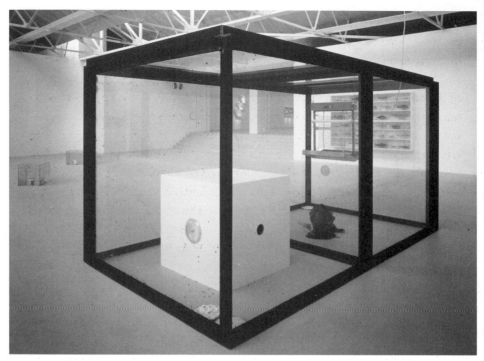

6 Damien Hirst, *A Thousand Years*, 1990

Saltz, writing in 1995, calculated that sixty generations of flies had lived and died within it. This, he says, makes you ponder mortality, since Hirst

> gets you to think about the fact that of the five billion or so people now on earth, all will be gone within, say, 100 years. That's a big thought to have in front of a piece of sculpture.[11]

Mortality is a big subject, but simply to say that a work of art gets you to think about it is a small claim. As the US comedian Bill Hicks commented about the conservatives' definition of pornography – material which causes sexual thought – almost anything, riding on public transport was one of his examples, could cause *that*.

Hirst is presented, and presents himself, as 'one of life's innocents', capable of reintroducing into art 'emotions long banished as being in some way embarrassing; curiosity and awe' so that 'the gallery is restored to one of its

least remembered functions – a focus for amazement.'[12] Sarah Kent, the critic of *Time Out* and another of the proselytisers, works hard to fit a mythology into place: the sources of Hirst's art are to be found in his childhood memories, and the artist still looks with a child-like, wondering gaze upon the absurdity of the adult world.[13] Hirst, then, despite his Goldsmiths training, serves as the tendency's Douanier Rousseau. In line with this, he is marketed not only as a mental innocent, but as a class primitive, someone who only got an E in A-level art, and who 'lives on a council estate in Brixton, built in the shape of a vast wall punctuated by windows – a shit-coloured cell block where lifts are broken, landings are strewn with rubble and plants are dead.'[14] (This was written before Hirst moved to a country estate in Devon.) So, in admiring Hirst's work in the gallery, art lovers can slum it a little, getting a direct and authentic experience of what 'life' is really like – without having to risk setting foot in some rubble-strewn block.

In line with this marketable naïveté, Hirst's work does have a highly literal side: the works named after armaments (*Heckler* and *Cosh*); the series of bull's heads, each bearing the name of one of Christ's disciples and all placed in glass cases with white frames except for that of Judas, who is framed in black; the medicine cabinets in which the drugs to treat ailments of the head are on the top shelf, those to treat the feet on the bottom; or the spot paintings named after drugs, rectangular ones after medications, while all those named after controlled substances are irregularly shaped – like wild, man. But of course, these are all also ironic statements.

To get away from such facile life-and-death nonsense, and from Hirst's constructed image, to the authentic sources of his art is no simple matter. Nevertheless, the critics sometimes hit on clues. Sewell recounted a comment made by Hirst about the serial-killer Jeffrey Dahmer, whose biography was apparently long a bedside companion for the artist: 'he has a kind of terrible curiosity to find how living things work, by taking them to pieces'.[15] Further, Richard Shone, writing about the exhibition Hirst curated at the Serpentine Gallery, says that from the time of the cutting-edge exhibitions:

> each time he showed a new work it was as if some art-world Jack the
> Ripper had perpetrated one more outrageous crime. The public's

reaction was the same admixture of horror and frank admiration that it reserves for the acts of the most elusive criminal.[16]

But, it seems to me, the subject is never actual serial-killing – or actual anything – but rather its representation in mass culture. Hirst's material and themes – drugs, vitrines, surgical instruments, containers for confinement or torture, dismemberment, experiments with insects – is the stuff of horror movies. Here high art meets a deranged and fictional science. If the minimalist frames of the vitrines refer to Francis Bacon, the flies in *A Thousand Years* are from Dracula, the butchered animals and pickled internal organs from a hundred Hammer movies. The attraction was also there in Hirst's choice of Hiroshi Sugimoto's photographs of waxwork horror ensembles for the Serpentine exhibition.[17] Imagine the artist's studio with its chemical apparatus, its specimens and dissection equipment, and Hirst, one of the 'rummagers in the tossed away envelope of the soul, up to their elbows in it'[18] – it's all so Peter Cushing. And what else could a boy do, growing up in the 1970s, who happened to be called Damien?

Hirst's materials are only incidentally objects in the world, for they live the greater part of their lives in the media. Does the shark really get us to think about mortality – who's really afraid of sharks rather than of cancer or being run over? – or does it simply remind us of *Jaws*? Hirst's impossible desires – to live forever – are caused, he thinks by media images: 'magazines, TV, advertising, shop windows, beautiful people, clothes. Images that can live forever and we are constantly being convinced that they are real.'[19] And, like the advertisers' products, and unlike the way works of art are often expected to be, they make a virtue of being thoroughly average.

Especially when Hirst's work is seen as a whole – from severed heads to spot paintings, from fly-zappers to the strict administration of the medicine cabinet, the combination of Hammer-style schlock and high-art minimalist rigour becomes obvious. The innovation was to bring the two together, to see that the vitrine is used to display corpses as well as art objects, to take the minimalist comments on bureaucracy and administered life literally, to produce a rigor mortis which reflected, albeit faintly, on life and the action of art on its objects.

Beyond the schlock, however, there is a vacuous quality which is the work's defining characteristic; Hirst recognises it himself in putting the stress on the viewer's readings, in seeking only to present, never to comment.[20] In this, as we shall see, he is entirely typical of high art lite. Hirst, though he worries about adding to the number of objects in the world, says of his work: 'You make a sculpture' (note the use of that old, conservative word) 'and it's exciting, and it's in a show, and you look at it, and you go "wow".'[21] And this is just the effect that much contemporary art relies upon: 'wow' is just what you say when you see a giant shark suspended in a tank, or a concrete cast of the interior of an entire house or a bust made from an artist's frozen blood. Beyond this amazement, though, Hirst's works often seem empty. He plays on this, of course, telling interviewers that he wants to call some piece, 'I sometimes feel I have nothing to say, I often want to communicate this.'[22] This emptiness is a product of the simple collage of ready-made elements, brought together not to build meaning but to throw opposed ingredients into unresolved opposition. The titles, which, as we have seen, are themselves often borrowed, frustrate rather than encourage particular readings. Again Hirst owns up: 'I really like these long, clumsy titles which try to explain something but end up making matters worse, leaving huge holes for interpretation.'[23] Now if Hirst always seems to have made the criticism of his work first, this is not only an ironic defence, but a claim to originality. Yet since these works are only assemblages of objects and titles, it is easy, once you get the basic idea, to generate your own:

> Four plucked vultures in formaldehyde, placed separately in glass tanks. They are suspended so that they appear to be in flight. The tanks are arranged on the gallery wall in a diagonal formation. The title: *Fair Game*.

> A series of works in which very thinly cut slices of calf's brain are wedged between pieces of glass, like specimens for a microscope. The title: *Legless, or, Bovine Spongiform Encephalitis*.

> A large cabinet with shelves on which stand jars of brightly coloured sweets – gob-stoppers, Smarties, Refreshers and the like. The title: *Knows Candy*.

As with much conceptually based art, if you like a piece and want to own one, there's no reason why you shouldn't make one yourself. It's just that those who say they like it, don't. And those who do buy it, really want to own the authentic object, even if it's just a piece of string. Where does this leave Hirst? According to Gordon Burn:

> Because his art is idea art – art drawn on the back of cigarette packets and beer mats, roughed out in airport departure lounges and the backs of taxis, usually delegated to and carried out by others – this leaves Damien a lot of time for what might loosely be called socialising. Hanging around.[24]

And his favourite place for that, Burn continues, is the Groucho Club, the place where you are least likely to risk rubbing up against any serious art talk (of course, there are all manner of places where that is no danger at all, but they are populated by people without money or celebrity). So it is not just that the artist is better known as a social animal than for making art but more that the art itself is a spin-off of the reputation for socialising, the product of a figure that, like the work itself, is a collage of quickly recognisable cliché.

Hundreds of spin paintings and spot paintings are made by Hirst's assistants (the spin paintings are disks onto which paint has been flung while they are spun at high speed; the spot paintings are regular grids of spots, the colours selected from ready-made household paints). Asked in 1995 whether he was still making spot paintings (he had made about seventy then), Hirst said that he kept trying to stop.[25] He is still failing in this attempt. Both sets of paintings are collectible items in endlessly variable series, not editions but 'unique' works that are nevertheless manifestations of a single idea. While they look a bit like conventional art, their value is supposedly conceptual. They are not objects that receive sanction from the artist's touch but as emanations of the artist's brain. Yet the only clever thing about either series is their exploitation of the market (which could also be read as an implied critique of market mechanisms, but equally well could not be); their value, the reason why Hirst is in a position to mount that exploitation, is entirely to do with his celebrity. Some of the titles make a virtue of their very media-informed banality: *beautiful, fleshy, spinning, expensive MTV painting*; while others support the Hirst

7 Damien Hirst, *beautiful, screaming, razors, screeching brakes, slicing skin, dark blues painting*, 1996

myth: *beautiful, chaotic, psychotic, madman's, crazy, psychopathic, schizoid, murder painting*. Indeed, he says of them that they 'are almost like a logo as an idea of myself as an artist. Some sort of sculptural consumerist idea.'[26] Furthermore, that:

> I always felt like a painter who couldn't paint and I liked the way you could create this formal way of making a painting, and that I could do it for the rest of my life. I like this idea of a created painter, the perfect artist. Art without the angst.[27]

The fashioning of the work as a logo for the personality, and the confection of a persona is something that many artists do; but here celebrity seems to function in a particularly pure fashion.

Hirst's track from the factory buildings of *Freeze* and *Modern Medicine*, through the ICA and the Saatchi Galleries to the official endorsement of the Tate and even the Royal Academy has been completed. In terms of making art, it is hard to see where Hirst goes from here.[28] As we have seen, this does not mean that his art making has stopped – rather, it continues apace at the hands of his assistants. There is a large market for replicas of things that Hirst has already made. There is also curation: for Hirst there is no distinction between making art, curating exhibitions and making video or films.[29] Indeed, making shows and making work are both forms of collage.[30] He has, though, been venturing into other activities, making films, including one very poor effort, *Hanging Around*, which even Hirst now admits was amateurish and 'very tacky';[31] and has opened a fashionable London bar and restaurant called 'Pharmacy' (despite the objections of the Royal Pharmaceutical Society) which is rather in the manner of a themed eating place, like Planet Hollywood, for those who desire the Damien Hirst ambience.[32] There was a collaboration with Blur on their video *Country House* in 1995, and a single, *Vindaloo*, serving as the half-ironic anthem for new lads in their support of the England football team in the World Cup, made with Blur's Alex Jones and the comedian, Keith Allen, that reached the top of the charts in Summer 1998.

There is also Hirst's book, *I Want to Spend the Rest of my Life Everywhere, with Everyone, One to One, Always, Forever, Now*, an extravagant and extravagantly banal production, devoted solely to the Hirst image, the mergence of the character of the cheeky chappie and bar-room philosopher and his visual products.[33] As Robert Garnett wrote of this self-consciously over-the-top production, '... I do not think I have ever seen a book that tries so hard to impress as this one.'[34] It is full of his dead-end images and equally dead-end sentences, placed on the page in a portentous manner.

Already by the time that he won the Turner Prize, the honour seemed less the apotheosis than the headstone of Hirst's art. His grand statements, both earnest and amusing, already looked old-fashioned alongside the archly crude constructions of many of those that followed. This was the ground for the

endorsement of the Tate: as the fashion wheel of the art world turned faster and faster, catching up with tabloid time, Hirst already seemed like a dated classic. There is another way of registering this same development. As early as 1990, Hirst was saying

> I can't wait to get into a position to make really bad art and get away with it. At the moment if I did certain things people would look at it, consider it and then say 'Fuck off'. But after a while you can get away with things.[35]

And it must be said that he has achieved that ambition.

In a work of 1991 Hirst is seen posing for a photograph in a morgue with the severed head of a dead man. In the picture, Hirst is grinning broadly, leaning forwards to put his head next to the head propped up on the slab, its eyes screwed shut, its face creased in an expression some find comic. When the photograph was shown on television, though, the relatives of the dead man recognised him. 'Sometimes you're negative, sometimes you're positive', Hirst has said, 'If you see people as flies, you can see them as butterflies, small and disgusting or fragile and beautiful. Something that intrigues me in all the work is the action of the world on things.'[36] And something he disavows is the action of his work on the world.

Hirst exemplifies the 'death (and resurrection) of the author' in a particularly clear fashion. In the first stage, the artist expresses universal themes in traditional works of art, but those themes are banal and instantly recognisable, like clichés in advertising. Being accessible, suitable for illustration in lifestyle magazines, it is an art that by necessity requires instant recognition and works using short cuts. Then, gradually, the clichés become associated less with their ostensible content and more with the figure of the artist himself, so that cigarettes, for instance, become a sign not of life and death but of Hirst's media profile.

Hirst says of his shark: 'You kill things to look at them … You expect it to look back at you. I hope at first glance it will look alive.'[37] And the resurrection of the artist is similar; a half-life only, like that of the zombies and vampires of his beloved horror films. As many writers pointed out on seeing the shark on display at the Royal Academy's *Sensation* exhibition, after years in

storage it looked tired, patched up in places, less alive than when it was freshly in its tank.[38] So with the artist: no longer the font of expressive feeling, or a site of conflicting impulses, but rather a media image from which the work is by no means clearly separated.

Gary Hume: WYSIWYG

In marked contrast to Hirst, whose celebrity and art are as one, Gary Hume, the most prominent painter in the high art lite tendency, is celebrated for what amounts to an absence of personality. When newspapers or magazines run articles about Hirst, they tend to show pictures of the artist; when they run articles about Hume, it is mostly with illustrations of his work. Yet there is a fundamental similarity between the work of Hirst and Hume: their manifest and self-conscious banality. Both in very different ways feed off media cliché.

Hume takes a deliberate distance from Hirst and the conceptual end of high art lite, seeking to make decorative, feel-good work. While Hirst's clichés are presented grandly and portentously, with gothic larding, Hume's make a virtue of banality, presenting themselves as pure surface. When he entitles one of his door paintings *Symbolic Representation of the Journey from the Cradle to the Grave and Beyond* (1991), it is in mockery of higher significance. He says, in a jibe at Hirst: 'I want to give a bit of love and wonderment and satisfy that part of people's needs. I want my paintings to carry more than "Isn't it horrible, people die".'[39] And further, about conceptually based art:

> Other works are not really designed to move you, they're designed to take you on a thought journey. And those often can only be appreciated once you know what the journey is. But I'm not making things like that.[40]

In his figure paintings calm slicks of household gloss, 'impenetrable, domestic stuff', delineate androgynous beings in poses holding no particular significance.[41] They are highly reflective, and the viewer tends to see their own reflection and a bit of their surroundings in the surfaces, which might lead to musing about their implication in the operation of the mass media.[42] The style is highly distinctive, the paintings nicely posed between being representations

8 Gary Hume, *Puppy Dog*, 1994

and objects, and the titles trendily refer to various very naff British media per-
sonalities. Tony Blackburn appears (at least what might be the outline of his
1970s hairstyle does), Patsy Kensit and Kate Moss. While in some of his paint-
ings Hume has drawn on sources of far greater historical import, including
the figures of the Fascist sculptures that surround the Olympic Stadium in
Rome, you would not know it from the results that have a sugary-sour flavour
entirely suited to their banal titles.

The pictures often start out as tracings on sheets of acetate of pictures from
magazines or books, and Hume uses an overhead projector to transfer them

9 Gary Hume, *Tony Blackburn*, 1994

onto the large aluminium panels on which he paints. Gregor Muir asks us to
imagine Hume at the breakfast table, flicking through these sources until he
finds something appropriate, and then tracing with marker-pen the lines,
'spare, light-handed, telling us all we really need to know' that will divide the
paintings' 'lakes of pure colour' that 'butt up against each other, forming thick,
creamy ridges.'[43] Liking the skin surface of enamel paint, Hume does not dis-
turb it with brushstrokes.[44] There is an obvious congruence between the char-
acter of the paint surface and Hume's own defensiveness.

The emptiness of this work is calculated: 'The surface is all you get of me',
he has said in a much-cited phrase.[45] The slick sensuality of these works is

matched with a near-perfect ambivalence. They can be read equally well as pure surface (a comment on the media simulacrum) or as vehicles for a quasi-religious redemptive beauty. One writer on a visit to Hume's studio starts out by saying that the paintings 'fill the room like a charm offensive – clean, candy-hued surfaces, beguiling, uncomplicated shapes. They disarm you, and make you feel suddenly, stupidly happy.' But after a bit, she decides, they exude a melancholic and poignant stillness.[46] Hume encourages that oscillation, claiming (aside from the saying that the work is pure surface) that 'All my paintings are religious.'[47] The result is a two-pronged marketing offensive. Hume carries the 'what you see is what you get' attitude so far that it comes close to flipping over into something else – that by trying his hardest to say nothing he might end up saying everything – and indeed the apparent potential of the paintings' tendency to do so is the secret of their being accepted as high art rather than as mere decoration.

Given the work's ambition to achieve total ambiguity, judgement about its quality is hard to fix upon; as with the common defence of the computer programmer, 'that's not a bug, that's a feature', it is difficult to say in Hume's painting which is which. On a visit to the artist's studio, Adrian Searle made a concerned remark about blips, accidental bleeds and other unintentional disruptions to the surfaces of the paintings but Hume assured him that once in a gallery they would 'look like nuances'. And, says Searle, so they did.[48]

If there is a precursor for this lack of affect, this dull but poignant repetition of mass media cliché, this utter disconnection between work of art and the internal life of the artist, it is in Andy Warhol. But in Warhol the effect is quite different, and for two reasons. First, that Hume does not present himself as a media personality in the way that Warhol did: there is no attempt to match the blankness of the work with that of paradoxical self-presentation. Second, that the considered nullity of the work does not emerge either out of copying notorious ready-made media images, or out of quasi-mechanical techniques of reproduction, or out of collective working practices (Warhol's Factory). Hume works at painting on his own, and makes highly individual images, so far from being readily known or immediately recognisable that some of them can be quite hard to read. Even so, the effect is the same: as one writer put it in praise of Hume, his various techniques 'make way in the end … for a

unique image, strongly individual and totally ambiguous.'[49] Total ambiguity is equivalent to vacuity, and to produce such nullity from the conventional practice of painting is an achievement indeed. Hume is at the opposite end from Hirst in that signature style is totally separated from media persona; but a similar emptiness lies at the heart of both the work and the artist's identity.

Tracey Emin

If Hume disappears as an artistic personality, and Hirst is pure manufactured celebrity, the connection of art and life in Tracey Emin's work seems at first to be very straightforward. She sells her memories, even her family snapshots and mementoes, to other people. What is there to say about Emin's art other than to hold it up for the viewer's appreciation, exclaiming 'here it is'? It seems to be very direct and to be about life as it is lived. Emin herself says of it:

> It's about very, very simple things that can be really hard. People do get really lonely, people do get really frightened, people do fall in love, people do die, people do fuck. These things happen and everyone knows it but not much of it is expressed. Everything's covered with some kind of politeness, continually, and especially in art because art is often meant for a privileged class.[50]

Her art, by contrast, is meant for everyone and much is made by her supporters of the reactions of 'ordinary people' who sometimes break down emotionally before it. Emin's exclusive subject matter is her personal life, and that life, as read off from the art, has included underage sex, rape, abortion, bouts of serious depression and long periods of drunkenness. These are represented in words and pictures, in small, edgy monochrome prints and in large assemblages of sewn material carrying inarticulate messages of love and hate. Most famously, Emin made a tent, *Everyone I Have Ever Slept With (1963–1995)*, the inside of which is covered with numerous sewn dedications to lovers, her twin brother and grandmother, a teddy bear and her aborted foetus.

Emin herself is far from ordinary, and indeed must count as a bit of an oddball, or at least she is concerned that she be thought of as one. A firm believer in reincarnation, she has proclaimed that this current life is her last, and that

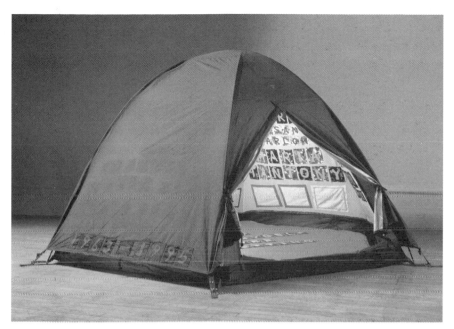

10 Tracey Emin, *Everyone I Have Ever Slept With (1963–1995)*, 1995

she expects after her death to become part of the sun.[51] She tells Stuart Morgan that her mother used to hold seances at home with the child Tracey under the table, and that the whole family is psychic,

> … especially Uncle Colin who died. He was decapitated in a car crash. It only took a moment. He was holding a Benson and Hedges packet just before he died. It looked like real gold.[52]

Emin has made a work about this death, including a newspaper cutting about the car crash (lest we should doubt); in her published statements, as in her works of art, there is a continual slippage between memories of an event and poetic imagining. Her eccentricities and the awkwardness of her expression assure her viewers that the art is authentic and sincere. Indeed, Emin frequently says that the work has no irony and should be taken as 'totally sincere'.[53]

As with Hirst, Emin is most tied up with the big themes of sex and death, though filtered through the circumstances of a life that, however particular

and extreme, is also one that should stand in for everyone's life and emotions as a whole:

> My big idea at the moment is for making this room that is eleven foot by seven. In it is a bed, and it's got wood panelling around it and a light bulb, and on the bed there's blood and used condoms and dirty underwear and creams. The pillow case has just been ripped in half, and there are feathers everywhere. And in the middle of the room is the hangman's noose, but it's made out of anything but rope.[54]

Likewise, in a monoprint, *Weird Sex* (1997) a young girl sits demurely, perhaps pensively, in a graveyard, her hands in her lap. These subjects are matched by a style that is concerned above all to impart the idea that the works had been executed in an unconscious outpouring of emotion, perhaps not entirely sober, or with the more labour-intensive pieces made over months, in an obsessive exorcism of painful passions restrained only by the soothing and mind-numbing rhythms of handicraft.

11 Tracey Emin, *Weird Sex*, 1997

Emin's writing, which is on occasion very effective in conveying emotion and economic in its story-telling, is rendered in a script that frequently teeters on the edge of illegibility or loss of control, full of misspellings and reversed letters. With the monoprints, and perhaps this is part of the point of using that technique which produces single prints, everything is drawn and written reversed; it is a way of hobbling the fluidity with which anyone used to it normally writes and of making slightly awkward the drawing of a much-practised hand, the rhythms of which seem to run the wrong way.

The cover of Emin's book, issued by her dealer Jay Jopling, shows her painting naked, and there are other similar pictures inside.[55] She is the art world's very own postmodern primitive, beavering away in a state of nature at words and pictures that place the sophisticated consumer of art in a state of half-belief, or suspension of disbelief. In this, her identity as an eccentric seems more important than the ratification of the work that might emerge from her being half-Cypriot, or working-class, or simply female.

Given Emin's state of beatific and indulgent primitivism, the scepticism of journalists who, investigating one of her more outlandish stories, discovered that no dinner lady had been killed at Emin's school with a medicine ball seems a bit impolite and beside the point (like trying to find out if a drunken street-dweller really had once been a millionaire), for her authenticity lies at the level of diction, not of discourse, in how she speaks rather than what she says. That viewers are at least prepared to suspend their disbelief is important if Emin's art is to raise anything other than a laugh; the viewer has to be constantly assured of its authenticity, by the works themselves and by those who write in its support.[56] Behind that attitude, among her privileged viewers lies a deeply patronising attitude: that of enjoying the safe spectacle of Tracey's performance – of everything that she does – in a manner that leaves all else in their lives untouched. Emin, who has rather a conservative view of what art should be, is worried about this expansion of each fragment of her life into her art, complaining that when she held a birthday party, it was seen as an art work.[57]

That expansion of the work is a product of Emin's celebrity, and her fame itself starts to collide with the message of her art. Emin is clearly worried about this, too:

People think that because my life has become more comfortable, my work will get insipid. On the outside it might look like my life is very comfortable, but inside my heart is still in turmoil over things. I still go to bed crying, I still pray to God for a better life, I still curl up in a small foetal shape and cower from the world and those feelings never change.[58]

Emin's celebrity is a problem for her work because it might compromise her authentic primitive self – thus her continued mining of her childhood, adolescence and home-town happenings, the ineluctable past time of innocence and its first loss, and thus her neglect of later events.

There are many people creating confessional and self-exploratory work of the kind that Emin makes, not for sale and display as fine art but as therapy. Most of them lack both Emin's art-school training and her education in philosophy; but since she herself makes such a concerted effort to ensure that this

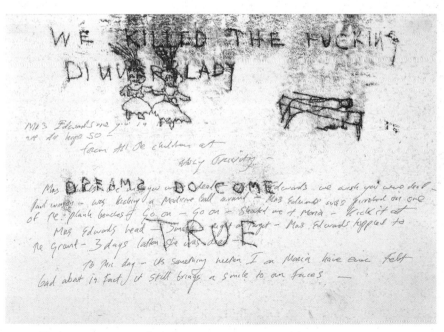

13 Tracey Emin, *We Killed the Fucking Dinner Lady*, 1995

learning leaves no evident trace in any individual work (as opposed to its mark on the overall project), the embrace of Emin by the gallery system may at first seem curious. Matthew Collings points out that Emin's work is very different from that of the others of her generation and social set, because it has immediate impact, rather than being an art that has to be appreciated by wondering about ideas.[59] But is all what it seems?

It is true that Emin's critic-fans, in the face of these revelatory displays of adolescent sex and angst, forget all they ever knew about 'theory' and, more particularly, about the critique of expressionism and authenticity, the death of the author, the fracture of the self and the gendered politics of representation. Indeed, in wittering on about religion and the soul, they have produced some of the most craven nonsense ever written about a 'young British artist', which is saying something. For Neal Brown, the Tracey Emin Museum (a space the artist ran in South London to showcase her work) is her 'spiritual shelter, corresponding in its own way to those historically most important spaces: the cave, the cathedral, and the cunt.'[60] The focus of such writing is fixed upon Emin's personal integrity, closing the gap between art and the self until the two become indivisible: to reject the art is also heartlessly to reject the artist, a vulnerable-tough fighter-victim.

Yet Emin's work, like Duchamp's, is not merely a collection of words and objects but their combination with the art gallery and the museum. As with Duchamp, she is cursed with the Midas touch (there were things, too, that Duchamp made – scientific and household devices, toys – that became works of art against his intentions).[61] Seen in this way, her project takes on a more conceptual tone, as the very extremity of her directness, her raw expression collides with the refined space of the white cube. To present there such undigested material sets up a conceptual frisson in which Emin's exhibited qualities are transformed into something close to their opposite in the minds of polite viewers. It is fitting that for Emin's first solo exhibition (at Jay Jopling's White Cube) entitled *My Major Retrospective*, she showed a piece, *A Wall of Memorabilia*, which was just that – a selection of purses and notebooks and trinkets pinned to a wall – and that the idea for this display had come from her boyfriend, Carl Freedman, a student of anthropology.[62] Sometimes the opposition creeps into the work itself, as in crude messages and drawings made

on the letter paper of swanky hotels. Emin occupies a discrete, logically necessary place on the high art lite scene, in a system which is bound up with the fine gradations of social distinction. The work is less a protest against politeness than dependent upon it.

This strategy allows certain mystical airs that used to hang about the practice of fine art but which had been ridiculed by many of the new generation, to be reintroduced under the protection of Emin's integrity – after all, she 'needs art like she needs God'; she has told us so.[63] Having it both ways, religious significance is used to raise the tone of the work with spiritual ballast, and to stamp Emin more effectively as an authentic primitive.

In Emin's case, as opposed to Hume's, there is little ambivalence in the work itself; instead, there is a world of it in the gap between the work and the implied viewer. To the extent that it has a life in truly public spaces – in the mass media, or even in accessible exhibitions – that gap may be reduced.[64] Yet seen in exclusive galleries, or toured in British Council displays to tasteful white boxes in Germany and Scandinavia, or hung on the walls of privileged collectors, it becomes immense. Emin's subjectivity and its expression become conceptual signs of the exercise of elite and knowing taste.

Gavin Turk

Gavin Turk first became known for a work he showed at his MA degree show at the Royal College in 1991 – a blue English Heritage plaque of the kind found on buildings saying that someone worthy lived or worked there. Turk's read

<div align="center">

Borough of Kensington

Gavin Turk

sculptor

Worked Here

1989–1991

</div>

and it was the only piece on display. He was not granted a degree.[65] Nevertheless, he was promptly signed to a gallery and the plaque became available in a limited edition.[66]

14 Gavin Turk, *Cave*, 1991

As well as Turk's name, his image appears insistently in waxworks and photographs, in a variety of guises. Alex Farquharson economically describes one well-known example:

> Gavin Turk's *Pop* is a waxwork portrait of himself as Sid Vicious singing Sinatra's *My Way* in *The Rock 'n' Roll Swindle*, in the pose of Elvis playing the part of the cowboy in a movie as silk-screened by Andy Warhol …[67]

In this work, the artist appears as a combination of handed-down stars, each with strongly negative as well as positive aspects to their personas; charismatic, but also abject.

Turk's art works are often clusters of art-historical references, assembled into objects that are both accessible and appealing: his signature formed by cutting into the shells of *One Thousand, Two Hundred and Thirty Four Eggs* (1997) arranged in a grid, the name born from the cracking of the eggshells, and at the same time a nod in the direction of assorted Surrealists (Magritte, Dalí and that well-known bird lover Ernst, as well as Manzoni).[68] While the references to other artists and source material of all kinds in his work form a

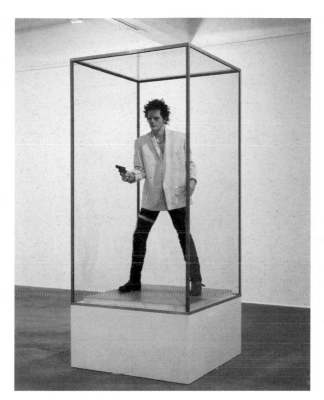

15 Gavin Turk, *Pop*, 1993

very complex web, Turk does have a tendency to highlight those artists –
Duchamp and Manzoni in particular – who asked the most radical questions
about the connection between artist and work.

Turk's collapse of the work of art into the signature is the turning of the
screw on an old Duchampian idea. He recounts how

> In the beginning I tried to create an artist who had the same name as
> me. I was interested in the cliché of art, the myth of the artist,
> stereotyping, all art as types of signature. And at first there was quite a
> clear and comfortable degree of separation. The artist Gavin Turk had a
> studio and made art under a certain kind of licence. Now it has become
> much more problematic to sustain a separation between myself and the
> artist Gavin Turk.[69]

This is because he has become better known. Of the signature works, Turk states: 'I could only make them in the first place because my signature wasn't worth anything, but now I suppose it is.'[70] A play on the notion of a 'signature style', these works make a critique of the market and its need to mark individuals off from one another but at the same time (because this is an original move, if only original because it is so very derivative) they become a very suitable vehicle for that market. Even fakery can be authenticated, as in Turk making his own signature on *Piero Manzoni* (1992), his copies of Manzoni's signature. While at another level of self-consciousness, since at another level of recursion from the traditional authentic art object, the same dilemma faces a viewer of these works as it does a viewer of Hirst's spot paintings: are they critique or exemplification or both at once?

Turk's stated ambition is to be the artist who ends art.[71] He is aided in this project by the condition of art itself, reduced to 'stammering', so that we can see that 'we are almost at the end point, the last work.'[72] This project is pursued through taking art to such a degree of recursive reference that it denatures itself, exorcising the old ghosts of the aesthetic and of expression, and permitting high art to dissipate outwards, losing itself in the culture as a whole. His linking of the two issues, the identity of the artist and the end of art, allows him to examine one of the contradictions at the heart of high art lite, and one embodied by Hirst, Hume and Emin. Turk may be more conscious of that problem than the others but he is no freer from it. He is condemned by the demands of the market to carry on, with whatever manifest stupidity or whatever blatantly borrowed means, to make objects.

The artist's persona

The new mode of artist-personality and its relation to the work did not spring from nothing. Again, Warhol was the obvious precedent: his 'factory' production, media profile and gnomic statements are all reminiscent of Hirst, the flat and vacuous quality of his work, as we have seen, close to Hume. Aside from Warhol, there was another model of the artist, closer to home and still present on the scene, that offered an example of the way that art, image and celebrity could be combined: Gilbert and George. For that artist-duo, persona

was all-important, and inseparable from the art in which they appear. Gilbert and George were important examples in their manipulation and provocation of the media, their ambivalent attitude to political correctness (highly conservative in their image and their statements but not above complaining of gay-bashing when they were attacked for those views), in their overt populism and in the performative aspect of their art. That image was carefully fostered by the artists and their dealers, for instance in literature that provides an early example of artist-celebrity hunting, with its endless, feature-article-style recitation of trivialities delivered with great import because brushed by the hems of the duo's suits, a style that was to become all too familiar when applied to Hirst and those that followed.[73]

In different ways, Hirst, Hume, Emin and Turk – and they reflect high art lite as a whole – show that it is possible to continue making art without an interior life, or without marking out a separation between life and art. The level of recursion of reference in these projects has moved on from what went before: these artists are not so much engaged in masquerade (in putting on an identity as you would a costume) as in a masquerade of masquerade. High art lite is post-psychoanalytic, not in the sense that it is so thoroughly imbued by psychoanalysis that it no longer has to make a fuss about showing that it is, but rather in that, following common sense and current scientific knowledge, psychoanalysis is simply ignored as irrelevant. Hirst has become a cipher for the expression of average desires and fears, expressed consciously and without conflict, and finally reduced to the status of a corporate logo, the visible manifestation of a brand with a unitary and fully knowable character. Hume's surfaces are the conduit through which, without resistance or disturbance, currents of fashion and trivia are conveyed to the gallery stamped with the imprint of high culture in raised welts of paint. Emin is the half-knowing, half-exploitative gender-, class- and race-primitive whose demi-Mediterranean passions and anxieties, far from being the product of repression, are the conscious playing out of excess and have become the conventional sign of authenticity and directness. Turk has set out to make of himself a name without a product, or with a product that is vanishingly small, to become the ultimate postmodern firm; but far from finishing with art, is forever condemned to bring his logo (his signature or the look of his body) into various material

forms.[74] Only in Emin's case is the work of art in any sense an expression of the artist's self, and only then at the price of the work virtually disappearing as Emin herself, and any statement she makes, any act she performs (such as misbehaving drunkenly on television), becomes art. With Hume and Turk it is variously different as the art work evacuates the self. With Hirst the process comes to a conclusion as both art work and self disappear into pure image, pure celebrity, as the time approaches when people will have forgotten how Hirst became famous in the first place (it was, after all, in terms of newspaper copy or trends in clothes or pop songs, a very long time ago).

3 Artist-curators and the 'alternative' scene

> Ah, me! … What can be more commonplace than
> an impecunious artist? If some good soul helped
> me to arrange an exhibition, next day I'd be rich
> and famous.
>
> Matthew Higgs/Vladimir Nabokov[1]

The celebrity of the artists of the 1990s has developed rapidly in the case of Hirst, slower with others, but it has done so partly because they appeared to be making a new and vital contribution to the British art scene, and it is that radical moment which we will examine here.

The most striking innovation of high art lite has lain not so much in any single characteristic of the work itself as in how it has been shown. Artists put together their own exhibitions in buildings once used as warehouses or factories, side-stepping both the temporarily defunct apparatus of the private galleries and the public sector, which was not yet ready for what they had to say. These 'alternative' shows could be very stimulating environments in which to see art, though the excitement of them was bound up with an implicit elitism. Typically, to go to one meant travelling to some unfamiliar part of London, and might involve walking through an industrial estate (an unusual experience for most art-world types). The pilgrimage, especially on a first visit to a space, would build expectation. It was difficult to predict what you would find when you arrived, and certainly the interaction between the various pieces shown was frequently surprising. Then there was the manner in which the art

was displayed, to which the building would often make a significant contribution: the best pieces were often those that found some way to respond to their environment. The vast, empty spaces of old factories were poignant places for the display of assorted postmodern artefacts; in Building One, a site for a number of the better known of these exhibitions, some of the fittings were still intact – there were regulations to workers pasted on the walls – and the building's massive rooms had their own life as the light changed, and as you moved through them. The art was, in a sense, an excuse for being there.

The exhibitions were unlike those made by professional curators. Put together by the artists themselves, they exuded an air of authenticity that encouraged viewers to leave their critical faculties at the door. While the private views of these exhibitions were sometimes crowded, the audience was a highly homogeneous one – an invited elite-to-be. Everyone knew everyone else, or at least knew someone who knew everyone else. The art, the exhibitions, the social scene that accompanied them seemed to be all of a piece, and you bought into it entirely or not at all. As Matthew Collings put it, exaggerating only slightly:

> The shows are usually a bit silly or giddy intellectually, with interchangeable titles and a lot of art objects that seem neither here nor there. The art is a secret code. Everyone involved understands it. Nobody else does. That's it.[2]

So to begin to look at the odd air of excitement and nonchalance, professional standards of management and slacker aesthetics, apparent openness and actual exclusivity that surrounded these exhibitions, we should consider the artist-curator.

If isolated amongst pure specialists, artist-curators would be curiously hybrid figures, but in fact they are surrounded by artist-theorists, artist-critics and artist-teachers, not to mention artists who wait at table, or work in warehouses, or sign on.[3] In a time of economic insecurity and in a world of temporary and part-time work where people turn their hands to many things, artists quite naturally adopt a curatorial role. Even so, the incidental appearance

16 Installation shot of *Candyman II*, 1994

of this particular hybrid has had consequences for art and curatorship that go beyond the merely expedient.

In 1988 some art students from Goldsmiths College, Hirst prominent amongst them, filled an empty administrative block in London's Docklands with their art. The exhibition was entitled *Freeze*, and, as we have seen, it was to achieve near-mythical status as high art lite's retrospectively established origin. Hirst and Carl Freedman, along with Billie Sellman, went on to found a company, Sellman, Hirst and Freedman (they liked the way the name sounded similar to 'a Jewish accountancy firm'), to present the work of recent art school graduates in large exhibitions.[4] In 1990 they made the exhibitions *Modern Medicine*, *Gambler* and *Market* (the first two being group shows, the latter a large installation by Michael Landy) in Building One.

These shows, a little more celebrated now than they were then, demonstrated that artist-curated shows in makeshift, temporary galleries could be successful. They garnered publicity and, at first, commercial success for their participants. Opened in the year before the recession took hold, most of the *Freeze* artists were picked up by private galleries. The show was a device for side-stepping the long, impoverished apprenticeship that it was expected young artists would serve before gaining such deals. Among those showing in the three parts of *Freeze* who went on to gain commercial success and artistic reputation were Angela Bulloch, Mat Collishaw, Ian Davenport, Angus Fairhurst, Anya Gallacio, Damien Hirst, Gary Hume, Michael Landy, Abigail Lane, Sarah Lucas, Richard Patterson, Simon Patterson and Fiona Rae (most have been collected by Saatchi). Set against the large numbers of artists without careers, and the tiny number who get gallery contracts, this was a remarkably high proportion of those exhibiting.

That success was not mere luck. The organisers, particularly Damien Hirst, went out of their way to mount a professional looking exhibition and to get the people who mattered to attend. *Freeze* had an impressive list of corporate sponsors, many of them associated with the service industries and urban redevelopment projects.[5] Further, the mailing list for the private view had been borrowed from various established arts organisations, and money was found to produce an impressive catalogue, essential if an exhibition is not to fade in the memory and leave no trace.[6] Sarah Lucas has said that shows like

Freeze might have been staged in old warehouses but that the people who made them did so 'to copy or emulate something much more professional than that and much more flash.'[7]

In no sense was this the establishment of a new avant garde, for there was no programme, only a certain arch positioning. Nor was it anything particularly new or radical:

> Everybody had quite grand ideas at the time [1988] which were best handled by doing big fuck-off shows that didn't need to be compromised by working within a gallery system. But it wasn't saying 'fuck off' to the galleries. It was just an alternative ...[8]

Freeze took place in a building vacated by the Port of London Authority and was funded in part by the London Docklands Development Corporation, so in the conception of this new art there was a link with state economic management and its fostering of urban development, with the driving out of old industry by the glossy postmodern businesses of finance and services. On this, Peter Wollen has aptly commented:

> ... Canary Wharf and *Freeze* are not so unconnected as one might assume. Or, to put it another way, Charles Saatchi's prospecting trips to the East End in search of art were not as alien to that other aspect of his life as we might at first imagine.[9]

Such exhibitions were in part a response to the withdrawal of state grants to individual artists in the Thatcher years.[10] They also evolved in reaction to the changing character of public art institutions in the same period. Since these were receiving steadily declining public funds, they had made systematic efforts to maintain their programmes by attracting private sponsorship. The alternative shows were simply a way of cutting out the public-sector intermediary; if the Tate or the Serpentine or the Hayward were reliant on private money to put on shows, why shouldn't artists go directly to private sources to get money for an exhibition, rather than wait for one of those institutions to recognise their worth? While the first alternative shows predated the recession, the fact that they became so celebrated in later years was a result of it: after all, artists had often curated and made such exhibitions in the past (if not on

such a scale) but *Freeze*, in particular, came to be seen as a prescient and successful tactic for survival in the hard economic circumstances of the early 1990s – a way to compete for the attention of the few galleries still dealing in cutting-edge art, or at least to maintain one's visibility until things improved.[11]

The organisers of these exhibitions intended them as alternative conduits to success. Carl Freedman later put the matter sharply and explicitly, showing that the change was not just about creating an alternative space in which to exhibit but about the wider failure of a culture of opposition:

> This success, especially the commercial side, brought a predictable sort of criticism. In Britain the Left has traditionally claimed art as its own, meaning art should be in the service of the people, and artists unequivocally anti-establishment. However, faced with such a tired and programmatic attitude, it was actually more radical to accept the establishment and to work alongside it.[12]

The passage is significant and disingenuous in equal measure. The Left's dominance of art in this country, if it was ever achieved, was brief and precarious, and just what distinctive contribution these artists wanted to make in working 'alongside' the establishment was never explained. The loose group show, the one which first and foremost says that the selected group of artists are to be taken as important figures on the scene, was a consequence of deep but masked scepticism about the effects and the ethics of art.

Yet, despite their disclaimers, what artists showed in those exhibitions did oppose the current art establishment, if sometimes inadvertently. In a country where the divide between the dereliction of the public sector and the conspicuous wealth of private business was becoming rapidly greater, and where contemporary art had tended to side with the world of polished marble and *haute couture*, the warehouse shows were unusual statements. Art was not shown in enclaves of slick affluence but in the circumstances of a wider degradation to which it sometimes referred and in which it was regularly illuminated.

In these shows, the attitude of the art and the character of the venue reinforced one another. The scepticism about art's higher purpose found an echo in the magnificent but ruined circumstances of display. As Robert Garnett has

put it, grand statements, such as 'an assault upon the "scopic regimes of modernity"' had a plausibility within pristine gallery spaces that was simply lacking when issuing from a disused shop in the East End.[13] The venues forced upon the art a certain levity and irreverence.

New versus old

The shows also implicitly criticised the slowness of the public institutions in recognising the latest art. Furthermore, they often contained work that attacked artists and conventions favoured by the established art world. What exactly was their critique directed against? Despite certain high points (in the opinion of the new generation) such as the work of Gilbert and George, Julian Opie, Tony Cragg, Helen Chadwick, Richard Wentworth and a few others, the British art world of the late 1980s seemed both backward-looking and parochial. The stars of painting – Lucian Freud, Leon Kossoff, Frank Auerbach – had been developing their painstaking practices for decades, and had been untouched by Pop Art, never mind any later innovation. Their work required the viewer to believe in the artist's integrity, and in the idea that a temperament could find expression in paint.

In sculpture the scene was dominated partly by work that came out of land art – by Richard Long, Hamish Fulton and Andy Goldsworthy. While this work was at least the product of a branch of conceptual art, it had been given a particularly British inflection, endowing it with a worthy, greenish air that pushed it away from the hard and specific lessons of conceptualism towards vague, universal truths about Man, Nature and the elements. The now aged rebels against the compromised modernism of British sculpture – including Anthony Caro and Philip King – had abandoned their industrially styled steel pieces in favour of vast, narrative works, often using traditional materials. The much-touted 'new British sculpture' of the 1980s, while it employed some non-art materials, still had a tendency to make grand macho statements. More recently, Shirazeh Houshiary and Anish Kapoor had endowed their work with an archaic religious sense, as had Antony Gormley, who used casts of his body to make figurative works – body containers, he insisted, like the case of a violin, rather than representations of a body – this tactic being a way

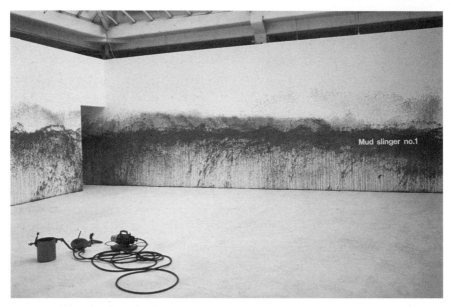

Mud slinger no.1

17 Angela Bulloch, *Mud Slinger*, 1993

of sneaking monumental figure sculpture back into contemporary art where it was quickly welcomed by the establishment.[14]

Between angst-ridden expressionist painting, and calm, latter-day-hippie melding with nature, and strivings for metaphysical significance, the contemporary world was largely passed by. What is more, these artists, almost all men, took themselves very seriously, and worked in the grand style. Despite the irruptions and rebellions of the 1960s, there seemed to be a direct line between much of this work and the older compromise between modernist, primitivist and representational elements, brought to most efficient combination in the work of Henry Moore. There was the same engagement with the rural landscape, and the same soft humanism, so convenient for consensual politics. It was that last aspect that made British art seem so worn out, for consensus had long since passed away (at least from the election of Thatcher in 1979, though there were signs of its demise beforehand) and by the late 1980s it was perfectly clear that no resurrection was in prospect. The innovation of high art lite, as we shall see particularly in the next two chapters, was to bring in a harder, cruder and more nihilistic element to art, one more suited to the times.

So the new generation of British artists had a strongly sceptical attitude towards the dominant art of the late 1980s and early 1990s, and of the specious justifications that surrounded it, from press releases to weighty catalogue essays. Sometimes this took the form of specific critique: Richard Long, for instance, was taken on by Angela Bulloch with her *Mud Slinger* (1993), a device that decorated the gallery walls with mud, as Long had done laboriously by hand, but now in a rapid and purely mechanical manner.[15] This not only took art-making out of the hands of the artist, with all the draining out of specious aesthetic experience that handing over to a machine entails, but also had the effect of making mud a matter not of the earth but of the media. Likewise, Matthew Arnatt made a Richard Long-style stone line, using large lumps of coal, displayed them in an 'alternative' show held in Building One, and called the piece *Slag* (1994). What was rural became post-industrial and, with the double meaning of 'slag', the once simple, spiritual line becomes sullied. Tim Noble and Sue Webster travelled to Death Valley to make the dour-sounding *Untitled Stone Formation* (1998) in the Richard Long manner: actually a love-heart containing the artists' initials.[16]

Another assault on what was most dear to the British art establishment was Glenn Brown's remaking of other artists' paintings, including those of Frank Auerbach. This was not merely an appropriation of an image and a comment on originality in the manner of Sherrie Levine (a US artist who notoriously made photographic copies of well-known works by modernist photographers), but also a specific attack on painterly touch as a vehicle of personal expression. In remaking paintings by Auerbach, renowned for the thick impasto of his surfaces, Brown creates the illusion of the paint's troughs and ridges on an entirely flat, slick surface. Not only is the process highly laborious and mechanical but what were records of a painter's action become part of an apparently effortless illusory representation, as in a magazine reproduction. In no way are these works a homage to the work of the older master, who Brown describes as a third rate Van Gogh. Indeed, Stuart Morgan has written that for Brown 'daft, culturally sanctioned gesturalism is an Augean stable, and he the Hercules whose duty it is to disinfect it.'[17] The mockery is carried further in the titles that Brown gives to his copies. They are generally drawn from low cultural sources – horror films, for instance: *The Day the World Turned Auerbach*

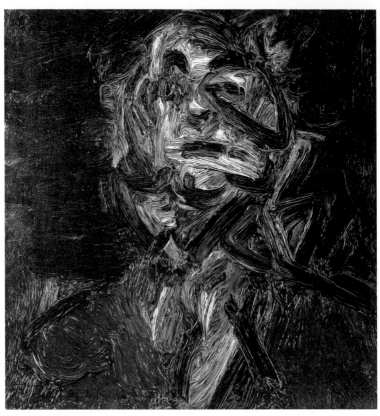

18 Glenn Brown, *The Day the World Turned Auerbach*, 1992

(1992) makes it clear that Auerbach's distortions of the human visage, being to
no good or higher purpose, are merely horrible. Of course, whether any dis-
infection takes place is debatable; rather the effect of such works, once the first
shock of seeing the old bore being satirised has worn off, seems to be to add
another marketing option to the world of art.

Further examples of this less than respectful attitude to previous British art
can be found in the work of Keith Coventry. He celebrated the act of mutila-
tion in which one head of a cast of Henry Moore's famous sculpture *King and
Queen* (1952–53), sited in a remote Scottish location, was cut off and taken
away by a persistent (sawing through bronze takes a long time) and perhaps
Jacobin or nationalist thief. Cheekily, Coventry cast his own copy of the

removed head. Further, in his works that highlight the use of the names of Homeric heroes on the signs of kebab shops, it is perhaps not coincidental that another much-revered father of British sculpture, Anthony Caro, had recently sculpted a vast and pompous assembly of Greek and Trojan heroes.[18] In a similar degrading of the high points of British sculptural modernism Hadrian Piggott, as part of a larger project, has made sculptures in soap that look similar to pieces by Barbara Hepworth, highlighting the fetishistic character of those streamlined stones and blocks of wood.

Even where previous British art was not directly referred to, there was still an implicit criticism offered by high art lite in its cool, youthful, resolutely urban stance, in the costume of hard modernity that it had slung over its shoulders in defiance of the hesitations of the past. This went further than saying even that the old art was provincial and reactionary: rather in its nihilistic outlook on art and the world, in its taking of degradation and violence as a form of spectacle, it took on the worthy, if generally unspoken, foundations of established British art. Among the statements implied by the older art and the manner in which it was displayed and supported by art institutions, and sent up by the new work are the following:

art is good for you
art has an ethical content
art illuminates the human condition
art reveals deep inner truths that cannot be expressed in words

The implied critique of these old foundational clichés was made partly on the basis that they no longer seemed plausible: no one much believed in ethics, the human condition or truth any longer, at least among the cultural elite, who were by now well educated in relativism. It was also clear that the spectacle of the art world of the 1980s hardly matched these humanist principles, being instead an unseemly scramble for money, a prime example of Thatcherite speculation.

The popularity of high art lite was accentuated, then, because of the elitism of what had gone before: both the money-grubbing, speculative, overblown neo-expressionist painting that had appeared so suited to the 1980s bubble economy, and had been sold to and made for a tiny and very well-heeled

cosmopolitan audience; and also, to a certain extent, the paradoxical consequences of conceptual art which, in favouring ideas over aesthetics, had sought to demystify art and make it more democratic but had frequently ended up producing work accessible only to those with a good education in philosophy (this will be further examined in the next chapter). Audiences used to being regaled with lies by professionals (advertisers, PR people, journalists) had developed reliable bullshit detectors, and the new art that had abandoned the high ground of aesthetics, moral improvement and spiritual enrichment, that made altogether fewer claims for itself, was bound to have an easier ride.

High and low, in and out

Even so, whether displayed in artist-curated exhibitions or elsewhere, high art lite could not quite abandon its claim to the cultural high ground. On the face of it, the embrace of mass culture by much of this new art seems to be a simple fulfilment of the postmodern proclamation that there is no longer a meaningful distinction between high and low culture. This work looks friendlier than the conceptual complexities that preceded it, and appears to speak directly to people's everyday concerns. When artists such as Sarah Lucas use spreads from tabloid newspapers (see fig. 30), they no longer need to belabour the theoretical grounds for co-opting this material; they appear to just go ahead and do it.

The accessibility of material drawn from mass culture became an important feature of the work; specialist knowledge, not only of cultural theory but also of art-history and curating, was to be rejected. Knowing about, say, cyberpunk, or football, or old TV shows like *The Partridge Family* – and as a fan, not an analyst – could turn out to be more important for the understanding of this art than knowledge of Velazquez or Picasso, or even Art & Language. The use of mass culture is more than an enthusiasm for the vulgar; it is an anti-elitist strategy that runs alongside showing art outside conventional gallery spaces. The effect of the new art and its form of display was a decided shift of power away from art-world professionals in the public sector (institutional curators and academic writers) to the artists themselves, their dealers, freelance curators and the mass media.

19 Abigail Lane, *Misfit*, 1994

Yet the apparent inclusion of a wider audience at the level of content and display produced a reaction of exclusion at another level. This new art was only apparently flippant and friendly. It exploited the transparency of mass culture to give itself access to markets beyond the high-cultural elite but, guarded by a small group of well-informed, theoretically adept insiders (often postgraduates from art and theory courses), reserved for itself a stern exclusivity. For those in the know, the works are loaded with in-jokes. Abigail Lane, for example, made a waxwork of a man lying on the floor wearing an anorak and little else. Called *Misfit* (1994) it was displayed in the exhibition that Damien Hirst curated at Serpentine Gallery, *Some Went Mad, Some Ran Away* Those personally familiar with the social circle of 'young British artists' would know that the waxwork is a portrait of Angus Fairhurst. Will Self and Hirst stand before the piece:

> 'Actually you know', says Hirst, 'the genitals of the sculpture are modelled on the real genitals of the subject.' And we stand for a while, thinking about the sensation that the cold stone would make pressed against our own scrotal sacs.[19]

The in-joke, like knowing art-historical references, assures sophisticated viewers that vulgar material has been encased in higher form. These artists' vulgar gestures are safe only because everyone in their world knows that they are a matter of choice, and that if they wanted once more to make difficult work based upon the writings of Derrida, Foucault, Kristeva or Lacan, they still could. So the work has a double face: outwards to wider audiences and media notoriety, inwards to the art world, where the old institutions, private galleries and public bodies, are definitely not excluded.

Curating has always been an odd mix of the professional and the aesthetic; if it is dominated by artists in contemporary shows, that is to play up its aesthetic side to the exclusion of specialist knowledge: we have seen that for Hirst there is no difference between making work and curating.[20] Artists' curatorial qualifications are of a primary order, and artists' selections and arrangements have a weight just because of who they are. As in the art, the titles of the shows compete with each other to be as flip and cool as they can. Such curatorial practices bear the mark of authenticity at the expense of critical distance.

Given this, the distinction we should look at is not so much that between pure curators and artist-curators, but between those curators who are part of the scene – whether or not they are artists – and those who remain outside. Carl Freedman, for instance, who as we have seen helped make some of the first warehouse shows, and curated *Minky Manky* at the South London Gallery in 1995, is not an artist, but given his social integration in the scene his exhibitions certainly fit the usual pattern of artist-curatorship.

The scene is exclusive aesthetically as well as socially but the grounds of the former exclusion are hard to define. In one sense, as Mat Collishaw pointed out, because of the fairly uniform post-minimalist flavour of this art, these alternative shows were not hard to assemble.[21] When the shows are considered as a whole, selection occurs less at the level of curatorial decision over the quality of the work than at that of what is included and excluded from the scene itself.

If there was a common attitude reflected in the work itself, it was that contradiction was courted and resolution abjured. The difficulty of defining the scene and the interpretation of any individual work are linked. When Martin Creed's band, Owada, takes apart the rhetoric of pop, starting a song, and then

20 Marcus Harvey, *Proud of his Wife*, 1994

continually restarting it, or beginning counting, 'one, two, three, four', but then carrying right on up to one hundred, it is easy to appreciate the humour and to know that some responses – like dancing – are inappropriate. Despite the recent influence of postmodern ideas over pop, we still have a good feeling for the rules that are being violated. With high art it is rather more difficult since this critical dismantling has been continuing for decades, and it is hard to know with what level of reference we are dealing: is a work referring to something else or to itself, to rhetoric or reference, or to some still further recursion? For example, Robert Garnett offers the following sophisticated reading of Marcus Harvey's paintings:

> He produces vibrantly coloured, intensely-worked parodies of post
> Abstract Expressionist painting, over which he superimposes in black
> tape, *à la* Craig-Martin, outlines of fragments from soft-porn magazines.

Whatever Harvey's intentions may be, on one level these invite readings in terms of rather commonplace notions regarding the relations between art, sexuality and the pornography of representation and the fetishistic, masturbatory nature of this kind of painting. There is, however, another way of reading them. They are executed with such manifest directness, slickness and almost formulaic ease, that they appear to be as much parodies of textbook Postmodernism as they are allegories of Modernist Formalism. What they might, then, be seen to register is the ease with which 'critical' content can now be read off the surfaces of work upon which the fashionable theories of art and gendered subjectivity have been illustrated.[22]

So is this work a critique of modernist expressionism or a critique of the ease with which such a critique can be made and read? It is hard to decide such matters, and artists, determined to have it both ways, exploit the difficulty.

Or further (to take an example about commerce, a key site of this fundamental ambiguity), a shop which Tracey Emin and Sarah Lucas ran from January to July 1993 to sell art-junk, most notoriously ashtrays with photographs of Damien Hirst stuck to the bottom (stub out your fag on the face of that celebrated lover of cigarettes) was in one sense a critical curatorial statement about commerce, but it was also an actual shop which made and sold goods, and, as Emin says, they lived off it for six months.[23]

Faced with such difficulties, the frequent recourse of critics and historians has been to rely on the statements of the artists. As we have seen, this has always been a dubious strategy because it assumes not only that these informants are open and honest but also that they know exactly what they are doing, and are able to express it. Now artists are often (rightly) refusing to let critics off the hook in this fashion; Hirst, as we have seen is anxious to place all responsibility for the reading of his work with the viewer, while Lucas responds to critical questioning with: 'I'm saying nothing. Just look at the picture and think what you like.'[24] It is not that the artists refuse to talk about their work — indeed, we shall see in chapter 9 that the interview has become a major vehicle of art writing — but they have become adept at evading definition, both in words and in making their work.

This difficulty in tying down high art lite is not a product of the postmodern condition, or the work's essentially liminal character, or of deconstruction in any essential sense, but rather of a specific situation in which art simultaneously addresses diverse audiences, facing outwards to the general audience and inwards to the in-crowd. Since the connections between the two are rather tenuous (the mass media were for a time intent on seeing some connection with so-called 'Brit-pop', for instance, that certainly lacked any substance), the task of the critic and the curator becomes fraught. A manifestly subjective and detached attitude is one of the few options open. This manner of working is a choice and a strategy. It breaks the dead hold of professional standards, of high theory over high art, but does so at the expense of a new powerlessness. While there is a certain radical charge in the act of negation against the industry of high-culture, nothing is recommended in its place except the loosest and hippest of liberalisms, defended but also defanged by irony. The inner art circle are far too cool to be offended by anything – ask yourself, especially if you are familiar with the scene yourself, what it would take to offend these people (the Chapmans don't come close – not, of course, that they are trying).

The result is lots of shows which all claim to be unique but which all say much the same thing: that they are 'alternative'. The most important claim that these exhibitions make is negative: it is to proclaim what they are not. That they are not earnest, forehead-creasing displays of postmodern orthodoxy, nor faux-naive nature- and spirit-vendors in the British tradition. As a consequence, the links between works in artist-curated group shows may have little to do with their content; for those in the know, they are much more to do with certain social sets, or who went to college where, or was taught by, and/or is going out with, whom. It is, of course, foolish to think that such factors do not intrude into professionally curated shows, but they are generally not so primary, and also a little better concealed.

Such shows certainly have many precedents, not in the public but in the private sector, in the numerous group exhibitions which brought artists together by commercial accident and celebrated their diversity. As a pure strategy, the fact that for a time such shows were run by artists rather than galleries may turn out to have little long-term consequence, and indeed private

galleries have found it easy to bring this work, and the practices which govern its curating (which were always their own) back within their confines.

Alternative alternatives

Yet not all artist-curated shows and other 'alternative' interventions had just this character. There are organisations and do-it-yourself galleries, including Bank (which we will look at in some detail), Beaconsfield, City Racing, Plummet and Strike that have made distinct curatorial interventions.[25] Making a

21 Adam Chodzko, *The God Look-Alike Contest*, 1992–93

virtue out of necessity in the first years of the recession, artists produced work that was difficult or impossible to market. Anya Gallacio spread a ton of oranges over the floor of the warehouse exhibition, the *East Country Yard Show* (1990), and let them rot. They were surrounded with silkscreen images of oranges so that the real fruit rotted while its representation remained the same. She has similarly installed slowly decaying flowers, and a room in which chocolate-covered walls turn from brown to speckled white. Gallacio's pieces, like Hirst's, are spectacular visions that encourage the viewer to think about decay, transience and death; but since these installations are non-movable, though repeatable, her practice has ultimately made her more reliant on state patronage.[26]

Some artists made work that, though not hard to sell or display in galleries, just sat for a time outside gallery circuits and traditional fine art media. Art was made with telephone calls, fan letters and advertisements in magazines. Angus Fairhurst put the headpieces of two telephones together to wind up gallery staff or other salespeople who would find themselves talking to one another and not knowing why (later tapes of such provocations were sold). Douglas Gordon got anonymous callers to phone the organisers of his one of his exhibitions, asking them inappropriate and personal questions, the resulting conversations being broadcast in the show. Georgina Starr, Gillian Wearing, and Adam Chodzko have used interviews, advertisements and opinion surveys to pursue their work and involve the public. Chodzko, for instance, staged *The God Look-Alike Contest* (1992–93) advertising for those who thought that they resembled the deity to contact him with a photograph: the results ranged from professional look-alikes wanting work (including one John Travolta) to a youngish woman photographed in her lingerie. These were simply displayed, an anthropological glimpse at the lives of the weird, uncultured and unwashed masses. Chodzko has also placed disorienting advertisements in newspapers where people try to sell no longer wanted objects, such as *Loot*, and in magazines where people advertise for sexual partners.[27]

The use of such techniques that side-step the gallery – the mail, telephone, faxes, the Internet (though the development of art there would become very different), of work staged in parks and streets – has a radical history in conceptual art and the Situationist movement. For the most part, though, in high

art lite, the tactics were employed without the attendant politics, and were filtered through the assimilation of conceptualism and Situationism into advertising.[28]

Even when an 'alternative' show looked like such a show should, the intention was not always conventional. In 1994, I was involved as a writer with *Candyman II*, in which the curators, Matthew Arnatt and Peter Lewis, were interested in making an exhibition that questioned the resolutely affirmative role of curating.[29] To make a show, in other words, which did not support the work, which was, at best, neutral towards its content. In many ways, the result resembled a typical 'alternative' exhibition, with a group of diverse artists showing in the vast spaces of the old biscuit factory, Building One. No attempt had been made to renovate the space which was so massive that even large works looked lost within it, and viewers were at one point herded into a confined space surrounded by an electric fence. Some of the work itself made tart comment about the 'alternative' art scene. *Candyman II* raised questions about the attitude of viewers and curators to art as a pursuit worthy of time, space and attention. When the show was reviewed, however, it was treated like any other such event. It was an instructive experience which showed the liberal tolerance of the system for an activity that tried to go against it, and the difficulty of doing anything that could stand visibly outside its ambit.

Bank

The most positive strand of high art lite – of negation – finds its most systematic and rigorous expression in the artist–curators' group, Bank, though it is notable that while they enjoy notoriety in the art world, this has not yet extended to either wider fame or significant financial gain. In a practice that has integrated the various institutional apparatus of the art world – exhibition making, overt curatorial intervention, press releases, supporting literature and the work itself – into a single critique, they have regaled their viewers with zombies and heaps of cocaine, entitled an exhibition *Fuck Off* (the point being partly to send out invitation cards bearing the name of the show), and most recently have offered an unsolicited service 'correcting' the press releases of other arts organisations.

22 Bank, *God*, 1997

Bank is a collective of artists which has undergone some changes in membership, the current group being Simon Bedwell, John Russell, Milly Thompson and Andrew Williamson. The burying of their individuality as artists in a collective practice is radical in itself, discommoding a market fixated on the practice of individuals (or at best duos, the members of which are each identified by name – Gilbert and George, Langlands and Bell, Noble and Webster, and so on).[30] In their paintings, for instance, Bank go to some lengths to achieve a collective style in which it is hard to identify any individual's touch. In their press release for an exhibition called *Stop Short-Changing Us. Popular Culture is For Idiots. We Believe in <u>Art</u>* (1998), Bank mockingly mark off their practice from those other art-collectives that parody corporate operation, saying that they, by contrast, are a caring family, supportive and nurturing, that also produces art. Yet their entire practice is a corporate one, with their creation of logos and mission statements, their frequent name changes and relaunchings of gallery venue, their creation of knowingly familiar marketing façades. If there is a problem with taking that role, it is that such a parody has already been co-opted, echoed in the slacker stance of the cool, youthful products that make anti-commercial statements while still managing to advertise themselves ('FCUK Advertising', for example).[31]

Bank's activity is hardly in the collective manner of old leftist practices but is rather the parodic creation of a corporate identity at the centre of which (as

their name suggests) is a noisy and constant reference to that matter of which the art world usually whispers: money. Bank's slogan is 'you can Bank on us'. One of the front covers of the series of tabloid newspapers that they made, a knowingly puerile but detailed satire on the mores of the art world, bears the headline 'Galleries "All Owned by Rich People" Shock'.[32] They also make much of the extraordinary investment prospect that the group presents. Invented quotes for the *Stop Short-Changing Us ...* gallery handout included:

'Wonderful ... in my opinion BANK's work represents a solid gold investment opportunity!' Iwona Blazwick – Curator, Tate Gallery of Modern Art

'A better investment than the Franklin Mint Diana Doll.' Sadie Coles – Art dealer

'I would recommend BANK as a wonderful investment to any serious-minded collector!' Matthew Collings – Art critic & TV presenter[33]

Some are suspicious of their motives, arguing that they have merely taken the ambiguity of high art lite into the realm of finance. By criticising with such precision the conditions of success, are they cleverly preparing the way for their own? If so, they have carried the game too far by biting the hand that feeds them in their amused if disgusted take on the activities of state funding bodies, the Arts Council and the London Arts Board.[34]

The most striking aspect of Bank's productions is that they take on the art world, not as a unity to which they have some principled objection, but with all the commitment of a realist novelist to the fine grain of its hypocrisies. Art-world slumming is a particular target:

Curators, born wealthy, wish to absolve themselves of their crimes, and become cultural middle-management; they do their bovine public a favour by glorifying oppression and financing socio-anthropological research into other people's lives.

In turn, this curational trend has spawned a legion of capitalist artists producing non-art-looking-art to feed the guilt market. With all the subtlety of the average rock video, 'the street' is identified as the site of 'the real' and 'the people' – with the guilty gallery 'not real', 'elitist'.[35]

That commitment to realism, hedged about with ironic ramparts, naturally, is seen in their art work: in the laboriously made waxwork figures for their show *God*, that drew on Grünewald to make a politically correct Easter spectacle of a crucified trio, including one black male and one female, hairs inserted one by one into their wax bodies; or in their remarkable pastiche renderings of 1980s neo-expressionist painting in which the overall-clad artist-workers appeared as heroes, simultaneously creating themselves and apocalyptic visions of the world.

These paintings appeared in *Stop Short-Changing Us*While it parodied the grandiose excesses of 1980s painting, its critique of the art world's feigned love for boring popular culture was no less serious:

> We are sick of popular culture, after all we grew up with it! We all watched children's television and pop music and it was all shit!

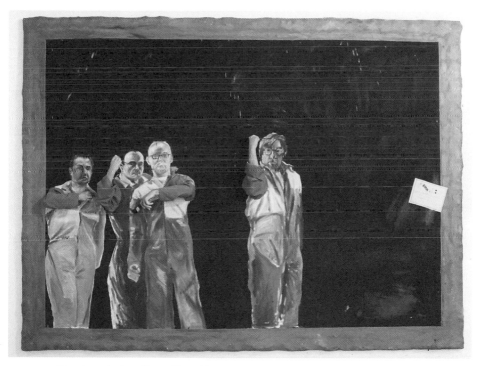

23 Bank, painting from *Stop Short-Changing Us*, 1998

Nowadays you're more likely to hear techno music *in an art gallery* than in a night club. We are bored with this. We believe in **art** and the idea of the **avant-garde**.[36]

Here two art-world obsessions are highlighted: nostalgia for the popular culture of the 1970s (think, for instance, of Brian Griffiths' *Doctor Who* style control panels made out of domestic items – bottle tops and cardboard and egg boxes, only a step or two below the BBC production values of the time) and the generally risible attempts of art stars to become pop stars.[37] The dismissal of both high art and popular culture leaves only the principled refusal to make affirmative interventions within a corrupted environment: this is the radical moment of high art lite carried to its logical conclusion.

It is not only high art lite that comes in for Bank's satire but the art world as a whole, and indeed the sanctimonious and politically correct strain against which high art lite itself has reacted. This is seen particularly in their various apparently anti-feminist shows and statements, that have included staging a mini-show by Dave Beech called 'Shut Up You Stupid Cunt'. Even the most supportive of writers worry a little about so extreme a gesture, though in the end, they decide that such interventions probably parody male pretensions to potency and control – that after all anti-feminism is a way of continuing with feminism.[38] The final effect is far from certain, but on the way, viewers enjoy material that sets itself against liberal and art-world orthodoxy.

While staging very popular private views, Bank also turn attention to what goes on at these events; at the opening of *Cocaine Orgasm*, Max Wigram discreetly filmed the guests, later showing the results in the exhibition; in *The Charge of the Light Brigade*, Matthew Higgs set up a home-brewing operation to make a beer, *Kunstlerbrau*, parodying Becks' operation to position themselves as the beer of choice in the British art world. Of that piece, Robert Garnett commented (modifying a witticism of Ad Reinhardt's about sculpture) that on the boozy London scene, art is often 'something you back into when you're trying to get another drink'.[39]

Or, to take another example of work that they have hosted, Wayne Winner mounted a mini-show called *House of Wax* within a larger Bank creation, *Dog-u-mental VII* (1996), with artists appearing by sole virtue of being

'conventionally visually attractive'. Again, something unspoken but obvious to all in the art world was brought into the open:

> It is very important to me that this show is successful and to do that I have utilised valuable assets that these remarkable young people possess. Aside from their work they have a value which is immediately transferable to all sorts of different circumstances. That commodity goes everywhere they go, is present everywhere they are. I think they are all very attractive. I think they are all extremely intelligent artists.[40]

Bank's distinct curatorial stance has been to find ways of framing other people's work within unusual, if not actively hostile, environments. Peter Doig's paintings of golf courses, pictures that would normally be treated with a degree of reverence, had to compete with papier-mâché zombies and Astro-turf hillocks in *Zombie Golf*. For a display of work by the veteran conceptual art group, Art & Language, they created a perfect white cube as a shell within their own far from pristine premises, complementing the older group's critique of art institutions with just a little too much enthusiasm.

Their last exhibition of 'corrected' press releases was a concerted and systematic attack on art-world habits of thinking, which Bank characterise as being simultaneously vacant and hectoring.[41] Their attitude to high-minded art-world cant is ambivalent, since they reject its facile, conventional statements while at the same time wishing on them greater rigour. The corrections on the press releases condemn slack and inaccurate prose but occasionally extend ironic praise to those passages that transcend mere carelessness to achieve total vacuity.

In all this, as Bank are well aware, irony is the central issue: in such a resolutely negative practice, can anything escape irony? Is there even an implicit positive in the slaughter of false ideals? In the way the art world normally runs, of course, there are certainly strict limits to irony. In their tabloid, *The Bank*, there appears a short article:

> Jovial prankster (with a ruthless streak) and funnyman Patrick Brill wasn't giggling yesterday. His ironic sense of fun has imploded all over him. 'It really hurts', he said in lightly sarcastic tones; 'I've been winking

and raising my eye-brow in an arch fashion for so long that the Doc says the damage may be permanent.' With a camp gesture, he added, 'It's straight-talking from now on for me.' Then he got serious for a moment, adding *'You'd better not put in my real name or you're gonna be in trouble.'*[42]

Thus irony stops short at the moment it affects reputation and money.

The question that Bank's activities raise is whether the art world can improve itself. Are their interventions prods to reform or mere raspberries blown in the face of an unchangeably corrupt system? David Barrett wondered, in reviewing *Zombie Golf*, whether Bank were not being overly idealistic, and whether recommending curatorial freedom was like trying to liberate a domesticated animal, the art world being too well trained in convention to take freedom when it was offered.[43] Yet the commitment with which Bank have pursued their activities, the fact that they have not abandoned high art but continue to work within it, strongly suggest that they do believe in some positive that might emerge from so consistent a negation. The problem that they consistently highlight is that, in current circumstances, it is difficult even to gesture towards that possibility.

Two shows by Beaconsfield

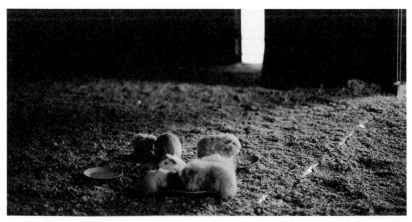

24 Beaconsfield, *'The Lisson Gallery'*, 1994, installation view

Others have tried to break with the atmosphere of pure authenticity surrounding the alternative scene, as two very different exhibitions curated by Beaconsfield – a curatorial organisation then run by the artists David Crawforth, Naomi Siderfin and Angus Neill – may illustrate. In a show curated with Matthew Arnatt called *'The Lisson Gallery'*, and publicised using Lisson-style adverts, an old pub was converted into a gallery showing drawings by David Mollins and text works by Arnatt. Crawforth had covered the floor of the pub with straw and had a herd of twenty-six guinea pigs living in the space – these are herd animals, you realise, when seen en masse. This was obviously to disrupt the viewing of art with defamiliarised domestic elements, but the guinea pigs also stood in for artists, and referred to competition and selection – based, of course, on experimentation – in the bright laboratories of the gallery system.

Very different was the Beaconsfield show *Cottage Industry* in which various women artists reflected, either in the gallery or from their homes, on their different roles as artists, workers and mothers.[44] Again, the lottery of the market was questioned, as was the fate of the vast majority of artists who do not 'make it', or at any rate do not make quite enough to give up their day jobs. This exhibition brought art up against the contingencies of the everyday, showing how it connects to the ordinary world of work and domestic life. It acknowledged that making fine art is very often a cottage industry, and allowed a more democratic identification with it from those who also have to manage work, family and the pursuits that happen to be their passion.

Tomoko Takahashi

The experience and trajectory of art shown in 'alternative spaces' is well illustrated by the rise to prominence of Tomoko Takahashi. One of her most impressive installations, *Company Deal* (1997) was made in an advertising office in Battersea in which she had been permitted to collect the firm's refuse for a month, and take over a part of the office to deploy that material. Much of the trash was paper and packaging, and with it Takahashi made huge three-dimensional collages that climbed the walls, crawled across the floors and swamped the furniture. Words and parts of faces were blackened out with thick

marker-pen, as if some manic but systematic functionary had censored the material. The installation was extraordinary because Takahashi, in an apparent whirlwind of activity, though actually through a period of long and considered labour, had both exposed and blocked the workings of this machine for churning out words and images, designed to make us buy. To be effective, it was essential that the installation be seen in the office, alongside the engine of publicity, and that its audience was not just those who came to the private view but, over a longer period, workers and visitors to the office. (Why, incidentally, would an advertising firm allow an artist to make such a work? To answer that question, and it must be answered in terms of the importance of image to those firms that deal in intangibles, is to grasp the limits – inextricably tied to the strengths – of Takahashi's intervention.)

Takahashi continued to make such installations, generally working with what was available in a particular place, transforming the waste produced by people's work into frenetic three-dimensional collages. The impression was always chaotic, as if some natural force had been at work, arranging things in an order that, like fractal images, is simple in its determinants but complex in its visual form.

In an installation for the Beaconsfield space (a nineteenth-century Ragged School converted into an art space), however, things were a little different because Takahashi chose to play down the character of the building. The windows were blocked out and the space of the old schoolroom all but disappeared, except where storage cupboards were opened and brightly lit, spewing out their contents onto the floor. The objects displayed had no obvious connection with the space – a gallery, after all – and this work was a moveable and saleable installation.

In the tall, darkened room, screens flickered and mechanical noises – a slide projector, a tape recorder – louder and softer, struck up a rhythm. A bewildering mass of junk was laid across the floor, selectively lit by old desk-lamps (relatives of the other detritus) and ordered by some obscure logic. Surveying this field of semi-functional trash, the scale began to waver. Were the lines marked out on the floor, dividing collections of objects into subsections and connecting them, the representation of circuit-board connections or road markings? Were we looking at some baroque, bricolaged microchip, its wiring tangled

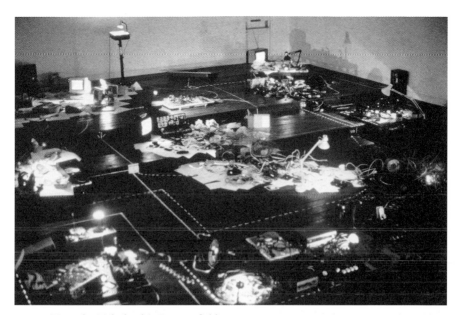

25 Tomoko Takahashi, *Beaconsfield*, 1997

like brambles, or an industrial estate, disposed over gently sloping land, at night?

Takahashi's work always seems to be in the throes of becoming – one old telephone facia in the display, with half its buttons missing, bore a single word, spelt out in capitals: 'process'. At Beaconsfield, the work stretched across the floor had a melancholy air: if seen as buildings, the junk became ruins; if as circuitry, it was obsolete. The machines that continued to turn over did so regardless of human presence, like those automated factories that operate in the dark. The relative stillness and desolation of the installation was at odds with the apparent frenzy of effort which created it, that labour being frozen in the array of ex-consumer-objects.

The viewer's attention before this installation was like that of a rag-picker, directed downwards, trying to draw sense and use from a display of dysfunction. The extraordinary variety of detritus which Takahashi had assembled was a reminder of the machine of the capitalist economy, throwing up whole genres of broom handles, for example, which can be laid out in taxonomic order – likewise keyboards, screens, clocks, bottles. When new, in all of them

human labour is embodied and invisible. The more they become useless, the more the contingency of these objects condenses – their surfaces speak of character and history, and begin to tell the stories of their origin and use.

In her labouring, Takahashi plays the role of the demon of Capital – a machine running without regard for people – laying out, ranking, discarding objects. Like that demon, her work aspires to the transformation of every single thing – in her separate installation in Beaconsfield's lower space, a collection of photographs of fragments of the gallery floor and walls was self-mockingly inscribed 'things I missed out'. Yet she does so, not to dispose of these prematurely aged objects (and the work that inheres in them) but to rescue them, giving them a new, pallid life in an order which is aesthetic, not economic. And, if these works have a power, it is because those two realms are more intimately linked than most art works claim, or most artists dare to admit.

As we have seen, the Beaconsfield piece was a gallery work and was not dependent on the specific rubbish of that place, being rather a saleable installation. It was purchased by Charles Saatchi from that exhibition, and Takahashi spent weeks reinstalling it in a very large space in his gallery, where it had a prominent place in the first *New Neurotic Realism* exhibition in 1999.[45] Many artists have come to view their work entering the Saatchi Collection with a mix of joy and trepidation, for Saatchi's ownership grants a favour of a particular kind, a stamp of approval but also a brand burnt into the work.

Takahashi did not leave the piece unaltered in its new display, and this was a case where Saatchi's appropriation of a work was only partly successful. First, she made visible in the work the processes of its creation, allowing viewers a less mysterious and more open experience than is usual before a resolved work of art. Since the work seems less finished than just halted at a certain point, viewers can easily understand the techniques by which it is made and can imagine continuing it themselves. It was also easy to see where the electricity that powers the display came from (there were tangles of cables overhead, messing up Saatchi's white geometry), some of the objects bore price labels, and the walls were defaced with scribbling about lunch breaks and trivial tasks. The writing even spoke of the ownership of some of the objects in the installation that had been lent to the artist.

In highlighting the process by which the work was assembled, its cost in labour and money, and the complexities of its ownership, Takahashi was making a very different statement from those made by the self-contained works that usually appear in the Saatchi Gallery, and that take on a uniform character as they are arrayed sparely in its clean halls. Rather than Saatchi coming to fully take possession of Takahashi, her transformation of that overbearingly large and minimalist space into a landscape of junked technology caused a temporary though radical disruption to the Saatchi image.

As with all such displays, though, their effects are passing and are limited to the relatively small number of people that get to see them first-hand. For the rest, Takahashi's work is framed in the setting of the 'New Neurotic Realism' (which we will examine in chapter 7), especially in the book devoted to the subject, and in Saatchi's efficient publicity machine.

Takahashi's progress illustrates the dilemma facing artists who work in 'alternative' venues: they can choose integrity, poverty and marginality; or they can make compromises, money and, more importantly, get their work seen by a wide public. In making the switch from the former to the latter, however, it is possible to bring a little more than the mere form of the earlier radical practice into the mainstream.

Seen in isolation, the alternative scene had much to recommend it, but it was never anything other than part of a larger system. Having looked at artist-curatorship, 'alternative' spaces and a few case studies, we should conclude by examining their wider significance. To do that, we need to take a brief detour through the issue of the character of the commodity.

The 'alternative' exhibition and the art system

The form of wood … is altered if a table is made out of it. Nevertheless the table continues to be wood, an ordinary, sensuous thing. But as soon as it emerges as a commodity, it changes into a thing which transcends sensuousness. It not only stands with its feet on the ground, but, in relation to all other commodities, it stands on its head, and evolves out

of its wooden brain grotesque ideas, far more wonderful than if it were to begin dancing of its own free will.[46]

How is it that quite ordinary objects, coal, for instance, or fan letters, are transformed, as if by alchemy, just by being displayed in a gallery? Naturally, most galleries try to cultivate this magic, setting their objects in hallowed ground against a virgin white. People often lower their voices in response. Yet a vulgar version of this same transformation is at work in adverts and shop windows. Aesthetic value, like price, is a single, universal scale on which all objects are placed, lending both works of art and consumer goods the same autonomy and phantom objectivity. They are objects, sure enough, but also the hosts of an obscure value which seems to appear from nowhere and connect with nothing.

Money and aesthetic value are absolutely linked in the eyes of the public. Try to find one of the many popularising articles about Damien Hirst, for instance, which does not mention money. Is a work of art worth £100,000 because of its indefinable aura, or is the aura a product of the £100,000? Art objects are near-perfect commodities: lacking the complication of usefulness, they are pure tokens of exchange, their value based on opinion alone. Yet the power of their exchange value is taken for an aesthetic charge: with ordinary commodities an apparent relation between things, mediated by price, masks an actual relation between people; with works of art this same autonomy of the object stands alone, yet the monetary value on which it is founded is concealed by an ideal relation involving people – the artist and the viewer.

Money is the necessary and often the sole raison d'être of the gallery system; yet, at least in terms of presentation, the galleries have a prissiness about it, carrying the conventions of mercantile display to such a rarefied level that the visible signs of commerce (price tags, special offers) tend to disappear. Money must simultaneously be gestured at and concealed, since it is both essential to aesthetic aura and what threatens to taint it.

New fuel is constantly needed for the contemporary art-world machine and, while, like oil, it must be refined, in the early stages crudeness may be an advantage. Since the fall of modernism, changes in contemporary art can no longer be described simply as progress, but are founded on the domestication

of the marginal, the dangerous and the alienated. One of the easiest ways to create marginality (especially for those artists whose accidents of birth do not allow them to play identity politics) is to flirt with the low. In the brave new world of postmodern art, taboos are forever being broken and borders constantly disrupted, and yet (with a few honourable exceptions) when we turn around and look again, all is magically back in place, ready for the next round.

The art market needs the marginal to feed its appetite for novelty; the manufacture of marginality is its business. The marginal is not so much what the art world repudiates or ignores, as what it pronounces marginal, in the next moment hoping to claim it as its own. Nothing is easier than appropriation: the offer of a contract is usually all it takes. Cultural relativism has led to a removal or reduction of the distinctions of value made between different kinds of work. We might favour the work of, say, Ian Davenport over Jason Martin but it is no longer the done thing to dismiss figuration in favour of abstraction, or conceptualism in favour of expressionism. This attitude is only the precondition for a more wide-ranging commodification, and is the aesthetic equivalent of abolishing barriers to trade. The path from marginal to central is, more often than not, merely a matter of moving work from one context to another. The creation of value demands that the different potentials between areas be exploited, like the price differentials between geographical regions across which products are moved.

Recently, as we have seen, contemporary art has often been displayed in abandoned industrial buildings. Heavy industry gives way to the cottage industry of contemporary art which, nonetheless, produces work on a massive scale, rivalling the history paintings of the old state Salons, and requiring the high ceilings and extensive floor spaces of ancient machine halls to house them. In *Candyman II*, for example, an old biscuit factory, which had catered to the sweet tooth of the general populace, was converted into a spacious mall displaying aesthetic sweetmeats for a cultural clique. Beyond this, there is a perverse attraction of opposites, in which consciously postmodern art, a product and expression of deindustrialisation and political reaction, flaunts itself within the very corpse of its victim. When the space has not been whitewashed, but left as it is, where works are shown against a backdrop of crumbling walls, peeling paint and damp stains, the effect is more blatant still.

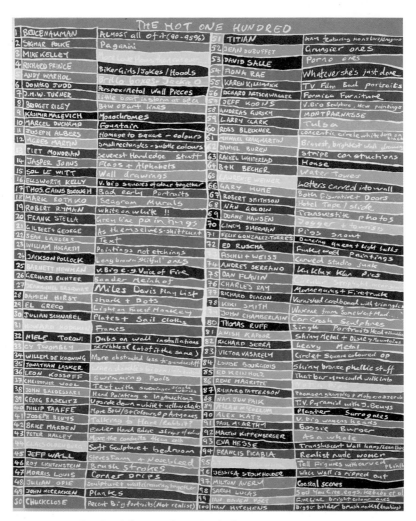

26 Peter Davies, *The Hot One Hundred*, 1996

Furthermore, this frisson is also about money, about putting art into contact with engines of commerce. Now defunct, these industrial halls become suitable for aesthetic appropriation, for they are themselves useless artefacts that match their new contents. Above all, however, the very movement of works from these tainted halls to pure white cubes, like the passage of coffee (or other drugs) from poor countries to rich, creates value.

We can imagine styles, subjects, media and their combinations laid out in a table. Within the bountiful but far from universal postmodern smörgåsbord, artists can be found to occupy most of the table's discrete positions. Individuals must paradoxically demonstrate their individuality by doing as all others do, searching for a unique position within the options. At first sight, it might seem as if there is little significance to the various places chosen, but value tends to adhere to certain areas more than others, at the extreme edges for instance, and among clusters of like-minded but differentiated artists, who form a tendency, a mass, attracting value as if they were a gravitational force. 'Alternative' group shows, for instance, attempt to create such clusters, acting as flags of convenience for artists who share nothing other than the desire to make it, hoping to be seen as part of an emerging trend that can be tagged to some place or decade, which will be lent significance as a manifestation of the zeitgeist. Of course, such a table would be constantly changing and while content as such has little significance in the competition for funds, position and trajectory are all.

The most important element in the progress of this system is forgetting; the recognition at the start of another round that we have been here before must never surface. This amnesia is in fact generally achieved, because content has so little intrinsic significance within the system, and because the weight of the support structures (advertising, writing, openings) tends to blot out the past by creating an absorbing, eternal present.

In pursuing aesthetic value, we embark on the old quest for the ghost in the machine of the fine art system. As that system is currently set up, money is both the fuel of the machine and its output, aesthetic value its exhaust, constantly evaporating in the polluted atmosphere of mass culture, and as long as the machine runs, constantly replaced. It is pointless to look for the ghost in the machine; look rather for the pecuniary machine in what appears to be the ghost.

4 **Dumb and dumber?**

A double-page spread in the art fanzine *Everything* offered 'Practical Uses for Theoretical Essays', with photographs showing a variety of feminist and leftist literature being used as carpet underlay, and an article by post-colonial theorist Gayatri Spivak serving as a sanitary towel.[1] (Incidentally, this issue of *Everything*, which carries a mock statement on its first page committing its editors to stringent theoretical rectitude, has a little portrait of Gilbert and George adorning each left-hand page.) Why this mocking dismissal of those who would think deeply about art and culture?

In Britain intellectuals who are not content to confine themselves safely to the academy but make forays into the wider culture tend to have rather a hard time of it (unless they become safe media commentators or are servants of the Right). Those with any intellectual range – examples would include Jonathan Miller and Peter Greenaway – are generally more appreciated in continental Europe than here, being considered by the domestic public to be too clever by half.

Yet in visual art a particular form of highbrow intellectual engagement did dominate aspects of the scene for a brief period from the mid 1980s to the early 1990s. It was less a matter of artists and theorists illuminating one discipline with others but rather of that odd potpourri of intellectual pursuits melded in uncertainty that came to be known as 'theory'. If the postmodern period has evolved an area of expression in which its character is most fully revealed, it is less in art or even architecture than in 'theory', a playful but deeply sceptical melding of philosophy with literary and cultural theory, grouped about the work of a constellation of European stars and their US interpreters. From that strange and contradictory mix, and despite its origins

in radically anti-rationalist if not fascistic thought, emerged standard views about the relativism of all knowledge, the inescapability of the cultural and the rhetorical, and of the imbrication of power and knowledge; all loosely attached to an ethics that somehow supported those causes dear to liberal opinion.[2]

'Theory' slowly came to be an orthodoxy taught on art and art history courses throughout the country. In the teaching of either subject, it is particularly difficult to know what contextual material is relevant and what is not – or rather, given the notorious looseness of the concepts 'art' and 'culture', it is difficult to know if *any* given material is contextual, for it might equally turn out to be the core object of study. On its own grounds, such as they are, 'theory' ought to take in a bit of everything; but in fact it is (at least in its high art strain) a specific and far-from-contingent mix of literary theory, psychoanalysis, feminist and post-colonial thinking, with fragments of European anti-Enlightenment philosophy, more often French than German. Among the disciplines generally excluded are sociology, economics, political theory, the more empirical areas of history, and the sciences (except as the object of a sociological inquiry into their conduct).

A much talked-about feature of high art lite was that it was less bound up with 'theory' than the politically correct work that immediately preceded it – or at least, it gave that impression. We have already come across one compelling force behind this change: if artists had to make their names by appealing to a wide audience through the mass media, then they had to make their work accessible. Art work that wore its theoretical grounding on its sleeve tended to speak only to those who had read the right books in advance. Even for those who had, it often appeared as a dumb rehearsal of well-worn theoretical themes. There was perhaps a complementary effect among the growing audience for contemporary art: that culture taken as a whole was increasingly likely to be experienced visually and as an activity linked to buying things. This ongoing trend is partly due to the increasing dominance of the visual mass media and their integration into advertising (everything from illustrated feature articles on furniture to product placement in films) that makes of the visual field a continuum in which lifestyle choices can be expressed. Within that context, visiting galleries has become a less intimidating and less highbrow pursuit than it was, for culture comes to permeate the shop and the café,

while commerce permeates the gallery. The effect has been further accentuated by the decline of manufacturing and the rise of service industries, a change that swept through Britain swiftly and painfully during the 1980s. In the new industries, culture is an integral part of the business, so a significant section of the middle class regularly encounters and has to deal with aspects of visual culture through their work.[3]

The art that put theory to the fore, though rarely commercially successful, was fostered in the academy, particularly on combined art and theory courses at postgraduate level, producing students who often emulated their teachers. Those teachers were artists protected by an academic wage and producing worthy pieces that played well in the art institutions, if not in the market, compensating with their earnest messages for the lurking, though justifiable, sense of guilt that attends high cultural production and consumption. Such work continually assured the viewer that the simulacrum of consumerism and the media was inescapable; of the poor, illusory and futile desires of that fractious polyp that is the self; of the eternal and unremitting nature of the oppression visited on black people, women or some other Other; of the snares of ideologically suspect visual pleasure. It was not cheery stuff, and only rarely did it allow the viewer any leeway, any response other than the sanctioned one, or any sense of its subjects other than as powerless victims.[4]

This type of work was itself the exhausted end of a more radical impulse, of an engaged leftist art and theory that had once made strong and radical statements – a part of the remarkable intellectual flourishing of the academic and cultural Left in the years following 1968.[5] But it was a Left that had been pressing against a bolted door for too long during the years of the Thatcher government, and had seen hope slip away; and many of its members, thinking that the door would remain forever closed against them, had slowly built that opinion into the fabric of their thought.

In the face of theoretical orthodoxy, an art that deliberately plays dumb may simply be making a critique of the conventions and the art that sprang from them, but it may do more than that. At its best, it can make the anti-intellectualism of large parts of British society a theme of the work. To play dumb is not just to defend yourself against attack for being a high-brow but to take the first steps to save your work from being ignored. The new art

provoked conservative critics, certainly, but also learned a good deal from them, accepting as valid their attack on liberal (and previously left-leaning) art as obscure, elitist and boring.

Very important, once again, in offering a model for an accessible, inclusive art were Gilbert and George, who continually proclaim that their work is meant for everyone. They condemn the great majority of the art produced by their generation for its difficulty and implied elitism. George, remembering his student days, says of his fellow sculptors at St. Martin's School of Art:

> We saw that all those sculptures that the other chaps were doing could not be taken outside the front door of St. Martin's, that they would cease to live at that moment, they would become invisible to those thousands and thousands of fantastic people from all over the world who walk up and down the Charing Cross Road.[6]

Or, more explicitly still:

> If you do some damn silly canvas with a black dot in the middle, unless you have it on the wall by itself with two spotlights, nobody would know what the fuck it is … There's no reason why an art-work must be completely baffling to anybody.[7]

Their work is open to non-specialist viewers, first of all because it is based upon a very readable type of photography which is then, as it were, brightly coloured in. Beyond this, their vast, figurative pictures that have often been compared to stained glass attempt to elevate the mundane (the naked bodies of two artists, well into middle age, and those of their objects of desire) to a level of religious contemplation. The opposition between content and presentation is an obvious one, and the viewer is further eased into the work by the constant presence of those walking stereotypes, the artists themselves. This work is the embodiment of a conservative populist attitude in which liberal elitism is associated with the over-cultured middle class and is pitched against the simple good sense of ordinary folk, the salt of the earth, people who know what they like. Gilbert and George's enthusiasm for Margaret Thatcher (as Brian Sewell points out, the only woman to break through their gender barrier) was no accident.[8]

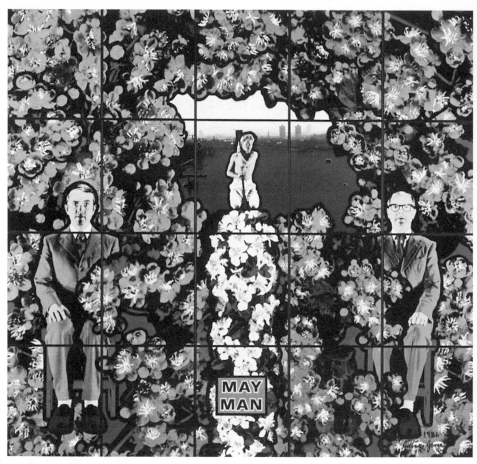

27 Gilbert and George, *May Man*, 1986

Gilbert and George were hardly isolated examples of this attitude to 'the people'. Throughout the 1980s there had flourished a variety of right-wing accounts of the English masses which, as Simon Frith and Jon Savage nicely characterised them, varied

> … from the considered conservatism of Roger Scruton or Ferdinand Mount, in which 'ordinary Englishness' is embedded in the tapestry of the English language, the organic community and historical tradition, to the anti-toff populism of Norman Stone or Andrew Neil, in which a

kind of basic British common sense is expressed through market forces, to the buffoonery of Woodrow Wyatt, Paul Johnson and Auberon Waugh, for whom 'the people' are mobile signifiers, now sages, now idiots.[9]

The result, the authors continue, was to make of the people a mythical site of authority — and this is just what they were to become in high art lite. It is important to see from the outset, then, that while the anti-authoritarian and anti-specialist tone of the new art was a positive matter in itself, this did not mean either that its sources were radical, or that it could not be turned to authoritarian ends.

The art of Gilbert and George could only provide an example, illuminating perhaps, but impractical to follow. Their anti-theoretical stance was all of a piece with their artistic personae, a couple of queer English gentlemen encased in peculiar suits, enamoured of Victorian knick-knacks and adolescent boys from the East End. What was required was an anti-theoretical stance that could be positioned at the cutting edge of art, not a backward-looking reaction against almost every novel product of the 1960s.

Among the new pioneers of a theoretically light but not naïve work is Fiona Rae whose cut-and-paste paintings can serve as illustrations of a number of very well-known postmodern doctrines. In her deliberately awkward paintings, attempts to tie the myriad of mark-making processes open to an artist into a coherent work always fail to gel — though only just. They exemplify the central postmodern contention that knowledge has fractured into a large number of discrete shards, each with its own rules, and of which no overall sense can be made.[10] Or, in a somewhat different reading, that originality has passed away, along with the author or artist, and that now all that would-be creators can do is come up with novel combinations of more or less fixed discourses that have gone before.[11] If one objects, saying that the argument that all creation is merely a collage of previous efforts is a good deal more plausible when applied to a system of conventional signs (words) than in the more open and contingent matter of painting, Rae, who once studied literature, is there to correct you: 'Language is the theme of the work ... but language only works through the combination and juxtaposition of words.'[12] To

28 Fiona Rae, *Untitled (T1000)*, 1996

the extent that the elements in her paintings do relate to one another, it is in a conventional manner in which 'one is reliant on the next', just like Saussure's signifiers.[13] The result is a painting that contains a dialogue, even an argument, between structurally differentiated elements.[14] But unlike much of the work that had gone before, hers was a friendly and decorative enactment of such theory, not a stern and prolix illustration of it.

With Rae, we have an example of a common move to retreat from the complex language in which theory was expressed. In her work, theory did not disappear but was concealed in the wings, quietly informing the painting. Rae's work is not against theory but rather draws on theory to produce pretty, saleable works that can stand some theoretical exposition but do not beat the viewer about the head with the artist's learning. But the turn against theory was to go much further than this, and to take a more explicit form than the submersion of an intellectual view beneath a decorative coat. Much of high art lite has become resistant to theoretical interpretation and deliberately so. The turn to demotic material, and the playing up of the yobbish artist personality, has meant that theory, on the increasingly rare occasions when it has dared to show its face, has been greeted with a knowing and dismissive sneer.[15] Against it is pitched a knowing, laddish and philistine attitude. Says Hirst, 'I think I'm basically getting more yobbish. Yobbish is visceral.'[16] Sarah Lucas is asked:

What is your most unappealing habit?
I run the gamut of bad habits. Smoking, nail biting, picking my nose etc. But I most dislike repeating myself and over-emphasising things.[17]

In this apparent burial of the intellect, the work of Sarah Lucas stands out. As Hirst put it sharply, there appears to be 'something missing' from Lucas's work. Much of her work cleverly plays to more than one audience – for instance, *Two Fried Eggs and a Kebab* (1992) has just these items laid out on a table to indicate a crude and fetishistic analogy with the female body. But it is not just a vulgar joke: while the pitta bread is tucked into a hole in one end of the table (just in case we miss the point), at the other, a photograph of the table and its contents is propped up, suggesting a face, and referring to Magritte's well-known condensation of face and female torso in his painting *The Rape* (1934). It is also possible, if you are so inclined, to make a feminist reading of the work in which the combination of domestic and sexual elements makes a telling point about women's role in the home.

Similar is *Bitch*, her table dressed in a T-shirt with two melons hanging in the fabric; on one level, a vulgar portrayal of a woman ready to be penetrated from behind; on another, a sophisticated parody of Allen Jones's infamous

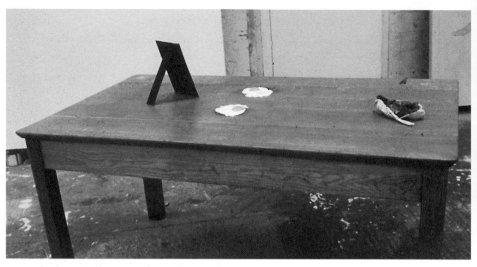

29 Sarah Lucas, *Two Fried Eggs and a Kebab*, 1992

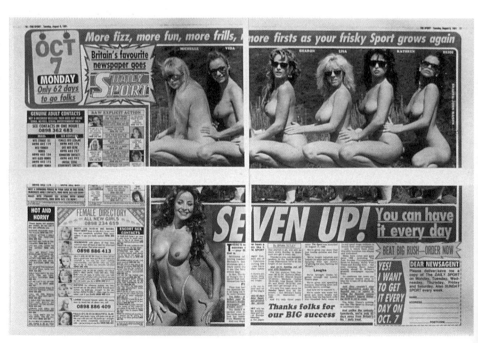

30 Sarah Lucas, *Seven Up*, 1991

Table (1969), a much slicker Pop Art production, a plastic babe on all fours supporting a table-top. Likewise, the many works in which the boyish Lucas presents herself as a sexual creature – if in the manner of *Carry On* films, suggestively eating bananas, or holding a large fish while loitering outside a men's public toilet – like much of high art lite where the artist appears masquerading as an artist, refer back to Duchamp, and particularly to the photographs in which he appears as a sexually ambivalent creature.

Yet there do seem to be works where no high cultural reference puts a spin on what are otherwise crude jokes. Lucas made a series of huge, seven by ten feet, enlargements of double-page spreads from the tabloid newspaper, *The Sport*. Aside from areas where words have been partially obscured by the pasting together of overlapping photocopied sections, these 'found objects' are left unaltered, so viewers can look at them much as they would at the newspaper itself. The works take their titles from the headlines: *Seven Up*, *Sod You Gits* and *40, Fat and Fabulous*. All are about the overt exploitation of the female body: one is a display of conventional topless 'beauty', one about a midget who works as a kissogram, another about an obese wife put up for sale by her husband. These features are surrounded by their customary satellites: pieces of trivia, adverts for telephone porn and escort agencies. So what difference is made by bringing these smutty snaps and scribbling to the gallery wall? Most obviously, they are held up for public examination in a space where a middle-class, liberal consensus reigns, where unreconstructed lumpen attitudes may be collectively sneered at, though also at the same time enjoyed. The use of *The Sport*, a paper on the margins of even the British press, with no pretensions to seriousness, is an easy target. Since Lucas makes no adverse comment on the material she uses, the work enacts what the newspaper itself does, glorying in its own bad taste and stupidity, amusing its readers with its crude and philistine attitudes. If the work has an effect, it is in placing the viewer in a situation where voyeurism and the pleasures of looking collide with conventional liberal attitudes.

Other works that do not seem to refer to previous art, and do not have the complication of using the media, include *Au Naturel* (1994), a mattress with fruit, vegetables and a bucket arranged to refer to the sexual organs of a man and a woman, or the series of pictures of a naked man, cropped at the neck,

holding a milk bottle and with a couple of biscuits propped up in front of his genitals. These works do seem simple, as if something was missing from them, relying entirely upon the current created by placing crudities of this sort into the gallery, by abutting high culture up against hackneyed expressions of vulgarity. Lucas says:

> My work is about one person doing what they can. I like the handmade aspect of the work. I'm not keen to refine it: I enjoy the crappy bits round the back. When something's good enough, it's perfect.[18]

So it is not just the content but the presentation of this manifestly home-made work that contributes to Lucas's grungy image, a purveyor of smut with a dark soul, eyes fixed steadily upon the cruelties and crudities of the urban world.

Like Gavin Turk, Lucas has created an artist, who happens to be called 'Sarah Lucas', though her persona is not solely concerned with the condition of being an artist.[19] In publications about Lucas, her image dominates, both in the art itself but also with photographs of the artist. There is again a blurring of the persona with Lucas herself; she complains that people expect her to be like her work and are surprised to find that she is not so tough.[20] With Lucas the subject is sexual identity and the way people can play it out as a role. Lucas has said that she fosters her tomboy image because she thinks that she can get sexiness into the work without looking particularly feminine, and that this brings out sexual ambiguity.[21]

Her creation of this persona adds another dimension to the work, even that which does not directly contain it, for all is the implied product of the clichéd bad-girl artist (this is something that has developed as Lucas's image has consolidated itself, and as she has become better known). So even the crudest of the works come to partake in a conceptual project, a reflection on sexual masquerade.

Despite appearances, then, theory is certainly not absent from Lucas's work: indeed, her entire oeuvre would be impossible without its insights. She admits:

> I did read a lot of feminist books exploring pornography … and questioned my use of it as material. But I'm not trying to solve the problem. I'm exploring the moral dilemma by incorporating it.[22]

Yet theory, at least as conventionally applied, in content and in language, does not seem to operate in sympathy with her art. This can be seen in the few instances where theorists try to make their words stick to Lucas's work: art historian Jane Beckett has produced that rare animal, an opaque account applying earnest feminist morals to high art lite, and written in old-style high theoretical jargon. She notes that Lucas, in talking about her tabloid pictures in the *'Brilliant!'* catalogue,

> acknowledged awareness of the feminist debate on the issue but negotiated what she saw as the closed avenues of meaning presented by the critical label 'feminist' in favour of deferred, unstable readings of the imagery.[23]

What did Lucas actually say? Did she favour deferred, unstable readings of her work? She was certainly concerned to shrug off the idea that she was saying anything definite:

> … in the end an important part of making those pieces for me was deciding not to be judged. That decision actually freed me. I'm not judged and don't have to be limited even by my own judgements when it comes to making something.

And, when pressed further by the interviewer, 'I'm saying nothing … just think what you like.'[24] Lucas's statements certainly have the virtue of clarity. They and her art are also, while taking as their basis an awareness of feminist and postmodern theory, thoroughly inimical to both, for there is no dimension of moral certainty here. It is as though this generation have learned their postmodern lessons too well, ditching its persistent but ungrounded moralising in favour of its licence to sanction anything except judgement.

Why does critical theory bounce off this work? First, because Lucas has deployed an artistic persona of the kind that we looked at in chapter 2. Issuing from that complex that is not quite Sarah Lucas, and not quite not her either, the work is protected by a fundamental ambivalence, and the viewer is placed in an interpretative trap from which there seems to be no escape. Certainly, as long as the work is considered only as the product of a persona rather than of a wider culture, it becomes impossible to place. As with spying, once a certain

complexity of bluff and counter-bluff is reached, there is no way of knowing what any statement really means. Second, Lucas – and she is entirely typical in this – presents her work as neutral, as gesturing towards a matter of concern but saying nothing about it: 'responsibility' for reading is placed entirely upon the viewer.

For theory, the combination of a false but ineluctable authenticity from which the art is supposed to issue and the neutral, non-judgemental position that it adopts, is lethal. It is not, of course, entirely new – as we have seen, these artists learnt a great deal from Warhol. While works of art built into themselves resistance to critique, criticism was having its own problems (as we shall see in chapter 9). The combination of the two gave high art lite an air of invulnerability that still lingers on. It is remarkable, indeed, how subdued the response to the tendency has been from theorists, how muted are the condemnations that one might expect on the grounds of high art lite's chauvinism, its dalliance with politically incorrect attitudes, and its dubious 'common people' outlook.[25]

So what is missing from such work? It is conceptual but not critical; it fastens upon the concerns of theory but gives them no play. Instead, a pervasive and disabling irony becalms the work in a manner that is supposed, in conventional wisdom, to challenge the viewer but which in fact conveniently opens up demotic material to safe aesthetic delectation.

Irony is the essential lubricant of this artistic mechanism. Collings nicely captures its full extent in recounting an encounter with the artist Henry Bond at a private view:

> Then he said he himself had never done any art that was of any interest whatsoever, and I couldn't tell if he was having a crisis and if I should say something reassuring, or if he was boasting.[26]

While it dethrones critical thought, irony enthrones the artist, for to see irony in the work is to believe that the individual creator has taken an attitude towards their work, and towards the viewer. The masks, then, do finally fall away in the grasping of irony, for we have to believe that the artist is at least serious about irony (or if ironic about irony, at least serious about the irony with which irony is taken – I could go on).

Looking like art

The theoretical element of high art lite tends to be underplayed, then, except by its conservative opponents, to whom its conceptual nature is obvious. If we think of conceptual art as work that tries to be art without looking like art, the reversal between previous conceptual moves and recent British art becomes obvious. It is highlighted by Liam Gillick who points out that 'there is an element in a lot of this work which is about the fact that it looks a bit like art.'[27]

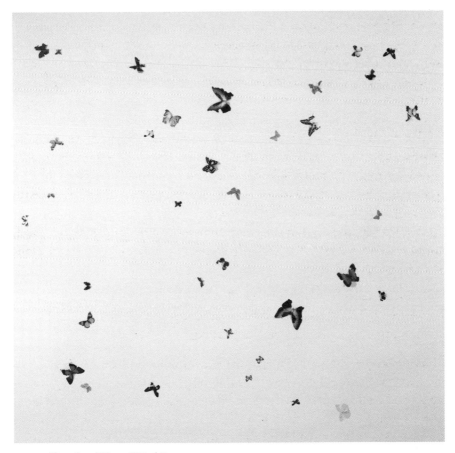

31 Damien Hirst, *I Feel Love*, 1994–95

A good example was the gauche film by Damien Hirst, shown at the Hayward Gallery's *Spellbound* exhibition, and much featured in the Sunday supplements at the time.[28] Hirst's film was to have been called *Is Mr Death In?*, an anagram of the artist's name – and with its contemporary art-world references, it is a very self-obsessed film; one character dresses in a spot-painting dress, there are fags, drugs and swish parties. The final image is of a butterfly burning on a fly zapper. For those in touch with the Hirst mythology, these are all familiar elements, and they are used for the deliberate construction of an internally reinforcing structure of cross-reference. As in Duchamp's work, the slightest bit of text or scrap of image feeds off its relation to the programmatic whole. But *Hanging Around*, as the film was eventually called, bears the puerile imprint of its earlier title. There are graphic scenes which may be designed to court controversy; of throwing up, shooting up and of a decorative, naked corpse in a bloody bath. Subtract the bolt-on Hirstian iconography, and it is a conventional tale of a man with 'special powers', who can be at more than one place at a time, and whose acquaintances death inexorably visits. This compact little man, played by Keith Allen, is bored with the mundane world of family and yearns metaphorically to fly straight upwards. At one point in his battle with a cerebral analyst, and here as at others he seems to speak for Hirst, he proclaims, 'Anybody can do *anything* – the hardest thing is deciding what it is you want to do … *intellect* has nothing to do with it.' Yet curiously, and despite the fact that this film looked very much like a film, conceptual, Duchampian matters had everything to do with it.

Or take the paintings made by Gary Hume before he turned to figurative work. They were strange objects that took their shapes and contours from hospital doors, and had a curious status, being half-painting, half-barrier. Adrian Searle commented about one of them: 'It is painted as well or badly as you or I might decorate a door. Any drips are accidental.'[29] As we have seen, this is a painter who defends his work with brief and ambivalent remarks. Early on in his career, he was a little more forthcoming, saying of the doors:

> I see them as unheroic. There is no essential core of meaning but they
> are meaningful through cognition and in relation to the synchronic state
> of art and society, whilst they remain an empty sign, a door motif in a
> potentially endless series – simultaneously spacious and oppressive.[30]

All this does is to repeat a by now familiar refrain (that the work has no fixed meaning but that it is up to people to reflect on its place in the world), though it does so in more overtly theoretical language than these artists would later allow themselves. As with Rae, such an outlook found decorative expression in Hume's works.

In this, Hume is symptomatic of a wider development: it was not that his stance changed greatly, or that it could no longer be expressed in theoretical terms, just that it was no longer necessary or interesting to do so. The early issues of the core magazine of high art lite, *Frieze*, were not anti-theory; indeed the usual European intellectuals were name-checked slackly, as in any art magazine, in an attempt to validate the artist's project to which they were attached. As high art lite settled into its mode of working, theory was less attacked than ignored, or only had recourse to when other marketing strategies seemed likely to fail. Within this atmosphere of neutral neglect, the attacks on theory, however ironically intended, in magazines like *Everything* and *Make* stand out as noisy and marginal, banging on about something that most in the contemporary British art world had just accepted as part of the new climate.[31]

Very often it is not so much that theory has been discarded as superseded: even now within high art lite there appear occasional attacks on modernism (the work of Langlands and Bell about the legacy of architectural modernism, much informed by Foucault, would be an example) but while this was a staple of 1980s postmodern art, few bother with it, any more than they worry about socialism, for to do so would be too much like kicking a corpse. That is not a register of the failure of theory, however, but of a task completed.

The conceptual basis of high art lite is most clearly seen in the prevalence of the one-liner work of art. Watching informed people looking at contemporary work is to grasp that the manner of engagement with art has changed: while you might spend half an hour or so with a single Cézanne, no one does this with any single piece of high art lite, for it makes its points swiftly, with conventional signs. To look at this work is a little like doing crossword clues; you get the answer (or more likely the dilemma) and move onto the next. An example: a doily by Simon Perriton is entirely composed of a pattern made from the symbol of anarchy – a simple but effective coming together of aged

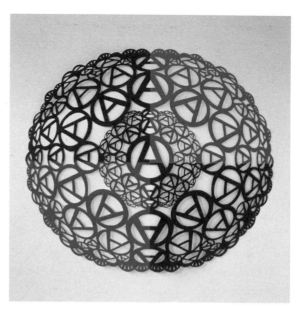

32 Simon Perriton, *Radiant Anarchy Doily*, 1997

decoration and decorum with youthful disorder and vandalism, and a suggestion that one may be as conformist as the other.

Or to take another simple example from the work of an artist with a more extensive project, Jordan Baseman's *Shoes (Size 8)* (1995), massively elongated footwear, switch the conventional fetishistic association from female to male.

Much of the work of Ceal Floyer is also in the form of visually impressive one-liners, playing with illusion: a light switch that seems real but is actually a projected image (turning on a real light switch will make it invisible), or a light bulb appears to be burning but again the light comes from a number of projections of a lit bulb, and the bulb you see is off; or the projected image of a nail in a wall, a variant on an old Cubist pun.[32]

In the synthesis of idea and image that is the visual work of art, these works greatly favour the idea, and do so to the extent that the two may become uncoupled. The image less embodies than illustrates the idea.

What is missing from such work can be seen clearly by comparing it with one-liner art that successfully convinced art-world professionals that it is of the deepest significance. Rachel Whiteread's distinct contribution, and in part

this is the reason for her success, is to combine the one-liner – few have been more consistent in the pursuit of a single idea, casting the spaces framed by objects – and a traditional engagement with material, with sculpture in a conventional sense, the result being a hybrid, part concept, part aesthetic presence. As Lucas says of Whiteread: 'All her work has the appearance of being proper sculpture and mine hasn't.'[33] The difference is not just in the use of materials, for Whiteread uses some (including plaster and rubber) that are as low and domestic as those of Lucas, but in the level on which the one-liner operates: with Lucas it is at the level of language, typically with visual punning; with Whiteread it is at the level of technique, and while interpretations circle around that base-line, being caught up with absence, death, the tomb, the uncanny, they are not bound by specific symbols.[34]

The usual rule of recursion is in force here: one-liners comment on themselves and their ostensible subject. An example is Glenn Brown's work – including, as we have seen, meticulous but flat copies of highly impastoed British painting (fig. 18). That practice can be read not only as a one-line comment on artistic expression and the 'death of the author' but also as a performance that comments upon repetition itself:

> Auerbach's portraits are like cartoons. He has a set way of doing the eyes, nose and mouth with brushmarks he has perfected over the years. He copies himself, everyone does. The notion of self-parody and plagiarism is in everyone's work; Picasso did second-rate Picassos.[35]

So Brown does only what every painter does, with the difference that he does it as part of a conceptual project that talks about doing it.

In extremis

There do seem to be occasions when theory has been needed, however, and one of the most striking examples is the catalogue to the exhibition of Jake and Dinos Chapman at the ICA. Plainly, the worry was that the Chapmans' kiddie dummies sprouting sexual organs in unusual places, or showing the victims of torture, would be condemned as simply attention-seeking and sensationalist, a crude gallop over the tender parts of the public and the media.

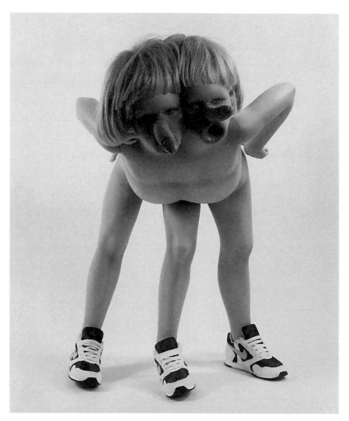

33 Jake and Dinos Chapman, *Fuckface Twin*, 1995

The defences offered were various (and others will be examined in the next
chapter) but the use of theory was strikingly prominent and unusual for a dis-
play of high art lite. Catalogue essays by David Falconer and Douglas Fogle
employed a familiar apparatus of vague gesturing towards the work of Freud,
Laplanche, Lyotard and Bataille, along with the full armoury of theoretical
jargon. Admittedly, some of the work encourages such an approach: *Cyber-
iconic Man* (1996) depicts a victim of a torture called 'The Hundred Pieces' that
Bataille describes in his book *The Tears of Eros* (the victim is slowly dismem-
bered while being given opium to prolong their life and thus their own
witnessing of the spectacle).[36] The mannequins also embody less specific ref-
erences to psychoanalytical concerns.[37] Even so, the degree and character of

the theory presented in this catalogue went far beyond the norm for high art lite.

The defence, however, could not remain in the old style – indeed the work was presented as a welcome relief from the worthy 'body and identity' concerns of the art world in the late 1980s.[38] The Chapmans were offering a radically negatory art, and if theory was to wrap its protective, elitist barrier around them, it also had to learn to be cool and self-mocking. The resulting prose was comic, though the line between what was intentionally and inadvertently funny is hard to draw. David Falconer's essay starts with an apparently straight rehearsal of theory which leads into an increasingly over-the-top description of the work, and ends with a narrative in which a perverse Doctor Who struggles unsuccessfully to prevent a mechanical vehicle of the libido from crashing. For Douglas Fogle:

> [The Chapmans] are triumphantly excremental artists whose work erects an edifice of compulsively anal proportions while depositing the traces of a sepsidic spoor amidst the hallowed halls of culture. Put simply, their work is shit.[39]

This new brand of theory has not been widely disseminated, and it is easy to see why. It combines the disadvantages of elitism with few of the pleasures of the yob. Yet its deployment here was significant for the 'it's so bad it's good' defence, and its corollary, 'anything that pretends to be better is just having you on', could not be stated with clarity if the work was to be welcomed by the ICA or institutions like it, for within that attitude was a much wider attack on the pretensions of high culture as a whole.

We saw in the last chapter that artist-curatorship was in part a matter of artists – but also business – grabbing back power from a coterie of state functionaries and academic specialists who seemed to have a stranglehold on the scene. In the face of this, specialist knowledge – and this includes knowledge of high theory – became, not redundant, but only a distinct part of a sophisticated intellectual and cultural game. The point was brought home to me when accompanying a very knowledgeable art-historian around the annual contemporary art exhibition and competition, *East*. We were confronted with a series of pictures of figures made from little plastic beads of the sort used to

prevent appliances scratching the surfaces on which they stand (I believe they are called 'bump-ons'), here attached to the wall. The art historian remarked to the artist that some of the figures reminded him of Matisse, and she replied that she had never thought of that; what he had missed – excusably, for at first they were difficult to read – was that they were all of couples having intercourse. Or equally, think of what a conventional art historian is supposed to think when confronted with a painting by Fiona Rae which contains forms that she, at least, associates with the fluid metal robot in *Terminator 2* or a painting named after a popular computer game, *Tomb Raider* (1997). It is not that art–historical knowledge is obsolete – far from it, it is necessary – it is just that, as Rae puts it, and she could be speaking for many others, 'I'm just totally unfussy about where my information comes from, it doesn't matter if it's Vermeer or the Spice Girls.'[40] Just as with demotic material, theoretical material is sometimes used within such work. The combination of the two is, however, important, creating a provocative complex that can only be fully appreciated by those with a passing familiarity with both: ruling out, that is, the crustier art–world types, cultural conservatives and all those with no grounding in the art of the past thirty years.

This qualified assault on specialist knowledge extends to the language used about high art lite. Artists very often play down the conceptual and theoretical sources of their work. Emin's tent, for instance, is very much in the line of feminist, 'the personal is political' work. Its emphasis on lived experience and a confessional mode of address is similar to that of some earlier feminist work, including that of the FENIX group of the 1970s.[41] Yet Emin is pursuing a new strategy and does not like her work discussed in the old way:

> *Your use of sewing and stitching seems to suggest the home environment – somewhere to be decorated and to perform.*
> That's a bit of a posh way to put it. I sew simply because I sew and I am actually quite good at it. It's not like I'm trying to come up with some kind of grand female statement.[42]

Likewise, the specialist language of art history and criticism comes under attack. Peter Davies says of his word paintings, which offer a flip and highly abbreviated tour of the art world,

There are great things about all sorts of different artists. Like Gainsborough or whoever. If you approach it from too learned an attitude you miss out on the reality, so the ways in which things are drawn in to culture nowadays are so quick. It's not meaningless because the meaning in things is so hyper-fast and sophisticated that people are able to understand much more quickly than they've ever been before so you can take Gainsborough and say 'he's cool because he's the original bad painter' rather than saying 'Gainsborough is very interesting to the history of British art because of blah blah blah' because you think well who gives a shit.[43]

Unfortunately, as can be seen in this statement, the attitude is not only of a repudiation of arcane jargon, of language that excludes the majority, but also of a suspicion of whole categories of knowledge, of the process of acquiring learning, and even of sustained thought itself.

One of the virtues of Matthew Collings's book, *Blimey!*, is that it offers a consistent pastiche of conventional art-world talk. His meandering prose, inability to sustain an argument and thinking in soundbites is an exemplification of that talk, and its careless but consistent mislaying of all that is important. Collings writes, for instance, about new museums in Eastern Europe starting from scratch and the possibilities inherent in that new beginning, given the ossification of Western art institutions. A director of a museum in Prague told Collings they had the potential to do something new, and Collings struggles to remember what it was:

I don't know. I can't remember what the different thing was now. In fact thinking about it I'm sure he would only have had some rather dry seminar programme or other in mind.[44]

Or, in a diary item, he thinks about looking at an article about Jasper Johns

… by an intellectual like W.J.T. Mitchell or T.J. Clark or someone else with initials. I would have started it and then glazed over and not finished it, in the time honoured fashion.[45]

Collings's self-mockery is also a mockery of art-world speak, of vagueness, lassitude and forgetfulness (drug- and alcohol-induced on occasion), but, and this

prevents the book from being truly critical, it does not escape the pervasive feeling that only this attitude is possible. The book is an exemplification, and by the fact that it appears in book form – at far too great a length and with too much permanence to be a vehicle for the verbal froth of the vernissage – a disorienting pastiche of the tyranny of received opinion that governs the art world.

But even Collings's sharp slacker prose is too elevated to capture the true character of self-indulgence and vacuity that has come to dominate art-world discourse in the wake of celebrity settling upon a few of its members. Here are Tracey Emin and David Bowie, in a small part of a very long interview:

TE Why don't you ask me what I think of Bruce Nauman then?
DB What do you think of Bruce Nauman then?
TE Fucking brilliant.
DB True.
TE Yeah. One of the top artists …
DB Top man.
TE Top man, yes – no, brilliant artist. Fantastic. He's influenced so many people … and I bet he's really good fun as well.
DB He's great fun.
TE Yeah, I've never met him, but I bet he's great fun.[46]

This was published in *Modern Painters*, the magazine founded by conservative critic, Peter Fuller, to defend the traditions of fine art, and the particular cultural virtues of the English, from the encroachments of modernism and postmodernism. It now has a decidedly ambivalent relationship with high art lite, with one strand of conservative populism understanding that the new art does contain a critique of the art-world establishment not so different from its own (and that is also more than a little starstruck), doing battle with another faction of conservative elitists who see it as a register of the long-term decline in culture and education.[47] In another interview, Emin performs again:

What have you been reading recently?
Tracey Emin, Tracey Emin, Tracey Emin, Tracey Emin.[48]

In looking a little further at this self-consciously dumb attitude, there are two very different examples that I want to highlight. The first is that of the

black artist, Chris Ofili, and his revisionist attitude to the theory that has engaged with black art in this country: given the themes his art takes on, and the type of theory usually attached to it, his practice offers a clear example of the fate of theory. The second is of a very unusual instance in which two critics tried to develop a theoretical framework in which to capture high art lite, not just to examine it but to support it.

Chris Ofili

Chris Ofili is among the most prominent of the artists whose work has been taken to express criticism of conventional theoretical views. For an artist in his position he really is rather young, only six years out of art school when, in 1998, he won the Turner Prize and had a solo exhibition at one of London's foremost venues, the Serpentine Gallery.

Such success brought him massive media attention. What was known of his life and development rapidly took on an air of mythology and Ofili encouraged this with the repetition of a set of mantras: the car he drives (a lime green Ford Cortina), the prostitutes he sees from his studio window in King's Cross, his love of rap music, and his British-Council-funded trip to Zimbabwe where he 'discovered' dot painting and elephant dung.[49]

His basic innovation and trademark – what he describes as a 'hook' – is succinctly described in the title of a work from 1993: *Painting With Shit On It*. He obtains balls of elephant dung from zoos and sticks them to the surface of his paintings, standing in for various items or appendages, from pendants to breasts and penises. The paintings also rest on balls of dung and are leant against the wall. Shit was Ofili's logo, and he did what he could to brand both himself and the product he had created, taking out an advertisement in *Frieze* magazine that read simply 'Elephant Shit', showing (though not selling) the substance on market stalls in London and Berlin, and having himself photographed smoking a 'shit joint'.[50]

In his work outside painting, Ofili has sometimes made clear and unambiguous anti-racist statements: there is *Shit Head* (1993), a dung ball stuck with the artist's hair and some child's teeth, to make a creepy dark brown homunculus or fetish doll. There the brutal association between shit and brown flesh is

made most explicit. And there was *Black*, a number of newspaper reports reproduced deadpan in *Imprint 93* (a series of art works sent by post) and in Bank's tabloid, each describing the crime and appearance of some black suspect.[51] Yet, as the dung became a trademark for Ofili, the sting of works like *Shit Head* was slowly qualified, for they came to be comments not only about the stereotypes through which whites have seen blacks but more prominently about Ofili's own particular persona.

Ofili started out making quasi-abstract paintings of a very complex, decorative nature, composed of many layers. Typically his pictures will contain from bottom layer to top, under-painting in sweet colours, collage material from magazines, glitter, drips and splashes of resin, and finally dot painting and dung.[52] The dung is not left in its found state but is covered with resin and often stuck with coloured map pins (like voodoo, says Ofili).[53]

Ofili's trademark works, though, which marked the beginnings of his considerable success, turned the elaborate technique of the abstract paintings to make readable figurative pictures that contained a panoply of black cultural references. The result was an intriguing mix, and one quite hard to interpret. The basic trick is to feed the largely white and certainly largely privileged gallery-going audience with standard prejudices about blacks, delivered in a manner that is so over-the-top as to be absurd; so there are pathetic macho performers or superheroes (a series of paintings featuring one 'Captain Shit'), a veritable stable of prostitutes and women of easy virtue, and a pimp in the form of an eight foot high penis with a smile on its head. While in the 1980s and early 1990s, many artists confronted these prejudices, or offered instead positive views of blacks, they did so in a manner that was urgent, earnest and rarely humorous. Ofili tries to give white audiences what they expect from a black artist, and then a little bit more:

> It's what people really want from black artists. We're the voodoo king, the voodoo queen, the witch doctor, the drug dealer, the *magicien de la terre*. The exotic, the decorative. I'm giving them all of that, but it's packaged slightly differently.[54]

The Holy Virgin Mary (1996), for instance, a painting that caused some controversy when shown at the *Sensation* exhibition, shows the black Virgin

resplendent in robes against a yellow-gold background, dots radiating outwards from the saintly head. The painting, like many of Ofili's works eight feet by six, rests on two dung balls, with pins stuck into them to read 'Virgin' and 'Mary' while another protrudes from an opening in her gown to form a breast. About her, like putti, float fleshy photographic cut-outs, crotch shots taken from porn magazines. The painting is clearly blasphemous, and the Bible-quoting Ofili may take that transgression more seriously than most, yet its overall statement is far from being forthrightly anti-Christian, especially because the figure is quite dignified and the elaborate decorative surface of the painting could serve as a homage to its subject.[55]

The tactic pursued in Ofili's work does have a direct relation to the failure of the 'politically correct' theory and practice of the past. 'Politically correct' thinking, a form of inverse if vulgar Marxism, assumed that if you changed the superstructure (and particularly the language), the base would follow; in the US, the polite words for black people changed from 'negro' to 'black' to 'African-American', each term becoming reviled as it was superseded, while the impolite ones did not change much. Though the language changed (partially), the social, political and economic conditions did not, so the polite terms became tainted, and had to be exchanged for something new and unfamiliar. With the end of PC optimism, another and more productive tactic emerged – to appropriate the impolite terms. Ofili's paintings are the visual equivalent of the use of the word 'nigga' by blacks. Of his use of 'blaxploitation' material, Ofili says,

> My project is not a p.c. project, that's my direct link to blaxploitation. I'm trying to make things you can laugh at. It allows you to laugh about issues that are potentially serious.[56]

'Potentially serious' is an odd phrase which we will come back to.

The dung is a trademark but it also functions to counteract the otherwise too pretty painting; the two elements are supposed to clash and enliven one another. Of this Ofili says:

> The paintings themselves are very delicate abstractions, and I wanted to bring their beauty and decorativeness together with the ugliness of the shit and make them exist in a twilight zone – you know they're there together, but you can't ever really feel comfortable with it.[57]

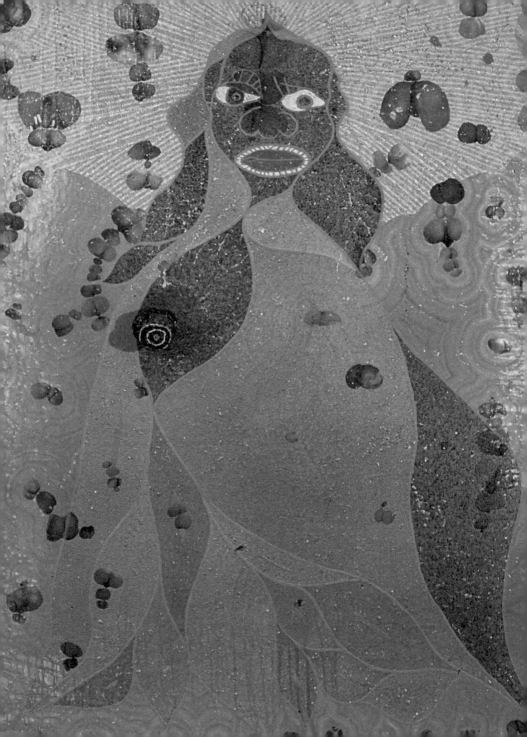

This is a conventional high art lite tactic, and the problem is that after a while viewers do feel entirely comfortable; the disturbance, slight as it was, does not persist as the viewer comes to think of the combination as the Ofili logo, his manner of brand recognition.

The shit – not just because it is shit, or because its use in art has a legacy (in Manzoni and more recently in Gilbert and George, among others), but because, used by a black artist, it acquires a political dimension – gives Ofili the licence to make some of the most decorative, elaborate and saleable paintings on the contemporary scene. It is also a licence that permits safe trespass from decoration into kitsch. In chapter 5 we shall see that there is a strong tendency in contemporary British painting to underplay – or, at least, to take a cool distance from – decoration, depiction and gestural mark-making. All are present in Ofili's laborious and complex creations, and in part he can stand apart from the mainstream in making these unorthodox works because his Nigerian origin is assumed to sanction his knowing association of, say, 'African' with 'decorative', one that has always been touched with more than a little condescension. Yet that association is not a simple matter of his appreciation of some African folk-painting tradition, used to mildly ironic purpose, but something altogether more historically specific, and class- as well as race-inflected. Akure Wall on Ofili's paintings:

> Someone described them as being like an African front room. Yes. A
> wealthy Nigerian front room in the decadent late seventies. Flocked
> wallpaper. Fitted shagpile carpets. Plastic covered velour furniture.
> Smoked glass coffee tables and gift framed photos of ancestors that
> stared down at you sombrely.
> And the room full of your parents' friends, glamorously dressed in
> every colour and fabric you've ever seen: textured brocades, ornate lace,
> jacquard, decorative damask, dazzling gold jewels and fuchsia pink
> lipstick. Drinking gin and laughing at jokes you don't understand.[58]

So for viewers less than familiar with the Nigerian living rooms of Ofili's childhood, the work makes a conventional association in which white prejudices are obviously flagged and then waved in the faces of his audience. For

34 Chris Ofili, *The Holy Virgin Mary*, 1996

those who do remember, Ofili acts out as well as he depicts, in the form of decorative excess, a particular flavour or atmosphere from which he takes an ironic but also a nostalgic distance.

Not only does the shit and the porn sanction the prettiness of these paintings, but the prettiness does its bit to make the demotic elements acceptable. This is a configuration often seen in art that incorporates controversial material, especially of a sexual nature: it can only do so by counterbalancing its transgression with a manifest display of formal beauty (think, for instance, of the photographs of Sally Mann, Robert Mapplethorpe and Jock Sturges). The combination, then, is a good deal less disturbing than it would first appear.

There are two basic defences of Ofili's work. In the first, the artist is thought to reject the dour excesses of a worthy but bitter and extreme political correctness, breaking down prejudice by pushing the limits of current cliché rather than dragging complex forms of identity politics into works understood by few and of interest to fewer. Multiculturalism was believed to have played itself out, becoming institutionalised and degenerating into an orthodox style.[59]

Yet Ofili's work is more an illustration than a rejection of multiculturalism, being entirely dependent on the notion of hybridity that is central to the multiculturalist project. In *Shit Sale* (1993), his market stall performances, Ofili says that he was 'sampling' David Hammons's similar sale of snowballs and (aside from the issue of influence and self-conscious copying) the use of that word, drawn from rap and dance music, is surely significant.[60] As Niru Ratnam has put it in an excellent essay on the artist:

> Ofili does not treat black culture as if it is something innately his, but
> something to be borrowed and toyed with – everything in his work is a
> found object of black culture, from the Matapos Hill dots to the
> stereotype figures and the elephant dung.[61]

Hybridity theory is the recent creation of a group of sophisticated and influential cultural critics including Homi Bhabha, Paul Gilroy and Stuart Hall; Ofili, along with Yinka Shonibare (who describes himself as a 'post-colonial hybrid'), is among the first to be able to place that theoretical outlook within a visual package that is attractive and accessible.[62]

Playing with diverse forms of culture is a privileged and cosmopolitan pursuit. As Tom Nairn points out, those people faced with the homogenising force of modernisation, and who resist it by fostering cultural differentiation, do not do so for fun but because it is a matter of communal life or death.[63] At its worst, hybridity theory produces an endless and pointless playfulness of content, and Ofili's presentation of unresolved issues fits in with that tendency.[64] Furthermore, multiculturalism of Ofili's kind is just what the establishment wants to hear from black artists, being a good deal less threatening than the cultural expression (in rap music, for instance) of separatist and Afrocentric ideas connected with the Black Muslim movements.[65]

The second defence of Ofili's work, founded on formalism, is incompatible with the first. Martin Maloney, for instance, sees Ofili as pioneering a move away from a 'hands-off cool school' that had dominated abstract painting in Britain. Maloney marshals a rich cluster of art-historical references to bolster Ofili's claim to be a great painter; he is mixing and matching the all-over look of Jackson Pollock, poured paint of the 1960s, and swirly linear patterns from Munch and Klimt: the results bear comparison with the mosaics of Ravenna. The use of dung and glitter invite discussion not about cultural stereotypes but about 'the status of the painting as an object'. For Maloney, it is important that Ofili has won the Turner Prize, not because he is black, but because he is a painter:

> Ofili will be heralded as part of the revival of painting … Much will be
> made of his black identity and how that is intrinsic to his work; this
> shifts attention from the paintings to the personality of the painter.[66]

Thus we should realise that the black cultural material that Ofili uses in his work is a distraction from the true nature of his achievement which is to advance the 'language of abstraction'.[67] Neither of these defences is quite adequate in describing the distinct nature of Ofili's work.

Rather, we can identify two linked models working in Ofili's representations of black people: in the first, comic-book images of sexual potency, hipness and over-the-top self presentation; in the second, a blossoming, sprouting display of organic fecundity, of fractal flows and cosmological significance.

35 Chris Ofili, *Mouini Thi*, 1996

The two models exhibit very different attitudes towards the subjects they depict: in the first, an inhuman force or principle is given allegorical expression; in the second, the figure is immersed in, and an integral part of, the broad cyclical flow of the natural universe. Both have a strong relation to that invidious strain admiring of some notion of the 'primitive' that has run strongly, if changeably, through British culture. In that attitude, primitives – not just black people, of course, but, in varying configurations, the insane, anyone who isn't a Northern European, anyone at all before the Renaissance, children, and so on – were both admired and condemned for their unconscious exercise of

culture, a culture that bred and grew as rapidly and naturally as weeds.[68] It is unsurprising, then, that in neither of Ofili's models do we see people who look capable of thought or speech, action or development. In the case of the first model we have seen why: a white stereotype is seized upon, exaggerated to the point of absurdity, and thrown back in the face of a white audience. In the case of the second model, the matter is less clear.

Among the paintings of the second group is *No Woman, No Cry* (1998), displayed at the Turner Prize exhibition. It shows one of Ofili's more digni-fied women in profile, crying, and in each of the falling tears was a little

36 Chris Ofili, *No Woman, No Cry,* 1998

photograph of Stephen Lawrence, the black teenager murdered in a racist attack in London in 1993. The police did not tend Lawrence as he lay dying, and through incompetence, racism or corruption did not take proper steps to prosecute those believed to be his attackers. Other than including the tiny photographs of Lawrence, however, Ofili's style and presentation did not change at all in tackling this 'potentially serious' subject, and the woman in the painting has a ball of shit for a pendant.

We can compare Ofili's work with earlier pieces by black artists that have commented on black deaths for which there has been no justice. Keith Piper, for instance, made a painting called *13 Killed* (1981) about what became known as the 'New Cross Massacre', a fire at a party in which the thirteen died, and which many think was arson. The differences are significant: Piper's message is clear and angry, and made in the face of silence from the mainstream institutions and the mass media. Ofili's work makes a curious contribution in what was a completely transformed situation. Unlike many earlier black victims of such violence, Stephen Lawrence has become a household name, his murder condemned by all, the long struggle of his family for justice praised by all, the media obsessed by the case. It is unclear, to say the least, what Ofili's work adds to that righteous chorus, except to place himself on the side of the angels. What it does make clear, however, is that the second model operating in Ofili's painting is more celebratory than ironic.

Even the first model plays a dangerous game, made safe only by the environment of the gallery in which it can be assumed that the overwhelming majority of the visitors are well-educated and liberal. Captain Shit may function a good deal less favourably if seen on a poster in Deptford or the Isle of Dogs, or any other area where there is a measure of white racist sentiment, rather than in the Serpentine Gallery.

Particularly in the second model, Ofili draws much from the painting of Francis Picabia, and does so in a way that is so obvious as to become a feature of the work, another 'sampling', rather than an unacknowledged influence. What are these references to Picabia about? It is not, after all, to the Picabia of the Dada period with his scandalous anti-cultural statements (a portrait of Cézanne, for instance, as a stuffed monkey), rather more hardcore than any on the high art lite scene, but the Picabia of the mid 1920s, of the transparencies,

mysterious but decorative paintings in which outline figures reveal others beneath them, and even the Picabia of the 1940s, content in Vichy France to make cravenly commercial paintings of scantily clad, easy-on-the-eye ladies.[69] It is not only Picabia the artist that Ofili wishes to emulate but Picabia the half-Cuban playboy, devoted to the pleasures afforded by fast cars and women.[70]

In the second model, in paintings like *Mouini Thi* (1996) and *Dreams* (1998), Ofili moves away from the comic-book stereotypes to create figures of dignified beauty, bearing beatific, mystical expressions. Even the dung has more definite shape and is made more decorative. Here the parodic elements – the dung, obviously, but also the excessive decorativeness, the psychedelic references, the syncopated rhythms referring to black music – once serving to satirise white stereotypes about blacks, are now pressed into service in an ambivalent celebration of black culture and identity. Their comedic aspect has not been undone, and the white audience's laughter still echoes in the gallery, though it is directed now less at themselves than at Ofili's subjects. The nihilist playboy, Picabia, is certainly present in a set of depictions that is clichéd but not critical, that displays its subjects exploitatively and without comment. Ofili's work has theory implicit within it, much in the way that Lucas's does, and given the more than potential seriousness of the issues with which he chooses to deal, its lack of critical bite is inadequate. Indeed, it is utterly of a piece with high art lite in its refusal to do anything other than present a dilemma.

The artist, critic and curator, Eddie Chambers, has written of the racial divide that characterises the art world: if you go into a gallery you will still find that the curators, administrators and artists are white, and that a large proportion of the caterers, cleaners and security guards are black.[71] Even now, there are only three black artists in this country who have contracts with private dealers: Ofili, Steve McQueen and Yinka Shonibare. The prodigious success of Ofili has done little to change this structure and perhaps a little to confirm it. The position that he occupies is clearly an exceptional and limited one that does not necessarily open up room for others to follow. Overcoming the tokenism behind his success – and, to Ofili's credit, this tokenism is one theme of his work – would require broad changes not just in the art world but in the wider world.

Philistines

This reminds us of the admiration of a republican man of letters who could seriously congratulate the great Rubens for having painted Henri IV with a slovenly boot and hose, in one of his official pictures in the Médicis Gallery. To him it was a stroke of independent satire, a liberal thrust at the royal excesses. Rubens the revolutionary! Oh criticism! Oh you critics! ...

Charles Baudelaire[72]

The recent success of 'young British art' has naturally attracted certain critics; some seek simply to celebrate it and ride on its coat-tails for as long as its popularity lasts; some to explain it; and a few, rather bizarrely, seek to give this most demotic of tendencies a rigorous theoretical base, not merely to explain but to guide it, to become the Clement Greenbergs of *Fuck, Suck, Wank, Spank*. One remarkable attempt, in particular, has been made to bring aspects of Marxist theory into contact with high art lite so as to support the tendency. The terms of this argument, and its fate, are not so much important in themselves – it had little influence either in the art world or in academia – but rather because this failure is indicative of the limits of theory when launched in favour of this art.

The work of Dave Beech and John Roberts on the category of the philistine, and the way in which they have applied it to high art lite, has had one significant merit: it has sought to explain and to contextualise the tendency as a whole, and has not remained satisfied – as so many had been previously – with fragmentary accounts, or with mumbling about deconstructive meaning.

Yet the value of Beech and Roberts's synthetic account was undermined by a peculiar tension between the writings in which they laid out their theoretical ideas and those in which they directly defended high art lite. We should first get a flavour of the latter. For Beech, defending the art against stern critics who accuse it of dumbing down and a lack of politics, and writing of those artists – Lucas, Emin, the Chapmans – who use the body but not in the old way, to participate in discourse about it,

… younger artists don't see the body … as a battleground, or any other architectural system, but as a layered open field. Sex is back, as is fantasy,

transgression, anarchism, and violence because these themes offer up the individual as a subject of intensities which are irreducible to the formulations of earnest wisdom.[73]

The pleasures and fantasies of the sexual body defuse earnest wisdom, and violence does the same so long as it is not organised on a battleground. This was part of an article called 'Chill Out', an accurate summary of what it suggested that those who furrowed their brows at the antics of these young artists should do.

Roberts supports high art lite partly, and rightly, for its implied attack upon the rigid doctrines of postmodern theory as they had become institutionalised in art schools and the academy generally.[74] Yet what he offers in its place is questionable for, as with Dave Beech, in an old, inverted Kantian formula, the naughty but also somehow pure pleasures of the body are set against the corrupt machinations of the intellect:

> Talking dirty and showing your bottom for the sheer delight of it, has become a proletarian–philistine reflex against '80s feminist propriety. Reinstating the word 'cunt', and embracing the overtly pornographic and confessional, have become the means of releasing women's sexuality from the comforts of 'progressive eroticism' into an angry voluptuousness.[75]

Thus the 'you're beautiful when you're angry' school of art theory. This is not the only occasion when Roberts has recommended playing dumb, shouting 'arse' and 'taking your knickers down'.[76] 'Imagine a kind of artist you've never met before', Roberts urges the reader in a revealingly puerile fantasy, 'she's openly sexual, bawdy, mischievous and wants to show you how good at football she is'.[77]

The idea in both authors' writing is the injunction to get in touch with your body and enjoy your pleasures before this art, just as you do when watching television, going to parties or flicking through a skin mag. This is to indulge in pleasures that acknowledge themselves as such, and to do so in full awareness of the alienation involved, rather than indulging in those haughty pleasures of disinterested viewing and the appreciation of intellectual structures that are elitist, that do not – in their bad faith – own up to being pleasures

at all, and that (even in their Adornian variants that are presumably more than aware of their negative aspects) are tainted with an idealism and an aestheticism that just will not do these days. While a bit more libertarian, their orders – Enjoy! Indulge! Chill Out! – have their equivalent in New Labour rhetoric, as we shall see in chapter 6, where they take the form rather of Create! and Consume!

Beech and Roberts have pursued their ideas in articles in *Everything*, *Third Text*, and *Art Monthly*, and in a long theoretical piece that they co-authored in *New Left Review*.[78] This last text did not mention new British art but discussed philistinism. Roberts, in particular, has expended many words in the elucidation of his notion of the philistine, and if it needs such lengthy elaboration, this is partly because what he means by 'philistine' is at odds with the usual meaning of the word. One of the clearer expositions is found in a catalogue about the work of Bill Woodrow: first we must understand that for Roberts the philistine is a totally reactive category, defined by what is excluded or suppressed by the art of the day, and in particular by what is at the forefront of fashionability. There is no core to it at all: 'there is actually no empirical content to philistinism …'. As a consequence, 'philistinism as the voice of the excluded has to be constructed *theoretically* in response to dominant and prevailing discourses and practices of art …'[79] So people who are actually excluded from the art world for one reason or another have no say whatsoever in the construction of the philistine; rather, the power to define this category accrues to the critic capable of surveying the scene.

Given this, it is odd that Beech and Roberts have given over much attention to unpacking the association between the philistine and the 'proletarian', though their writings are largely innocent of any thinking about the way in which the latter category has changed under the impact of deindustrialisation. This is, in any case, a surprising association, for the philistine has generally been a term employed against the middle class, at least in this country.[80] No matter, the association is an irrelevance; for what is also clear from this account is that the philistine, as Beech and Roberts define it, can have only a contingent relation to the popular and the proletarian. Given that it is a purely relational category, what happens when working-class forms (or at least middle-class artists' views of them) move into the mainstream? If they are consistent, Beech and

Roberts will take up recommending bourgeois high seriousness as the excluded alternative.[81]

It is striking that Roberts, in particular, has made an attempt to become the theoretical leader of a tendency that is in flight from exactly the kind of worthy, authoritarian and 'politically correct' theory that he was pursuing throughout the 1980s and early 1990s. 'Young British artists' are, as we have seen, most unlikely to look to any theoretically entangled scribbler for guidance (indeed, on the evidence of a questionnaire conducted by Rose Finn-Kelcey, they are much more likely to read James Ellroy than Jacques Derrida).[82] The authors are not unaware of this, and have secreted within their theory something of its 'Other'. Beech and Roberts's essay, theory-laden though it was, stressed the submission of theory to circumstance, and its helplessness in the face of bodily pleasures in a fashion that was very close to uncritical postmodern positions.[83]

This covert anti-intellectualism allows various terms within Beech and Roberts's writing to remain entirely unexamined, and of these the most obvious is the British 'popular'. In the category of popular culture, Roberts, at least, includes cinema, pornography, television – aspects of culture largely produced and managed by multi-billion-dollar corporations. The use of such 'popular' forms in high art are nevertheless considered to be 'gestures of proletarian and philistine disaffirmation'.[84] Contingent though the association may be, the way Roberts links the rude, demotic trend within new British art with the 'proletariat' is somewhat naïve. The working class is allied with the wild body, with unregulated hedonism, with violence, drug abuse and filthy sex. For the majority of working-class people who are not fans of the *Sunday Sport*, this simple-minded identification of their culture with the products of pornmongers and media monopolists is pretty insulting. Long ago, Georges Bataille had the number of those who hold such patronising views: 'Communist workers appear to the bourgeois to be as ugly and dirty as hairy sexual organs, or lower parts …'[85] The negative value of those associations in that old liberal, primitivising view might have been switched to positive, but they remain as clichéd and inaccurate as ever.

The configuration that has led to these assertions about the use of low culture in high art is not a novel one: T.J. Clark analysed it in compelling detail in

his book *The Painting of Modern Life*, looking at nineteenth-century France. Perry Anderson, drawing on Clark, writes of that same cultural scene:

> Here the alchemy of the spectacle was already at work, in those café-concerts where a petty-bourgeois audience patronized popular singers in sham-plebeian identification with those below, and would-be connoisseur aspiration to those above …[86]

Further, in this experience, there was:

> an unending expropriation of the imaginative forms of working-class experience, rendered into innocuous simulacra of themselves, for the reanimation of a middle-class sensorium. And in this process the notion of the 'popular' operates to suppress that of the 'collective'.[87]

That structure is still alive in this old country where, if the working class has been flattened politically, the visual and apparent forms of class distinction still reign. But the purpose of passing material from low to high no longer has even the political charge that it did in the time of Manet and Degas (when democracy and socialism were in formation, and no one knew for sure what character they would assume or what possibilities they would bring about), and has instead become merely a cultivated voyeurism.

There are a few basic lessons to be learnt from this incident: first, given the failure of Beech and Roberts's views to achieve resonance in the art world, that the artists and the institutions behind this tendency do not need theory – or only do so in extreme cases (as with the Chapmans) to defend the work against charges of sensationalism and manipulation of the media. High art lite has coasted along for ten years without any such theoretical support. Tied into the zeitgeist and efficiently serviced by more popular writers, it is a consumer article that requires only the usual puffery. Second, that a radical theory that sets out to support such work puts itself in an invidious and contradictory position that is, in part, due to the works' own neutrality. Third, a theory that is to say something significant about high art lite has to take a distance from its subject, and in that attempt theory's standard configuration of intellectual disciplines may not be the most effective tools to use, since the art has thoroughly inoculated itself against most of them in advance.

We have seen that such work puts the viewer in a state of suspension between often crude (though it must be said also mild) visual pleasures and liberal objections. Insofar as a justification is made by critics for such work, it tends to be along the tired lines of the art confronting the viewer with the abject, making of itself a liminal object, destabilising meaning, and so forth.[88] For instance with the Chapmans, and as we have seen critics have to tread carefully here:

> … these objects are simulacra or bad copies of the ideal, they are not real or serious, they are puerile, slippery and annoying. Here are entities with no fixed identity or allegiance to the ideal, nomadically breeding in an unlimited becoming.[89]

Indeterminacy, deconstruction, the sublime oscillation between opposing alternatives, the return of the repressed, the universality of artifice; all these are linked and serviceable tools for saying everything and nothing, for stamping a work with the mark of value, while never being reductive, never subjecting discourse to closure, never trampling over anyone's subjectivity, never completing a thought.

But the defence stops with such 'unlimited becoming'; it is assumed that to do this is useful in itself, or is just the distinctive thing that works of art do. It is rarely asked, what is liminality for? Yet without an answer to that question, theory does no more than the art itself. Nevertheless an answer is not easy to come by. The position adopted by much high art lite is not deconstructive, since no one reading is considered privileged at the outset. It is hard to employ psychology to illuminate the question since the artists have simultaneously developed and had foisted upon them reified and external personae, and seem to take internal life of any kind with a marked lack of seriousness. Instead the viewer is left in a state of suspension – and not, as in earlier work, with the supposed payoff that some hierarchical barrier might crumble in the resulting conceptual tremor, but rather in an entirely non-instrumental reinvention of the enclosed aesthetic, leading nowhere. This is the anti-theoretical heart of high art lite, and it applies even to work that appears quite theoretical: theory is used only in the service of the work's autonomy.

Part II
Playing for time

5 That's entertainment

'... what the *fuck* is wrong with visual candy?'
Damien Hirst[1]

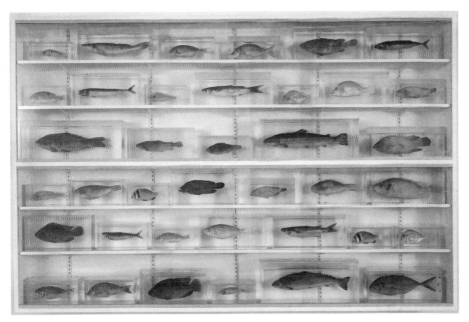

37 Damien Hirst, *Isolated Elements Swimming in the Same Direction for the Purposes of Understanding*, 1991

While the new generation of British artists are sometimes referred to as 'Thatcher's children', and it is true that (like it or not) they have had to tailor their art and their way of living to the transformed economic and cultural

climate that her governments had created, high art lite is a creature of the Major years. The Conservatives were re-elected in May 1992, in the midst of a deep recession, to the surprise of some who believed that the end of Thatcher would mean the end of her party's electoral success. In September, sterling was forced from membership of the Exchange Rate Mechanism by the markets, this disaster leading the government into a flagrantly opportunistic change of economic policy from stern, 'this medicine is good for you' tight money to a Keynesian stimulation of consumer spending. During the prolonged period that followed, until the Conservatives' defeat in 1997, the Right were no longer a triumphant force, and Major's government seemed aimless, divided (particularly over Europe) and often incompetent; it nevertheless hung grimly on throughout the full length of its term.[2] In this peculiar period, an interregnum between two confident, nationalist and demagogic governments, the country seemed to drift. Those years were marked first by a severe economic downturn and then by a period of uncertain, faltering revival. From what we have already seen about the character of high art lite, there seems to be a congruence between its determined eschewal of all ideology, its principled rejection of all principle, its strong inclination to make no comment, and the period of political vacuity and economic uncertainty in which it found itself.

As Britain emerged slowly from the recession and the art market revived (its recovery very hesitant at first), the character of the art changed a little and consolidated itself, turning aside from some of the more radical moves outlined in chapter 3, and becoming more evidently about the making and selling, showing and marketing of impressive objects. Yet there was an important feature about the character of the art that did not change. Near the inception of what was to become 'young British art', the dealer Karsten Schubert remarked of the new generation that they were 'playing for time' and doing so successfully:

> I think it is about creating space in which to operate. And I have this sense of an emergency situation with all of them. It's probably the best response to what's going on in the world right now.[3]

A decade and more on from *Freeze*, they are doing much the same thing. This section of the book will examine aspects of high art lite as it settled into this

period: this chapter will look at the art's relation to the mass media, the next at its dealings with public and private institutions, and chapter 7 at the role of Charles Saatchi and the embrace of the tendency by the mainstream art establishment.

Tabloids

The character of a tendency in art cannot just be read off from the prevailing political and social atmosphere of its time. To do so is to play down the conflicts and contradictions of a period, to efface the different experiences that various groups of people had within it, and also to say nothing about how it is that an art comes to reflect that atmosphere. With high art lite, however, the task of discovering how the social and political components of the 1990s come to appear in the art is not so difficult, since this was an art focused upon and very sensitive to mass media concerns. Its reflection of those concerns, themselves only a partial representation of the political and social forces of the period, was less a matter of unconscious expression than of deliberate strategy.

We have seen that high art lite took the mass media as its arena, initially in response to the recession that forced the art market into retreat. This switch of attention produced a profound effect on the art's concerns which came to reflect, more and more closely, those of the national mass media, both the tabloid newspapers and also the feature and lifestyle sections of the broadsheets. We can list some of the points of attention around which the art came to cluster: in its content, violence, sex, child abuse, the British character, celebrity, gossip and an obsession with itself; in its style, the speedy delivery of messages, leading to the prevalence of one-liner art, jokes, clichés, the use of advertising strategies, glossy surfaces but equally the appeal of grunge and anti-intellectual posturing. As a whole, it was an art that could be quickly understood, at least on some level, and was camera-friendly, looking good when reproduced in newspapers and magazines. These are quite novel subjects and qualities in art but are not in the least surprising in the British press, at least not since the competitive trivialisation pioneered by Rupert Murdoch. This chapter will examine some of these media obsessions as adopted by contemporary art.

First, though, why and how did high art lite come to court the media? British visual art has always been the poor relation of music and literature (certainly in terms of public funding) and was even more disadvantaged when considered against the money and celebrity generated by the pop and fashion industries. There has been a deliberate attempt to change this situation, not only by drawing in material from fashion and pop but also by drawing upon the particular concerns of mass culture, those of contemporary 'real life'. These concerns were largely seen through media eyes, as they had to be, for an appeal to a wide audience could only be mounted through the media, and success would be measured largely by media visibility. So high art lite became such an accurate reflection of media fixations that it had soon filled all the available slots (even the cranky ones, like the obsession with crop circles and UFOs in the work of Rod Dickinson).[4]

Artists and their dealers set out to attract the attention of the mass media with a variety of tactics. Hirst's dealer, Jay Jopling, is open about his manipulation of the mass media to generate publicity for his artists:

> It was a deliberate strategy to go to the tabloid newspapers to draw their attention to these works of art. I'll never forget the *Daily Star* getting a reporter to get a bag of chips and stand in front of Damien's fish piece, the cabinet with all the fish in. They called it the world's most expensive fish.[5]

Indeed for Jopling the visual art world is no longer an entity to itself but 'is working hand in hand with communications – media, film and rock 'n' roll.'[6] Tied up with this manipulation was a deliberate strategy by artists to appeal to more than one audience at once. Like the best products of mass culture, they had to speak to different people on different levels. So the art had to transform itself, to take on the other consumer products competing for people's attention. As Damien Hirst put it,

> If you go up to anybody in the street in the North of England and you give them a *Flash Art* and you say 'Go on have a look at that' they would just say 'What a pile of fucking total bollocks, it's shit, I've never seen anything like it', and to me that's just what it is. Art has got to be able to

stand up to everything else and if it can't then it doesn't work, I think. That's why it has to be multi-layered, because if you have an idea of an audience then it has to be to communicate with everybody.[7]

For Hirst to say 'everybody' is not quite as disingenuous as it might seem, for while those who went to see his works in galleries were still drawn from the educated and privileged sections of society, those who came to know his work through television, magazine and newspaper articles − or even cartoons − formed a much wider public. That public might not have much of an idea of what Hirst was doing, or why, but it recognised the work as a presence on the commercial cultural scene, as we have seen, rather in the way that a logo might be.

Such art borrowed the techniques of advertising, and sometimes advertisers would return the compliment. Allying a simplicity of approach with considerable complexity of subject matter, Gillian Wearing's work has been particularly suited to a commercial plagiarism that has tended to seize only on the former. Volkswagen stole her device of getting people to hold up signs that they had written in an advertisement which reduced the subtlety and surprise of Wearing's results to a series of clichés: sensitive bouncers, intelligent models and so on. Levi's did the same in a US campaign, though this time with the artist's permission. Most strikingly, following Charles Saatchi's purchase of a work, *10−16*, in which adults' voices were dubbed over by children's, M&C Saatchi produced an advert using the same technique, much to Wearing's chagrin.[8] What these incidents highlight is the manner in which art and the mass media, including advertising, have moved together. While in the past advertisers have certainly raided works of art for material, it has often done so mockingly, to play upon their notoriety (Henry Moore's figures with holes through them used to advertise dietary products); but for advertisers to steal the techniques of an art work that the broad public will not recognise is a very different kind of appropriation, and almost a homage.

We should move to specific instances when high art lite has shadowed the concerns of the mass media. I can do no more here than illustrate what I hope are a few symptomatic examples: the range and the sheer number of parallels are beyond systematic description.

Henry Bond's large book of photographs, *The Cult of the Street*, is telling of many characteristics of high art lite and its engagement with mass culture and the media.[9] It takes as its subject not just the conventions of the street but youth and their modes of display in shops, clubs, parties, restaurants and even private homes. Unlike much similar documentary work, the lens is turned on rather well-heeled consumers – the crowds of South Kensington – rather than on the picturesque disadvantaged. Bond has been involved with *The Face* magazine, and those on whom he turns his recording eye are the subject of much media attention, and the targets of the greatest intensity of consumer propaganda. They don't do much, Bond's people; they shop, of course, persistently, and present themselves to each other and the camera, dance sometimes, but the book is composed above all of an intricate fabric of exchanged glances and gazes. Given the streets and interiors he habituates, the crowd is not just young, but very largely white, and – given perhaps the inclination of the photographer – mostly female.[10] With its mix of girls seen in the street, girls at parties and clubs and restaurants, and girls, some of them unclothed, in private rooms, the book comes across – at least for one specific set of viewers – as a diary of sexual opportunity.

Yet, as a project on the high art lite scene, it cannot be quite as simple as that. The voyeurism must be taken as an examination of itself, as must the photographer's documentary impulse. Many of the pictures (bad photographs, complain straight photographers) are blurry or fragmentary, showing snatches of clothing or shoes, or odd bits of the street and its architecture. They simulate the succession of impressions, aspects of a person or a scene fixed upon suddenly and as quickly discarded, that constitutes a walk down a busy shopping street. Further, Bond – and in this he is an entirely conventional example of high art lite – says that the work does not produce meaning but examines how the codes and conventions of photography work, and seeks to put them into 'contention' and stop them operating. This is in part to try to make images of glamour, of idealised beauty and its promise of pleasure unfamiliar.[11]

This task is attempted through a juxtaposition of various photographic techniques that have conventionally had diverse associations: now the pictures

38 Henry Bond, *No. 119*, 1998

are in colour, now in black and white; now grainy verité, now seamless high definition; now grab shots, now deliberate pictures taken with the subject's collaboration. The making of meaningless pictures, or at least pictures that put meaning into question, starts to reflect upon Bond's subject matter, the inhabitants of the consumerist simulacra, the gerbils on fashion's treadmill. And after a while, turning the pages of *The Cult of the Street*, this is just how the individuals appear, as a decorated mass, made up of sharp and blurry fragments – flashes of bags, labels, shoes, fabrics, looks, portions of flesh.

Comparing Bond, an artist with some engagement with the world of fashion, to Jürgen Teller or Wolfgang Tillmans, fashion photographers with artistic pretensions, it is clear that in Bond's case there is a critique of the aspiration to beauty. Compared with the models they try to emulate, and no matter how attractive they are, Bond's creatures always seem clumsy and misshapen, getting some element of self-presentation slightly wrong. Yet what is present in this book is not a critique of the simulacrum or the system of fashion – indeed by his technique Bond endorses both – but a parade of its victims, and one which is slightly mocking, slightly sad, but also somewhat enjoyable. It is enjoyable both for its snob value for those who like to think that they really are at the cutting edge of fashion, and in its appeal to voyeuristic instincts, but the world that it portrays is one without remission or exit. That prison house of representation remains locked because of the way the people in it are seen and also, it is true, sometimes conspire to be seen: as images without will, thought or the potential to act.

Sex and death

Bond's work is unusual because it is in part about mass culture itself, whereas much high art lite merely reflects mass media concerns, particularly with work focused upon crime and violent death. A renowned critic of an older generation, David Sylvester, asked whether there was anything British in the character of recent art, recounted Baudelaire's comment about Hogarth, 'that ineffable breath of the sinister, the violent and the ruthless that dominates almost every product of that land of spleen'.[12] A little more spleen might be in order, however, for the current fashion seems to be rather to present the

worst of things with a light, breezy air, in an atmosphere of calm enjoyment, if not jollity.

We have already looked at the main lines of Hirst's work, and it should be clear that these fit media obsessions closely. One more example of his work, bringing together (as usual) a prurient interest in sex and death, will suffice here: a project for a sculpture called *Couple Fucking Dead (Twice) Corruption*, of two flayed cows in an empty tank. Hirst says:

> One's stood upright, and the other goes on its back, giving it a really tragic, slow fuck. They're both cows, so it doesn't matter. And they'll just rot. By the end there'll just be a mess of putrid flesh and bones. I just want to find out about rotting.[13]

This work was planned for Hirst's first solo show in the US, at the Gagosian Gallery, but was ruled out for public display by health officials.

There are yet more literal manifestations of mass media concerns. On a simple level a piece such as *Untitled (Pregnant Schoolgirl)* (1993), Kerry Stewart's life-size plaster figure of a pregnant girl in school uniform, painted with enamel paint and with a rounded base, as though she was a plaything, appeals to persistent media concern with underage sex and teenage pregnancy. Innocence and sexual knowledge are brought together in a neat and accessible package.

In an exhibition shown at the ICA, Abigail Lane, aside from presenting body parts dangling from the ceiling, papered the gallery walls with an innocuous looking wallpaper bearing a repeated red and white pattern. This *Bloody Wallpaper* (1995), however, took its pattern from the bloody spatters and hand prints of a murder victim's final struggle (the source was a photograph in New York police archives).[14] It was shown in a room that also featured a loop-tape of frightened whimpering coming from behind a locked door. The point of such work is to say that behind domestic banality lies abjection and horror – wife battering, violent sexual perversions, child abuse, perhaps. This is by now an entirely conventional media view: think, for instance, of the way that Hirst's friend Gordon Burn dwelt on the banal details of the home furnishings and decoration of Frederick and Rosemary West, as though every D-I-Y enthusiast lodged corpses beneath the floorboards (Burn is best known for his

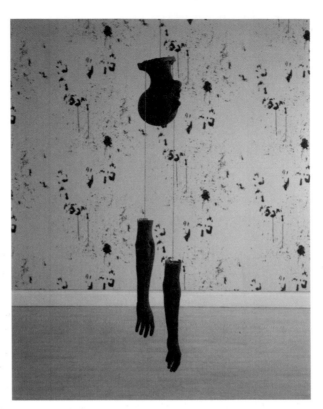

39 Abigail Lane, *Red Vertigo* and *Bloody Wallpaper*, 1995

books on gruesome crimes, one on the Yorkshire Ripper and then that on the Wests, called *Happy Like Murderers* and bearing a cover illustration by Hirst).[15]

In another work, planned but not executed, Lane arranged for signs to lead wanderers on a paper trail through a park to find a partially buried body of a young woman – a waxwork, though this might not have been apparent at first sight.[16] Again, a contrast is set up between innocent, childish pursuits and the horror to which at any point they may lead.

Marcus Harvey's pictures (fig. 20) show figures whose poses are taken from soft porn magazines. Their white borders mimic those of Polaroid photographs (which you don't have to risk at the chemists).[17] These are painted directly with the hands, 'a brisk and frequent masturbation in paint', built up with caressing gestures that mould the body.[18] For Harvey there is certainly

supposed to be an association with paint and blood, with the apparently frenzied act of such painting and the violent penetration of someone else's body:

> When I was a student the bloke next to me got angry and scraped his painting off his canvas with his hands; it was thick oil paint and he couldn't wash it off under the tap. He panicked a bit and said 'I feel like I've got the hands of a murderer'.[19]

Kinky sex is obviously more newsworthy than vanilla, so a dash of violence helps. As we have seen in chapter 3, this violent and visceral matter is opposed to an overlay of lines of a type used by Michael Craig-Martin so, while the work retains its spectacular and media-friendly aspect, art-types are satisfied in more ways than one.

It is certainly not the case that any work dealing with sex and death falls under the general outlook of high art lite, which we will have to determine with greater specificity shortly. Christine Borland's work is a good example of a more serious engagement with such subject matter, feeding upon its grisly and voyeuristic side but at least to fairly serious purpose. In *From Life* (1994) she had a team of forensic scientists reconstruct the face and head of a skeleton that she had obtained, and say what they could about the person. The details were brief, 'Female, Asian, 5ft 2in tall. Age 25. At least one advanced pregnancy.' As Ian Hunt has pointed out, the work can make the viewer question the standards that we apply to compassion, to those we consider as individuals and those taken as statistics, to victims worthy or unworthy of our help, near and far.[20] In other pieces that use highly charged and media-worthy elements (guns, bullet-proof vests, bullet holes), the impulse is not simply to entertain. Borland's work, with its strong element of restitution, its forlorn hope of repairing damage done (as in her sewing up the holes in a blanket used on a firing range), of remembering people forgotten, is far from the smirking enjoyment of some of her contemporaries.

With a similar outlook, Gillian Wearing made a pair of large photographs in raw, unmanipulated colour, showing a man and a woman masturbating, each holding in their free hand a smaller version of the whole photograph, which is, of course, infinitely recursive. These untitled images are shocking, but clearly comment on the use of photography in pornography, showing the

40 Gillian Wearing, *Masturbation*, 1991–92

rarely represented purpose of this vast and continuous output of images. Narcissism is implied by the way these subjects hold themselves in both hands, as it were, while the endless recursion of images is analogous to the unending flow of pornography, the continual urge for the next, though essentially similar, image.

The contrast between tickling the media's fancy and more serious purpose can be seen most clearly in a comparison with those British artists who really have something to worry about: in the video work of Willie Doherty there is the same bringing together of the mundane and the threatening that we find in Lane and many others: of a night drive on quiet roads, for instance, or the static surveillance of a city street, also at night, with soft voices speaking, that takes on an air of great menace; but the menace here is not unspecified, since Doherty is an artist who lives in Derry and his work is about the Troubles – a matter often under- rather than over-played by the media, at least in the

regular mutilations and murders that seemed to form an endless procession in the years before the peace process got under way.

The dormant conscience?

So what is it that distinguishes the outlook of high art lite towards its media-friendly subject matter? Against the previous art-world consensus, the new generation are insistent that their work has no social responsibility and no moral sense. Indeed, both are rejected as being not just out of fashion but no longer possible. It is important to realise that this is less some Generation-X style neglect of these dimensions, and more in the way of an ideological and theoretical refusal of them.

In his flip-book, Damien Hirst reproduces colour photographs of corpses with wounds. The pictures are accompanied by various statements, including 'I have no social conscience … I couldn't make some kind of effort towards working at integrity, it would be nonsensical.'[21] He has a collection of pathology books, with illustrations of people with various mutilations that he thinks are 'completely delicious, desirable objects of completely undesirable and unacceptable things. They're like cookery books.'[22] The attitude to death displayed here is one of fascination but also of compensatory flippancy – the combination that leads to the horseplay with corpses by medical students and mortuary attendants. Carl Freedman writes of an occasion – presumably it yielded the Hirst photograph in which he poses with a severed head – when Hirst and Marcus Harvey illicitly entered a hospital mortuary in Leeds and took pictures of each other holding cadavers. Before leaving they stole an ear which Freedman's brother later received in the post.[23]

What is reflected here, and in the general refusal of artists to take responsibility for the work they produce, is another feature of the tabloid press: the knowing exploitation of their subjects, the indifference to their subjects' feelings or their fate when set against the imperatives to produce spectacular copy, to best rivals and pull in profit.

It is a common theme, this falling away of morality and responsibility, cutting across many different sorts of work, and presented with absolute certainty in a complex of views otherwise plagued with doubt. Douglas Gordon

introduced his work in a catalogue with this single quote taken from a television broadcast of *Colombo*: 'Morals are conditioned, Lieutenant, they are relative like everything else is today.'[24] Gordon also believes that he is playing with corpses, for cinema is dead and he thinks that his work is effective in 'temporarily reanimating some of its limbs'.[25] Much of Gordon's work is about placing the viewer in a sadistic relation to the subject shown. His well-known piece, *24 Hour Psycho* (1993), a much slowed-down and silent projection of Hitchcock's film, takes as its métier the mode of attention indulged in by kids with a video, watching and rewatching violent sequences frame by frame, but snatches the remote from their hands to produce a hypnotic re-run of the whole film. It drags out to great length the level of anticipation of those famous few seconds of violence that punctuate its long scenes of edgy banality. In *10ms^{-1}* (1994) he manipulated and looped archive footage of a World War I shell-shock victim who, on trying to stand, would always throw himself to the ground, in a work that is partly comic but also disturbs the viewer as they think about their relation to the image.[26] Like most of the 'young British artists', he purports to do little more than present material for people to make of it what they will. His brother, writing in a catalogue essay, puts it like this:

> I think that he likes his work to be a game for other people to play with. Once he described it to me, at a cousin's wedding (he's always talking about art, no matter where, or when, the occasion) and he said the situation was something like the following: he was the guy who supplied the game board, the dice and the pieces for playing but it was entirely up to the people how they wanted to play the game.[27]

The attitude is so common as to be a stable element of high art lite doctrine. Jake Chapman, in the run-up to the controversial display of the mannequin work in *Sensation*, was asked to explain the meaning of the work, and replied: 'That's for you to work out. I mean, the work works. If the work didn't work then we'd need to say what it all means.'[28]

Sam Taylor-Wood and Henry Bond made a photograph, called *26 October 1993*, in which they recast the famous picture of John Lennon and Yoko Ono, John clothed, Yoko naked and curled up next to him. In Taylor-Wood's version, the gender roles are reversed. The work refers to naïve 1960s idealism,

though not entirely mockingly, rather asking the viewer to contrast the situation of the 1990s with the 1960s. It does so, not in the usual way, remarking on how Britain has become cool again; instead, there is a nostalgic yearning for what has been lost, and also somehow an emphasis on how great the divide is, how unlikely it is that such idealism could ever be regained.

For such artists, it is clear that we are living in a time of the twilight of ideals: the gods have fallen, humanity is very likely doomed and there is nothing anyone can do about it apart from coast along, perhaps bettering one's own situation while enjoying the spectacle of general collapse. Not only gods but heroes have been put into not-so-genteel retirement. For Keith Coventry, describing his works derived from kebab outlets named after ancient Greek heroes:

> They basically put the idea of progress to the test by saying that these names are still with us, but their resonance has declined. From nobility they are now a mere name above a kebab shop. They have become integrated into the modern world. This world has somehow progressed and the characters have failed.[29]

Artists are among the failed heroes, naturally. To register the distance travelled, it is enough to read a novel like John Berger's *A Painter of our Time*, in which the exiled artist-hero struggles daily and mightily with the weighty problems of politics and painterly form, and the conflict and sympathy between the two.[30] His efforts and the loneliness of his battle, let alone his final decision to surrender art for political engagement, could not be more alien from the concerns of high art lite. The character is well aware of his own weaknesses, and there are many aspects of Berger's protagonist with which we could take issue, but the gap between his interests and those of the present raises a fundamental question: are we any longer talking about the same thing, art?

Among the artists who have adopted the most extreme stance of amorality and nihilism are Jake and Dinos Chapman, Sam Taylor-Wood and Matt Collishaw. Praising the work of Taylor-Wood in an essay entitled 'No-one's Mother Sucks Cock in Hell', Jake Chapman presents her as a nihilistic and indeed misanthropic artist: our 'post-contemporary period marks our hilarious slide into a "degenerate sublime" which erodes the edifying proposition of a culture engaged with the triumphs of progress.'[31]

Taylor-Wood has indeed made some of the most extreme work of the high art lite tendency. One piece simply presents the word 'Cunt' in Gothic script. In a well-known image, *Fuck, Suck, Spank, Wank* (1993), she poses before the camera in contrapposto, trousers around her ankles, and a T-shirt (made for gay activists) spelling out the message of the title. As with Lucas, here is the artist as bad girl, daring to confront the viewer with her sexuality bared, and (again, as with Lucas) there seems to be something missing from this work. There is a cabbage in the picture which the artist admits that she included so that people would say 'What about the cabbage?'[32] The work can be enjoyed on a number of levels, be found humorous, would shock some, but that seems to be it.

Similar is *Slut* (1993), a photograph of the artist, smiling, her neck covered in love-bites. Taylor-Wood hired a make-up artist for this shot, to get the

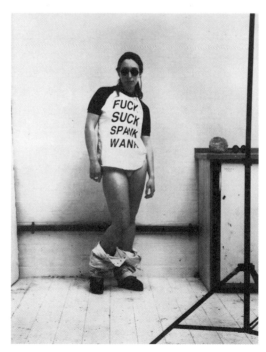

41 Sam Taylor-Wood, *Fuck, Suck, Spank, Wank*, 1993

picture looking as much like magazine work as possible, with the neck of course left bare. Of this work, Taylor-Wood says:

> One of the things I was interested in doing in these photographs was putting myself in a seemingly vulnerable position and then turning that on its head by using humour and other simple devices. In *Slut* I have these love bites, but my expression suggests that I'm happy about it. Happy that I had wild sex the night before, rather than being the victim of something.[33]

So this work takes a stance against earlier feminist art that tended to see women as victims and their sexuality as something likely to betray them, but it does not simply say that everything is fine these days. They rely on a particular brand of British prurience towards sex that makes its open display seem, not transgressive so much as a bit naughty, and not something that you would expect to come across in fine art.

Taylor-Wood's interventions are reliant on the gallery, and when they depart from it, become less spare and accurate in hitting the public's sensitive spots. She fly-posted the Brick Lane area of London, an area where the population is largely Asian, with a picture of herself wearing a T-shirt bearing a swastika and the name of the symbol written in Sanskrit. While the swastika was the original kind, not the reversed version used by the Nazis, such niceties were lost on the inhabitants of the area, for the posters were swiftly defaced, usually to leave either the word or the symbol intact.[34] In the gallery, most viewers would assume that Taylor-Wood is not a Fascist, or at least that no gallery would show the work of a Fascist (or not a young one anyway, for Reifenstahl is shown), and would interrogate the work for ambiguity, or appreciate it as a knowingly transgressive gesture. To paste such a work up around Brick Lane which, though subject to a slow process of gentrification, is still the site of potentially murderous conflict between its Asian and white populations, was to make a very different intervention – not perhaps effective enough to be dangerous but nevertheless frivolous and irresponsible.

In later works for which she has become better known (shown at the Turner Prize exhibition in 1998) Taylor-Wood has made 360° photographs of large interiors, the homes of very affluent and cultured people, with scattered

42 Sam Taylor-Wood, *Five Revolutionary Seconds XIII*, 1998

figures who seem lost in these minimalist or richly decorated spaces, unable to settle in their surroundings or deal with one another. They stand at the other end of the spectrum from the photographs of Richard Billingham (which we will look at in more detail in chapter 8): in Billingham's snapshots of his family in their council flat, there is claustrophobia, passion and intimacy amid heaped-up clutter, kitsch and filth; in Taylor-Wood's highly considered, posed, high-definition photographs there is lack of human contact, alienation amid clean surfaces and fine, select furnishings. The photographs in the series are each called *Five Revolutionary Seconds*, and while sometimes dramatic events occur in these pictures – violence, sex, intrusion, nudity – it is all treated with an extreme distance and reserve, as if the lens of the camera had become a telescope looked through the wrong way. Only the camera revolves in those seconds it takes to complete the shot, and the subjects are bound firmly in their opulent prisons. As James Roberts put it, there is no room for idealism or hedonism in these pictures, for those things seem to belong to another time: 'All that remains of them today are a sequence of poses, a look, a lifestyle'.[35]

When asked by Carl Freedman about this quality of the work, Taylor-Wood said that it reflected reality:

> *I don't find myself responding to the pessimism of the idea of isolation that runs through your* [Taylor-Wood's] *work. It's too bleak. People unable to communicate, bored or arguing, always alienated from each other. There's no sense of change, or hope or love even.*

I don't think it is as pessimistic as you're making out. Certainly, I'm not offering any answers. And why offer hope when in many instances there isn't any hope. I'm showing things how they are.[36]

In this strand of high art lite there is a naturalistic attitude, content to reflect – and exploit – the worst. Or as Jake Chapman put it, making it sound a bit more appealing, a somehow principled apathy, Taylor-Wood's 'artistic reluctance amounts to an aesthetic fatalism which opposes dynamic content with a transgressive and vertiginous passivity …'[37] It is important, though, and certainly a positive feature of Taylor-Wood's work, that she makes no pretence of slumming it, that in looking for the dark side of life she does not have recourse to the benighted underclass but instead finds it in the circumstances of the creators and consumers of high art. This is what disturbs Freedman: that Taylor-Wood's photographs and films are not an anthropological window on the life of someone very different from yourself whose helpless degradation only you, the sophisticated viewer, can fully appreciate but – for a certain stratum of the art-world audience – a look in the mirror.

In high art lite, the most specific campaign of nihilism has been launched by Jake and Dinos Chapman. Much of their work is a programmatic attempt to wind up liberal opinion, and like so much of this art, its power is largely dependent on its display in the gallery. They started out beating up on anti-war sentiment, a fundamental liberal orthodoxy, making a piece called *Disasters of War*, model soldiers grouped into little dioramas, meticulously chopped up so as to represent each of the eighty-three scenes of Goya's famous print series of the same name.[38] The idea, said Jake Chapman, was 'detracting from the expressionist qualities of a Goya drawing and trying to find the most neurotic medium possible, which we perceived as models. It gave us a sense of omnipotence to chop these toys up.'[39] The meticulous making and painting of the figurines is a re-enactment of domestic pursuits involving plastic kits and enamel paints, that collides with the high drama of the subject. Carl Freedman, drawing on the Chapmans' views, says of this piece that any 'namby-pamby antiwar sentiment' would have got in the way of its radical negation of meaning.[40]

The Chapmans play at being bad as much in their statements as in their art. This is what Jake says about what he likes to watch on TV:

I like it when people hurt themselves. I liked it when the policeman taped his own death. It was hilarious. It was great. It was pretty rotten but funny.[41]

Aside from violence, there is commercialised sex: they produced a porn video, *Bring Me the Head of …* (1995), made as revenge on an Italian gallery owner who refused to show their sculptures. In it, a model of his severed head with penis-nose is used to penetrate a professional porn actress. Asked about this

43 Jake and Dinos Chapman, *Übermensch*, 1995

work by a very dubious Martin Maloney who admitted feeling 'like the liberal teacher of "Beavis and Butthead"' in objecting to their use of pornography, Jake Chapman claimed to have 'the same sense of morality as everyone else' (a double-edged statement, of course).[42]

Another Chapman violation of liberal opinion was *Übermensch* (1995), a representation of Steven Hawking atop a rocky crag that he has conquered in his motorised wheelchair, the soaring of the Nietzschean intellect contrasted with the debility of the physicist's body. Yet while this sculpture kicks against liberal attitudes towards the disabled and the awe with which Hawking is regarded, its message is conventional postmodern stuff:

> Hawking sits as an impotent monument to the wet dream of a purely
> enlightened science, a physical dismemberment of the Platonic Idea,
> freed from the vulgar passions of the body in order to contemplate the
> mind of god through a computer voice synthesiser.[43]

So this work contains the familiar and dated refrain of science-bashing, along with the trite apposition body-good, intellect-bad – standard theoretical niceties dressed up in a mildly entertaining and politically incorrect form.

The Chapmans' kiddie-mannequin sculptures with added sexual organs play much the same game. There is the strong suspicion hanging about the Chapmans' work that it is just that, a game designed to court the attention of the media. At the time of the controversy over *Sensation*, in which the Chapmans' kiddie dummies featured, the *Daily Mail* found the brothers' Uncle Peter, who paints pictures of horses, 'unmutilated', and asked him to comment on the art of his nephews:

> It's totally outrageous and offensive to a lot of people and perhaps is
> even intended to cause disgust. I don't know what's in their minds,
> except I do know my nephews are a couple of smashing and very
> normal blokes. I also know that these days offensive art makes money.[44]

All this is presented, however, as more than mere provocation: it is, rather, a consistent attitude of critique against liberal ideals and morals, not from the Left but from the Right; it threatens 'social and capital power', claim its supporters, 'with the enslavement that is inherent in reaction.'[45] This is an art of

44 Mat Collishaw, *Bullet Hole*, 1988/93

resolute anti-idealism, supposed to 'reduce the viewer to a state of absolute moral panic ...'[46] In fact, the Chapmans' sculpture most often produces laughter, an uneasy laughter their supporters would say, an indication of deep conflict. But perhaps it is just laughter at these oddly familiar objects, so well streamlined for insertion into the mass media.

Very similar in his relation to both mass media concerns and conventional ideas of morality is Matt Collishaw. He has a reputation for being the nastiest of the 'young British artists', and certainly on the surface of it, the work deserves that reputation. He has made light boxes depicting children with Downs Syndrome; in *Period* (1992) colour photographs of women, naked from the waist down, using sanitary towels; in *Suicide Suite* (1993), slickly presented images of suicides from police files; there are overtly voyeuristic pictures of girls in school uniform lying (asleep, unconscious?) in woods surrounded by the detritus of a chemical debauch; projected images of women hung by ropes, taken from sado-masochistic magazines, and an entire porn magazine reproduced in black and white.[47]

Artists like Collishaw do not merely present disturbing material, but play on moral distance from it by using the cool, abstracting devices of minimalist and conceptual art. Those devices, once a register of the coolness and systematisation of modern, administered life, are loaded with material that ought to be highly emotive and disturbing for its viewers. If the trick succeeds, both are made unfamiliar, and the viewer is thrown into an abyss between emotional numbness and high passion or revulsion. So Collishaw's *Bullet Hole* (1988/93), a massively enlarged forensic picture of the entry wound in the head of a suicide, is cut into rectangles by a frame that forms a grid across the picture. Of this Collishaw remarks that 'The bullet hole could be looked at as an abstraction, due to the structure of the picture.'[48] Yet the work also pulls the other way since, for many viewers, its fleshy opening surrounded by hair is sexual – at once alluring and repellent.[49]

Pressing on another currently exposed media nerve is Collishaw's *Lost Boys*, a series of photographs of young naked boys posed coyly and cloyingly in pious, devotional poses suggesting innocence, and set in abandoned buildings, clearly a paedophile's fantasy. For Freedman:

> It's as if Collishaw were toying with ideas of beauty and morality in the same way as a cat might amuse itself with a caught mouse; as if they were simply a way of extracting some kind of sensation from the flat and deadened surface of contemporary life.[50]

Again the trick is the same: to see how far you can go in exploiting emotional and aesthetic numbness. Naturally, the pictures are also open to recursive interpretation – perhaps they are not immoral but are about immorality, or about the assumed congruence of documentary photography and morality.[51]

Of his overall project, Collishaw claims:

> I'm mourning the loss of humanism. There's nothing didactic about it. It's more a curiosity. I'm not taking a moral stance. I'm side stepping all that and saying look at the incredible richness, beauty and texture of this fucked up world we live in.[52]

Mourning, then, but without morals, just nostalgia, and coupled with an enjoyment of our current situation, heightened by that sense of loss (and here

45 Mat Collishaw, *The Awakening of Conscience: Emily*, 1997

we are back to Taylor-Wood's version of the John and Yoko photograph).
Given the very flatness and lack of affect in such works, they are open to a var-
iety of meanings: the refusal of conventional morality may itself be moral or
immoral or amoral; emotional flatness may be a protest against the numbness
of conventional culture, or a sociological observation about it, or a celebration
of it. The matter is complicated further because, even in some supportive writ-
ing, Collishaw's work is seen less as a conscious intervention in the culture than
a symptom of social malaise. Remarkably, even the artist blames society: 'If I am
sick, I think it has to be because I am the product of my environment, the soci-
ety in which I live.'[53] Similarly for Jake Chapman, writing about Taylor-Wood,
she is simply on a runaway train to who knows what destination, for one trans-
gression engenders another 'in oblivion to quality or control'.[54]

On this schema, in which the character of high art is self-consciously as
much a sociological indicator as, say, levels of vandalism, it does not matter

whether the works are nasty or nice, though the nasty ones might impart their message with a little more force. For Martin Maloney who owns up to 'playing with shallowness', making childishly sweet and banal figure paintings (see fig. 57), it is not that the work comments on the media but that the media has made the work, and its author, what they are:

> The dreamy qualities in the artworks do not express a personal poetic.
> They come from the commercial exploitation of our desire for that
> poetic. The artworks show the blank beauty of a generation seduced by
> the romantic poses of people, places and things from t.v. and magazines
> … When I look at the work I feel shocked by the artists' fascination
> with the trivial. I see the emptiness of the superficial but somehow I've
> been made to enjoy that.[55]

This is well-digested Baudrillard, turned to deeply conservative ends: there is no escaping our current situation, this hall of media mirrors, so we may as well enjoy our enjoyment of it.

To begin to decide on the questions of interpretation that this relation to the mass media raises, we need to take a step or two back. We should be clear that the artists are going to be of very little help in this matter, though their tactics of obstruction may in themselves be revealing. Matthew Collings, writing about the artists in *Sensation*, and looking around for what they have in common, suggests that they are united by their 'realism' and by their deliberate refusal to offer solutions:

> Rather than 'deconstruct' the bad world and serve up thoughtful
> solutions as to what can be done about it, the artists in 'Sensation' seem
> to say, Here is the world as it is, I refuse your systems for sorting things
> out. Or, sod you gits![56]

This refusal to interpret the work – while making work that is hard to interpret – was, as we have seen, a way of reclaiming the work from academic art-world professionals. Another and less desirable effect has been an aggression towards the viewer, disguised occasionally as democratic openness, and a refusal to accept any responsibility for the readings that a work can generate. It is Hirst who has been most insistent on this, taking from Warhol the strat-

46 Sarah Lucas, *Sod You Gits*, 1990

egy of paradoxical and dumb statements, openly spinning a web of contradiction. To take some of the statements from his book, placed on the page with huge spaces around them to let them breathe in their full profundity:

> I want the viewer to do a lot of work and feel uncomfortable. They should be made to feel responsible for their own view of the world rather than look at the artist's view and be critical of it.
>
> I try to say something and deny it at the same time.
>
> I'm a hypocrite and a slut and I'll change my mind tomorrow.[57]

This refusal to make consistent comment could be seen as a strength, being a welcome relief from the endless moralising and neatly tied-up narratives of the mass media. The attack on morals was also pitched against the hypocrisy of the established art world. But, as so often in contemporary art, the reaction was brought to an absolute extremity, as if the means of communication were so poor that only the most frantic signalling, and messages in tones of dead black and pure white could get through. To refuse to offer neatly packaged

solutions, to recognise complexity and ambiguity, does not have to entail refusing to say anything at all.

The attitude of extreme negation that characterises the work of the Chapmans, Collishaw and Taylor-Wood is of interest, yet its radical indeterminacy and the pussy-footing of some of its defenders serves to withdraw much of its sting. Such work plays to a wider world than that of the specialist art audience, and there people continue to demand explanations because this art, with its paradoxical coupling of opposites, looks like it is making statements. The readings of that wider public, as we shall see, are not ones that the artists or the art world would welcome.

The option of extreme negation is also deadened because it does not lead into anything else. Behind Dada lay the hope that the destruction of autonomous high art would yield something better. Such hopes seem terribly old-fashioned now, this new art seems to say, so we may as well enjoy the spectacle of our fin de siècle impasse. And it lends bite to an otherwise insipid cocktail to add a dash of disdain and a Nietzschean admiration of the powerful, knowingly filtered through postmodern disillusion.

Such an attitude is plainly convenient to the propaganda operations of big business, as culture and the market become more entwined, as advertising becomes more like visual art and vice versa, and as business tries to push that closure – without destroying the niche market for fine art; a delicate and perhaps contradictory operation. But it is comforting for business to believe, and convenient for its propagandists to have sophisticated audiences believe, that there is no essential difference – that both high art and advertising manipulate people, tell lies, explore the mechanisms of representation, and so on.

Strangely, though, no matter how much you suppress meaning and morality, they crop up again in unexpected places. These artists seek our admiration for their honesty, for giving us a view of life in all its horror and beauty together, and not comforting us with hollow parables. If not along the lines of 'Brilliant!', Sensation or Emotion, the names of high art lite exhibitions strive to illustrate the tendency's attachment to the concerns of life as well as those of art: Life/Live, Real/Life, Common People, Real Art. The mass media are the medium through which 'life' is both experienced and transmitted. As we have seen with Emin, there is an 'expressionist' wing to high art lite in which a

direct line from personality to work is drawn, fostered by celebrity, encouraged by scene writers and gossip columnists, and there are others for whom art and lifestyle are closely linked, including Hirst, Ofili and Lucas. These are artists who know about 'real life' and tell it like it is. There is a supposed congruence not only of art and 'life' but of art and the life that the artists themselves lead. The Chapmans, in choosing a 'date' for a TV programme in which they got to make a work for someone, chose Justine Frischman from the band Elastica, hoping that anyone used to a 'sex, drugs and rock 'n' roll' lifestyle would like what they did.[58] Again Gilbert and George are important in manifestly living their art, and in making sure that art and life are congruent:

> We used drinking as the subject and the content [of art]. We had artist chums at that time drinking with us and then they would get up in the morning and make these appalling, abstract, cool, sober pictures. We thought it was unfair and unrealistic and dishonest. Why not use drink as the subject. Everyone is drunk, everyone understands drunkenness ...[59]

This honesty, an oddly moral quality, is central to high art lite. In 1990 Sarah Lucas made *Sausage Film* showing the artist skinning and eating a sausage and a banana. Angus Fairhurst praises her work:

> Exemplary lack of style means no embarrassment, means not having to say you are sorry. No expurgation of the dirty bits, no fine-grooming to put out the bowdlerised style, the immorality of distance.[60]

For Lucas herself such work treads an ambivalent line: 'With only minor adjustments, a provocative image can become confrontational ... converted from an offer of sexual service into a castration image.'[61] But it is her bravery and honesty in exposing both that provocation and herself that is raised up by the work for admiration.

This brings us back to an issue raised near the beginning of this chapter: that there is no single 'real life' that can be served raw, as one half of this art and one half of its critical defenders would have you believe. Whose 'real life' is it, and how does it connect with that of others? What governs it and how does it change? How can it be changed? These are the questions that the dumb naturalism of much high art lite is in no position to ask.

The childhood home

Against the trend to have art showcase the most sensational media obsessions, there is another, apparently contradictory aspect to much high art lite, and that is its air of domesticity. In part, this is an aspect of its anti-intellectual pose – the shabby, the miniature, the mundane, even story-telling are pitched against the grand themes of high theory, politics, economics and other great intellectual engines.

David Batchelor, summing up the character of recent British art, argued that it shunned pristine and high-tech forms in favour of the 'small scale, domestic, urban consumer item … usually distressed, tarnished, used or abused.'[62] We can see this aspect, less in the aspirant monumental statements of Hirst, than in the home-made work of Lucas, Lane, Emin, Brian Griffiths, Elizabeth Wright and many others.

For Richard Shone (who has written much of the Edwardian era, as well as on contemporary art), selecting the *New Contemporaries* exhibition of 1996, the opportunity to see a great quantity of work led him to reflect on the general character of the art that passed before him; it was, he explained, much obsessed with popular culture of the past – with B-movies, comic strips, period design, *Coronation Street* episodes and stand-up comedy.[63] It manifested a particularly British sensibility:

> Our art has been domestic in scale, dominated by the figure and by landscape and by a strong literary or narrative strain. Knotted through it are conjunctions of down-to-earth realism and heightened poetic moments. If the urban landscape has replaced the rural and the high literary strain has been outstripped by more demotic narratives – Reynolds and the Pre-Raphaelites overtaken by Hogarth, Richardson and Sickert – we can find here, I believe, still familiar themes injected with the vivid local colours of our time.[64]

This is a vision that offers the same comfort as the art itself: of a national culture changing in its contingencies but constant in its essence, allowing us to recognise, in tabloid papers as much as in old *Carry On* films, a bedrock for identity. It is a vision of British childhood in which a filter of domesticity is

placed over the appreciation of mass culture; a nostalgia for a lost world of innocent pleasures (or for a time when even guilty pleasures were only innocently naughty).

We have already seen a similar nostalgia for the idealism of the 1960s, made poignant by its dizzying juxtaposition with the nihilistic 1990s; looking back to the years of childhood is at the root of this. Such nostalgia is there in Gary Hume's painting *Love Love's Unlovable* (1994) that has figures surrounded by a pattern of flowers painted in the colours of the sweets, Refreshers.[65] In a different register, one of youthful if ironic and doomed rebellion, it is there, too, in the references to punk music, to the 'Pretty Vacant' attitude of the music of

47 Marc Quinn, *Self*, 1991

these artists' youth, satirised in Gavin Turk's resurrection of Sid Vicious in the guise of artist-cowboy (fig. 15).

We have also seen that the domestic is supposed to conceal horrors – another childhood fantasy brought into art. Marc Quinn's frozen blood head, simply called *Self*, is contained in a perspex box, mounted on a louvred, stainless steel refrigeration unit. It was cast from nine pints of the artist's blood, about the amount contained in a body. An LED indicates the temperature inside. The head is deteriorating, cracks showing a deeper, glossy red against the frosted surface. Its calm, banal expression contrasts with the violence apparently wrought on it – the crumbling ears, the deeply cracked chin and neck, as though its throat were cut. It gives the impression of tremendous age, as if it were some unearthed ancient artefact, displayed and maintained in its robot casing. We might be tempted to read it less as a death mask and more as a preserved ancient corpse, but for the tell-tale flange of ice that encircles it, a diminished halo, the result of seepage from the mould. If the head and fridge are seen as a whole (not as work of art and plinth) then they appear in their true guise, less as sculpture than high-tech Gothic horror evoking, along with a thousand movies, childhood memories of *Doctor Who*.

Quinn's *Self* is a macho and mechanistic version of a strong British engagement with shabby interiors that take on an uncanny air, at once homely and unhomely. This trend takes in Whiteread whose *Ghost* (1990), she claims, is a cast of a room similar to the one in which she grew up.[66] It is a spectral and reversed image of the space, exploring the traces rooms leave on their inhabitants through the presentation of the traces left by the inhabitants on rooms. For Waldemar Januszczak it is a 'tearfully sentimental' work, producing an atmosphere 'that is pure Coronation Street, circa 1968 …'[67] Jane and Louise Wilson also mine this vein, with their photographs and videos of uncanny domestic spaces in which objects take on a strange and menacing air. Similar are Elizabeth Wright's shrinking and expanding of familiar objects, such as packets of cigarettes and the telephone directory, to create uncanny ensembles of mismatched objects. The trend is one that cuts across artists who are not normally associated with high art lite: we might think of much of the work of Mona Hatoum, particularly her doormat, that says 'Welcome' but is made up of stainless steel pins, and her cots with razor-sharp wires where the springs

should be; similar in intent are Permindaur Kaur's weirdly disproportioned cots. Here high theory, wrapped safely in a domestic package, still holds sway. It is obvious that all these artists have spent time with Freud's essay on the uncanny – or with the now vast secondary literature with which it is surrounded.[68] In this strand of work, an older feminist attitude is still apparent, partly because the older generation (Hatoum is a good example) have made accommodation to the accessibility of the new, partly because domesticity ensures a certain accessibility, and partly because horror in the home is one of those few subjects that is open both to feminist readings and to media sensation.

The turn to the domestic is one factor that has favoured women artists who are strikingly more prominent in British art than they were even ten years ago – and this development must count as one of the signal achievements of high art lite. A simple way of registering the change is to look at the proportion of women in exhibitions that are meant to give an impression of the British art scene to those in other countries. While the previous wave of British art to come to prominence (the 'new sculpture') was dominated by males and by work that often made mystifying claims to its own spiritual significance, current exhibitions, such as *Real/Life* shown in various venues in Japan, contain art that is more domestically inclined, and a little more modest in its claims to cosmic import: of the twelve artists showing in *Real/Life*, eight were women.[69]

Whether made by women or not, the mass media convention of the home as the site of some unnameable horror or founding disturbance is a distinctly modern one, having its roots in Romantic and Gothic fiction, and inflected by Freudian fantasies of the 'primal scene'. Yet few of the works that use it also engage with the role of the media in fostering its contemporary version, let alone with their own likely life in the media. There are, however, some works that take this combination seriously, that allow the viewer to see clearly that they are about the transmission of the real through the media, and into the minds of domesticated creatures, rather than being rawly about the real itself. Exemplary in this respect are the text pieces of Fiona Banner. She makes huge word canvases, the shape of cinema screens, filled regularly with texts that she has written following the plot of films. Slowing down videos, Banner types a reverse-engineered screenplay into a computer. Once finished, a word count

48 Fiona Banner, *Chinook Drawing*, 1995

allows her to calculate how to fill the canvas completely and evenly, creating a uniform block of hand-written text.[70] The resulting objects disorient the viewer with their walls of text, the lines being far too long to read without great concentration, so the text tends to break up into unsettling fragments.

Banner also made a thousand-page book, *The Nam*, a text of one unbroken paragraph, the pages unnumbered, that blow by blow recounts the incidents in six well-known US films about the Vietnam War: *Full Metal Jacket*, *The Deer Hunter*, *Apocalypse Now!*, *Born on the Fourth of July*, *Hamburger Hill* and *Platoon*.[71] In this breeze-block of a book, with its lurid cover and brutally heavy type, the narratives of the films are merged into an unremitting, semi-coherent parade of horror or impending horror.

Such works capture the way in which Hollywood films build a war almost beyond imagining (an attempted genocide launched by the world's most powerful military force) into grand moral tales, often of redemption granted to those who conducted that slaughter, and then how these epic and bloody fictions are shrunk from the silver screen to the domestic box. In the home they are open to many forms of attention, or partial attention, or lack of it.

One manner of enjoyment is that of the obsessive adolescent, the sort who makes careful pencil drawings of military machinery (Banner has mimicked that activity), or, with a video, plays and replays the film until they can recount every turn of the plot, the particulars of every killing, the dialogue line by line. Banner takes that obsessive attitude and uses it to marry grand horror with domestic claustrophobia in physically impressive works that do, in their mind-numbing repetition, indicate the endlessness of political crimes, and equally the endlessness of their small-scale enjoyment by spectators. This is a more intelligent and self-aware practice than much that draws on media cliché in high art lite, though one still trapped, however consciously, in the simulacrum, for which reality is illuminated only by the glow of the cathode ray tube.

Dulux

A striking oddity about high art lite is that this most demotic and sensationalist art, this irruption of the 'real' into the gallery, is accompanied by a strain of abstract painting that occupies itself with rather abstruse concerns about painting as an object, painting as the visible traces of process, and the liminal spaces between abstraction and figuration, representation and object-hood. Attempts by critics to link these works to the mainstream of high art lite sometimes seem to be reaching a little:

> The simplicity of the painting gesture and the resulting shiny, seductive, sensual objects highlight contemporary preoccupations: the elegant choreography of sex, our fascination with boredom and our enthralment with staged violence.[72]

Thus Martin Maloney on Ian Davenport's slick but silent work.

Yet any attempt to grasp the full range of high art lite has to take account not only of the much-publicised media-friendly work but also of a tendency in painting that at first sight seems to be at its opposite pole. While one part of this generation of British artists looked outwards to 'real life' and the mass media, another looked inwards to the language and the means of painting.

On one level, there is a simple explanation: it is that the private market has a greater dominance over cutting-edge painting than over installation and

49 Damien Hirst, *Apotryptophanase*, 1994

other forms of object-making, let alone those practices that, as we have seen, resist commodification. In the pursuit of new painting, the established galleries, notably Waddingtons, did not bow out, even during the recession. Paintings remained readily saleable objects even when the market was very sluggish. We have seen that Hirst, whose formaldehyde works – difficult and dangerous to maintain and move – have not always reached reserve prices in the secondary market, has assistants working away on spot paintings, three hundred of which have been made up to 1999.[73] As the art market revived, painters only had to appeal to the tastes of their galleries and buyers, in an arena less open to the mass media and somewhat less dominated by the taste of Charles Saatchi.

Yet there are similarities, too, and perhaps this painting is – albeit less directly – as much a creature of the Major interregnum as its more spectacular siblings. When Stuart Morgan wrote a catalogue essay about Fiona Rae, he called it 'Playing for Time', and such sentiments and phrases have often been applied to high art lite painting. We have seen that ideologies, principles and morals were having a hard time of it, and according to some views were even finished. Many consider art to be in a similar situation, and it has become a truism to say that painting, in particular, is in crisis.[74] There has been much talk of 'endgame' painting, the analogy being with chess, where it is possible to get to a point when there are so few pieces on the board that the options have become very limited but the game can go on indefinitely.

For Morgan, writing about Rae:

> Faced with the problem of how to go on, Rae simply ploughs ahead. Treat this as pig dumbness if you will. The choice is yours. But don't forget that the elaborately witty play on problems of intention and accident; the doleful suggestion of letting things go to rack and ruin before trying to pull them into shape; the perpetual straw-clutching, are all part of the act. If Rae can just bring it off and keep bringing it off, the problems may right themselves. Playing for time means *making* time, after all.[75]

That very recursion, such that we never know whether a feature of the art is just a feature or really a theme is, as we have seen, typical of this art. Four years later, Rae was doing much the same thing, making, as Richard Shone put it, 'a beguilingly gauche approximation of "beautiful" painting'.[76]

So the first parallel between this practice of painting and the rest of high art lite is its constancy: these artists have found something that works and they will keep doing it until it doesn't. This is not just a matter of artists sticking to individual projects but of the configuration of the scene as a whole; *Freeze* threw up a number of successful painters – including Hirst, Rae and Davenport – most of whom are still in place over ten years later.

Another parallel is the common play with the domestic, largely highlighted through the use of household paint, which sets up a mocking parallel between the paint on the canvas and the paint on the wall on which it will be hung, and

a knowing reference to easel painting as decoration. Hirst's spot paintings are made with ready-mixed household paint. Hume's paintings, as we have seen, use household gloss, and there are occasions when he has let other people pick the colours because he worried that his choices were becoming too tasteful.[77] Likewise, Alex Landrum's monochrome paintings take their ready-made colours and names, inscribed into otherwise smooth surfaces, from Dulux's 'Mix and Match' range.[78] (Duchamp's quip that all paintings are actually ready-mades because they are mere blends of industrially produced consumer objects, tubes of paint, is one that these artists have taken to heart.)

The tendency to select is symptomatic of the way that the space in which painting operates has shrunk. These works are not so much paintings as objects: in Zebedee Jones's paintings the work of art disappears under the weight of its own materiality as paint.[79] Jason Martin sweeps a big squeegee across the length of a canvas in a single stroke, producing a series of uniform horizontal lines and a surface that is the subtle record of that gesture. Martin says of his paintings that he wants the viewer to be as close as possible to an awareness of how the object came into being, that object being a document of its making rather than a depiction of anything other than itself.[80] The concern is quite an old one in painting, the technique having been made famous by Gerhard Richter to rather different purpose (often the erasure of depiction), and the result is a series of half-automatic but highly individual and recognisable works. In general, that these paintings aspire to be objects is due to the suspicion of representation, since these days image-making can only be conducted with high irony. Images you can get from television and magazines; impressive material objects you cannot, and that is what painting, if it is to justify itself as an elite medium, must manifestly become.

An indication of this closure is the degree to which artists court chance in their work, letting their canvases become as much natural objects as, say, the weathered patterns on a wall. One of the most successful painters to employ this strategy is Ian Davenport who uses household gloss and matt paints, pouring one over the other, turning the canvas, and allowing the streams to interfere with each other. The paintings are the product of this deliberate process, and not at all to do with the touch of the artist's hand.[81] The disarming straightforwardness and simplicity of Davenport's approach marks these works

50 Ian Davenport, *Poured Painting: Lime Green, Pale Yellow, Lime Green*, 1998

out as a conceptual project; like Hirst's spin and spot paintings, they form part of an endlessly variable series.[82] As simple as an idea in advertising, they yield impressive and alluring physical objects.

Davenport is open about his technique. He describes one set of paintings in which a graceful arc of paint of inhuman perfection borders the square canvas:

> The paintings ... are made by pouring household paint, straight from the can onto a board placed on the floor. I continue pouring until the pool of colour has nearly filled the entire picture area. The painting is then stood up, allowing gravity to pull the mass of material down and

off the bottom edge. This process is repeated, and a line of colour is left, as one layer obscures and nearly erases another.[83]

The painter's touch is mistrusted now. Artists continue to paint only by allowing some other force to participate in and to an extent determine the form of the painting. Or they paint only to undo what they have made: having painstakingly constructed a painted surface, dripping turpentine over it (Callum Innes). Or they make of their gesture so large and single a sweep that physics and physiology must intervene and undermine the – in any case, suspect – transmission of emotion into touch (Jason Martin). Or they animate dead black fields of thick paint with the minimum hand-made texture necessary to let a flickering carry across the surface, as though it were the last moment of a dying light (Zebedee Jones). Or they mechanise gesture, painting facsimiles of touch inch by inch, with the meticulous attention to detail of a Pre-Raphaelite painter, to forge and denature the expressivity of painting (Glenn Brown).

Yet the market does not permit these painters to surrender agency entirely, to let go into pure contingency. Mark Harris has argued that, reduced as the scope for action among these painters is, there is still in their practice a core of authenticity, to do, if not with touch, with aesthetic judgement, which is not present in more radical interventions, such as that of Angus Fairhurst who has hired sign painters to make his flat, conceptual works.[84] Similarly, Angela Bulloch has made drawing machines that respond to the actions of viewers, laying down complex grids in ink that are pretty good simulacra of some of the abstract-chance work (see fig. 76). The issue on which she presses here is to automate the process and to allow viewers who come to understand that the machine responds to their own movements to try to change the work – striking at the heart of authorship.

The works of these endgame painters are largely about the condition of painting. They are a critique and a continuation, half-apology, half-bravado, of subjective painting and of painting as object. What good fortune that the critique allows the continuation of what the market requires: many coloured objects placed in rows, first in galleries and then in the houses of collectors.

They have also acquired another resonance. Given the context of the art

that surrounded this painting, and that of the political impasse of the Major years, this brand of painting came to be read as symptomatic and expressive not only of the crisis in painting but also of the more widespread bonfire of ideals. The strategies of these painters do embody a desperation, an impulse to snatch at the last possible moment some meaning, some freedom of action, some grain of expression from the encroaching vacuum.

How are the concerns of endgame painting to be reconciled with the other side of high art lite, that takes on 'real life', directly and in all its plenitude? Against the 'real' is pitched not so much the unreal (for the real is no longer really real, everyone understands that) as nothingness. In high art lite, there is found an overtly empty abstraction, an extravagant emptiness, that refers both to itself and also to the failure of reference generally. The real and the void are linked and dependent on one another: emptiness can tip over into sensual plenitude in much of this materially thick abstract work while real life, presented raw but infected by simulation, can fail to refer at all. Artists play across both boundaries.

The opposition can be seen most clearly in a quirky attempt to extend this autonomy to that medium most crudely in touch with the 'real'. Steven Pippin makes cameras out of household objects, including wardrobes, toilets and washing machines. In the last two cases, since the 'cameras' have plumbing, they develop as well as expose the prints. To do this is both to associate photography with the domestic and to invest it with lavatorial humour. Yet there is another aspect: what these odd cameras take pictures of is in part themselves and, in part, whatever their apertures are pointed at – the artist generally puts himself in their way. Pippin says that photography seems to be directed towards giving an ever more convincing rendition of reality, but his purpose is to work in the opposite direction:

> I have become fascinated with the idea of constructing a camera whose viewpoint is not some external subject, but instead one having the capability of looking back in on itself toward its own darkness. An instrument designed with the intention of recording its own mechanism and features. A singular entity bearing no relationship to anything other than its own intricate and elaborate operation.[85]

This is the odd application of autonomy to a medium to which it is radically unsuited. In these works, there is a strange synthesis of autonomy and the impulse to record the real, and it is entirely fitting that in them it is the spectral figure of the artist that takes centre stage.

Believing the hype

There is a fundamental question to be asked about this art as it ties itself more closely to the consumerist world of fashion, pop music and lifestyle magazines. Can it compete, in the way Hirst would have it do, with mass culture? Does it function as entertainment? This was the question asked by Kitty Hauser in her review of the *Sensation* exhibition, comparing the art to what it tries to measure up against, the immediacy, complexity and popularity of, for instance, pop music.[86] As soon as the question is asked, the answer is obvious: if art is not to be high art, then its place as entertainment is at best secondary, a sophisticated game for an elite niche market. As Gavin Turk puts the problem:

> I think art actually has a very difficult job at the moment because it has become aligned with the entertainment industry and, as entertainment, art isn't particularly entertaining.[87]

Art has two main advantages over mass culture in its bid to be entertaining: the first is that of surprise, since people generally do not expect art to entertain them – a feature that plainly has a limited shelf-life; the second is that, in the gallery, it can present the viewer with objects, not representations (with cadavers, blood, ice or sump oil) that have a physical and sensuous appeal that television cannot match. Equally, when art deals in representations rather than objects, its shocking material can only be a pale reflection of the vast and increasingly integrated industries of simulation – the cinema, television, computer entertainment. Cinema cannot display the actual bisected corpse of a cow but it can noisily and effectively simulate the effects of an asteroid slamming into the Earth. Computer games as yet appeal to only two human senses, but there is no art work in which one can take on a squad of passably intelligent Marines with an assault rifle, or beat a gangster about the head with a

lead pipe. When works of art deal in representations – particularly film and video – the gap in technology and resources between the mass media and the art world becomes vast, and all artists can do is exploit the rough and amateurish qualities that are forced upon them.[88] To the extent that high art mirrors the mass media, it enters a realm in which it is ill-equipped to compete. Its own spectacles of violence and eroticism can only be pale reflections of increasingly palpable simulations, and indeed cannot be quite the simple reflections of mass media 'real life' that they purport to be.

Matching the work up against the best of what mass culture has to offer raises some disturbing judgements. For George Walden, writing of high art lite:

> Some of it is capable of affording entertainment or distraction, but if those are the criteria, in terms of wit, intelligence, originality, social commentary or philosophical undertones, it rarely rises to the level of the most accomplished American television shows, such as *The Simpsons*.[89]

To hold up *The Simpsons* against this art is instructive, for it very successfully does what high art lite is supposed to do – appeals to different viewers on a number of levels. Its consistently critical message is delivered to huge audiences, the references being complex, knowing and piled on at huge speed. It has many of the qualities of high art lite without the signal disadvantage of being high art. As with high art lite, the spectacle of degradation it presents is an entertaining one. Yet *The Simpsons'* critique is radical because it implies that fallibility and corruption are not just a matter of individuals but of systems, and it offers some small and faintly glimpsed positive elements to set against the dystopian vision, particularly in the feelings of the main characters for each other. The challenge such a programme offers to high art lite is the following: is there anything that it does that art can do better (other than sell unique objects to millionaires)?

Bank, in a statement that typically contains only a small amount of irony, ask:

> Why bother to make artwork when you can pack it in, get a proper job, enjoy a better standard of living and use your free time sitting on your arse watching well-crafted American movies on video?[90]

And it is a point as much for the consumers as the producers of this art. If it is enjoyment, pleasure or entertainment you are after, there are multi-billion dollar corporations devoted to its provision. To go to some cottage-industry artist instead seems a bit perverse. If the activity of making or looking at art is to be justified, it has to offer something else.

It is often said of high art lite that it has a dark view of things, and it does; the true depth of its cynicism, though, is not to be found in its representation of suicides, or torture victims, or abused children, or in its multitude of corpses, but instead in all that it turns its back on, all that it leaves out when it comes to what art can be.

6 **The market and the state**

Despite the steady increase in the popularity of gallery-going, it is still very much a minority pursuit. Eric Hobsbawm notes that in 1994, 21 per cent of the British population had visited a museum or art gallery in the last quarter, while 60 per cent had read a book in the last *week*, 58 per cent had listened to music and 96 per cent had watched television.[1] Although the others are pursuits that do not necessarily involve leaving the house, the disparity is still striking. The reason, as Hobsbawm argues, is obvious: that unlike every other element of culture, whether catering to an elite or to popular taste, visual art has not fully embraced reproduction, being fixed upon the production and appreciation of one-off objects sold at high prices.

Yet the products of high art, while made for a few collectors, make grander claims on the cultural consciousness. Not content to allow them to dwell in the homes of millionaires, along with other trophies, states feel obliged to hoard them in grand buildings for the edification of the public. Are these two realms in which art dwells, private and public, in symbiotic harmony or contradiction?

High art lite raises the question with greater urgency than the art that preceded it, for its cradle was the temporary subduing of the private market, and it makes noisy claims to speak to a wide public or even to everyone. We will look at the separate realms separately (first public, then private), then briefly at their interrelation, and finally at a new attitude in government that promises to change it.

Art in the public realm

While it remains an unpopular activity compared to other cultural pursuits, the figures for attendance at museums have been steadily increasing, and that at art galleries and art museums faster than at others.[2] This is quite a long-term trend and shows no sign of ceasing. In a now classic study, Pierre Bourdieu and his collaborators showed how closely gallery-going correlates with educational level, and it is very likely that this increase is linked to the growing number of people going through higher education.[3] Visitors to the Tate Gallery, for example, are quite a particular group: they tend to be quite young (50 per cent between the ages of 15 and 34), they are slightly more likely to be female than male (55 per cent female), but it is their social makeup that is most uniform: 90 per cent of them are from social categories ABC1.[4] We shall see that this class and age makeup of art gallery visitors is an important factor in drawing in sponsors.

We can look at the Tate Gallery's attendance figures to get an indication of the increase in the audience for visual art as a whole.

Tate Gallery, London: attendance figures

1980	1,330,937
1981	885,168
1982	1,219,102
1983	1,270,925
1984	1,265,605
1985	980,105
1986	1,137,070
1987	1,725,084
1988	1,581,467
1989	1,234,281
1990	1,562,431
1991	1,816,421
1992	1,575,637
1993	1,760,091
1994	2,226,399
1995	1,769,662
1996	2,203,001
1997	1,757,735

I have taken figures from the London Tate Gallery only because they show the longest uninterrupted development. There are marked variations year by year, presumably to do with the popularity of the Gallery's temporary exhibitions, particularly the success of so-called 'blockbuster' shows such as the Cézanne. The recession, despite the large number of tourists visiting the Tate, does not seem to have had any impact (admission to the gallery is free). What is evident is that, despite the variations, numbers have increased, particularly through the 1990s. How much is this due to contemporary British art? One way to judge may be to look at the figures for attendance at the Turner Prize, which displays nothing else. Unfortunately, these are only available from the last three years because before that it was a free exhibition, and visitors to the Tate Gallery wandered in and out without being counted. The figures are as follows:

Turner Prize exhibition attendance [5]

1996	57,000
1997	85,000
1998	121,000

What is clear from these figures is that attendance at the Turner Prize exhibition has seen a steadier and steeper increase than that to the Tate Gallery as a whole. We shall see that the Turner Prize selections for these years have been focused upon high art lite, so the figures are an indication that the audience for that tendency is growing fast, and faster than that for art museum and gallery going as a whole.

Even so, it would be naïve to think that the increase in a public for contemporary art was solely to do with the changing character of that art. Institutional factors are very important, and there have been marked changes in the public art sector throughout the period since Margaret Thatcher came to power in 1979.

Chin-tao Wu, in a study of the relationship between business and the arts in Britain in the 1980s and 1990s, has revealed the determination within government arts policy to make public art institutions reliant on business sponsorship. This was only partly for financial reasons since the sums involved were paltry. The Conservative government calculated that the need to attract

sponsorship would change the character of these institutions and that this, in turn, would change the nature of the art produced for them.[6] The effect, though it cannot be put down wholly to these changes in funding, has been striking: there was a strong radical strand in British art of the 1970s, producing work of an explicitly political kind (and such work was always, naturally enough, more dependent upon state patronage than the market); in the 1980s this persisted in some highly theoretical forms, though it was pushed to the sidelines by a buoyant private market that favoured bombastic neo-expressionist work; in the 1990s high art lite has produced a knowing synthesis of the two, combining idea and expression, theoretical niceties and visual spectacle in a neat, market-friendly and thoroughly apolitical package.

The increase in private sponsorship has affected the presentation as well as the content of the art, and has been congruent with art galleries and museums having to put more emphasis on money making from selling books, cards, posters, food and knick-knacks. It makes a difference to the art displayed to brand an exhibition with the logo of a main sponsor, just as it does to sell coasters or carrier bags bearing reproductions of the exhibits. The more exhibition-going has come to be seen as an extension of shopping, a leisure activity rather than an educational one, the more it can feature in the lifestyle magazines. While such developments well predate high art lite, the tendency is highly suited to this new environment and makes the relation between art and commerce more visible, being a postmodern paradigm of such consumerism, especially in its unconcern with the activities of business.

The changing priorities also began to transform the character of the art galleries and museums themselves as many more staff were devoted to the tasks of press and publicity, development (fund raising) and so forth, at the expense of specialised curators.[7] (A consequence of this was the increased area of operation for freelance curators, including artists.)

While this is not the place to analyse in detail the changes to public arts institutions brought about by commercial pressures and sponsorship, two further points are worth mentioning. First is the gradual weakening of the 'arm's length principle', the idea that government would not directly interfere with funding decisions made by the Arts Council. Second, in the moves towards the devolution of funding to the regions, the replacement of the independent

Regional Arts Associations, run by local arts organisations and local authorities, by the Regional Arts Boards, quangos chaired by ministerial appointees, has been a significant attempt to establish state control over funding decisions, and is typical of the wider assault on local democracy in favour of bodies that would be subservient to central government and business interests.[8]

Companies providing sponsorship get a range of benefits: they associate their name with a form of philanthropy and cultural distinction (and those businesses with troublesome images – those dealing in oil or arms or tobacco, for instance – are keen to do that); they get an impressive venue for corporate hospitality; and they get the chance to display their name before a distinguished group of consumers, notably wealthier and better educated than the average public.[9] Aside from manufacturing companies with actual image problems, sponsorship – and, indeed, art collecting – is important to all those businesses where image is key to success, to those dealing with intangible services and to those whose products are differentiated from their competitors largely by way of packaging and advertising (brewers of lager, for instance).[10]

High art lite is certainly neither anti-business nor anti-consumerist; yet, given the controversy it has attracted and the anti-authoritarian stance of some of its adherents, the smoothness with which it has attracted and cohabited with sponsorship has been striking. Only in the most extreme cases has there been any disruption caused by the content of high art lite. The exhibition of Jake and Dinos Chapman at the ICA was one example:

> Toshiba is proud to support the ICA in its mission to promote a better understanding of contemporary arts to an ever-increasing audience. As a company committed to people and the future through innovation and creativity, it is both exciting and appropriate that Toshiba should join forces with an organisation that shares our determination to promote a better appreciation of the arts, science and technology.[11]

The sponsorship of the ICA by Toshiba was a major deal, handing the high-tech company a good deal of publicity and in effect branding the Institute with Toshiba's logo.[12] While we have seen that the catalogue essays for the Chapmans' show tried to conceal the anti-scientific, anti-Enlightenment, anti-cultural message of the work with arcane jargon, the work itself was clear

enough. The resulting fuss exposed one of the contradictions of high art lite and the commercialisation of art institutions, and it is one which may produce trouble in the long term: those privileged individuals and businesses that buy into high culture want something in return that they cannot get from buying other luxuries, or owning the means of production of mass culture. An art that too resolutely opposes the grounds on which that distinction is made, that is too well linked to the organs of mass culture and publicity, undercuts the ground for its own existence.

So what is the role of art today?

The Turner Prize

One ground over which some of these issues concerning the public art sphere have been raised and fought over is the Turner Prize. This is an annual award to British artists for particular exhibitions or other contributions to the art scene, run by the Tate Gallery. It was designed as a mechanism for generating publicity and it has certainly become an efficient one. Each year, arts correspondents have to cover at least three separate Turner Prize events: the announcement of the shortlist, the opening of the exhibition and the announcement of the Prize. Since Channel 4 started sponsoring the Prize, it has been assured of considerable television coverage, with live broadcasts from the Tate Gallery for the prize-giving event and profiles of the short-listed artists.

The television programmes show very clearly the tactics used by the contemporary art world to defend itself from its enemies. They have lots of positive opinion from professional critics, of course, but these are leavened by condemnations of the work on display in the Prize, usually from wizened conservatives. The result is clear: when ogres from the *Daily Telegraph* are wheeled on to oppose contemporary British art, the (flawed) logic is that, if people like that despise the work, it can't be all bad.

Up until 1991, the Prize had failed to settle into being an accepted art-world institution. There were those, including one of the most influential critics, Peter Fuller, who objected to it as being no more than a publicity exercise.[13] While it is modelled on the Booker Prize, it is not given for a single work of art – as the Booker is for a novel – and despite the idea that it is

awarded for something specific, it acts more as the endorsement of a reputation than of a body of work, so its temporal aspect is something of a fiction. To begin with, before an age limit on the nominees was imposed, there were problems with its remit, particularly given the mix of older and younger artists. There was a risk of offending older artists if they were nominated but did not win, and a risk of predictability if the artist with the most established reputation always won. Richard Long, nominated three times before he finally received the Prize in 1989, did not turn up to collect the award. Furthermore, the display of artists' work was unsatisfactory, with the Tate deciding sometimes to display a little of each of the nominees' work, sometimes to confer a small monographic exhibition on the winner.[14] In all, the Prize seemed lacking in direction and something of an irrelevance on the contemporary art scene.

It was the recession that changed matters, at least indirectly. While the market was resurgent, the Turner Prize seemed a distraction, and the popularity of art among the non-buying public an irrelevance. When the market went into hibernation, the mass media became more important in making artists' reputations and the Prize became a good way to encourage their attention. The sponsors of the Prize, US investment company Drexel Burnham Lambert, went bankrupt, and in 1990 the Tate was forced to suspend the event.[15]

When it resumed in 1991 with Channel 4 sponsorship, the Prize had been refashioned: the prize money was doubled to £20,000, the shortlist was reduced to four, and each artist was to be given space in an exhibition so that the public could see a good sample of their work before the result was announced. The idea that the Prize was being awarded for a specific body of work shown at a particular time was clarified. Most important, the rules were changed to establish an age limit: only artists under the age of fifty were eligible.[16] While this did not entirely eliminate the problem of artists at different stages in their careers being pitted against one another (the 1991 Prize did just this, having Anish Kapoor up against three much younger artists, the result being a foregone conclusion), it was diminished, and juries have become more careful in arriving at a balanced shortlist. Matching the cool and alternative image of Channel 4, the emphasis was placed on youth, and the first new shortlist dramatically reflected that change: in 1989, the average age of the

nominees had been fifty; in 1991, it was thirty. In general, as can be seen from the table, the average age of nominees has hovered around thirty-five – somewhat younger than the age-rule alone might lead us to expect, for if the Prize takes reputation into account, one might expect a bias towards the upper end of the age range.

Average age of Turner Prize nominees

Year	1984	1985	1986	1987	1988	1989	1991	1992	1993	1994	1995	1996	1997	1998
Age	44	46	43	39	45	50	30	37	37	38	36	35	35	33

If we think of the winners over the last few years, the change in the character of the Prize becomes obvious. The leap from Antony Gormley (the winner in 1994) or even Rachel Whiteread (1993) to Damien Hirst (1995) is a considerable one. While Whiteread was a young winner and the first woman to win, her work and Gormley's is in a recognisable tradition of serious British sculpture. If she is counted as a 'young British artist', it is most of all because of the controversy over her work *House* in the year that she won the Prize.[17] The selection of an all-male shortlist in 1996 – Douglas Gordon, Craigie Horsfield (an older artist, but associated with the scene), Gary Hume and Simon Patterson – sanctioned the high art lite tendency more generally, although a rather safe and polite version of it. The all-female shortlist in 1997 – Christine Borland, Angela Bulloch, Cornelia Parker and Gillian Wearing – gave us more of the same, though some of the expected female artists making cruder work were not included (notably Lucas and Emin). A big change in that year was the lack of the usual media bean-counting, whereby one could expect to find at least one painter, one sculptor, one 'media artist'. This time there was no painting and nothing that could be identified as conventional sculpture. In this sense, the triumph of neo-conceptual art was total. The two subsequent shortlists have confirmed both trends: the prevalence of high art lite, and the relaxed attitude to new media.

As we have seen, the success in gaining viewers for what can be quite a difficult exhibition of contemporary art has been remarkable. The Prize display is an overtly educational show: this is evident in the information area of the exhibition, where TV profiles of the artists are shown and literature is available. It appears to be a model example of state support for the arts, fostering public

51 Simon Patterson, *Untitled*, 1996

interest through the mass media, and encouraging public debate. The gap between the opening of the exhibition and the announcement of the Prize is designed to allow the gallery-going public to make their own minds up about the selection, and to allow the jury to be guided at least in part by public response.

Yet there is much about the Prize which is still mysterious. The resulting exhibition is a peculiar one: each shortlisted artist, in collaboration with the

Tate's curators, makes their own little monographic show in the uniform spaces allocated to them. The four are bundled up into a package, and the viewers left to make sense of the mixture. Sometimes, the exhibition looks a little like a themed show but, of course, it is really a competition. Few artists have commented upon the institution in their displays, but some of the more thoughtful and self-reflexive did so by choosing to exhibit work that high-lighted the idea of competition – Mark Wallinger with work about horse racing, and Simon Patterson with his racing sails inscribed with the names of writers (neither won, naturally).

Further, while the process encourages public participation, it is very far from being democratic. Brian Sewell rightly objects to:

> the fraudulent apparatus of democracy that is employed to camouflage the narrow orthodoxy of the Prize with nomination forms that imply public participation in the final choice, generously (but ungrammat-ically) stating that 'there is no restriction on the number of nominations which may be made' – for of these and their number we are never vouchsafed another word.[18]

This system of nominations – asked for, but then lost in an opaque process of selection – is very similar to that of the reformed honours system introduced by John Major in which the public were permitted to nominate candidates for elevation. Worried lest a two-tier system of honours should emerge – those elected by popular support versus those elevated by political patronage – the government declined to say who had been chosen by the public. It was the anomalous product, as Tom Nairn puts it, of a 'hopelessly starched hierarchy' desiring the form of democracy but suffering from an acute mistrust of the people.[19] The art world reflects this attitude exactly.

The art audience is still deeply split between the defenders of tradition and the evangelists of the new. Art magazines with large readerships, such as *Arts Review* and *Modern Painters* (though the latter has been somewhat undecided of late), take as their editorial line the rejection of the state art establishment, dominated by what they see as the disparate but degenerate heirs of concep-tual art. The split is demonstrated by the vandalistic actions of those who feel helplessly excluded from the art establishment: after Ofili won the Prize in

1998, the *Guardian* of 11 December 1998 carried a photograph of an artist, Ray Hitchins of Cheadle, Staffordshire, protesting against the state of modern art by dumping cow dung on the steps of the Tate Gallery. If there is something holding back the art world from greater democracy in these matters, it is not only that the taste of the provincial masses cannot be trusted but rather the operation of another mechanism, that produces a very clear hierarchy within the art world, and one at variance with the diverse factions of public taste: price.

There is another set of state art institutions that I want to look at, albeit briefly: the art schools. My father, looking at a picture in a Damien Hirst catalogue recently of some cigarette butts on a shelf, asked if such a thing could be art. It is a question that people in the art world tend to be impatient of, hearing it too often from outside (though never from inside) that world, because it is often not a question about the definition of art but about the definition of quality in art; and because it is often asked not as a genuine question but rhetorically, as an accusation. The other reason, of course, that people get upset about it is because it is a very difficult question to answer – especially so when, as in many theoretical circles, the issue of quality is ruled out, for an obvious move in answering would be to say that we can be relaxed about our criteria of what is and is not art, so long as we are not relaxed about what counts as good art or bad.

The question cannot be dismissed, though, and I want to offer an answer, not in terms of an ideal but in terms of current practice in the art world. The brisk reply, 'if it's in a gallery, it's art' is not quite adequate, no matter how alluring the fixtures and fittings. By far the most successful definition – though still imperfect – is to say that art is something done by those who went to art school. The closed shop operates with remarkable effectiveness, and you will find very, very few artists endorsed by the gallery system, private or public, who have not been through an accredited course.

The art schools are at the opposite end of the process to the public galleries but both have the same role, that of sanctioning a particular set of objects or practices as art. Between and alongside them, however, comes the private market; to which we shall now turn.

Private galleries

It would be easy to think, looking at work made from stuffed stockings and old chairs, or based on concepts rather than impressive hand-crafted objects, or only existing as objects incidentally (videos or cassette recordings), or existing as objects only for short time, that the market had only a small say in the production of the new art. But in all this, the market has not gone away. No matter how conceptual the basis of a piece, the objects that comprise it take on a glow of value and authenticity. Hirst made a piece called *Away from the Flock* (1994), a lamb held in leaping position within the usual vitrine, and while it was on show at the Serpentine Gallery a disgruntled artist, Mark Bridger, in a witty act of vandalism, poured black ink into the container. Hirst was far from amused at this addition to his handiwork. It is significant that, rather than simply obtain another dead lamb, Saatchi spent £1,000 to restore that particular one – the original art object.[20] This strongly suggests that the relation of the art market to its unique objects has not been undermined by such work – as indeed it was not by many more radical movements before it. (Later Hirst attempted to draw this incident into his legend; on one page of *I Want to Spend*

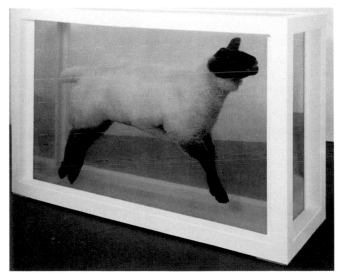

52 Damien Hirst, *Away from the Flock*, 1994

the Rest of my Life Everywhere ... there is a picture of *Away from the Flock* – pull a tab and the vitrine turns black.)

Private galleries are shops but of a very odd sort. The market is highly controlled, not just in terms of production, as one would expect, but also in terms of consumption. Galleries are able to insist on this because the pool of serious buyers is very small and most of them are known to the shop-owners personally. These proprietors are generally uninterested in casual buyers: if someone unknown to them was to walk into a gallery with the asking price for a work of note, the response would be not 'Here you are' but 'Who are you?' It is important for a gallery to know that they are selling to someone who is serious about collecting – that is, someone who is a consistent buyer of work in a certain price range and who can be relied upon not to dispose of the work irresponsibly. The price of art is a delicate matter, only vestigially attached to the cost of production. Like the price of stocks and shares, it is highly subject to the vagaries of opinion. If the atmosphere of the art world tends to paranoia, it is with good reason, for it is in the circulation of judgements and rumours that fortunes are made and lost. Thus the dominance, for art-world types, of the private view, the event at which is found the highest concentration of that opinion-making, to the extent that the subsequent progress of the exhibition is little more than a coda.

Consumption is also controlled in more transparent ways, as when a gallery buys back work from its stable of artists that have come up at auction, so guaranteeing that the work will not circulate below a given price.

Production, too, is controlled – or at least greatly influenced – by private galleries: the type of work, the amount of it, the size of editions and the setting of prices. There is a strong presumption (except perhaps for the best-known artists) that they should continue doing what they have become known for doing. Bank's cruel headline about Simon Patterson's work – 'One Idea, Eight Years' – only picked upon a particularly clear example of a general tendency in which constancy is a virtue.[21] The idea is that if you keep plugging away at a single trick for long enough, the buyers (some of whom are a little slow) will get it, and in any case it becomes recognisable and therefore accessible through its very familiarity. By insistent repetition, the artists in effect brand their work.

In an extraordinary passage in an article about Gary Hume, Adrian Searle pointed towards the dilemma that faces an artist who manages to achieve a degree of recognition with one smart idea (as so many of this generation have) and at the commercial pressures that keep them doing what they have done in the past:

> First your friends, and then your teachers, and then your dealers, and then the collectors and critics and curators and all of the others watch as the one idea grows and flourishes and comes to be expected.
>
> And this one idea of yours ceases to be an idea and turns into a product, a waiting-list, a schedule, a production-line. Now this idea comes Classic, Deluxe, Series or Straight. It comes pocket-size or mural. You're eating better now and sending your clothes to the laundry. Your address book's fatter and so are you …
>
> It was a good idea. It is still a good idea, but not the only one. There are forces at work, though, to keep things as they are. Market forces, psychology, paranoia, a sense of self-esteem. If you change track now, will it wipe out the one idea? The collectors are getting nervous. If you switch now, will people think you're ambulance-chasing? … Keep your head down, stay low. You're a character trapped by a chance remark, stuck inside an old routine.[22]

That this was written about Hume was no accident, for the artist took a considerable risk when he turned from making the door paintings for which he had become known to take up figurative work. At that point he was dumped by his dealer, Karsten Schubert, though he was then taken on by White Cube.

For artists of previous generations, the demands of dealers were sometimes less of a problem for, while the pressure to make decorative and saleable objects could be tiresome, the demands for constancy fitted in with the requirements of the work. Painters who have spent decades honing their craft could only change direction with great difficulty, and few of them wanted to, seeing in the slow, organic development of their skill an integrity that was bound up with the very means of their expression. For this generation, however, things are very different: many artists see themselves as making specific interventions in the culture, and there is no reason why they should not switch rapidly between

ideas and media. One solution, as we have seen, is to come up with a schema to produce work in series in which each individual work, aside from being a thing in itself, serves as a conceptual adjunct to the sequence. The imperative to produce leads to the making of work that can be mass-produced without too much effort. Of his poured paintings, Ian Davenport has said revealingly: 'I always try to do very little but a lot of it.'[23]

For the most successful artists, this small and self-enclosed world is where they make their living (others make a living with part-time jobs and the occasional public commission) and, despite the populist aspirations of their art, it is this world that they have to satisfy. The money is not quite where it might appear to be: with Hirst, there is far more to be made from the mass production of paintings than from the formaldehyde installations, which are hard to sell and expensive to produce. The latter might almost be regarded as loss leaders in the way that haute couture is for fashion houses. Taken this way, many works that appear to resist commodification actually play along with it: if producing a work that degrades over time or destroys itself makes your name, then the investment is plainly worth it.

As we have seen, the art market revived slowly and falteringly following the recession of 1991. For 'young British art', the secondary market (in which works are sold on from their original buyers, especially at auction) only really got going in 1997.[24] Colin Gleadell notes the development of a three-tiered price level for recent British art: Hirst and Whiteread, whose major works can sell for six-figure sums, form the highest category; the middle rank is made up of those selling work for sums between £15,000 and £50,000 and includes Lucas, Rae, Hume, Quinn and Ofili; finally the third rank, selling in the £5,000 to £15,000 range, includes Billingham, Glenn Brown, Coventry, Marcus Harvey, Nicky Hoberman and others.[25] While it is true that the two artists in the top rank have a high public profile (though each for very different reasons) it also seems to be the case that public notoriety in itself does not ensure high prices – note the positions of Harvey and Billingham. The realms of the mass media and the private art market are linked but distinct, each operating according to its own rules.

This is further reinforced by comparing the price levels for high art lite to that of other work, even other British work. Gleadell points out that when

Saatchi sold 130 works from his collection of contemporary British art in December 1997, it raised £1.6 million, and the sale dominated the news, partly because people were looking for a disastrous fall in prices that would spell the end of high art lite. That did not materialise, but even so in the same period, and largely ignored in the press, £2.2 million was paid for a single work by Gerhard Richter, and £2.8 million for a work by Lucian Freud.[26] Both are established artists of a different generation and, in Britain, both are a good deal less famous than Damien Hirst.

The private market is not entirely confined to those wealthy enough to spend, with some regularity, a few thousand or tens of thousands of pounds on a work of art. There is a smaller market for editions, prints and books. Some cultural commentators and entrepreneurs believe that this will grow in importance, that cross-overs between the exclusive world of the art collector and the mass consumer will grow, that the ground between them will become occupied with more complex forms of consumption, and that the popularity of high art lite is an indication of this development. For Peter Wollen visual art is a luxury market that flourishes along with other creative industries in global cities, like London:

> The art world is now inextricably linked with advertising and publicity through sponsorship of museum shows and through its association with 'lifestyle' marketing in the media, which leads to a convergence of art with design, fashion and even cuisine.[27]

Artists work on the interface between the corporate world and the canny, moneyed leisure consumer, finding a way past the usual defences of cynicism with a dose of knowing high culture.

It was typical of the late self-styled art-entrepreneur Joshua Compston, who ran a gallery called Factual Nonsense in Shoreditch and staged a number of art events in public spaces, that he should noisily proclaim that he was initiating something that was already well in train: to 'exploit and eventually explode the gap between art, advertising, entertainment, high-street retailing, and real estate development.'[28] Indeed, his aim was to carry advertising from the media into daily life in spectacles that would produce 'the aesthetisation [sic] of daily life no less'.[29] Thus, in this alliance of aspects of business and art, a perfect and

seamless life and culture is prepared for us, an authoritarian, public-relations version of utopia in which the rich tapestry of artistic innovation serves mostly to raise property prices, improve advertisements and burnish the image of high-street shops.

The buying audience for the spin-offs from fine-art objects are well-heeled metropolitan cultural workers – advertisers, web-designers, fashion consultants and assorted PR-types and marketeers. It is for them that luxurious and over-designed books such as Hirst's *I Want to Spend the Rest of my Life Everywhere, with Everyone, One to One, Always, Forever, Now* and Marc Quinn's *Incarnate* have been made (they cost £75 and £50 respectively).[30] Furnishings shop Habitat has collaborated with artists – including Emin, Hume, Noble and Webster, Perriton, Turk and Wearing – to make in-store exhibitions and sell prints (in limited editions of 50 for £200 each). They have also set up an arts club, for which a quarterly arts magazine is produced. Clothes shops, such as Jigsaw, show that they are on the cutting edge of high culture as well as fashion by displaying art work in their windows.

However, these moves are uncertain; they are marginal to the main business of the art market, and may even have a tendency to conflict with it. Limited editions tend to sell better when the number of copies is kept low and the price high, even if it is for a mass-manufactured object – for instance, a video, with a certificate of authentication attached. What is being bought, after all, is exclusivity. In these terms, the popularity of high art lite can prove to be a disadvantage. It is surprising that on your way to Cork Street, passing through Piccadilly, you might see a Damien Hirst spin painting hanging in the window of Tower Records; but if you are a buyer of one of these exclusive objects, is that what you want to see?

Only rarely does art work refer either to money or to the existence of this private world on which it depends. A striking exception is Angela Bulloch's 'Rules Series', which lays out the rules by which the work of art (itself a list of rules) is owned, can be reproduced, and is validated as authentic. The idea was to produce a self-referential work of art that could take on any visual form, and had three different types of ownership, related to differing layers of the market: the first was as photocopies, distributed free (for publicity purposes); the second a limited edition of signed and numbered prints; the third a unique

RULES SERIES

1. The rules are lists of rules that pertain to particular places, practices or principles.
2. Each list is an individual work; however it is also part of a series.
3. Each list is a unique piece with no fixed form; however a collection of ten lists has been produced as a printed edition of 20.
4. Each unique piece is accompanied by this list, which becomes a certificate when titled and signed by the artist.
5. The unique pieces have no form; buying one confers the right to produce or reproduce the piece in a form or medium.
6. A rules series edition may be photocopied; buying one confers the right to photocopy the lists in any size or colour.
7. The artist asserts the usual moral rights and copyrights.

53 Angela Bulloch, *Rules Series*, 1993

piece that does not exist as a material object until the owner decides to exercise the right to realise the work granted in the certificate that they purchase. Bulloch herself thinks that the simultaneous existence of these forms undermines the idea of ownership, and notes that some of the owners of the unique pieces have asked her to realise them (rather than wanting to do it themselves), thus showing their disorientation.[31] Yet, if these works have a radical aspect, it is less in questioning ownership than in making thoroughly transparent its normally veiled conventions.

For art, the market is both a stimulus and a ruination; a stimulus because it establishes a realm of comparative freedom, of sanctioned play, where the usual laws of consumer culture and mass manufacture do not apply; a ruination because that play is only permitted to licence distinction, and is rarely able to turn its analytical force upon the conditions of its own existence.

Public and private

The orientation of the two art worlds, public and private, is quite different; but the two are interdependent. Even if the state bodies themselves are subject to the influence of private business through sponsorship deals, the interests of those large companies and their publicity machines are very different from

those of the small-scale and specialist contemporary art market. Certain private galleries are aided by what amounts to state subvention and accreditation. State institutions in Britain are not powerful or wealthy enough to make large initiatives within the private market: rather they feed upon it, using the private galleries as their research arm, ratifying many of the decisions made by the most established among them.

While state subsidy for the arts at home was the subject of politically motivated neglect, the marketing of contemporary art abroad by the British Council was pursued quite aggressively. One German writer complains that in the fiscal year 1997–98 the Council supported the showing of 153 British artists in Germany in seventy projects and twelve group or themed exhibitions, while the German state had only supported between five and ten artists to show in Britain over a similar period.[32] The export effort has been extraordinary: in writing of art in the 1990s, Patricia Bickers notes that the list of group shows of British artists placed in cities all over the world from Brussels to New York and Tokyo would fill a telephone directory.[33] The complaint is regularly made in Britain that the domestic support of the arts in Germany runs at a level several times greater than that we enjoy; yet state support has not been lacking – it is just that the British government has been running a consistent and quite successful export-oriented programme to support British art, riding on the back of US cultural hegemony and the global dominance of the English language. (The results have been better received in Germany than in France, the latter traditionally resistant to cultural forays from across the Channel.)

If high art lite is just another consumer product, why should it have state support? Is it still thought of as an educational and moral force to be fostered by the state? In the end, high art lite has been successful within institutions, public and private, because they needed it: the private galleries to provide new and comparatively cheap blood during a period of retrenchment and then gradually renewed speculation; the public galleries to help justify their existence and their funding at a time when old commitments were being questioned, by drawing in new and wider audiences. Nevertheless, the support for this art under the Conservatives was qualified and uncertain, tailored – as we have seen – towards exports. Under the Labour government things are

looking quite different; their policies may sharpen the divide between public and private interests.

New Labour

George Walden, once a Conservative MP, describes a remarkable development within state attitudes to visual art that just predates the embrace of cool British culture by New Labour:

> Shortly before the 1997 change of government in Britain, the then Heritage Secretary, Virginia Bottomley, described British contemporary art as the most exciting and innovatory in the world. Unexceptional as it seemed, her observation was in fact profoundly innovatory, indeed in its small way historic. To my knowledge, no Cabinet minister – still less a Conservative – had ever before given official approval to what is conventionally regarded as avant-garde art.[34]

The statement of support was surprising because the artists themselves hardly appeared to be the friends of authority. As we shall see, there is a well-developed ability on the part of government figures to praise British art as a phenomenon while side-stepping the issue of its content. For Walden, it was the proof that this new art retained only the ghostly form of the avant garde and concealed conformity and conservatism:

> Like method actors, they have entered into the spirit of the style they are impersonating, striking the bold or nihilistic stances of early modernism, for all the world as if their work were not taught as orthodoxy in art schools, financed by the State, and with approved curricula.[35]

If we are moving out of the configuration in which high art lite thrived, it is only slowly. It will be interesting to see how, having dealt admirably with government indifference, if not hostility (except in the area of exports), the tendency deals with the more difficult matter of official endorsement.

At the *Powerhouse::uk* exhibition, a New Labour initiative held in 1998 to showcase British design and technological talent, high art lite was seen

54 *Powerhouse::uk* exhibition, 1998

alongside other elements of the culture – clothes, music, even furnishings – that were supposed to add up to a new definition of Britishness. In the 'Creativity in Lifestyle' section, Phaidon art books were built into displays of objects that came to model the lines of London, and Hirst's flip-book was seen being turned page by page on one of the large video screens that hung over viewers' heads. On those screens there was also beamed a sequence of exhortations, direct and indirect: Respond, Fashion, Eat, Reflection, Tradition, Home, Memory, Community. The first four might perhaps be embraced by artists such as Hirst; the last four, however, would be treated with suspicion at best.

It is perhaps the exercise of someone's dark humour (though not, it is safe to assume, the author's) that has caused a Damien Hirst spin painting to appear

on the cover of Chris Smith's book, *Creative Britain*.[36] The creativity involved in these works is of the lightest sort, and the generation of unique product from the initial idea potentially endless. In this book by the Secretary of State for Culture, Media and Sport, cultural creativity is considered vital to the regeneration of Britain. Since the nation's fate is no longer tied to traditional industries, its population must be educated into the alchemy by which value can be conjured from the immaterial (or from products where material is only incidental to their value) – from computer software, design, music, all kinds of service, and from works of art.

Such value is created most efficiently at the cutting edge, the margin at which objects and ideas move towards the centre of cultural acceptance; thus the Britain of 'Victorian values' and gathering shadows across cricket greens, if too much fixed upon, will be inimical to it. It is the Britain of the pop and fashion industry, and of high art lite, that should receive the attention and aid of the government. Indeed the change of name of Smith's department, from the Department of National Heritage to the Ministry for Culture, Media and Sport, was made because the new name 'captured more accurately the new spirit of modern Britain, that signalled the involvement of all.'[37]

This strategy is certainly distinct from that pursued by Thatcher and even by Major, whose policies had favoured service industries only by default (given the successive recessions that had ravaged manufacturing) and sought to create a climate in which cost- and especially wage-cutting would generate competitive advantage. Yet it was also a ratification and celebration of that older policy, made more consistent, a realisation that, while state support for industry is expensive and disliked by the markets, state support for culture is relatively cheap and has come to be seen as a legitimate arena for the exercise of government largesse – within the limits of prudence, naturally. The Labour government have implemented a substantial increase in arts funding and have promised to reverse the tendency under the Conservatives for national museums to charge entry fees. The strategy is to pursue the area, culture, where the UK has an advantageous position, largely because it shares its language with the culturally dominant world power, and is thus in a position to make a distinct, if minor, complementary addition to the output of the United States. The stress on education is plainly a part of this project.

The 'Third Way' is much in evidence in Smith's book: the various funda-mental and persistent contradictions that have characterised culture are here wished away in the serene progress of anodyne prose. We can list some of them:

tradition and innovation
high and low
artistic quality and commercial success
art and life
access and excellence

So, for instance, the high–low distinction is effaced by the sheer excellence found in both areas of culture, and in the many manifestations which cannot be defined as either.[38] By bringing attention to this prominent feature of the book, I do not want to say that these oppositions are never to be conquered, only that Smith says nothing about how to go about it, or the prospects for success. Rather, he seems to assume that it is enough to point towards them for everyone to see that they are a ridiculous part of the old order; upon which, they will vanish.

Yet this is not quite the attitude in practice: Labour have begun to put in place institutional structures that are supposed to ensure that access to culture is widened. As Andrew Brighton points out, in a piece of intellectual kite-flying comparing New Labour arts policy to that of the Soviets, widened access is to be enforced by a cultural watchdog, Quest (the Quality, Efficiency and Standards Team) that will set access targets and monitor progress; those bodies falling behind can expect to find their funding under threat.[39]

In a direct and practical way, subsidies to galleries and museums and the encouragement of business 'partnerships' with them can be an important part of urban and regional regeneration. Funds from the National Lottery have been important in funding the spectacular projects that are supposed to draw new economic activity to an area. Newcastle is a model of this development: with the opening of its new centre for contemporary art in the huge Baltic Flour Mills building, the city will go from having no substantial venue for con-temporary art to enjoying one of the largest and most impressive in the coun-try.[40] This is coupled with various projects improving the city's infrastructure,

including its metro, and the building of a major Museum of Life. The whole is heralded, or one might say branded, by Antony Gormley's massive steel figure, *Angel of the North* (erected in 1998), that stands sentinel by a stretch of motorway as you enter the city from the south.[41] Smith recommends the sculpture as a 'grand in-your-face project' and a 'prized symbol of the entire region'.[42] This rust-coloured masculine angel, raised in the face of considerable public opposition, its wings outstretched like those of a plane, its supporting structure thrust into a ground veined with old mine workings, is meant to be read as a tribute to the old heavy industry of the region, mostly passed away, and its workers. This rusty elegy is also a tombstone placed over the old era, its spirit taking flight, and supposedly heralding the new.

Newcastle is only a prominent example of this trend. The new Tate Gallery at Bankside is set to gentrify that central but run-down area of south London, while a footbridge – a cultural feature in itself, designed by Norman Foster and Anthony Caro – will link museum and district to the City.[43] Smith makes much of the fact that the arts can boost local economies: when the Tate Gallery opened in St. Ives, he says, it led to 'the levels of economic activity in the town' rising by a quarter 'almost overnight'.[44]

Such regeneration is supposed to be not merely economic but social and even spiritual:

> There is a resurgence in the extent and quality of creative activity in Britain, and no government can stand idly by and ignore the potential this has to uplift the people's hearts and at the same time to draw in a major economic return to this country.[45]

In tying together wealth and the uplifting of hearts, the body is not ignored: Smith suggests the establishing of 'healthy living centres' where welfare and health advice would be linked to cultural programmes.[46] Creativity becomes compulsory, and participation in culture may become as much a part of civic duty as refraining from the abuse of alcohol or ensuring that the children's homework gets done. In this, culture is no optional extra but an integral and essential part of the programme:

> Without culture, there can ultimately be no society and no sense of shared identity or worth. For a government elected primarily to try and

re-establish that sense of society that we had so painfully lost, this is a very important realisation.[47]

There is a one-nation ethic at work here in which unity will be the product of an expanding middle-class cultural sector, elite only in the quality of their output, and of whom the new generation of British artists are a good example. For Smith, 'A flourishing creative and cultural sector, and one which is supported by the body politic, is a symbol of a confident and energetic society.'[48] But there is also the strong implication that the reverse is true: that a confident and energetic society can be brought about by the support of the creative and cultural sector. If this is so, it is because the benefits of business sponsorship of the arts run both ways (and not just in terms of sponsors gaining cultural kudos):

> Increasingly, the qualities demanded for business – such as communications skills, flexibility of approach, improvisational and creative thinking, working as a team so that the parts add up to a whole – are precisely those that can be inculcated through exposure to the arts.[49]

Thus, in a thoroughly postmodern argument, the distinction between base and superstructure falls away before a Third Way agglomeration of the two. Mundane labour will decline, all work will be creative and fulfilling and all those doing it will become classless, united in gentle satisfaction and the striving for creative excellence. There is a precedent for this policy in Australia, says Smith, with Paul Keating's 'Creative Nation' policy in which culture was used as a means for securing identity for Australians of whatever ethnic origin.[50] Indeed, the analogy is a good one, and the British Labour Party has drawn much from its Australian counterpart (and from the French Socialists); the combined pursuit of neoliberal economic policies and cultural liberalism is similar in both cases and it has proved a dangerous game, fostering political reaction as the divisions between cultural inclusiveness and widening economic inequality become ever more obvious.[51]

Perhaps the most damning aspect of the government's endorsement of all that is new and cool in British culture is that it fails to take it seriously at the level of content – though it must also be said that some of the art fosters such

New World Order!

an attitude. The cosy messages of New Labour issue from a different world from that of the dark mutterings of high art lite. Smith puts the matter blithely: 'Not all artists are rebels or questioners, but many are, and it is a powerful and praiseworthy aspect of art that they are.'[52] Similarly, Tony Blair's response to the pop stars who criticised his government for its friendliness to established interests was to claim that 'The important point is not their politics, but the fact that they are part of a new and exciting cultural renaissance in this country.'[53] A broad church (except in matters of political doctrine), the government treats disagreement or revolt with the condescending attitude that it is only to be expected of creative types, skittish and childish as they sometimes are; never mind, it is their creativity that is the important thing – particularly since it is now a requirement of business – and the establishment can always learn from listening. Yet it is not rebellion, exactly, that this new art represents. New Labour's old-fashioned and starry-eyed outlook on culture is met rather with high art lite cynicism, in which the role of culture to do anything other than entertain and make money is totally dismissed.

7 Saatchi and *Sensation*

Beyond the state and market institutions analysed in the last chapter, there is one important and particular factor in the development of high art lite that has influenced much of its direction, and even now may determine its fate: Charles Saatchi. While his gallery had long been an important venue for art-world people, *Sensation*, the exhibition by the Royal Academy of his collection of 'young British art', brought his activities to the attention of a much wider public.

This chapter will not provide a general account of Saatchi's activities in the art world. Instead, it is divided into four sections, each with a particular task: the first will look at Saatchi's influence over high art lite; the second at the controversy caused by *Sensation*; the third at the broader meaning of that exhibition, as a register of establishment approval for high art lite; and the fourth at Saatchi's latest move in collecting and naming a new tendency in British contemporary art.

In a small domestic market for British contemporary art, and given the impoverished and sometimes slow-to-act state institutions, the scale of Charles Saatchi's buying has meant that he has had a considerable effect on the entire market. Worries about his influence over the market and state art institutions go back a long way, predating the rise of the art with which he has become most associated.[1] His decision to move from buying blue-chip artists to focus upon younger, home-grown talent, and the series of exhibitions in which he showcased his purchases, were a decisive factor in launching high art lite. His buying power, combined with his avoidance of the media and indeed much of the art scene, his bulk-purchase of works, and the secrecy of his business practices, have endowed this figure with the qualities of legend. The great success

of the advertising company, Saatchi and Saatchi, that Charles ran with his brother Maurice – success that included the notorious campaign that helped Margaret Thatcher to power in 1979 – followed by its spectacular failure, after the brothers (with some hubris) had tried to buy out one of Britain's major banks, adds to the legend. In the art world, he is spoken of with awe and hatred in equal measures. Unknown artists (I have sometimes heard them speak it) sadly bear the hope that he will sweep into their shows, chequebook in hand.

The switch from buying work by established artists to buying work by those relatively unknown gave Saatchi a huge amount of leverage over those whose work he chose to purchase. Sculptor Richard Wentworth describes the experience of Saatchi's arrival at art-school degree shows in a way that captures the oddity, almost the impropriety, of such an event:

> You're being an assessor at the Slade, in what is [sic] essentially examination conditions … and he'll just appear. This little figure in the background. He's gone shopping, and he's first in the line … People perceive a proper collecting culture in this country, and it's not there. There's Charles Saatchi, and there's no one else.[2]

Naturally in this situation, the power is all on one side: Saatchi's usual practice is to buy very cheap and pay very late. Few are in any position to refuse his offers.

While the art market is highly international, the market for 'cutting-edge' work tends to be more nationally based. This was more so with the British art of the 1990s for two reasons: first, the reconfiguration of British art to domestic concerns meant that some, at least, of the work was likely to befuddle foreigners; second, the emergence of the multitude of small galleries and warehouses in which this art was shown demanded an unusual level of commitment on the part of the buyer. To come to an understanding of what was going on it was no longer adequate to fly in and take a brief wander around the elite galleries concentrated in the Cork Street area. To cover the London scene alone it took an *A to Z* and a great deal of effort over a sustained period.

Why is Saatchi the only serious British collector of this tendency of art? Is it simply that high art lite is his creation? The matter obviously mystifies

Saatchi himself who has said that he hoped that his example would lead others to follow in his path.[3] Despite the efforts of some pop stars and media figures, this has not happened. Historically, there have been few major collectors in Britain, so that the isolated individuals who have spent a good deal of money on art have stood out as patrons. High art lite has not changed that situation.

In any case, Saatchi is an unusual collector in other ways for his business practices, with which his collecting is entangled, are highly secretive. The firm Saatchi and Saatchi was involved in art collecting from its inception.[4] While Saatchi often buys with considerable publicity (except when he is defending the prices of artists in his collection), he usually sells in great secrecy, and these sales have included work by 'young British artists' at the core of his collection.[5]

Objections to Saatchi as a collector have focused on his habit of selling as well as buying work in bulk. The case of the neo-expressionist figure and landscape painter Sandro Chia is often raised, since Saatchi's simultaneous sale of his entire holding of Chias naturally had a disastrous effect on prices. Beyond the issue of Saatchi's power over individual artists' careers is the complete transformation of his collection through auctions and other sales. A generation of mostly older British artists once in the collection were disposed of, among them Lucian Freud, Howard Hodgkin, Leon Kossoff, Malcolm Morley and Sean Scully – painters all, and much safer choices than the purchases that followed. In addition, the collection that made Saatchi's name in the art world, especially through exhibitions in his own gallery, of the most renowned and expensive artists of the 1980s, including Georg Baselitz, Anselm Kiefer and Julian Schnabel, has also gone. It is not that Saatchi is merely a dealer but that a dealer-collector can have more influence over a market than either someone who only collects or someone who only deals.

Saatchi began by buying work from established and rather expensive artists. While this activity was unusual in Britain – particularly since he showed the work purchased in his gallery from 1985 onwards – neither collecting on such a scale nor the opening of a gallery to showcase the collection would have been a matter for surprise in Germany, Japan or the United States. And while the work he showed was certainly an eye-opener to the British art world, that was only a measure of how provincial that world had been.[6]

That Saatchi abandoned the established art that formed his previous collection and embarked on the buying of art by 'young British artists' is connected with the recession that initiated high art lite. The art stars' work was sold near the height of the market, at the end of the long, steep climb in prices through the 1980s, though also at a time when Saatchi and Saatchi was in trouble with falling profits. The collector-dealer made £10 million in this way in 1991.[7] This was also the year in which the advertising company made a loss of £64 million, and Charles Saatchi had his pay cut in half. He turned to collecting cheaper British talent, from artists who had not established the value of their work in the open market (or in what passes for the open market in the art world).[8] His divorce from Doris Saatchi, who had enjoyed much say over the development of the collection, was expensive and contributed to the shift in buying.[9]

The eventual public fruit of these purchases, *Sensation* gave a false impression of British art through the 1990s, despite the implication that it was a survey of some kind: it was, after all, founded on the taste of a single collector, that of an advertiser, who is partial to impressive, punning and immediate work. Charles Saatchi is drawn to a literal strain of naturalism. He also has a penchant for waxworks (Lane, Turk, Siobhan Hapaska, John Isaacs, Ron Mueck) which, as Turk points out, are good accessible works that can step around the alienating aspect of high art; animal bodies or skins (Hirst, the German artist Thomas Grünfeld); and works that involve freezing (Quinn, Rose Finn-Kelcey, Jane Simpson).[10] Despite his undoubted power over the British contemporary art market, even his patronage cannot guarantee success for the artists he buys. Looking at the 1994 catalogue of his British collection, it is striking how much has passed into obscurity. The spectacular but hapless Surrealism of John Greenwood, for instance, or the gut-ridden fabrications of Katherine Dowson have been passed over by the public eye.[11]

Even so, Saatchi's identifiable tastes have encouraged a certain type of output from artists. As Martin Maloney has put it, laying down the conditions of success for young artists: 'If you haven't got a clear product, then it's more difficult.'[12] Of this trend to produce with the advertiser in mind, Chris Ofili (who has work in the Saatchi collection) has written:

> A lot of artists are producing what is known as Saatchi art ... You know
> it's Saatchi art because it's one-off shockers. Something designed to
> attract his attention. And these artists are getting cynical. Some of them
> with works already in his collection produce half-hearted crap knowing
> he'll take it off their hands. And he does.[13]

(We shall see shortly that a particular 'one-off shocker' was to cause a good
deal of trouble.) But the greatest worry that Saatchi artists have is that they
become known as just that. If they have work in the collection, and shown in
the gallery, especially in force, it can mean that they become more identified
with Saatchi than with their own output and artistic personality.[14] Gavin Turk
arrived at the opening to *Sensation* dressed as a homeless person – a stunt, some
thought, though he said it was a way of showing that he felt alienated from his
work as it appeared in that exhibition.[15]

Occasionally, artists make gestures that oppose Saatchi's dominance:
Stewart Home in an exhibition called *Vermeer2* at the bookshop-gallery,
Workfortheeyetodo, in 1996, established a pricing system in which the more
works you bought, the more you paid for each one: given Saatchi's habit of
buying the entire contents of a show, this was plainly an anti-Saatchi device.
There are also artists who set out to attract Saatchi in such a blatant fashion
that it almost becomes a theme of the work: this is true of Tim Noble and Sue
Webster with their visually spectacular and often extraordinarily vulgar work,
playing on the techniques of marketing and advertising, and playing also to
some of Saatchi's known predilections, including waxworks. As 'Absolut Arse-
holes', they have posed with the vodka that supports the arts. They have pasted
images of their heads over those of Gilbert and George, dubbing themselves
in the manner of those fathers of high art lite, 'The Shit' and 'The Cunt'.[16]
They also masquerade as 'young British artists', white trash yobs with inflated
egos and a pressing desire for fame that does battle with natural indolence.
Whether this exposes the dumbness of the scene or merely exploits it is, nat-
urally, left to the viewer to decide.[17] And so it is with their works, assemblages
of rubbish that cast shadow profiles of the artists when illuminated, and are
meant to serve as flypaper for Saatchi. If large-scale collecting has failed to take
off as a consequence of Saatchi's activities and the rise of high art lite, we

should not be surprised. Saatchi's taste is very much for art that looks like advertisements, and who – except an adman – would want to own one of them?

Sensation and the press

Sensation: Young British Artists from the Saatchi Collection, shown in the galleries of the Royal Academy of Arts in the autumn of 1997, was a media phenomenon, and it is worth looking at its life in the press.[18] The Saatchi Gallery holds two overweight files of press clippings, collecting the media reaction to the show. As Gordon Burn has pointed out, *Sensation* was a great success simply because it earned Charles Saatchi many thousands of column inches, contributing to the 'brand stretching' of his name in a way that advertising or the mere gathering in of money could not.[19] 300,000 people visited *Sensation*. This was not the most that had attended a Royal Academy show by any means (that honour goes to their Monet exhibition in 1999 which was seen by 813,000 people) but it was well above average, particularly for an exhibition of contemporary art. Perhaps as important from the Academy's point of view, it attracted a different type of visitor, many of whom had never been inside its galleries before: people less aged and less Home Counties than the usual crowd. One of the exhibition's major sponsors was the London listings magazine *Time Out* (which ran a large pull-out supplement detailing all the artists showing) and whose youngish urban readership the Royal Academy was eager to attract. Visitors were also able to buy Sarah Lucas socks decorated with fried eggs, Jake and Dinos Chapman phonecards, and a Mona Hatoum badge showing a fleshy opening.[20]

The Royal Academy set out to generate press controversy, encouraging attendance at an exhibition that would be important for them financially – due to mismanagement and embezzlement, it was £2 million in debt.[21] It released information about the most controversial pieces to be shown well before the exhibition opened, and stated that some of the artists included in the show would be put up for membership of the Royal Academy. The latter was a speculative move, since the number of members is fixed and they tend to leave only by dying, but it was designed to highlight the perceived contrast

of the Royal Academy, with its worthy, aged artists, slow accumulators of hard-won skills, to the brash stars of the new scene, casual collagers of ready-made symbols. The young rebels, of course, responded in the expected manner, rejecting the idea of membership, and condemning the Royal Academy as 'fat, stuffy, pompous' (Hirst's description), or worse.[22] Jake Chapman, equally conventionally, remarked:

> I can hardly say Royal Academician; I don't know if I could *be* one … Although I'm sure I could be a whinging, alcoholic old fart as much as I'm sure that when I'm in that situation I'll have lost my faculty to realise that it's a really bad idea.[23]

The Royal Academy had anticipated this reaction, and such outbursts only helped the institution raise awareness among the public that it was trying to update its image.[24] The point was to generate hype from the combination of 'cutting-edge' art and the traditional frame that would hold it, not merely the physical grandeur and ornate character of the Royal Academy's rooms but also the character of the institution itself, encrusted with tradition and the illustrious names of its members from Sir Joshua Reynolds onwards. There was another matter, given that royalty was much on people's minds at this time; as Will Self put it:

> I personally think that it's the bloody word 'Royal' that makes everyone freak out about what's on show here. Get rid of that and no one would give a toss.[25]

But freak out they did, and the Royal Academy got more attention than it had anticipated, much of it very hostile. The attacks were concentrated especially upon Marcus Harvey's painting of Myra Hindley, but wrath was also directed towards the Chapmans' mannequins and Ofili's *The Holy Virgin Mary* (1996) – the figure surrounded by paper butterflies that turned out on closer inspection to be cut-out crotch shots from pornographic magazines. The controversy led to demonstrations outside the Royal Academy and the resignation of four of its members, and endangered the job of the exhibitions organiser, Norman

55 Marcus Harvey, *Myra*, 1995

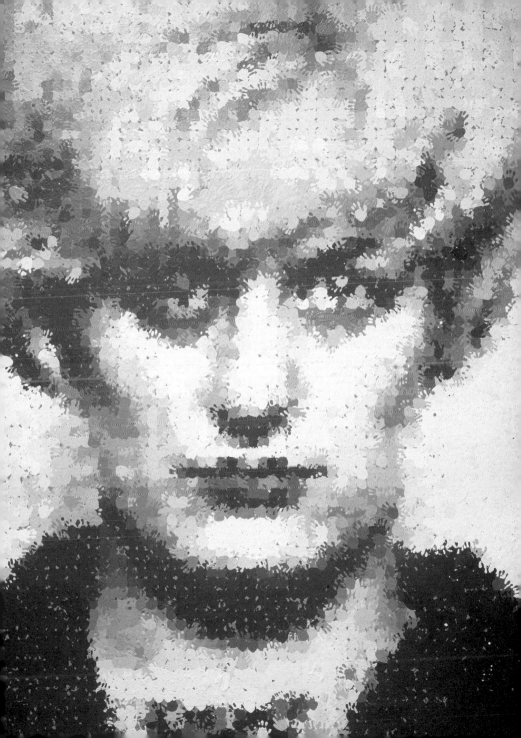

Rosenthal, who had made the galleries such an important exhibition space in the first place.[26]

The dispute over *Myra* was the more intense because Hindley, one of Britain's most notorious criminals, convicted for having taken part in the torture and murder of children, was at the time contesting the decision of the Home Secretary, Michael Howard, that she should spend the rest of her life in prison (she had been jailed in 1966). The subsequent dispute over the image raised fundamental differences about the reading of the painting, and more broadly about art's relation to reality.

Harvey's painting, then, used a very well-known photograph of Hindley, taken at the time when she was first held for the murders, in which she stares with apparent malevolence at the lens. This photograph is usually reproduced when Hindley is referred to in the press, and she has protested against its use, believing that it does the case for her release no good (she was also to object to the showing of *Myra*, though it was easy for the Royal Academy to say that it had not the slightest interest in *her* views on the matter, at least).[27] An image that in Britain has come to represent evil incarnate, for Harvey it also has 'undeniable sexual appeal'.[28] The artist has rendered the image on a large scale (the painting is over eleven feet high), emphasising the pattern of dots that make up the newspaper image – an old trick for making viewers aware that what they are seeing is a representation – but making the pattern by using a cast of a child's hand. The use of the handprint ties this work, visually very different from Harvey's 'expressionist' porn pictures, back into that earlier work made not with brushes but with fingers. The result, as has been frequently noted by those wanting to find US forebears, resembles the work of Chuck Close.[29]

Harvey's own comments about the work, as the scandal developed, were contradictory, apparently torn between a desire to foster media attention and a more cautious wish to deny his enemies ammunition. Among those statements, he has claimed that he wanted to imbue the image with a child's innocence.[30] Or that the result of using the hand-prints was to produce

> The most simple image of innocence absorbed in all that pain. And that kicks the image into reality. There's an absolute realism. It's a real event. I realised that you had to break the surface of this image, so it's not just glamorous posturing.[31]

Or again, of the photograph from which the painting was made:

> It's a terrifying image, and I realised I had been attracted to it lots of times, just pulled in by it. It's quite exciting … I was very aware that the pull of the image was a sexual thing and that this is part of the taboo that increases its appeal. The whole point of the painting is that photograph. And I really don't want to get beyond that.[32]

In fact, he did go beyond that, stating that Hindley was not a murderer but someone who had been led astray by her love for a killer into forgetting her maternal instincts, an opinion that – along with Harvey's idea that Hindley is the 'Love Goddess, who secretly, secretly, in our heart of hearts, we all want to shag' – Julie Burchill has rightly mocked.[33] Already in the artist's own statements there is an ambivalence: is the painting about an image, or about something real, or about the relation between the two? The work itself, a good exemplar of the 'present a dilemma and let the viewer decide' school of art, is as ambivalent as the artist.

If this work alone was not provocative enough, matters were not helped by other pieces in the exhibition that could be read as comments upon child abuse, and particularly by the juxtaposition, through the Academy's broad doorways, of the glowering *Myra* and the Chapmans' kiddie mannequins with their displaced sexual organs. While some of the newspapers' most resolutely positive critics thought this combination clever, most found it insensitive, to say the least.[34]

For those sympathetic to *Myra*, and some of the broadsheet critics were, the combination of this inflated image (a Pantocrator, a malign deity glaring over its viewers, wrote one) with the tiny hand-prints that compose it, reactivated the horror of a tired and over-familiar photograph. For writers in the *Daily Telegraph* and *The Times*, in strikingly similar formulations:

> Far from exploiting Hindley's notoriety, this painting makes what she did – and our feelings about it – real again.[35]

> Far from cynically exploiting her notoriety, Harvey's grave and monumental canvas succeeds in conveying the enormity of the crime she committed.[36]

Waldemar Januszczak, writing for the *Sunday Times*, withdrew his earlier condemnation of the work in a prolonged homage to Saatchi, proclaiming:

> It is no celebration of Hindley's image, no casual betrayal of the innocent hands that have shaped it. Instead it is a work that asks how a famous portrait of a mass-murderer could ever have acquired its dubious glamour.[37]

Likewise, Matthew Collings assured his readers that the painting does not glamorise Hindley but takes as its subject the process of her glamorisation.[38] The problem is, in the face of this extraordinarily mute work, how do we decide between the two readings – glamorisation or a comment upon glamorisation? Can they in fact be separated? Here's another reading, as plausible or implausible as any: that the painting is about their inseparability.

More conventionally, in the defence of such work, many liberal critics were to state that *Myra* does not condemn but simply presents, leaving the viewer to sort out a response: *Myra*, as is typical of such art, invoked a 'difficult reality' only to 'leave it there, as a confrontation'.[39] This might be a good thing to do (it makes people think, apparently) or it might not – for William Packer the work was 'archly sentimental' and indeed 'innocuous'.[40] Either way, the bourgeois critics were far too canny to take this picture at face value, or to let it shock them. In general, the broadsheet papers supported the showing of *Myra* against those who sought to have it removed from view, but their critics were not necessarily impressed by its quality: this was not purely an anti-censorship issue, although there was a strong element of that, for the argument tended to be that Harvey was making a comment about press images and our relation to them, and had not set out merely to shock and cause offence.

Fundamentally opposed to these readings of the work were those that took it seriously as a representation of a particular individual, and so also took seriously the reactions of those who had been wronged by that person. *Myra* was first shown at the Saatchi Gallery, and relatives of Hindley's victims had called for it to be taken down. Its display at the Royal Academy, however, was deemed more offensive: here it was to be shown in a blockbuster exhibition to hundreds of thousands of people, and in an apparent effort to create controversy, producing publicity for the Saatchi collection and money for the

Royal Academy. For Harvey, Hindley is no more than 'a piece of cultural orna-
mentation, like a bowl of fruit.'[41] For those who objected to the image, such
as Winnie Johnson, the mother of one of those murdered, 'The very idea of
using a child's handprints to make a picture of this evil woman is beyond
belief.'[42] Johnson took to standing outside the Royal Academy in an attempt
to persuade people not to enter, though to little effect. Ann West, the mother
of another victim, and a child-protection charity, Kidscape, also urged a boy-
cott of the exhibition.[43]

The divide between these two views of the painting was deep. So uncom-
prehending were the Royal Academy of the revulsion of the relatives that they
issued an invitation for them to come to see the painting. It was, of course,
scornfully refused.[44] As Bryan Robertson commented:

> It's impossible not to feel sympathy for the mother of one of Hindley's
> victims who asked how the secretary of the RA would feel if he were
> invited to contemplate the enlarged portrait of the murderer of his
> child …[45]

Similarly, Michael Sandle, one of the Academicians who resigned over the
matter, argued that once the Academy had received a letter from Winnie John-
son asking them not to show *Myra*, that alone should have been the deciding
factor, for she was the mother of a child who had been tortured and whose
body had never been recovered: 'We have left the realm of art now.'[46] Further,
in an article on the persistence of class distinctions in the art world, Mark
Wallinger put his finger on the condescension present in such a painting and
the Royal Academy's invitation to the relatives: 'Presumably the work said
more about the nature of evil than anything their imaginations had managed
to summon up in thirty-odd years.'[47]

While there was a definite class divide over the issue of *Myra*, there were a
few commentators in the 'quality' papers who were prepared to say that the
painting should not be shown. Julie Burchill, in a controversial essay published
first in the *Modern Review* and then in the *Guardian*, did make that argument.
It was a typically over-the-top piece, and its crude prejudice against the sexual
behaviour of men in general (like dogs, they'll shag anything), and its claim
that artists and writers were trying to promote paedophilia, masked a more

serious point: that this art took as its subject issues of great seriousness and that the *Sensation* artists were not of a quality to tackle them. She argued further:

> Some things should simply not be seen, and some things should simply not be written, because they are bricks in the wall of affectlessness which eventually blinds society with spectacle and makes it less sensitive to such issues as the ongoing sexual war against women and against children.[48]

Without, naturally, the feminist sentiment, this was a claim sometimes echoed in the conservative broadsheets.

The most extreme press reactions were occasioned by the attack on the painting by two artists, acting separately. Peter Fisher brought two containers of Indian ink into *Sensation*, threw them over *Myra*, and then rubbed the ink in with his hands, while trying to pull the painting from the wall (he caused quite serious damage). The other, Jacques Rolé, saw this happening but realised that this attack had only encouraged people to crowd about the work more than ever. He went off to Fortnum and Mason's, across the road, bought half a dozen eggs and managed to throw three or four at the painting before he was stopped by an off-duty policeman.[49]

Although these attacks broke the law, a number of newspapers supported the attempted destruction of the work, as did Craigie Aitchison, one of the artists who had resigned from the Academy.[50] The *Mirror* on its front page hailed the two artist-protesters who had, it said, 'struck a blow for every right-thinking person in Britain.'[51]

The insults did not by any means fly one way, and what developed in the press was a form of class-cultural skirmishing. When Burchill condemned the Chapmans as 'Fascist' (and it was a perceptive comment, for there is an attraction to radical right attitudes evident in their work), Jake complained of the uneducated masses and said that entry to galleries should be 'means-tested' (presumably meaning that the educationally challenged should be excluded).[52]

The dispute raised a more fundamental issue, for the attack moved on from a particular piece of cultural insensitivity to being an attack on the sort of people who tend to do such things – on those who make and view high art.

The most poisonous comment – and that which most clearly objected to art as such because of the kind of people who indulge in it – appeared in *The Sport* (the degraded rag that, as we have seen, Sarah Lucas had raided for shocking content). Harvey is described simply as 'the young bastard', a different gloss on the usual label, and his social habits are luridly imagined:

> [Harvey] probably swanned around Islington enjoying the toasts of artworld ponces and practically having a w★nk over the reaction to his painting before it was improved by an amateur paint-thrower yesterday.

What is more, and here the populist sentiment is most threatening, neither Harvey nor Saatchi are 'ordinary Britons' for whom 'art is an episode *of Only Fools and Horses*'.[53] Slightly more restrained – but purveying the same notion that there are real, straightforward and decent Britons, and then there are corrupt and decadent cultural types – was Paul Johnson's essay on no less a subject than the fate of the nation, illustrated by *Myra*. In markedly homophobic tones, Johnson asked whether good Britain, seen at its best in the mourning for Princess Diana, would win out over bad. And bad Britain was very bad indeed:

> Perverted, brutal, horribly modish and clever-cunning, degenerate, exhibitionist, high-voiced and limp-wristed, seeking to shock and degrade. This is the Britain of a corrupt and depraved cultural elite, who control much of our art, cinema, TV and literature and whose overwhelming passion is to spit on everything the rest of us value.[54]

It was *Myra* that stood at the head of this list, and became its visual symbol. We have seen that high art lite has relied upon the outrage of such red-faced bores to make it seem young, cool and oppositional. Such critics also, however, distract attention from the fundamental issue of interpretation, and from more measured statements opposing the piece.

To appeal to the work or (as we have seen) the artist to settle this dispute is pointless: like much high art lite, it purports to make no statement, solve no problem, merely to place a dilemma before a public. The work itself is dislocated from the response it elicits. The controversy over *Myra* demonstrated with great clarity just what had changed and what had stayed the same on the

British art scene. This was not a work of art that had shocked because it was unconventional or because public money was involved in its purchase (as in such previous art controversies as that over Henry Moore's *Torso* or Carl André's 'bricks' at the Tate Gallery).[55] Nor was it even a controversy in which high art was considered to have been sullied by vulgar or obscene material (as with the various and extreme disputes that surrounded Epstein's work from the Strand carvings onwards, or with what argument there was about Ofili and the Chapmans). Rather, it showed a deep divide between those who thought that the display of that image was appropriate as an artistic presentation (and they were not confined to a small artistic elite but encompassed a large liberal public) and those who condemned it as necessarily celebrating 'that woman'. The debate, strikingly, was less about tradition and the avant garde – though there was a small element of that in the reaction of the conservative broadsheets – and more about crime and its depiction. The class divide in the debate was strong, and it was a divide that reflects broader attitudes to the treatment of crime: which side of that debate you fall on is highly dependent on whether crime is something that you see on television and may very occasionally experience, or whether it is something that you and those around you live with day after day.

The claims of high art lite were also well tested: did the throwing of viewers into uncertainty, into the realm of non-judgemental presentation, lead to some overturning of established models of thought, some advance in thinking on the subjects of child murder, or on attitudes to it, or on the way it is handled by the mass media, or on the presentation of any of those issues in art? The press and the comments of the public relayed through it (and these are partial, of course, but all we have) suggest the opposite: a hardening of opinion into two opposed camps that never listened to one another, and damned their opponents as hypocrites, dupes or philistines. High art lite, then, had – successfully and spectacularly – broken with the autonomous concerns of the art world, had intervened in 'real life'; but in running out into the street only to cry 'no comment', it had merely succeeded in reinstating that autonomy – with all its attendant elitism – at another level.

The meaning of *Sensation*

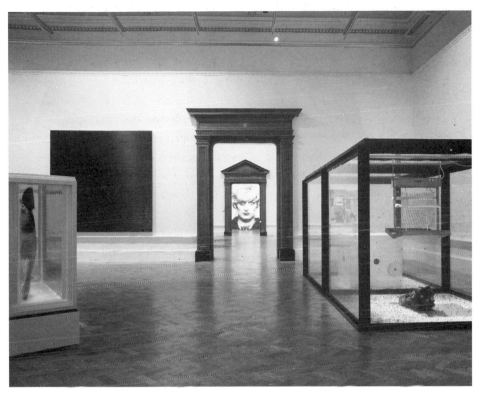

56 Installation view of *Sensation*, Royal Academy, 1997

Tracey Emin wrote an account for *The Face* about *Sensation*, teasing the reader with the idea that she might have had 'a good hard fuck' on the steps of the Royal Academy, and contrasting the excellent time she had at the opening party, surrounded by her friends, to her horrified reaction on going back during normal opening hours:

> My tent looked like shit. Some prat had loosened the outer tent covering. It was all saggy and wrinkled. Sarah Lucas' two fried eggs and a kebab looked really weird. The kebab was one solid lump of red mince. I tried to see Jake and Dino's little garden thing, but too many people stood in the way.[56]

Reading this, you realise that these artists are not much used to looking at art in circumstances other than the private view, and that in the case of a block-buster show like *Sensation*, the difference between the opening reception and the general run of the exhibition is considerable. Also, that placed before the mass of the general public, the freshness of the art, its tautness could be lost.

Yet there was another reaction; the supporters of high art lite within the establishment found the combination of the high, decorated halls of the Academy and the hybrid artefacts that dwelt there during *Sensation* a provocative one, and hoped that it would be productive. The first room, in which Hirst's shark floated alongside Wallinger's meticulous paintings of racehorses and Quinn's blood head, came in for particular praise in many quarters. Andrea Rose, the British Council's Head of Visual Arts, wrote:

> There is … a recognition in this setting that the art of young British artists has its antecedents in other art … Stubbs and Wallinger; Hogarth and Hirst; Gainsborough and Gary Hume: who is to say that the rising stars of the British art world should not take their place alongside names that have long been synonymous with English art, and all that 'Englishness' entails?[57]

(The slip from 'British' to 'English' is telling – but the national character of this art will be the subject of the next chapter.) So, between loss of afflatus and induction into the annals of national history, this section will look at the significance of the establishment's adoption of high art lite. From the start, it should be said that there was a wide variety of work on show at the Royal Academy – there is a world of difference between Marcus Harvey and Gillian Wearing. But with the tendency's induction into the high art establishment in the Royal Academy's halls, it all began to seem the same. In this homogenising mainstream view, the art becomes best known for being (somewhat) notorious; the *Evening Standard* feature articles, whether about Chris Ofili or the Chapmans, all purveyed the same standard hype. This is the perspective that will be taken seriously here, despite its flattening of the scene. And it must be taken seriously because it is now the dominant view.

The most positive features of new British art were always negative. One of its early catalogues, *Modern Medicine*, read:

There is a gamble that takes place every day in your contact with other people, that your own logic (the way in which you think or do things) will not contrast too greatly with theirs, otherwise you might not have too smooth a ride.[58]

Seeing its uncouth art for the first time in unmanicured rooms was often an unusual experience – quite different from the managed displays of most art galleries, or the culture industry as a whole for that matter – and one which might well bump your logic off its usual track.

Of the works in *Sensation*, Damien Hirst's *A Thousand Years* (fig. 6) is the set-piece of that negative impetus. Even the Academy could not tame it – the stink of the rotting head induced nausea, and its flies escaped to settle on other works or dwell in Emin's tent. As we have seen, the actual concerns of Hirst's work are not to be found in banging on about life and death, but instead in their mass media representations, particularly horror flicks. *A Thousand Years* refers to Dracula, the glass enclosure and the life cycle of the flies conjuring up the shade of the Count's incarcerated servant, Renfield, who fed on the blood of small creatures. The great majority of the work on show likewise fed off mass culture.

If the barriers between high and low culture have apparently been breached, the claim is often made that this is due to the lessening of class distinctions. The new audience for the new art is supposed to be anyone who cares to look. We are a classless nation now, says Tracey Emin, echoing John Major. In economic terms, such a claim is sheer nonsense – the long years of Conservative government may have seen a marked decline in traditional manufacturing industry and conventional patterns of work, but also saw a great rise in inequality, as business took back from its workers the gains of previous decades and many people ceased to work at all. But culturally, perhaps, the claim is more plausible.

Artists, and the middle class as a whole, have for a few years now been discovering the joys of white boys' pop, of football, of watching self-consciously trashy TV while quaffing large quantities of lager – or so we are led to believe. Perhaps, at any rate, they are more prepared to celebrate these activities openly. What has brought about this open embrace of 'low' culture and manners?

What has allowed the surrender of the vestiges of bourgeois deportment and morals? What indeed has led certain sectors of the middle class to come to regard lager-drinking as 'culture' at all? There are two interlinked causes, and neither of them have much to do with lessening class distinctions.

The first is the collapse of Eastern European communism alongside the political and economic defeat of the working class in this country. With the power of that class apparently shattered forever, and with the restraining force of communism over capitalism gone, it is safe for the middle classes to let blur those distinctions that held them apart from their lessers. As Herbert Marcuse put it in the 1960s (a period with which this art is supposed to have some connection):

> The greatness of a free literature and art, the ideals of humanism, the sorrows and joys of the individual, the fulfilment of the personality are important items in the competitive struggle between East and West.[59]

With that struggle over, these matters (always something of an embarrassment because both systems flagrantly failed to live up to them and besides, they were an impediment to money-making) become subject to down-sizing.

This is a negative condition for the emergence of the new lager lads' culture; but what of its positive attractions? There are some who would have you believe that these activities are simply enjoyable in themselves; but we can surely go further than this.

Art often feeds on that which is passing away and, in doing so, assists its passage. In Britain, with its precipitate deindustrialisation, much of traditional working-class culture has now acquired a nostalgic patina, celebrated in the clichés of a film like *The Full Monty*, in which social collapse is recast as what is meant to be bitter-sweet comedy.[60] Similarly in *Sensation* there were crude jokes, kebabs, tabloid spreads, fragments of pornography, confessional and lurid pieces – in short, artists trying hard to behave badly. The mere form, the shadow of working-class culture is celebrated but only in its grossest and most clichéd outlines (of course, it is silly for anyone to object, because this art is *so* knowing, *so* ironic). The solidarity that those forms produced and were produced by is forgotten, and the result has only the appearance of life. So this vampiristic art draws life from its already anaemic subject.

Now it is true that for those raised on polite painting, this work is a surprise – people's reactions at the Royal Academy showed that. But again, the positive charge of this development is mostly of a negative sort. The nationalist and apparently popular aspect of the art is in part a reaction against the cosmopolitan, bourgeois taste of the international art world, associated as it is with neoliberal capital. It is part of a much wider process in which people are looking around for alternatives to the technocratic, globalised and economically orthodox world which is being prepared for them. Lacking any concrete political and cultural alternative, however, we are left with dubious cultural nationalism and ineffectual misbehaviour. Further, in the case of this art, its adoption by the very people and institutions it seemed once to be pitched against removes most of its sting.

The second factor in this bourgeois yearning for the authentic image of working-class culture is equally important: the failure of communism has been accompanied by a prolonged and increasingly serious malady of capitalism. This is a crisis going back decades, although in the West it is only recently that it has been felt with such harshness that people no longer expect things to improve, and have begun to believe that life will be worse for their children than for themselves. Now that the middle class has been freed from the spectres of both socialist and capitalist improvement, what else is there to do but party? In these circumstances, the ideals of bourgeois society – and with them, those of conventional high art, previously so resilient in Britain – are in poor health. Only now can the establishment countenance the surrender of its lofty principles for a more plausible and marketable alternative.

In Madame Tussauds there is a newish ride, 'The Spirit of London' (opened by John Major), which takes visitors on a nightmarish animatronic tour of British history and identity. The last historical cliché, among the Beefeaters and the Blitz, is an ensemble showing Carnaby Street in the 1960s. It is no ideological accident that the 1960s should now be so much revisited. The usefulness of the image of Britain as a unified, classless nation – a bit eccentric, a bit raunchy but basically safe – which can be marketed to the British, obviously, but also to others, especially tourists, is plain to those professional boosters of the economy and the culture. Yet the often-heard parallels between the current scene and Pop art – or for that matter with Situationism – bear little

examination. Both Pop and Situationism were products of glut, born of a time when it seemed as though capitalism would go on delivering increased goods to everyone forever. That an art can be made in our currently straitened circumstances which has certain formal similarities with Pop is a matter partly of wilful blindness, partly of the hope that success will materialise if its mere image is aped. Again, in this farce, only the ghostly forms survive.

An art often gets the literature it deserves, and this publicists' art, as it is drawn into the mainstream has in this respect been exemplary. Louisa Buck's recent book, *Moving Targets*, which is meant as a user's guide to the current scene, actually does tell you everything you need to know, though not in quite the way that she intends. With its relentlessly upbeat tone, the book is a digest of the current hype, never missing the opportunity to deploy some journalistic chestnut, and as one reads more and more of it, the suspicion grows that the hype is all there is. The piece on Charles Saatchi actually begins: 'What Cosimo de Medici was to quattrocento Florence, Charles Saatchi is to late twentieth-century London.'[61] Likewise, the *Sensation* catalogue – while it looks like other Academy productions that have sometimes contained serious scholarship – is little more than an inflated PR exercise.[62] Richard Shone gives a detailed account of the rise of new British art with much useful information about art schools, galleries, exhibitions and networks between artists.[63] But tellingly the detail runs out when it comes to the few passages on those who have criticised this work. Rent-a-don Lisa Jardine writes an extraordinary piece, entitled 'Modern Medicis', on the history of British private collecting this century, seeking to glorify Saatchi by bathing him in the reflected light of figures such as Samuel Courtauld.[64] This has the advantage of praising Saatchi while saying absolutely nothing definite about his activities. The methodology is on occasion breathtaking: might collectors sometimes collect for financial gain, asks Jardine, not unreasonably, and if they are important enough, might not the very fact that they collect a certain type of work assure its value? But the motives of the collectors she has talked to are above suspicion, for they have assured her that they collect only for love.

The early promise of not-so-new, not-so-young British art has not been kept – instead, it has become thoroughly complicit with the mass media that it once regarded askance. Thus the text in *Modern Medicine* quoted above

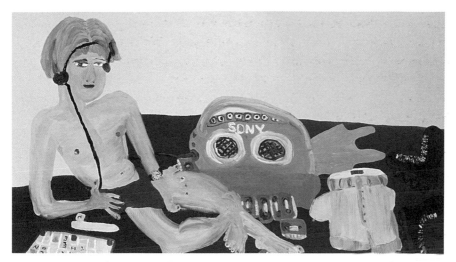

57 Martin Maloney, *Sony Levi*, 1997

continues (ironically offering some comfort to those who fear the odds in the gamble of the individual against conventional logic):

> Fortunately the stakes are usually kept low by the services of such as tv, magazines and other advertisements which set guidelines and patterns, so that you can align your logic in preparation for the outside world in the privacy of your own head. Personal experience has become a realistic extension of tv documentary or an improvisation of mingled feature films, to make the job of connecting far less involved, smoothing the awkward movements of your thoughts.[65]

And the artists of the Saatchi Collection, and their many hangers-on, advertisers and PR people, have finally made a very smooth ride for themselves. Martin Maloney's painting, *Sony Levi*, with its assured cack-handedness and considered vacuity can stand as an emblem of the movement. It looks critical but the teeth of its gears have no purchase and spin in the air.

Saatchi's turn

We have seen that within the small domestic market for British contemporary art, Saatchi has the buying power to influence the direction that the art

world takes. His collecting of high art lite has been a major cause of its success, and his recent decision to sell even a very small part of his collection – and even when the cause was to support art-school students – produced some panic among its supporters. What has become a source of longer term concern is Saatchi's apparent turn from supporting the 'young British artists' to buying the work of a still younger generation. In a sense, this was bound to happen if Saatchi was to carry on collecting so as to speculate, and it is surprising that it did not happen sooner. Saatchi has made his collection, and sometimes made a good deal of money, by buying very cheap and in bulk, and selling dear; and those whose reputations he had helped make in the early 1990s began to gain reputations that went beyond his control.

What is more surprising is Saatchi's attempt, in alliance with artist and critic Martin Maloney, to give the group of artists he is now buying a name (rather than waiting for one to be foisted upon it) and even some intellectual justifi-cation. The 'New Neurotic Realists' was the formula unwisely fixed upon. The move was pursued in a number of shows, most notably the eponymous exhibition at the Saatchi Gallery, and in an exhibition called *Die Young Stay Pretty*, curated by Maloney and shown at the ICA. The transition from *Sensation* to the New Neurotic Realists is far from clear cut. The new term is broad enough to include much of the old, and Maloney and Peter Davies, part of the new tendency, also showed in *Sensation*.

In the essay that introduces the Saatchi Gallery book, *The New Neurotic Realism*, following in a tradition of one avant garde succeeding another by marking out the virtues but also the limits of the old movement, it was made clear that it was time to finish with 'young British art'. Despite its 'youthful success' and garnering of media attention:

> Inevitably, the YBA cult of personality became tired. New artists and curators began looking elsewhere. Artists wanted to make art without anyone peering over their shoulders. They became enthusiastic about making things again. Art started to look like it was having more fun while artists remained serious in how they reflected their concerns … Cynicism was finally *passé* and the art star a bore.[66]

That such a sentiment should come out of the Saatchi Gallery, of all places, was

more than ironic: having the nerve to make such a statement is to place much faith, an advertiser's belief perhaps, in the power of the unceasing cascade of products to ensure forgetfulness.

Distinctions between the older generation and the new are hard to fix upon, and they are a matter of degree, but even so a few can be identified. If high art lite is sometimes a little nasty, the new Saatchi bunch are almost always nice. They follow more in the school of Gary Hume than the Chapman brothers. One of their number, Jane Brennan, says that she 'likes things to be nice and to have nice things around me'.[67] What is more, their works are nicely made. The 'legacy of pathetic, throw-away art', it is claimed (and Sarah Lucas is mentioned here), 'had played itself out'.[68]

58 Dexter Dalwood, *Paisley Park*, 1998

There is a strong trend in the work itself for adolescent-style painting – for instance, Dexter Dalwood's painted fantasies of celebrities' homes or the bridge of the Starship Enterprise – much of its taking as its theme the stupidity of painting (or even the stupidity of painters). The sweet and knowing dumbness of these paintings is matched by those of the artist's statements ('it's alright to be slightly obsessional if it is what you are really interested in').[69]

Irony is also out, although only in a rather knowing way. Maloney says of his paintings that they use humour and it is fine to laugh at them. Even so:

> These paintings are not bad paintings, that is, they are not ironic. I am
> not anti-painting or stating the opposite of my intentions. I am painting
> what I hope will be regarded as serious paintings … I am like anyone
> else in the twentieth century who uses bright colours, simple shapes and
> finds a use for the inaccuracies of their hand, but it does not necessarily
> follow that these characteristics are bad, naïve or child like.[70]

This half-knowing innocence, a wide-eyed look at a sometimes bad world, though also one full of wonder is supposed to be poignant:

> I hope you can find, that the comic sometimes masks the serious, that
> knowledge can be displayed to look dumb and the sadness of the world-
> weary can contain an innocent wit full of gentleness.[71]

The remarkable thing about this painting and the statements that try to support it is the lengths to which Maloney and his collaborators have to go in their attempt to rescue high art from the clutches of cynicism, philistine attitudes and the suspicion of high motives or intellectual engagement.

Art-historical references abound in the paintings shown in *Die Young Stay Pretty*, and the catalogue makes very sure that no one misses their importance: in their written contributions, the artists frequently stress their sources, listing them as if they had been instructed to, while Emma Dexter in her Foreword makes a list of her own of the 'grandiose art-historical inspirations that would normally be considered off-limits for young artists', adding that 'The work has a distinctly formal feel, any hint of installation has gone.'[72] Maloney himself says: 'I've given myself complete freedom to choose any of the things from Art history and it's not join the dots and spot where it's from.'[73] The last comment

may be a jibe at Fiona Rae and similar mix-and-match painters. He claims that he is trying to integrate art history and his observations of daily life – again, in a non-ironic way.[74] The attempt is to keep this stuff young and hip but also to regain the full force of cultural distinction, to produce a synthesis of high art lite authenticity and full-brew high art references.

Maloney protests too much about irony. If almost everyone thinks that his cack-handed paintings are ironic, and he alone thinks they are not, then maybe there is something badly awry with his project. Yet, as with the art, the protests are not quite what they seem. To proclaim, 'I'm not the Kylie Minogue of painting', would be to put a fatal weapon in the hands of the opposition, but only if you believed that such an opposition existed, and only if you didn't really want to be known as just that.[75]

In the art world, this new tendency has been seen largely for what it is: a cynical ploy, given the growing dissatisfaction with the antics of high art lite, to push the art market on in a direction that Saatchi can control. While individual works have been praised, reviews of both exhibitions as a whole have been overwhelmingly negative.[76] Critical reviews are unusual, as we shall see in chapter 9, so a group of them probably reflects art-world consensus.

Saatchi's most recent moves seem calculated to defuse the undertone of critical comment building up against him, though they are a good deal less altruistic than they at first appear. There are the Saatchi Young Artists' Sponsorship Bursaries, awarded to students at certain London art schools. It is suspected that they will encourage the production of more art in the Saatchi mode. While this initiative was sponsored by the sale of 'young British art' from the collection, it is clear that the money raised exceeded the amount required by the bursaries even if they are to continue indefinitely (for which there is no guarantee), and it is unclear what has happened to the rest.[77]

In 1999, Saatchi also donated works to the estimated value of £500,000 to the Arts Council Collection.[78] This was not a donation of the stars of Saatchi's stable but of artists whose reputations have not yet been assured, so representation (or, in some cases, additional representation) in the Arts Council Collection will help their prospects and prices. Such a donation, large in comparison to the meagre sums allotted to Arts Council acquisitions, and amounting to more than three years' worth of their purchase grant, also skews

the collection of this government body towards the tendency of high art lite that Saatchi has supported.

There is a definite satisfaction in all this at seeing the discomfort of those conservative critics who believed that what they thought of as the hideous state of contemporary art in this country was the result of elitist state support and of the narrow and bureaucratic minds that governed the public art institutions. It was always their contention that the conceptual and minimal art was the natural expression of state bureaucracy.[79] The implication was that a thriving private sector would produce something more popular, democratic and colourful.[80] Well, the reduction of funds to the public sector has played a role in the appearance of a more populist art, though it is hardly rendered in the polite colours that would pacify the conservatives; but it is the product of a virtual monopoly, more partial and idiosyncratic than what went before and, at least in the opinion of some critics, rather more corrosive of the public good.

Part III
Everything you want

8 The Britishness of British art

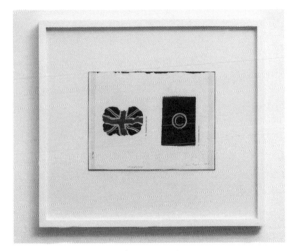

59 Gavin Turk, *Crumple Zone*, 1997

'Look at James Joyce. He didn't get where he was
by trying to be international.'

Sarah Lucas[1]

British art has become more British throughout the 1990s, and the main
reason should by now be obvious: the turn by artists and dealers to making
their products known through the mass media, particularly through news-
papers and television that have primarily a domestic market and domestic

concerns. In itself, however, this tells us nothing about the form that British character has taken in the art. This chapter will attempt to deal with three main issues: the first (and easiest) is how and where art becomes self-consciously an embodiment of Britishness; the second, the role and fate of that self-conscious Britishness in the global marketplace, particularly in relation to the United States; and lastly (and this is treading on thinner ice), whether there is some general character of the art which, consciously expressed or not, we can identify as British.

We have seen that there is much in high art lite that makes an appeal to particularly British concerns: the references to 1970s children's television shows (indeed, that whole current of nostalgia); the display of the face of Myra Hindley; the appeal of British slang; goings on at run-down seaside resorts: all are matters that, if not entirely opaque to a foreign audience, are not likely to have for them quite the full effect. Such work tends to appeal to the unity of a British audience in a common culture, to the experience of a culture that, though its roots were often in working-class entertainment, was transformed in the mass media and marketed to a broad section of the population. This is the importance of *Doctor Who* or Morecambe and Wise, of Tommy Cooper or the *Carry On* films: low 1960s and 1970s entertainment, lovingly embraced at the time by children (rather than by discriminating adults); now, graced with the gentle patina of nostalgia, they can unite people from widely diverse backgrounds in fond remembrance.

If British art has played with the forms of Britishness, this is in part another case of picking over the corpse (in this case, of a triumphant and united nation), so familiar in high art. The Thatcher government in its long tenure, aiding the forces of deindustrialisation, did much to shatter the traditions that had sustained national identity, though the US-style society that was supposed to be released from the bonds of the declining British one never quite materialised.[2] The widening disparities between the regions, and particularly between southern England and Scotland and Wales, instead contributed to the rise of another sort of nationalist feeling that may yet lead to the break up of the United Kingdom.

There are artists who are not content to draw on the appeal of British culture merely to add a veneer of comfort to the otherwise alienating experience

of looking at a work of art. There has been a persistent strain among black, politically engaged artists such as Sher Rajah to express their exclusion from British identity, or their status as hybrids, by using the Union Jack.[3] The use of the flag by white artists on the more critical margins of high art lite was to be rather different. While that earlier work was often complex and layered painting, making a number of points about identity, the work of the 1990s has tended to retain and exploit the instant recognisability of the flag as a symbol.

Mark Wallinger, for example, remade the Union Jack in the orange, green and white of the Irish tricolour, calling the result *Oxymoron* (1996).[4] This was an actual flag, rather than a painting, and it made a simple but very sharp comment about British identity, both upon the identification of the Unionists with the United Kingdom and on the presence of many Irish Catholics and Protestants on mainland Britain itself. It was an uncomfortable condensation of colonial history and current dilemma. This is only a fragment of Wallinger's sustained and critical interest in British identity, part of which has worried at the association of the Union Jack with forms of national pride that can easily turn to chauvinism or worse. Much of his work has been about the ownership of cultural signs, and their condensation in physical objects. While the flag has been claimed as the property of the white masses, Wallinger in a linked series of projects around horse-racing – that has included buying his own race horse and calling it *A Real Work of Art* (1994) – has highlighted issues of breeding and its identification. He has painted four very fine renditions of racehorses against a white ground, emphasising their status as objects of connoisseurship, related to art objects. Viewers are unlikely to miss the point, since Wallinger called the series *Race, Sex and Class* (1992). (Similar, though dealing with proletarian experience, are Kate Smith's photographs of pigeons' eyes – breeders believe that they can tell a good deal about the lineage of a bird from its eyes.[5])

We will return to Wallinger later, but his combination of high art lite tactics and political engagement is a salutary one: it shows that such tactics do not have to be turned towards creating mere dilemmas with which to confront the viewer, and that oddly the techniques (so many drawn from advertising, after all) can serve to convey a message without patronising the viewer or settling into propaganda.

Gavin Turk's work with the Union Jack is in some ways similar, though more focused upon British cultural identity, and in particular upon its relation to modernism and the international art world. His *Indoor Flag* (1995) is a picture of a limp Union Jack against a plain white ground, the blue painted in International Klein Blue pigment (invented by Yves Klein and used as his trademark). Aside from the borrowing of another artist's means, which as we have seen is a common feature of Turk's output, another opposition is in play. As Alex Farquharson notes: 'Mix the traditionalist iconography of Britishness – the flag, our tabloids, the royals – with lofty Modernism and you get a contradiction of hostile terms …'[6] This is to point towards the much-noted discomfort of the British with visual modernism: radical interventions greeted with deep hostility, while various domesticated forms were tentatively embraced.[7] Turk has also satirised the supposed fate that high modernism has met in the damp British climate, making replicas of Robert Morris's immaculate mirrored cubes, but having them rust (*Robert Morris Untitled 1965–72*, 1990).[8]

Turk has talked of the ambivalence that surrounds the British attitude to their former empire, both of embarrassment at having had it and sorrow that it is gone, and says that the nostalgia in his work operates as a 'theme' and a 'condition'.[9] He is also clear that it is a marketable one; in *Crumple Zone*, the Union Jack appears like a crumpled tin can, next to a regular rectangle bearing the © sign. Turk sees himself as 'flogging' British culture – in the sense of both selling and beating it. He says that he is trying to keep dominant US work at arm's length by finding ways to work around it: 'It's cultural warfare in a way …'[10] Turk's *Window* (1991), reproduced a jingoistic front page from the *Sun* published during the Gulf War showing the face of a soldier against a Union Jack, the headline reading 'Support Our Boys and Put this Flag in Your Window'. Turk replaced the soldier's face with his own, the beret now being as much bohemian as martial, and the subject becoming cultural warfare.

That may seem an extreme way of characterising the cultural competition between nations but it has an element of truth. While work with British references may not be understood in quite the same way abroad, its general point is the appeal to a unitary and nostalgic image of Britain, a land of character and

cliché. Patricia Bickers has described how British art has been presented in the United States, examining the language of patronising amusement at the antics of those brash and crazy Brits. The opening of *'Brilliant!'* at the Walker Art Center in Minneapolis featured attendants dressed in Horse Guards and British bobby outfits.[11] She also points out that while British art has been successful in terms of media exposure in the US – she looks to covers of *Artforum* as an indication of this – it is still treated with critical condescension: Hirst, indeed, won the title of 'worst artist' in the same magazine.[12]

That condescension is in part deserved because it is a result of making an appeal to a particular niche market – of the sort targetted by *The Full Monty* and *Four Weddings and a Funeral* or, more recently, *Notting Hill* – and to which a cosmopolitan art audience is a good deal less sympathetic than the general public. It is what the self-critical and reflexive practice of an artist like Turk is working against. The result of that appeal is that British work in the US is charged not merely with seeming derivative and behind the times, but with lacking seriousness. The take-up of the high art lite was slow – Hirst not showing in a solo exhibition until 1996 – and its reception has been far from smooth.[13] Despite the prominence that British art eventually achieved within commercial galleries, the critical response in the US has been cautious. Peter Schjeldahl, for instance, reviewing an exhibition called *Twelve British Artists* (1992) at the Barbara Gladstone Gallery and the Stein Gladstone Gallery in New York, highlighted the efficient, sophisticated and commercially directed character of the work shown, including pieces by Anya Gallacio, Damien Hirst, Gary Hume, Abigail Lane, Sarah Lucas and Marc Quinn. In his judgement,

> the tendency is certainly clever, exploiting the present exhaustion of
> artistic form and institutional ambience to heighten the contrasts with
> organic reality … The tendency also feels last ditch, part of a dwindling
> arsenal of resources for not being excessively boring when one must put
> on an art show.[14]

To call artists 'clever' is one of the worst things that you can say about them, since with that word comes a host of not-so-subterranean implications about shallowness, opportunism and lack of integrity.

While high art lite takes particular influences and makes of them a self-conscious theme of the work, the relation with work made in the US can be an awkward one. There is a US view that would see most British work as derivative of previous pieces by US artists: for instance, Bruce Nauman had cast the space under a chair in the 1960s, and Rachel Whiteread has apparently based an entire career on that one idea; or indeed her famous work, *House* (fig. 2), could be seen as merely the realisation of an idea by Ed Kienholz in 1967, *The Cement Store No. 1*, in which he proposed removing the roof of a shop and filling it with concrete.[15] The charge is strengthened when we remember the importance for British artists of Saatchi's exhibitions of US art in the 1980s, which included the work of Robert Gober, Jeff Koons and Bruce Nauman. Jake Chapman, asked about how the work of the Chapmans relates to that of Charles Ray, Kiki Smith and Paul McCarthy (figures to whom they are often compared), replied, not entirely honestly, 'We steal their ideas. They steal ours. Everyone is happy.'[16]

The same suspicion was aired in a very hostile article by Alexandra Anderson-Spivy about high art lite published in the *Art Journal*. There, *Sensation* was seen as a boosterish and chauvinistic exercise, and the hope that Norman Rosenthal expressed in the catalogue that British art would 'vanquish' American art was certainly not a welcome one.[17] In any case, claimed Anderson-Spivy, this is an art that privileges marketing and design over aesthetic innovation, and conceals behind its shock strategies something 'deeply aesthetically conservative'. Worse still, it is old hat:

> To an American weaned on Vito Acconci, Bill Viola, Jeff Koons, David Salle, Carolee Schneemann, Chris Burden, Paul McCarthy, Matthew Barney, Kiki Smith, etc., 'Sensation' came across as a fascinating but day-old pluralist salad of art historical and design references, pop culture borrowings, social documentary, autobiography, domesticated formalism, and eighties video and installation art.[18]

While one might have some sympathy with the overall judgement, the tone of condescension here is unmistakable. It is the patronising fascination of a metropolitan elite for provincial culture, where the surprise is that the yokels are so good at imitating the art of the centre and so nearly get it right. Thus the

60 Steve McQueen, *Bear*, 1993

attitude of the US to its cultural colonies, fully justifying Turk's stance on the matter.

There are British artists, however, whose work is better received in the US than in Britain, and of these the film and video artist Steve McQueen is a symptomatic example. His slow, hypnotic films, shot from strange angles – echoing early modernist innovations – and showing odd, sometimes ritualistic actions, leavened with issues of race, are a world away from high art lite. In a lecture given in Oxford, one of the directors of London Electronic Arts, George Barber, outlined three rules for 'young British artists' to follow in making fashionable video:

1 Rough it up.
2 Don't try too hard.
3 Keep it short.[19]

Some artists, alarmed at the sharpness of digital video and editing equipment, have been led to patch their films out and back from VHS until they get the amateur, scratchy, low resolution effect they desire. A few of McQueen's films do follow these rules (*Exodus*, 1992–97, is one, though its theme and title – a reference to Bob Marley as much as to the Bible – might break rule 2) but most go out of their way to violate all of them: this is a theoretically and

politically inflected art that is at the same time not too explicit with either its politics or its theory.

David Frankel, writing in *Artforum*, distinguished McQueen from the work of his British contemporaries: his films are black and white, silent, and refer to no clear story-line or real life situation (as against the work, say, of Georgina Starr); unlike the work of Sarah Lucas, 'their erotic politics are usually more insinuating than confrontational', and, although the artist sometimes appears in the works, they are not confessional; nor does McQueen draw on or parody advertising or the mass media.[20]

McQueen's virtues, then, are an absence of vices, a matter of not falling into the clichés that make up the niche market that is high art lite. Here is a mature black artist who never clowns, whose themes take in issues of race but not too specifically, giving them a universal resonance – a convenient and dignified figure for the US art world.[21] Robert Storr nicely expresses the distinction of McQueen's handling of race:

> The fact that McQueen does not make an obvious issue of his race – or that of his predominantly white art world public – is a mark of confident take-it-or-leave-it self-acceptance and of an explicitly political sophistication, which assumes that assertion rather than protest, intelligently structured poetics rather than structuralist 'critique' may be, at this moment, the best means for imparting new or difference-defining information.[22]

Quite what this 'information' might be, McQueen's critics never vouchsafe to reveal but, no matter, this is art for grown-ups. Another way of saying the same thing is that McQueen's work is just more boring than that of his contemporaries. He is making art that is safe for elite consumption, drawing on both film history and, through references to modernism and beyond (particularly to Bruce Nauman), to art history.[23] This is very deliberately, indeed ceremonially, gallery art. Or another way of making the distinction is to say that McQueen examines the techniques and the rhetoric of filmic language itself, much in the way that some abstract painting is mostly about painting itself.[24] In this way, given the imprimatur of formalism, McQueen's work is assured of its status as the highest of high art.

A British character?

There is an argument, and it should be taken seriously, that there is nothing British about the contemporary art scene in this country. In a review of the *Sensation* exhibition, Peter Wollen made a detailed and compelling comparison between the art he saw in the Royal Academy and that he was familiar with in Los Angeles.[25] There are indeed many points of comparison between the two, not least because Saatchi and many contemporary British artists had been keeping a close eye on the West Coast scene. West Coast art has a cool, even depressive, and distanced lack of affect that contrasts with its frequently dark and violent subject matter; in using the issue of crime in art, it does so often to make no explicit comment.[26] The parallels with the British art scene are obvious, and indeed, such considerations have led Michael Corris to write about the Americanisation of British art.[27] One way of accounting for the ebbing in Britain of the philistine attitude towards visual culture is to see literary and musical concerns as being tied ever more closely into the visual through film, television, pop videos, even computer games, and especially advertisements – a global, US-led phenomenon – that has initiated the British public into complex readings of the visual, and into a participation in transnational culture.

Wollen's argument, however, is more fundamental: that 'there is nothing specifically British about "Young British Art" any more than there is something specifically American about its Californian Southland counterpart.'[28] Both London and Los Angeles are large urban environments, with a concentrated, cosmopolitan population that encourages the flourishing of the art market. Both are global cities that compete on the global stage for cultural supremacy – and on that stage it is not Britain versus the United States or Germany or Japan that is important but London versus New York or Los Angeles or Düsseldorf or Tokyo.[29] The specificity of this art, insofar as it is not turned entirely outwards to its global market, is not national but narrowly local.

There is a good deal of force to this argument but it does not fully take into account the particularities of the British situation: here, as we have seen, artists were required to turn to the mass media to further their careers, and since that

mass media is nationally based, this meant taking on national concerns. The resulting cultural effect outlived the recession itself, not least because recovery has been uncertain. To the extent that Wollen's view is correct, it holds for the production of art and for its consumption by global cultural elites, particularly as competition between cities is expressed in international exhibitions and biennales. It is false for those whose main experience of art comes, not from a trip to Kassel or Johannesburg or São Paolo but from reading about it in newspapers and magazines, seeing it on television, and occasionally visiting a nearby gallery.

Although it is the product of particular circumstances, the British orientation of high art lite is also a pursuit of a popular identity-based culture, a reaction to cosmopolitan, globalised elite culture, though also, as we have seen, a niche market ploy within that cosmopolitan realm, a self-conscious device to exploit identity. This can be seen with particular clarity in Sarah Lucas's German catalogues which are centred around her eccentric, rough self-image, presented in interviews and numerous photographs of the artist.[30] There is a dialectic between the homogenising forces of globalisation, and the reaction to create a specifically British subject matter, the latter being a product of the former, not just a reaction against it, but a way of handling it, of making a distinct product that can appeal to segments of the global market.

When it is not a specific and self-conscious theme, however, the manner in which national character is made apparent in art is notoriously difficult to pin down, and it is likely that the very aim of doing so is misguided. Sometimes contemporary artists have commented upon the question, but certainly no coherent view emerges, more a tapestry of opinions and prejudices: for the Chapmans, the British have a predilection for abjection, but this only means that they are the 'first people over the top' in the 'global death drive' that we are now apparently witnessing; for Gary Hume, the fact that visual artists still have to justify themselves culturally in Britain in a way not necessary in the US makes their work distinctive, but there is also 'a memory of British imperialism and that cultural validity. It's a vague echo of arrogance.'[31]

There have been many attempts to define a national identity, nonetheless, with generally English, rather than British, art and character being the object of investigation. These studies, most of them written some time ago, are

generally agreed that the English character is formed by some complex of racial and historical forces, moderated by the constant balm of England's temperate climate but, as to the character so produced, there are widely varying assessments.

For Eric Underwood, writing in 1933, the French character demonstrated the rule of the classical, the 'supersession of the emotional and the sensuous instinct by the intellectual', and a preference for the rational and the regulated, demonstrated in the clarity, balance and organisation of French painting, while English painting favoured imagination and poetry, beauty over truth, extravagance over restraint, the search for hidden meanings, the arousal of emotion and the telling of tales.[32] This was a view that would also have various airings in the early post-war period.[33]

For Nikolaus Pevsner, addressing the subject directly in his book *The Englishness of English Art*, based on lectures first delivered during the Second World War, the English character had a more complex, not to say contradictory, bent, displaying at various times both the imaginative, narrativising excess of Underwood's account, but also – particularly in architecture – a pragmatic, rational, moderate and instrumental quality. In fact, England's climate, both 'moderate' and 'misty' is reflected in the double character of its art: 'On the one hand there are moderation, reasonableness, rationalism, observation, and conservatism; on the other there are imagination, fantasy, irrationalism.'[34]

Pevsner begins his book with a warning that has a highly contemporary ring:

Those who are against stressing nationality in art argue that in an age of such rapid communication as ours, with such an international force as science in command, with daily press and illustrated journals, with wireless and film and television keeping everyone all the time in touch with all other parts of the world, everything ought to be avoided that glorifies obsolete national divisions. It is bad enough, they argue, that nationalism has had such a come-back in the last twenty years, and that new small national States have appeared and are appearing everywhere on the map.[35]

Despite these well-judged misgivings, the account he gives, while often stimulating in its detail, lacks any notion of the means by which English character might be transmitted: it is invoked, its existence is assumed, it is caused by some peculiar complex of race, language and climate. Yet, since its attributes are neither constant nor consistent, this lack means that their description can only be speculative, for who can tell what is part of the enduring English character, what passing historical contingency, or how to sort out the manner in which the two interact? Pevsner himself says that

> The geography of art is no more a science than the history of art. The qualities which the historian detects, and dockets, are not only impermanent, they are also ambivalent.[36]

Yet there is in his chapter on 'Hogarth and Observed Life' material of interest for the 1990s: the English predisposition to depict mundane, everyday scenes, full of humorous incident, which Pevsner sees as being connected both to preaching (conveying a moral) and to empiricism in philosophy. If the impulse survives in high art lite, it is detached from both: explicitly eschewing morals, and often, through dwelling on the conventions of representation, calling into question any notion of simple and direct access to the facts. Yet the simultaneous condemnation and enjoyment of urban decadence is still relevant. Indeed, since the rise of modernism in Britain led to the neglect of the political art of Hogarth and all that sprang from it, one might expect modernism's fall to allow a revival of this tradition. The interest in narrative and observation has not, however, generally been accompanied by the political interests so prevalent in Hogarth's work.[37]

Linked to Hogarth, there is one particular tendency that does seem prominent in British art – which is not to say that it is quintessentially British, only that it is a prominent feature now, and is connected with peculiarities of British society – which will be examined next. Given Pevsner's warning, this is an attribute that I will argue springs not from climate or language or race, but rather from a particular social configuration in the inner cities; though it is certainly linked in its expression to recurrent British cultural concerns.

The urban pastoral

… Living in a country that is supposed to have a landscape tradition. This is the landscape. Tottenham Court Road. I wanted to look at that kind of landscape.

Tim Head[38]

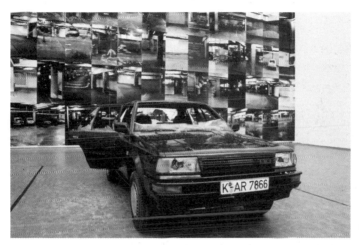

61 Sarah Lucas, *Car Park*, 1997

Let's begin with a curious aspect of the character of British art of the 1990s. It is well illustrated by one of Sarah Lucas's pieces called *Islington Diamonds*: part of an installation of a car with a smashed windscreen and a display of photographs of an underground car park; 'Islington diamonds', we are told, is slang for the blocky fragments of smashed car windows, at once a sign of vandalism or theft, and also an oddly attractive thing, worthless gems that shine against the dull hues of the pavement.[39] So the work is about seeing something valuable in something trivial and associated with the less advantaged sections of society, and bringing that to the attention of art-lovers. Much of Lucas's other work operates in the same way.

The critic Anne Hamlyn, in trying to get a fix upon the characteristics of recent British art, has written of how those who are not quite artists also take delight in such urban raw material:

I recall a walk through the city, armed with an SLR, trying to locate a subject. In a large vacant lot a stolen car has been parked, stripped of its useful parts, vandalised, ignited and, after its spectacular transformation, abandoned. I stop my walk and range over this corpse with a kind of sensuous delight.[40]

Such tourism of the inner city, the collection of objects or images and their display, is part of the pastoral strain that runs through contemporary British art. The application of the idea of the pastoral to contemporary art is a subject that has had some airing lately, particularly because of Thomas Crow's use of it in a fine essay in his book *Modern Art in the Common Culture*.[41] But Crow was far from the first critic to discern elements of the pastoral in modern art: for Clement Greenberg, in some sharp but brief comments, the pastoral in modern painting depended on two linked attitudes: firstly, 'a dissatisfaction with the moods prevailing in society's centers of activity'; and secondly,

… a conviction of the stability of society in one's own time. One flees to the shepherds from the controversies that agitate the market-place. But this flight – which takes place in art – depends inevitably upon a feeling that the society left behind will continue to protect and provide for the fugitive, no matter what differences he may have with it.[42]

This passage offers important clues about pastoral as it operates in British art today.

But first, what is pastoral? The term summons up bucolic images of shepherds and shepherdesses at play, enjoying rustic, artistic and erotic pleasures in sunlit Arcadian landscapes.[43] And my argument will be that the outlook embodied in pastoral has been turned from the rural to the urban, particularly to the landscape of the inner city. But that image of rural pleasure is, in any case, only one example of the pastoral attitude. William Empson, in his book on pastoral in literature, on which Crow draws extensively, outlines the more general meaning of the term:

The essential trick of the old pastoral, which was felt to imply a beautiful relation between rich and poor, was to make simple people express strong feelings (felt as the most universal subject, something

fundamentally true about everybody) in learned and fashionable language (so that you wrote about the best subject in the best way). From seeing the two sorts of people combined like this you thought better of both; the best parts of both were used.[44]

The essential point is that simple truths were expressed in complex and sophisticated form. In this pact from which both sides apparently benefit – though the pact is made by the learned and fashionable – the folk wisdom of simple people is adorned with the refined expression of the gentleman. Pastoral is plainly an art that is about common people but not for or by them.[45] But insofar as it is an attitude of the rich, it involves them in a double view of the poor: both that the rich accept that they have better powers of expression, that they can bring to full consciousness and representation the unconscious virtues of the poor, but at the same time that the virtues of the poor really are virtues, and that, in their unconscious exercise, the poor may have an advantage over the rich. In other words, there is a qualified humility at the heart of the pastoral outlook.[46]

It is this aspect which Crow takes as paramount, and in his sophisticated essay he brings it to the illumination of a number of complex artistic projects which, on the face of it, have little to do with pastoral as subject matter (these include work as various as analytic Cubism, Dan Graham's work *Homes for America*, and the displays of objects and insignia in the work of Annette Lemieux). Yet Empson warns the reader that 'taken widely' his formula might include all literature, and perhaps it is best to make the argument about British art of the 1990s in quite a specific manner.[47]

The first chapter in Empson's book on pastoral is focused upon 'proletarian literature'. In many ways, this chapter is a conservative essay, committed in its denial of the very possibility of proletarian literature to the distance that an artist or writer must maintain from their subjects and their public. That distance is for Empson the very condition of art and will always be so (propaganda is another matter).[48] Nevertheless, the essay contains many sharp and currently pertinent observations about an art that takes 'low' themes and expresses them in 'high' style.

Pastoral, says Empson, can give expression to a critique of social injustice,

at least in a limited way, since the excluded or those who have little or no stake in society have less to risk by relating some home truths about it.[49] Now it has to be said that in Britain art that criticises social injustice has been thin on the ground for some years (there are a few exceptions, which will be reviewed in the last chapter) but nevertheless contemporary pastoral art has contained a critique of the way things are, not so much in the wider society as in the art world. The snobbishness, cant, and false high seriousness of the art world is at least implicitly criticised by an art that uses the forms of high art to relay obscenities, crudities and the detritus of modern urban life to polite gallery-going viewers. Such art marked a sharp rejection of high theory, of the elite and autonomous concerns of art, and of the conventional pieties of those artists beloved by the art establishment.[50]

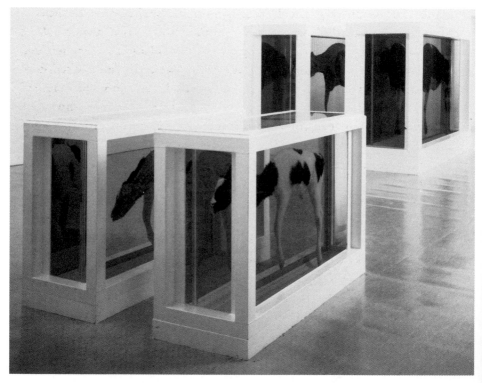

62 Damien Hirst, *Mother and Child Divided*, 1993

Some among that older generation of artists were pursuing a degraded form of *rural* pastoral, seeking profound truths in natural wildernesses, bringing the essence of nature into the urban gallery – whether in the form of paintings, photographs, or bits of the landscape itself, mud or rocks. Indeed one way to look at this renewal of pastoral in British art is to see its originary move as being to shift the site of pastoral from the countryside to the inner city; and again, Damien Hirst serves as the usher, with his metaphorical murder of the rural idyll.

There are, however, definite peculiarities in the form that the pastoral attitude takes in the new British art. The most obvious is that pastoral is now attached not to the countryside but to the city. The reasons why the rural idyll is no longer an attractive option for the culturally sophisticated are obvious enough: the industrialisation of agriculture and, as a result, the greatly reduced numbers of people who actually work on the land and the greatly changed nature of that work; the 'corruption' – from the pastoral point of view – of the simplicity of rural life by modern incursions, particularly suburban housing, major roads and out-of-town superstores; the packaging and marketing of what charms are left by the heritage industry. It's hard to invest any pastoral fantasy either in such a landscape or in the people who inhabit it – who, when they enter cosmopolitan consciousness at all, appear as a bunch of cramped and conservative pursuers of foxes and obstructers of footpaths, many of whom, in any case, are probably commuters. John Major's attempt to do so ('long shadows on county grounds, warm beer, invincible green suburbs, dog lovers and pool fillers') was met with ridicule.

Yet the reasons why the inner city should have taken the countryside's place are rather less obvious, and lead us into particularly British concerns. Before going into that issue, we should look at some more examples of recent British pastoral. Keith Coventry makes textbook examples of the loading of high forms with low material: in his series of 'Estate Paintings', the forms of Russian Suprematism are made to carry the plans of South London council estates. And there is his *Looted Shop Front* (1997), a window recovered by the artist after the 1995 Brixton riots, cast in bronze and given an apparently aged patina, then displayed against the white gallery wall, so that a blankness appears at its centre. Coventry has also cast crack pipes and doner kebab spits in bronze.

63 Keith Coventry, *Looted Shop Front*, 1997

Similar again is *Burgess Park* (1994), a bronze cast of a sapling planted in a South London park and snapped in two by vandals. The piece, says Carl Freedman, comments on the 'casual, directionless violence that has become the calling card of a bored, frustrated underclass.'[51] Furthermore, Freedman's article about Coventry explicitly buys into the urban pastoral, beginning with a long passage establishing the artist's credentials as a rustic wanderer, taking long walks with his lurcher (a proletarian dog, we are assured) through South London with its 'vast tracts of council housing, endless tower blocks and sprawling housing estates.'[52]

In a somewhat different register, the photographs of Rut Blees Luxemburg show inner London at night.[53] The charge of these photographs is that the clean lines associated with modernism, along with an objectivist style which includes references to early modernist photography, and the high resolution of 5x4 plates, often used to depict the pristine forms of newly built cutting-edge constructions, are here turned to run-down, perhaps threatening urban land-scapes about which the speculation of polite viewers can run wild. In some pictures, the rigorously straight style of Bernd and Hilla Becher and their fol-lowers is echoed, in others such as *Vertiginous Exhilaration*, the disorienting

64 Rut Blees Luxemburg, *Vertiginous Exhilaration*, 1995

perspectives of Moholy-Nagy or Rodchenko. Blees Luxemburg has spoken of the way high-rise buildings, in a possibly Freudian way, are associated with sexual adventure and strange happenings; while normal people live in suburban houses, the high rise produces 'a kind of pull', an excitement which is to do with 'spiralling downwards, about letting go' – perhaps socially.[54] She certainly wants to cast their modernist forms into tension with what we think their lumpen inhabitants are getting up to in there (that this work parallels the rehabilitation of the tower block as a desirable residence for the footloose cultural inner-city dweller is an irony but not a coincidence). The grime and dereliction of the environment, safely distanced in these photographs, acts as an alluring patina, endowing the otherwise alienating geometric modernist lines with character. Modernism in ruins takes on a strongly Romantic and sublime character.

65 Rut Blees Luxemburg, *Meet Me in Arcadia*, 1996

There is an ambivalence at the heart of both these projects which criticise modernism, particularly modernist architecture, by placing the forms of its ideals against the subject matter of what, in conventional wisdom, is its worst legacy. In one sense they contain social critique, in another, an enjoyment of the degradation that they survey, and the perversity that they imagine. Coventry says that his estate paintings are an indictment of Malevich's utopian vision.[55] Some of Blees Luxemburg's pictures refer to and at the same time undermine the Corbusian dream of urban high-rise buildings standing in extensive parkland.[56] In her photographs, there is considerable beauty, as night strips away many of the most distracting and vulgar contingencies of the urban landscape, allowing the modernist forms to stand out, unified in their tones by the street lamps. The result is certainly a pastoral vision of sorts, and Blees Luxemburg shows an awareness of this, entitling one of her photographs of the ground enclosed between council blocks, *Meet Me in Arcadia*.

This type of engagement with the inner-city environment is particularly marked in Britain. The reason, I think, is to do with the manner in which

social forces and their expression in the urban environment have developed. London – for much of this work is centred there, though again not only there – has its run-down and poverty-stricken areas but they are not *that* unsafe or *that* distinct from many other parts of the city. In Britain, and perhaps more here than elsewhere, there is an inner city fabric which is run down, agreeably and often entertainingly shabby, full of incident but which at the same time is not overly ghettoised or dangerous. Compare the United States, where racial ghettoisation is a good deal more marked than here, where the lack of welfare provision produces a more desperate and dangerous poor, and where much of the populace is armed. (It is true that crime has been falling in the US, making parts of New York, for example, newly available for gentrification, but we should be aware that this has little to do with the amelioration of poverty, and is caused more by demographic change, and the vast gulag of the US prison system.)[57] Or compare the situation with much of Northern Europe (the other main rival for artistic hegemony) where again ghettoisation tends to be more extreme, and more based on race, and where the poor are often confined to the suburbs of cities like Paris, leaving the centre as largely a business and heritage ghetto, scrubbed clean and made fit for the wealthy. Or Japan where, despite its recent economic problems, income differentials are far lower than in Britain, the urban fabric is more uniform, and there is very little crime: lacking culturally expressed class distinctions and with a racially homogeneous population, there is little edge to city life.[58]

Empson recognised the phenomenon, for it is not new in this country, writing of those simple characters in literature who 'keep their souls alive by ironical humour', commenting tartly that this is 'a subtle mode of thought which among other things makes you willing to be ruled by your betters; and this makes the bourgeois feel safe in Wapping.'[59] The pastoral is a product and an expression of the fact of that safety.

False London

In London there are large areas where gentrification is taking place, and larger ones where there is a mix of diverse populations, in terms of race, class and income. Cultural workers, including artists, often lead the way in the

process of gentrification, and they choose to use their urban environment in their work (many of Blees Luxemburg's photographs, it is worth noting, are taken only a short walk from the Shoreditch wine bars that many artists frequent). This is not to say that Britain is some utopia of social calm but rather that social stratification has not reached the point where the middle class, at least the young and liberal sections of it, feel that urban life is more unsafe than entertaining. Indeed, a little edge, just the right amount, is energising, and is necessary to spark off pastoral fantasy: simple rural folk enjoying rustic pleasures have become replaced by the characters of the inner city, similarly devoted in middle-class fantasy to the joys of politically incorrect humour, the circulation of obscenities, the joys of violence, crime and vandalism, carefree sexual encounters and drug-taking.

Once again, Gilbert and George were models to follow in their exploitation of the urban pastoral. For George, remarking on their inspiration:

> ... just go out of the door in the morning, it's raining and there's a pool of vomit there, and there are pigeons pecking away at it, there's a matchstick with a little bit of groundsel growing beside it; everything is in there anyway. There is nothing that is not in that immediate scene.[60]

The effect is reinforced because of the relative homogeneity of London's areas in one specific sense: Brixton is not notably more run down than the Tottenham Court Road, which is not so much better off than Finchley Road. That comparative uniformity of decay is due to the long neglect of urban infrastructure, something of a British tradition, and connected to the peculiarities of the British state and its relation to its people, though much exacerbated by the Thatcher administration. Its clearest expression was the abolition of the (solidly Labour) metropolitan councils, which meant that London and other major cities had no city-wide democratic representation, a matter only now being addressed by the Labour government. Most British city-dwellers have become used to putting up with bad public transport, run-down public spaces, rubbish in the streets and poor public amenities of all kinds. The urban pastoral presented in these artists' works, then, is perhaps exaggerated but is also very recognisable. (When an artist uses material from British locations outside these familiar urban centres, it takes on an almost exotic air, as the

seaside town of Margate does in Tracey Emin's work, being a bracing maritime jungle of boozing and shagging between feeble sun and chilly sea.)

If there is something British in this shabby environment, it is linked to the more general question about the particularity or even peculiarity of the English and, by extension, of the British state and its culture that the English have largely run. It has been the source of much debate and controversy, in part turning on the issue of whether the nation, with its laissez faire policies, its minimal state, ramshackle infrastructure and so forth, is capitalism hobbled by historical compromise with the old feudal order, never properly overthrown, or whether it is one of the purest expressions of untrammelled capital, relatively unburdened by state intervention and planning.[61] Either way, for our purposes, there is a link between the urban environment in which this art exists and long-term structural features of British state and society.

London is also in flux, as the art world well knows, with its colonisation of the East End through numerous galleries and lofts: the pastoral is not merely a product of tourism between London boroughs but of the mixes of people in an area undergoing change as the poor are displaced – sometimes after a decent interval – by the rich. Gentrification and the cultural celebration of urban debasement are closely connected: gentrification is the result of economic speculation, the attempt to profit from the regeneration of an area that has fallen into decline. Recession, especially as it has affected manufacturing industry, has been a powerful ally of that speculation, draining old working-class areas of funds as many of their residents became unemployed or had to move to find work. People with capital, looking for rates of return that were higher than those they could get from depressed manufacture, turned to these run-down but central areas of cities and put money into real estate there.[62] The first of the new residents to move in were often artists and other cultural workers, galleries and other businesses where a little urban excitement might help. And what did they do when they got there but sing the praises of what they were assisting to the graveyard?

This brings us to the second peculiarity of contemporary British pastoral which is that, with a few and special exceptions, it is more to do with the artefacts and the appearance of the urban environment than with its inhabitants. This art is about the expression of common truths but taken from a distance,

66 Gillian Wearing, *Signs that say ...*, 1992–93

as if it was viewing the archaeological remains of some disaster or the passing of an era. We shall look at why this is so later, but for now I want to examine the exceptions – the works that do focus upon people.

The exceptions are of two kinds: in the first, where there is the use of documentary photographs and video; in the second, where the artists themselves stand in for the pastoral subject. The most obvious example of the first is Gillian Wearing's long engagement with the tradition of documentary photography and film. One of Wearing's best-known projects is the series of photographs, *Signs that say what you want them to say and not Signs that say what someone else wants you to say.*[63] In these, people photographed in the street

collaborate with the artist by holding up signs on which they have chosen what to write. At first sight, the series does not seem to be about the inner-city poor, since the approach is inclusive, and many types of people appear, from tourists to office workers. But Wearing's method – to approach people in the streets of London and ask them whether they would like to collaborate – determined a particular kind of selection, detracting from the apparently random element of the project that might otherwise have built into a schema surveying the nation's inhabitants and visitors, rather in the way that August Sander tried to do for Weimar Germany.[64] Instead, she got a high proportion of the under- or unemployed, the eccentric or bewildered, and unsurprisingly a large number of those who live in the streets. The messages of the latter, in particular, are often very moving, complemented as they are by the photograph's merciless recording of the details of their appearance. One battered-looking man holds up a sign which reads simply, 'Good Afternoon Peaple'; others make political comment – 'Give people houses. There is plenty of empty one's. OK!' (true, of course, there are); another, 'Signed on and they would not give me nothing'.[65] This strong current of poignant and political messages, along with the others – strange and telling – give an impression of London streets full of peculiar characters, a panoply of oddness, yet also full of ordinary human sentiments with which the sophisticated viewer can well identify and understand.

There is a straightforward expression of pastoral here, of truths written with all the crudity and peculiarity of Wearing's subjects but framed within a sophisticated project that reflects upon the nature and limits of documentary photography. As pastoral, the work does give critical expression to social injustice. That Wearing makes her subjects write their statements – and this is not to do with the structure of this project alone, for it is a feature of other works, like *Brian* (1996) where speech could equally well have been transcribed – reinforces the distance the polite viewer has from the people represented, who mark the authenticity of their statements but also undermine them with their mistakes: 'would not give me nothing' is presumably the opposite of what that man meant.

The second exception is where the artist poses as a common person so as to speak in a pastoral first-person voice. This is a more complex phenomenon,

Permission to reproduce denied

67 Richard Billingham, from *Ray's a Laugh*, 1996

that we have looked at in our account of Emin's work in chapter 2. Uniting the two types of exception, however, is the work of Richard Billingham, whose subjects are his own immediate family.

Billingham's book, *Ray's a Laugh*, is another clear example of pastoral, though the elite component is less to do with the medium as such (snapshots) than with the form of the art book, or with gallery display of the prints.[66] It is there in particular in the complete lack of comment or framing with text of the pictures: there is no text inside the book, and the outer covers contain only an endorsement from Robert Frank, and Billingham's own flat description. This is all of it:

> This book is about my close family. My father is a chronic alcoholic. He doesn't like going outside and mostly drinks homebrew. My mother Elizabeth hardly drinks but she does smoke a lot. She likes pets and things that are decorative. They married in 1970 and I was born soon after. My younger brother Jason was taken into care when he was 11 but is now back with Ray and Liz again. Recently he became a father. Ray says Jason is unruly. Jason says Ray's a laugh but doesn't want to be like him.

Permission to reproduce denied

68 Richard Billingham, from *Ray's a Laugh*, 1996

Lacking explicit critique, the lives of these people are put up for aesthetic appropriation. With the prints, the lurid patterning, decorative knick-knacks, tattoos, filth and general disorder of his parents and their home are brought into contact and contrast with the minimal space of the gallery. More broadly, given the current taste for minimalism in home furnishings among a section of the cultured middle class, the book can produce that contrast even without the need for gallery display.

The pictures show Billingham's mother, father and brother, sometimes relaxed or pensive but often tumbling, tripping, scuffling, spilling and throwing things, including the household cat. There is violence and degradation in these pictures – someone described them to me as 'middle-class porn' – but also a leavening of affection and communication, even of an aspiration to make things better, present in the mother's decorative drive, in pictures of Billingham's parents embracing, of the mother cuddling and feeding a tiny kitten.

The twist in these pictures is the identity of the artist, for he is photographing his immediate family, and is to an extent a product of the environment he is representing – albeit one who managed to escape into higher education. Billingham is careful to endow his photographs with the signs of authenticity, including blur, slapdash composition, the use of out-of-date film

and even damaged negatives, which allow the better pictures to appear as if by happy accident rather than calculating design, in a coming together of subject matter and the positioning of the artist-insider. Billingham says that the best pictures are those that he takes quickly, and that he is open to chance.[67] The photographs of the family are interspersed with a few pictures of birds out-doors, their freedom to fly away contrasted with and heightening the claus-trophobia of the family flat. Billingham as an artist on the scene has brought these lumpen types into a proximity with the civilised which goes further than their presence in the pictures alone, the artist himself being one of the rare birds that have flown the coop.[68]

There is an implied snobbery in this line of appreciation and, despite the artist's proximity to his subjects, pastoral remains intact in Billingham's work: connoisseurship is applied to the lives of those who have hold of some truth without knowing it, indeed as a condition of their not knowing it, for if they were considered to be aware, there would be nothing for the artist to add.

Furthermore, Billingham expects that the viewer will respond to these pic-tures as vehicles for the aesthetic. First, he is clear about what the work is not meant to do: 'It is certainly not my intention to shock, to offend, sensationalise, be political or whatever.'[69] Moving on, he says that it was not photography that was an influence on his work but rather British figurative painting – the work of Sickert, Bellany, Auerbach, Kossoff – and that he believes in Peter Fuller's idea that that the purpose of art is to achieve a quasi-religious 'redemp-tion through form'.[70]

This attitude is apparent above all in the stasis of his subjects as represented both in the book and the subsequent television film. Billingham says: 'My family always stays the same, they watch the same things, they have the same patterns to their lives, they talk about the same things.'[71] They are indeed a picture, still and without the possibility of change, and there is a certain para-doxical comfort to be gained from their constancy, even if it is a constancy of degradation, of what is in legend a particularly British stoicism and resilience, in the face of the tempest of modernity.

These works that deal with people in the pastoral mode are exceptions, however, and in general, the status of the artist (and of the gallery-going

public) ensures distance; there is also a concentration on objects of the urban environment, which are made to speak in place of people. The reason for that transposition is a class issue – much of the focus of pastoral is thrown back in time as well as displaced in space – and an attitude towards the supposed way of life of an unreconstructed working class. Think of the changes that have taken place in that class since the mid 1970s, changes that are in no way particular to Britain but have taken a sharp form here (and one that under Thatcher was defended on ideological principle, rather than seen as the inevitable outcome of the globalised market place). The changes are highly familiar: the insecurity of employment, part-time working, continuous mass unemployment, falling real wages for those at the lower end of the income scale, the decline of the unions.

The result has been two-fold: the falling number of those among the working class who could be assured of their skills, status and income, confident that they could provide for themselves and their families; and the growth of a distinct lumpen class, cast aside from the regular world of work and consumption – Billingham's parents, who appear to subsist on welfare and home brew, are a good example. In Will Hutton's clear formulation, 40 per cent of the British population are economically secure; 30 per cent are earning but without much assurance that they will continue to do so; and another 30 per cent are unemployed or economically inactive.[72] Yet in high art lite there is generally no sympathy, no engagement with that now large latter segment of the population – only with an environment which they help to produce and which may then become the subject of appropriation by a section of the cultured middle class: artists, gallery-goers and fine-art book buyers.

The fracturing of the working class and the rise of a marginalised urban poor does much to explain why there is so little positive, non-sensationalist work in high art lite that engages with class. Visual pastoral of old (particularly its British version) was centred around the figure of the industrious and thus virtuous peasant. Plainly, today's lumpen urban underclass cannot serve as the repository of industry and virtue, nor are these attributes as attractive as they once were.[73] Instead, the fashion is to refer indirectly to that deflated, unemployed and lumpen segment, with pleasure at the opportunity they present for wallowing in abjection.

Yet some commentators have compared the current situation to that of the 1960s, seeing a common engagement with working-class subject matter, and even a similar population of the art world by working-class artists.[74] The parallel is a historical mirage: in the 1960s the working class was increasing its wealth and exercising its power effectively due to a labour shortage. A working-class lifestyle was seen as cool and hegemony seemed to beckon as a section of middle-class youth bought into its culture and almost everyone bought into consumerism. In the 1990s the working-class is destroyed as a political force, exercising little influence even over a Labour government, and as long as the glut of labour persists, it has little chance of changing the situation. That a section of the cultured middle class ape the past manners of a vanished working class may lead to a situation with superficial similarities (and these have been exploited by those determined to invest the 1990s with 1960s style) but only an analysis totally fixed upon the vagaries of the present scene could mistake one for the other.

This raises another question: why should the impulse for the middle class to look even to the working-class culture of the past be so strong? In part, this is because it is culturally in flux (as we have seen in the last chapter, due to the long crisis of capitalism and the end of the Cold War), but also because its position, too, has been altered. It has not been immune to the forces that have broken apart the working class: the middle class has become larger, vaguer, more fluid, and less certain of itself. Raphael Samuel has tracked part of this change in a provocative essay on the British middle class and the Social Democratic Party, as then was. He describes the old caste system of that class, 'a society of orders, each jealously guarding a more or less self-contained existence, and exquisitely graded according to a hierarchy of ranks.'[75] These ranks were defined by work, of course, and mobility was restricted and constant employment generally the norm. If Samuel was right, the SDP was the expression of a class finding its own identity, no longer content to ape the manners of its betters. But the essay was written before the long assault of Thatcherism had taken its full course, marginalising this middle ground of politics and subjecting the liberal professions to the rigour of the market, even when that market had to be artificially created. The result was disorienting, politically and culturally.

The past cultural behaviour of fast-changing classes has been the subject of a notable study by T.J. Clark, in his examination of an insecure petit-bourgeois strand of white-collar functionaries in late nineteenth-century France who took their amusements at what appeared to be working-class cabarets. Of that audience, Clark commented:

> ... they define themselves by their difference from the popular but also in their possession of it, their inwardness with its every turn of phrase. They are the connoisseurs of popular culture, its experts, its aestheticians; but that expertise is a way of establishing imaginary distance and control.[76]

This describes all too recognisably the class attitude of the current consumers of this art of the 'popular', and makes a nonsense of those claims that this new art is properly popular or proletarian. For Clark that new, uncertain segment could in a limited way travel across the boundaries of class so that, while the avant garde of the day treated its members with irony, it also needed them as its point of insertion into modern life.[77] Again, with respect to the neo-avant garde and postmodern life, the description has an uncanny familiarity.

There is, then, an 'other' behind the artistic engagement with the pastoral inner city, and that is the suburbs: a place of fairly homogeneous social makeup, with little street life, dominated by the car, with what entertaining misbehaviour that does take place confined largely to the home. Occasionally the snobbery of the elite for the wider populace slips out: for instance Adrian Searle let himself go in a description of the county (Essex) that Mark Wallinger comes from:

> ... this county of stolid yeomen does harbour its quota of off-duty criminals and flat-land hillbillies, New Town oiks, little Englanders, Tory-voting yobs and assorted dumb-fucks: much like the rest of Britain, Essex is profoundly depressing.[78]

Not a sentiment you would get away with in a national newspaper, perhaps, but perfectly safe, indeed an orthodoxy, in an art magazine like *Frieze*. It is the suburbs, and their attendant boredom and stupidity, that gallery-going audiences escape in the idyll of urban pastoral. But that cannot be all, for otherwise Hollywood film or any other low entertainment would do as well.

For Crow, linked to pastoral's ironic take on art's high-mindedness and professional character, is a further very positive feature, that:

> the pastoral entails a final recognition that the fine arts' inability to transform themselves further, to become a genuine culture for all, remains their great and defining inadequacy.[79]

British high art lite puts a different spin on the issue: it has succeeded in generating a new audience for art, and while this hardly amounts to 'a genuine culture for all', it pretends that it does, and its pastoral attitude contains little of the humility that Empson would think one of pastoral's components – nor, certainly, the recognition that Crow would have it elicit. But in this new version of pastoral there is still an unacknowledged component of distinction, even of morals, though some might find it distasteful.

To pursue it, there is another clue that Empson can provide on the value of pastoral: he does so in describing the various paradoxes to which it gives rise by putting words into the mouth of an imaginary adherent of the pastoral thinking of the common man:

> 'I must imagine his way of feeling because the refined thing must be judged by the fundamental thing, because strength must be learnt in weakness and sociability in isolation, because the best manners are learnt in the simple life ...'[80]

So what is it that the art-goer gets from the profanities, humour and filthiness that is, in clichéd thought, associated with the lumpen masses? The confirmation of the opposite in themselves; the feeling that, however much they may be holidaying in other people's misery, they never lose their sense of who they are, that sense being continually affirmed by the consumption of its opposite in art.

Only the rich benefit from pastoral. As Greenberg says, while its adherents are people who are out of tune with the surface values of the establishment, they are also confident that the establishment will protect them in their dissidence. Further, and anti-modernism is important here, the accommodation between low subject matter and high style is a rather British matter. Pastoral was always a minor genre, unsuited to the grand statements of history or

religious painting but a suitable vehicle for compromise and small utterances. It not only makes safe the low (as we have seen) but also takes the edge off the high: it is another form of British accommodation with the advanced aspects of art. In this way, high art lite takes its place alongside the long line of watered-down avant-gardes from Bloomsbury through primitivising sculpture, hobbled forms of Constructivism and Surrealism, neo-Romanticism, 'hard-won' realism and latter-day hippie land art (one harsh critic of this provincial compromise even identifies Damien Hirst with Duncan Grant).[81] A protagonist of one the few uncompromising avant-gardes we have had in this country – a reactionary one, naturally – cursed that '… 1000 mile long, 2 kilometre deep body of water … pushed against us from the Floridas, to make us mild. Officious mountains keep back drastic winds. So much vast machinery to produce …', complained Wyndham Lewis, aesthetes, domesticated policemen, wild nature cranks and the like; or in Michael Corris's version, 'The Turner Prize, *Technique Anglaise*, Wild Nature Crank, "Desert Island Disks" …'[82]

Finally, Empson also says of the pastoral attitude that the 'clash between style and theme' that it involves cannot quite be acknowledged since, if it is, the effect becomes comic. Rather, 'the writer must keep up the firm pretence that he was unconscious of it.'[83] This is indeed demonstrated in artists' statements: asked whether his kebab works say anything about class or race, Coventry replies with the single word 'Nothing', and refuses to elaborate.[84] So while pastoral demands that the low subject be unaware of their virtues, at its heart lies a pretence, at least, to unconsciousness on the part of the artist. It has been the task of this section to puncture that pretence.

Writers on art who have wanted to link their analyses into an illumination of social and economic forces have often had a hard time of it in the twentieth century, as art became tied up with its own specialist concerns (the solution of taking that autonomy as the subject of analysis was of course one solution, grasped most notably by Peter Bürger).[85] But in this new art, there is work that can be read as precisely against the social scene as Victorian narrative paintings moralising against the demon drink or some other menace to the community. The next chapter will ask why such a reading has been lacking, and why the critics have been mostly uncritical.

9 The decline and fall of art criticism

There is an advert for lager which begins with dire warnings about the consequences of global warming (flooding, encroaching deserts and so on) and, showing a burning globe, suggests that viewers have recourse to the usual political moves: write to your MP, they are urged, campaign, or – and at this point the scene changes to a winking kangaroo quaffing lager by a pool – say 'bollocks to it' and enjoy the sunshine while it lasts. This advert clearly demonstrates a common feature of business propaganda: it incorporates the critiques that might be levelled against it. There is no point in criticising adverts for soap powder or instant coffee for being clumsy and overt, if they are knowingly clumsy and overt. The lager advert is unusual only because it contains a critique that is levelled against the entire system of consumerism.

Perhaps this tactic gives a first clue to untangling a phenomenon much remarked upon and little analysed: the decline of serious art criticism. Maybe art, like advertising, has inoculated itself by slipping a tiny dose of critique into its aged veins. Indeed, it is commonly said in Britain these days that art has become more like advertising, and in the same breath that it is no coincidence that the dominant buyer of British contemporary art made his fortune in ads. Yet the decline of criticism is not purely a British affair.[1] While the situation in Britain has its peculiarities, and is perhaps more extreme than elsewhere, it is part of a more general tendency.

First, we should try to establish that there has been a decline. In a short space, this can only be done in an impressionistic manner. Consider, to begin with, that (in contrast to academic art theory) there are no longer any British art critics who have a credible intellectual presence both within and without the art world, whose writing is seen as important for the culture as a whole: whatever one might think about their views, critics of previous decades such as Roger Fry, Herbert Read, Adrian Stokes, John Berger and even Peter Fuller did have such scope. The three art critics who are known now to a public outside the specialist art audience – Matthew Collings, Sarah Kent and Brian Sewell – far from being intellectuals, are figures of fun (two of them self-consciously so).

69 Martin Maloney, *The Lecturer*, 1997

The BANK

AUTHENTICATION

£1 only

Fri... ...vember 1st 1997

The beast inside

TOWARDS THE MILLENIUM

Issue 20

...ky no's ⑦⑧⑨⑩⑪⑫&⑭

SARAH KENT- STUPID OFFICIAL!!!

Sarah Kent - Time Out critic - was fuming yesterday when an official at a well known gallery behaved in a stupid manner.

FUMING

A close friend allegedly said "This stupid official really had Sarah's blood boiling.

I've never seen her so angry. She's such a perfectionist she doesn't tolerate fools gladly".
(CONTINUED INSIDE)

Whatever one might think about the art, the British art scene has recently been undergoing a radical transformation of the greatest theoretical interest; yet, despite some few analytical contributions in the form of articles, there has been little debate about it, and certainly few attempts to examine it in the light of wider trends. This is not because there is a dearth of critics with talent, far from it, but it is in part because those who are not merely dismissive of high art lite usually defend it on the conventional grounds of indeterminacy and liminality (as we saw in chapter 4), and that defence rules out a broad synthetic view of the scene.[2] The book-length discussions of the subject by single authors have been either such perfect exemplars of the attitudes of the scene that they can take no critical distance from it, or simply risible.[3] In an essay attempting to sum up the character of the London art scene, US critic Jeffrey Kastner admitted defeat (being overwhelmed by the sheer diversity of what he had encountered), except in one respect: he was in no doubt that the art criticism here was inadequate, suspicious of novelty and frequently philistine.[4]

A further register of this decline of criticism is the predominance of interviews. It has become the main form in which high art lite is explained, and indeed one art magazine, *Transcript*, produced by the Duncan of Jordanstone College of Art in Dundee, is devoted to nothing else. Curator Iwona Blazwick, in a revealing essay defending the interview form because it lacked critical distance and thus questioned objectivity, and because it allowed the interviewer to bathe in the glamour of the artist's fame, and the artist to achieve media exposure, also explained the appeal of the form to the reader:

> After scanning the pictures and the ads, most art magazine readers instinctively head straight for the interview. The layout of type on the page is itself seductive. Instead of seamless and impenetrable blocks of type, Q&A transcripts exhibit an inviting textual rhythm, punctuated by white space where the eye can rest.[5]

Seductive or restful or not, it is an inadequate form of explication. We have seen that artists can be singularly unhelpful informants, far less concerned with elucidating the work for people who might be puzzled by it than with using

70 Bank, front page of *The Bank*, no. 20, 1997

the opportunity to foster a particular artistic image and fend off criticism. Nevertheless, such statements have an air of authenticity: no matter how disingenuous or evasive, they have issued from the mouth of the artist, they emanate from the inner circle, the exclusive scene, and thus take on an ineluctable quality, as symptoms of an alluring aesthetic malaise. Precisely because of this, they are no substitute for critical thought.

Another indication, though this is not something specific to high art lite but affects the art press as a whole, is the extent to which it has become dominated by articles and features devoted to single artists: many periodicals, from established and prestigious book-like journals such as *Parkett* to some of the journals produced under the auspices of the art schools, devote themselves exclusively to the exposure of individual bodies of work, the stars in the firmament examined one by one, while no attempt is made to map galaxy or cluster.

Finally, I offer some concrete evidence in the form of quotation; plainly, in any era it would be easy to pick out published idiocies, and my claim must be that they are now more prevalent than previously, which a few citations cannot prove. Instead, the purpose of exhibiting them here is to give a taste of the character of current art criticism, of art critics, and of those who permit such sentences to pass unscathed to publication.

Let us start with an instance that demonstrates the very common problems of inaccuracy and non-sequitur. Stuart Morgan, an influential critic, beloved by the commercial galleries and a regular contributor to *Frieze*, writes of a photograph by Mat Collishaw, *Narcissus*, in which the artist is seen lying by a muddy puddle in an urban setting, gazing into the water:

> … the motive was desire and the Barthesian *punctum* lay between the artist's legs, the point at which his fist, gripping the button of the shutter release, served also to conceal his genitals. No stronger statement could be made about the mendacity of the photographic image or the role of objectivity in art.[6]

Now this sounds like plausible stuff. But a cursory glance at the picture in question shows that Collishaw's hand rests on top of his thigh, not between his legs, and that his genitals (unconcealed by his hand) are adequately covered by his jeans. It is also obvious, given a moment's reflection, that there is no

71 Mat Collishaw, *Narcissus*, 1990

connection whatsoever between the first sentence and the second. Such specious and over-heated prose is unfortunately commonplace.

To move on to the next example in which a pop star takes on the role of art critic (a consequence of the lessening importance of specialist knowledge is that all kinds of people indulge in writing about art) and criticism takes on the role of gossip:

> ... there in the centre of the floor is one of the icons of late twentieth-century art: not Jeff [Koons] himself, of course, though he is, but the *Hoover Celebrity Trance (Quiet Series)*. All soft round plastic form and leaf green and cream. Jeff and his assistant, Gary, have detombed the pristine piece from twenty years of storage and are now standing before it scratching their heads and muttering. The apes before the obelisk. 'Is this for the Guggenheim retrospective?', I ask. 'Or has some collector decided to make an extremely late purchase?' 'Not at all', replies Jeff Koons, the puzzled child. 'This place is getting so messy that I just wanted to vacuum.'[7]

If you wanted to parody pseudo art-speak, you could hardly do better than this passage by David Bowie, and (like the adverts for coffee or soap powder, or Koons's work itself) critique is hard to mount because the text is aware

of its own absurdity. The interest here is legitimate enough: the reverse-Duchampian move of taking a ready-made and making of it once more a functional object (Joseph Kosuth, so I have heard, sacked his cleaner for using his edition of Duchamp's *In Advance of the Broken Arm* to shovel up some rubbish). The tone, however, is simultaneously fawning and pally, and the passage is the prelude to a prolonged exercise in sycophancy – one of many that now grace the pages of magazines like *Modern Painters*.

Last, and worst because published in *Art Monthly*, one of the more serious British art magazines, and in their special 200th edition at that, was an essay by David Barrett which propounded the universal truth that living art must always and can only be experienced within its original social environment. Since for all the works in the National Gallery that environment had long passed away, they are dead, and no one who goes to see them is really appreciating art. Aside from the obvious point that people remake contexts around old objects, the piece was prey to the prevalent fault of schoolboy relativism. Since the works in the National Gallery have lost their original, specific charge, wrote Barrett, the 'most meaning we can hope to derive from them are the good old universal truths, which are of course not worth knowing since the idea itself is specious.'[8] It is obvious that even if this statement can avoid internal paradox (that there are no valid universal truths sounds like a universal truth itself – but perhaps it is a new one), it could be applied against the main argument of the article itself.

To move away from these depressing examples to the more general picture, it is necessary to reiterate briefly the story of the British art world from the 1980s on. The changes that occurred were closely tied to the trajectory of the economy as a whole, and this became more and more transparently so as time went on.

In Britain, the growth of service industries was particularly strong, due to the great and indiscriminate destruction of manufacturing industry that took place under the Thatcher government's economic strictures. We shall look at this in a little more detail later, but there was a marked rise in the profile and profitability of businesses which sell intangible goods and which rely heavily on marketing and advertising. For businesses which sell essentially the image of themselves, their perceived cultural profile is extremely important,

and they burnished it through an involvement in buying or sponsoring high art.

After the recession of the early 1980s had ended, the art market became part of the speculative boom in which money was funnelled from poor to rich. For some, a way to make sense of the prodigious growth of a new and brash art market was to say that it had left the thinkers behind. The dealer Karsten Schubert argued that critics lost their position during the 1980s because the narrowness of their views was overtaken by the market which went ahead and did the things that they had sternly legislated against: the market 'totally undermined critical judgement'.[9] Already at this stage, elements of the situation that made criticism difficult (or simply irrelevant) were in place. Art criticism might and did make justifiable complaint against the crass, dubious art that passed fluidly through the sale rooms, but as long as so much money was being made from it, who really cared?

The Conservative 'economic miracle' turned out to be a short-term, consumption-driven boom of the kind Britain had often experienced before and, when recession once again struck in 1990, the British art market burst like a balloon. This did not, however, lead to much revival of criticism. As we have seen, artists were for a time forced to look for new markets outside the commercial gallery scene. Many of them did so by appealing to the mass media, and their art became a mirror of the mass media's concerns. Yet to say that art has become more like advertising, or more like the press, is only a fragment of the truth. Rather, art has become more like business, at the same time as business has become more like art. This convergence is the secret of contemporary art's limited popular success.

This is not to argue that high art was ever not a business, at least not within the confines of advanced capitalism. Yet, with the fall of 'actually existing' socialism, and the consequent if temporary rise in capitalists' self-confidence in the inevitability of their system, the once spectral connection between art and business has become explicit. An article on Gary Hume which appeared in the *Guardian*'s 'Living' pages illustrates this well. His 'easy serious' paintings are presented just like any other consumer object. The accompanying article made little pretence to any higher significance, and was followed, as logic demanded, with an 'exclusive print offer'.[10] This at least had the virtue of honesty.

In Britain, the fact that art has become more overtly like business has been due to the gradual, long-term withdrawal of state funding. Museums and galleries have become increasingly run on business lines, judged primarily by the numbers who are channelled through their halls. Museums and galleries have also become prized venues for business wining and dining – the display of corporate largesse – and, as we have seen, important focus points in urban regeneration schemes and land speculation.[11]

Art has followed the changing character of its institutions; the avant garde has fallen away for, as in fashion, there is expectation of novelty but no longer of development. The dissolution of a generalised, universal politics implicit in much modernist art gave way first to a divisive and atomised identity politics, and more recently – in a move from atomised identity to the atomised exercise of that identity – to an art of pure consumer choice.

If art has been pulled towards business, driftwood on an outgoing tide, the impulse has largely come from business, which lately has itself become more like art. In the advanced capitalist world, since the advent of 'postmodernism' (a cultural expression of a shift in economic structures), the greatest profits have been made in offering services, often in conjuring value from the intangible.[12] When an artist signs an object it may leap in value; similarly, well-known brand names are applied with great flexibility to a range of objects and services, and can create value in and of themselves. The brand name 'Virgin' is used to sell flights, condoms, cola, Internet access and financial services. Brand names are not unlike artists' identities, but they can be rated at specific monetary values (and are, for accounting purposes), and can be bought and sold. Though intangible, they can be copyrighted and defended in the courts – as Damien Hirst has fought advertisers who plagiarise his art. Some firms, like Benetton, are little more than brand names – the company makes no clothes (branding those made by others) and owns no shops (they are franchises). In the drift towards marketing the intangible, which has been particularly strong in Britain, as we have seen, image becomes all-important. So companies such as Pepsi are planning to brand the hues which they hope have become inextricably associated with their products.[13]

Given this cultural and commercial convergence, it is hardly surprising to find that art criticism serves largely as an adjunct to the business of art, and the

art of business. The places in which the debates of serious art criticism were once aired have either fallen silent (like *Artscribe International,*which folded during the last recession) or transformed themselves. The most widely looked-at art magazines are now picture-sheets, charting the shifting micro-fashions of high art lite. Not unlike style magazines such as *The Face,* their images are vastly more important than their words. Text still serves a purpose because its length and prominence within a magazine confers importance on its subject – it gives the appearance that someone has bothered to think about the stuff on show, and implies that this stuff is worthy of that homage. With the dissipation of art into the broader cycle of business, art criticism increasingly rejects the specialist language it picked up in the academy (no bad thing in itself) and value is built up around work less through heavy theoretical constructions than through rhetorical devices – whimsical references to music, literature or popular science – or through precious exercises that flaunt a critic's sensibilities. It matters rather little what is actually said, so long as it is affirmative. Better, in general, that it is anodyne than that it risks offence. Intellectual rigour, logic, truth (conveniently unfashionable concepts) matter not at all.

Above everything, the battle is fought over column inches, for the worst fate in a world so dependent upon received opinion is no press. Artists and dealers, press officers and PR types tussle over them, and are not above purchasing them with advertisements and other inducements.[14] The result is that critics are rarely critical, and that there is a small and impoverished market for the criticism that is.

Critics themselves are in an even less favourable position with relation to artists and galleries than are the magazines. They are generally very badly paid, and as a result keen to receive hand-outs of whatever kind. Brian Sewell (one of the tiny number of well-paid art writers) has only contempt for that sorry mass of critics unattached to any paper or magazine, being:

> merely members of the British Section of the International Association of Art Critics, from which body of bogus poseurs God save us all. I once met one [member] … walking north in Bond Street – 'You're going in the wrong direction,' she said, 'there's food at Wildenstein's' …[15]

Critical instincts are moderated by the demands of career or even of stomach. Indeed, so little negative criticism is published about high art lite in the specialist art magazines that, on the very rare occasions when it does appear, it causes a stir. Martin Maloney, defender of painting and sweet neurosis, interviewed Jake and Dinos Chapman for *Flash Art*, and throughout the piece his comments that they were making sensationalist art for the sake of it grew more explicit. He concluded that theirs was an art made for art magazines, the equivalent of the pop band Bros, lauded for a brief moment then totally forgotten. Worse,

> I look at the work of Jake and Dinos Chapman, and I feel deep
> embarrassment and utter boredom. Embarrassed not because it is sex or
> kids or dicks or cunts or arseholes, but because it is second-rate art with
> a pretence to being something grander, profound and endurable.[16]

Here was a judgement of aesthetic quality, and of a most forthright kind. I remember people in the art world saying at the time when this appeared, with an incredulous air, 'there's a negative article about the Chapmans – in *Flash Art!*'

The Chapmans did not take this lying down, and their response was a clear assertion of power over Maloney, and critics in general. They took out a full-page advertisement in the next issue of *Flash Art*, mocking the writer for shallow egotism, for attempting to police their work, for what they took to be his vanity, jealousy and personal frustrations. No doubt with Maloney's sexual orientation in mind, they wrote that he 'licks his lips at our deliciously long column inches. Our press is egg on Martin's face.' They accuse him of avoiding their calls, finally picking up the phone to face their abuse with the pathetic riposte 'but you *are* on the front cover'.[17]

The incident was symptomatic in a number of ways: it showed that the coverage of the specialist art magazines had become so dominated by puffery that it was plausible to take an exception as a case of apparent vanity or jealousy on the part of the reviewer. It was a register of the power of successful artists that they could simply buy the space to reply. It was an indication of the decline in the power of writing that Maloney thought the artists should favour coverage – a lead article and a cover – over content.

Signs of resistance to high art lite are few and far between, except from the conservative circles where we would expect to find them – and that opposition, as we have seen, plays no small part in the tendency's success. The memory of the hostile climate in which contemporary art had to dwell for so long in Britain lingers on, producing the feeling that if you support contemporary art, to criticise any part of it, especially outside specialist journals and in clear language, is to betray it as a whole. Older critics generally remain silent on the new art: a letter from David Sylvester is reproduced with most of the text blocked out in Damien Hirst's flip book. In an accompanying note, we are told that Sylvester had agreed to interview the artist for the book but on seeing Hirst's film, *Hanging Around*, had been so 'appalled by its mediocrity, banality, self-indulgence and lack of self-criticism' that he withdrew the offer.[18] Sylvester may have made his name writing about Moore, Giacometti and Bacon but he is still one of our foremost critics, and he was absolutely right about *Hanging Around*, a dull and puerile effort. Yet it is curious that it was Hirst's decision, not Sylvester's, to publicise this criticism, a decision taken presumably to show that, having failed to court a prominent member of the liberal art establishment, he at least has value in getting up their noses.

Like the gravitation of art towards business, the loss of critical purchase in art writing is only in part a result of changes in the art world, since it is also a reflection of wider changes in the media as a whole. There has been a growing split between specialist academic journals, flaunting the difficulty of their prose and catering to libraries and tiny groups of professionals, and those magazines that aspire to a wider audience and depend upon advertising. The publications between the two where art criticism could flourish have shrunk, if not in number, in readership. In the group dependent upon advertising, particularly the newspapers, there has been a flight from ideas into consumerism – to satisfy not the readers, many of whom yearn for a diet with more roughage, but the advertisers, who require copy to support adverts and dislike brow-furrowing disturbances of the buying mood.[19] The degree of control advertisers exert over magazines and newspapers is systematic and considerable. By way of illustration, McCann Erickson, one of the ad agencies dealing with Coca-Cola, issued a memo to magazines advising publishers on the placement of the company's advertisements. They required 'positive and

upbeat' editorial content, and considered inappropriate juxtapositions to include politics, environmental issues, sex-related issues, articles about drugs, health, food, or indeed any kind of hard news.[20] This is the source of competitive dumbing-down which, being an industry-wide trend and not the result of the whim of this or that proprietor, does indeed affect readers' habits and expectations. So newspaper critics generally treat their readers to a mix of condescension and triviality, anxious lest these skittish, skimming buyers bolt at the appearance of anything difficult.

This division between academic publications and the popular press has been an important factor in the decline of art criticism. The discipline is, after all, a curious one – part specialist, part general; part exegesis, part reading against the grain; part education, part publicity; part historical, part oriented to the future. In Britain, it typically flourished in those publications (such as the *Listener* and the *New Statesman*) that were founded upon the idea that there was a single and unified national intellectual life which could be drawn upon and appealed to.[21] At least since the eighteenth century, that realm has been in crisis and conflict, divided by material interests and the demands of commerce. Its defence, in liberal opinion, has been an ideological matter that often involved the wishing away of acute divisions in the name of social calm.[22] Yet the abandonment of that liberal ideal allows us to see the positive, indeed utopian, aspect of its appeal to universal intellectual interests: the belief that people can come together equally as thinking beings in rational discussion, and that from thought and conversation will flow development and agreement.

The shift from seeing art as an integral part of an intellectual culture which also involved politics, philosophy, music, literature and the sciences, to one that sees it as a lifestyle issue, a complement to an interest in furnishings and floor coverings, is a profound one. In one paradoxical sense, it is a victory for criticism in that contemporary art, which for so long needed to be defended by critics from the small-minded and philistine suspicions of large sections of the British middle class, has now found acceptance in their homes as decoration and on their screens as entertainment.

The decline of serious criticism is a register of the more general decline in a unified intellectual life but is also connected to the linked disappearance of

any agreed perspective from which to judge things, or organise perceptions. This has affected conservative views of culture, too, but has much to do with the demise of the avant garde, both in art and politics. Without it, there is no stable or concrete position from which to criticise, no shared trajectory or vision of the future, and no link to wider social or political issues, since even the limited ideals of postmodern orthodoxy have fallen to consumer atomism. Without such a view, flurries of incidents remain just that. Art criticism becomes like fashion writing, obsessed with the minutiae of the season's trends, and addicted to their facile exposition.

As art and business draw closer together, it becomes increasingly difficult to criticise art because that amounts to criticising business. The trend in British high art lite to use material from mass culture, to present it but not to comment on it, to be neither affirming nor condemning, is a precise reflection of the place in which art criticism finds itself. To praise or criticise seems, on the face of it, to be as pointless as judging the weather. Sarah Kent makes just this assertion in her essay introducing Saatchi's collection of British art of the 1990s, saying that passing judgement does not seem a relevant or adequate response, citing Thomas McEvilley to the effect that to offer a value judgement about art is like publicly and authoritatively announcing what flavour of ice cream you like.[23] Yet to make no judgement is to accept complicity with a system of things which only appears natural, or at least to play down the conflict and contradiction in a structure seen as unitary and functional.

The system does indeed take on the guise of a second nature, monolithic and irresistible, particularly so in Britain, where media figures such as Damien Hirst tie their colours to New Labour's mast, and where political opposition, like critical art writing, and for reasons that are not unconnected, appears to have evaporated. Is it fanciful to see in high art lite the aesthetic face of Blairocracy – of a grimly youthful, strenuously egalitarian, British bulldog regime, obsessed with the media, yet committed to the terrible orthodoxy of its predecessors? Both have found a 'Third Way' through the oppositions that for so long divided previous generations, and in both the paradoxical and illusory synthesis takes the form of occupying the middle ground and, like advertisers, anticipating criticism by co-opting and rendering powerless elements of critique. Yet such tactics can only work in times of relative calm. There are already

signs that relativistic intellectual games have had their day (among the most obvious, the revival of interest in the work of Darwin and Marx); for the time being, the shopper shambles along, picking at this or that; but the Real lurks around the corner, axe in hand.

Even in the art world, the system is contradictory and unstable. Art cannot both be seen as a consumer good like any other, and remain the repository of transcendental values that allow millionaires and corporations to let people know that they value more than mere money. There is a focus for criticism here, and at other pressure points of the system. The rise of high art lite was in part possible because it subjected the elitist, established art world to critique. Its promise of opening art out to the world, and the use of accessible, non-specialist language in art and writing are positive features which can be turned to radical uses.

For finally the fate of criticism will be determined by what people – the wider audience, not merely art-world insiders – want from art. If they are satisfied with an art that offers no more and no less than the system of consumer culture, then criticism has no role to play. If they are dissatisfied with this fare, especially if they once again look to art for some sliver of the utopian, some element of resistance, then criticism will have an essential function in reflecting on the present and looking to the possibilities of the future.

Guerrilla raids on the absurdities of the contemporary art scene can be effective when they compete with the art itself in terms of accessibility, wit and cool – not perhaps such a high requirement. But for criticism to be truly effective, it must take on the art world as a whole, showing how it is thoroughly entangled with the society, its economy and politics. Such criticism will have to start with an examination of its own apparent powerlessness in the market-led vacuum. Its success or failure will depend on factors far outside itself, particularly those events and social forces which throw into question the inevitability of the economic and cultural ocean of capitalism – of that which flows over the gills of high art lite.

10 The future for high art lite

'Where's it all going? What are we fucking up to, if anything, that we all think is so important?'

Sarah Lucas[1]

Evolution in art

72 Mat Collishaw, *Infectious Flowers (Metastases from Malignant Melanoma)*, 1996

One of the early exhibitions of high art lite was called *Wonderful Life*, after a book by Stephen Jay Gould, the idea being that his view of evolution, a non-teleological parade of joyous variety, was an apt description of the current state

of the British art world.[2] In looking at the work of Chris Ofili, we reviewed briefly the old view of 'primitive' creation, of an art that just grew, as plants grow, without regulation or consciousness, with great and pleasing complexity that surpassed the knowledge of its apparent creators. The more recent view has been to say that all culture is conscious creation, and that artists, no matter who they are, must be accorded full credit for the character of their work. But there is another less comfortable solution that can be explored: that all culture has the form of unconscious, organic growth and that, particularly in this new art that so often takes the form of overt personal display, evolutionary models of a harder, more deterministic kind are the more fitting description.

Plumage, petals, bristling fur, bared teeth, and wit: we may appreciate, or fear (or both), all of these things, and be dazzled by their ever-branching and beautiful ramifications. We, the viewers of art, may think of the art world as a country garden, cultivated but full of natural wonders, the gentle scene of mortal struggles, the stage on which living things act out their strategies of display, camouflage, mimicry, feigning and intimidation.

Why is it that in that garden, the artists are so frequently present at the birth of the work? They hover over it, or live parasitically within it, or preside over its emergence with some ritual movement of their bodies. Often their presence seems necessary to its very existence. Each artist is parent and midwife at once, and when the head appears, it is no surprise to see that it bears the artist's features.

This indulgent concern is in part the result of a justifiable suspicion of objects severed from their makers when they become saleable, collectable, and easily turned to dubious ideological work. Far better to keep these children in hand, to stamp them, not with the minor authenticity of signature or certificate of provenance, but with the artist's presence as a whole, run through and through, as genes instruct the growth and decay of a body's cells.

Such an art, of behaviour and object-making together, fosters a feeling that it must be authentic because of its intimate link with the artist's self, no matter how sham that self may be. Some wasps make burrows for their eggs because that is what they are programmed to do so as to be wasps, and nothing short of death will prevent them. Similarly with this art, it seems, artists do what they have to do, and what they have to do is inseparable from what they are.

Surely, though, long ago everyone stopped believing that artist and work could be so simply identified. The artist, along with the author (and humanity, even), were supposed to have lost the struggle for existence, perishing at some moment in the last geological period. No one is sure that they, or anybody else, can be a coherent unity any longer: identities are unstable, and irony has become a pervasive, corrosive force, defeating straightforwardness everywhere and then turning inwards, preying even on its own critical character.

Yet this has barely affected that authentic personal presence. Any quality of instability or irony, conscious or not, is co-opted into the monad of the artist's personality, instantly branded as an essential part of both the work and the person. It doesn't matter if this confessional work is true life or fiction, honest or ironic, narrative or symbol, for it seems to serve a purpose beyond its own content, a purpose which is centred upon the display of the artist's image, and its relation to all the other images in the art-world garden.

There are certain strange texts, dubious both logically and ideologically (tainted, for instance, with Fascism), which have acquired an inflated status in recent art theory – they are the far-flung territories over which herds of theorists scatter as the forest fire of paradigms continues. Among the more foolish was an old essay about animal mimicry by Roger Caillois which tried to read a luxurious form of expenditure, indeed of art, into what appeared to be the evolutionary adaptation of organisms to mimic their surroundings.[3] Perhaps it is more productive to take the opposite approach: to see behind the complex and luxurious display of artists' behaviour the workings of an evolutionary system.

In the cultivated garden, says Darwin, the face of nature seems bright with gladness. And like the garden, the art world, bright in appearance, is a competitive system, punishing and rewarding its inhabitants. Like any market, it encourages diversity with impersonal mechanisms, and produces a knowledge about what is most efficient at any one time. The knowledge of the system far exceeds that of any of its individual participants, no matter how well-informed. So within the art world, beasts of great fitness to their environment evolve, thoroughbred racehorses, specialists in relieving institutions and individuals of their wealth in exchange for kudos. Scaling the heights of improbability in the search for novel efficiency, ever more obscure and elaborate

methods are discovered. While the diversity of its forms is great, the rewards that the system offers sit on a single scale; in this sense (like the content of authentic personal expression) individual motivation is redundant.

As with the evolution of species, major changes in the art world come rapidly, in comparatively sharp breaks with the past which we characterise with inadequate but necessary names, like 'minimalism'. Artists are well aware of how some cosmic catastrophe (recession, for example) can explode over the system with all the force of a celestial body smashing into the Earth, wiping out whole classes of obsolete organisms. In the aftermath, different genera may evolve, and weird hybrids breed, such as the splicing of conceptualism and pop.

Of the many objections that can be raised against applying evolutionary theory to culture, the most pressing is this: that culture is more Lamarckian than Darwinian, since conscious knowledge, as well as raw instruction, is transferred from generation to generation. This allows for much faster and more directed development than selection from the options produced by the largely random swapping of genes.[4] Yet this view assumes that knowledge actually is transmitted over generations, and, if it is, that the sum of that wisdom is cumulative, and directed towards some goal. But in a culture in which information exponentially increases as generations pass, and the chance of grasping it as a whole decreases, in which the directed project of modernism appears exhausted, and in which the speed of fashion makes forgetting advantageous, the system may be more Darwinian than it at first appears.

Perhaps, after all, the death of the artist has had an effect. There must be viewers who expect from contemporary art the same intensity and meaning promised by artists of old. The new and the old do bear superficial similarities. For Caillois, a stick insect imitating a twig did so as a static form of expression that opposed life. Now there are artists who mimic the animated expression of past art, though their rigid postures hold the signs, for those who know how to read them, that they know that this is a ploy. Vampires, they feed from the corpses of the old authenticity and, its blood in their veins, they become like those eighteenth-century anatomical models of human torsos and limbs in which real veins and capillaries are filled with wax – ungraspably intricate in their branching, terrible in their beauty, and lifeless in their complexity. The infection spreads backwards and outwards until, mobile and lively though it

may appear, the garden becomes a parade of hollow forms, its inhabitants' bodies being mere vehicles through which deeper instructions execute and reproduce themselves.

Darwin, thinking of the 'endless forms most beautiful and most wonderful' that were produced by his long tale of copulation and death, found 'grandeur' in his view of life.[5] As with nature, so with human culture, there is extensive spillage in any public display. Advertisements for, say, luxury cars are seen by far more people than those able to buy such products – even children avidly soak up their slogans. Likewise, humans admire petals and plumage though these displays are not meant for them. Despite the appearance of meaning, there is a sense in which the production and reproduction of the cultural artefacts that the art world displays feeds a system that far exceeds its viewers. Despite the presence of the artist, the show is not really there for us.

Needing God, if not art, Darwin balked at the moral implication of his system, trying to mitigate its savagery by claiming that it was dedicated finally to a higher good:

> When we reflect on this struggle, we may console ourselves with the full belief, that the war of nature is not incessant, that no fear is felt, that death is generally prompt, and that the vigorous, the healthy, and the happy survive and multiply.[6]

But God turned out to be superfluous to evolution, and of its higher purpose, we may now be a little less certain.

The end of art?

For some artists and thinkers, however, the blind march of the art system, whether with higher purpose or not, is faltering perhaps in part because its character has become too well understood.[7] We have seen that for Gavin Turk, art is 'stammering' and that he hopes to produce the last work, the piece that will make all others unnecessary.[8] The desperation of the tricks to which artists have had recourse, and in which critics have taken comfort, is suggestive of this faltering. For Sarah Kent, writing of Marcus Harvey's take on pornography and painterly expressionism (she quaintly refers to his paintings as

'nudes'), and remember this is a critic who is usually keen to mouth feminist pieties, and to quote chunks of Kristeva, Irigaray and even Jeanette Winterson at the least opportunity:

> Once the shock of the work has worn off, Harvey's nudes will look as elegant as Roy Lichtenstein's swooning blondes. They will be seen as a strategy for continuing to make beautiful, juicy, erotic paintings at a time when painterly painting is an exhausted genre and the nude, by and large, an unacceptable scene. By being unrepentant as a painter and a sexual predator, Marcus Harvey transforms an untenable position into a revitalising challenge.[9]

This is a passage that sums up, inadvertently, the extreme state of debility in which such art finds itself. The promise that, with the passing of time, it will come to be seen just like the art of previous generations, that it carries on traditional tasks with other means, makes light of its critique, while asking viewers to be satisfied with the mere appearance of serious art. If this is truly the destination of high art lite, it will have lost the negative force of its critique while failing to acquire any virtues, other than a talent for simulation, in its place.

There are others who take on the critique of culture with more consistent and weighty purpose than does high art lite, who defend themselves a little less with irony, and who are less prepared to play at culture while condemning it. Alan Sinfield, in the Foreword to a new edition of his book, *Literature, Politics and Culture in Postwar Britain*, identifies one novel element emerging in the 1990s: a marked attitude of hostility to high culture as a whole which is seen as being tied to political image-making and the exercise of wealth, not as an unfortunate accident but as its very essence. Irvine Welsh's novel *Trainspotting* is symptomatic of this development, Sinfield argues, the main characters objecting to the colonisation of Edinburgh with English 'white settler types' and 'fat, rich Festival cunts'. The characters' attitude to culture is of active revulsion, and includes the satirical emulation of the cultural productions of their 'betters', produced on toilet walls in noxious substances.[10] Such actions are also characteristic of high art lite, its scandal being to rework the sophisticated forms of art in low materials and subjects. Yet, because artists make

valuable objects, because their careers are linked to the public and especially the private galleries, the scandal can only be limited, and as this style staggers onwards, its critique is revealed as a sham. Artists are still, as Clement Greenberg famously put it, bound to the ruling elite by an umbilical cord of gold.[11]

This ever greater entanglement of culture with the myriad forms of commerce, to the extent that the two come to seem identical, has led certain thinkers to ask whether we might not be better off disposing of art and its pretensions entirely. If we want serious and radical thought or action, perhaps art is just the wrong place to look. In an intervention in the debate about the philistine that Dave Beech and John Roberts initiated, Malcolm Bull set out the case for an ending to art with great clarity.[12] He pointed out that in the history of previous negations – atheism, anarchism, nihilism – the concept long preceded any actual adherents to the position. So the word 'atheist' was used to condemn assorted heretics who did, at least, believe in God. Once the concept had been invented, however, people eventually appeared to fill the category. Currently, Bull argues, there are no real philistines – people who are aware of but genuinely indifferent to all forms of culture – though the term is widely used as an insult against those whose culture is considered to be impoverished or vulgar. Philistinism is linked to the other negations, particularly through communism that contains within itself a synthesis of them all. The fundamental question that Bull's article raises is whether art is a necessary and constant part of the social being of humanity, and therefore not subject to negation, or whether there might be, as yet hard to glimpse, advantages to a liberation from art, as there are in the liberation from God, state, ideology and private property.[13]

This is also the question that the condition of high art lite raises, for it can only be asked at a time when art appears to flaunt its own debility. It is certainly not one that we shall settle here, though I hope that it can be illuminated in a discussion of the radical content, contradictions and trajectory of this new art. High art lite is a form of diffused and expansionary aestheticism. In its testing of the boundaries of art and taste, it explores the limits of what can be taken as aesthetic (in the dispute over *Myra*, for instance, the two sides disagreed about whether the murderer's image could be legitimately viewed as an aesthetic object). There is a comparison to be made with Susan Sontag's

characterisation of 'Camp', a way of seeing the world as an aesthetic phenom-
enon, in terms of stylisation rather than beauty, and a disengaged favouring of
style over content.[14] For Sontag:

> Camp is the consistently aesthetic experience of the world. It incarnates
> a victory of 'style' over 'content', 'aesthetics' over 'morality', of irony
> over tragedy.[15]

A modern dandyism, it has turned from the cultivation of refined pleasures to
make peace with mass culture and to sanction low enjoyment.[16] What high art
lite makes visible, in its slack stylisation of life, is the possible advantages of the
opposite attitude, of a privileged, philistine rejection of aesthetics.

A classless class

Matthew Collings has commented, rather wearily, that art cannot be taken
seriously now:

> if it isn't scribbled casually in biro and doesn't have a slightly unhinged
> air of negativity and world-weary black humour, and seeing the black
> heart in everything, but at the same time being in an oceanic sea of
> oneness with ordinary people and their obsession with pop culture and
> street fashion and the movies.[17]

This passage nicely captures the social limits of standard high art lite. In that
oceanic sea of oneness, in the depiction of 'real life', there is no movement or
development, only a still snapshot of the various forms of degradation. There
is an odd comfort in this naturalism, as nostalgia is turned towards the present
in the depiction of the enduring and unchanging British masses.

The world of high art lite is very much that of New Labour, of a classless
class that is quite particular but pretends to the universal. It is a bohemian
nether-region in which proletarians can play up and, more often, the haute
bourgeois play down, and the petit bourgeois bob, in a pantomime of pally
equality. We have seen that this configuration, in which various denatured
elements of working-class culture are drawn into the arena of middle-class
consumption, is an old one. Matthew Arnold lamented the hypocritical praise

with which the upper-class landowners (whom he described as barbarians) mollified the philistine middle class: 'A Barbarian often wants the political support of the Philistines' but 'when he flatters the self-love of Philistinism, and extols, in the approved fashion, its energy, enterprise and self-reliance, he knows that he is talking clap-trap.'[18] Indeed, the new wave of British artists are praised for just such qualities, and those qualities are entirely middle-class, as is their pallid philistine outlook. They praise their underlings with the same measure of nervous hypocrisy that the grandees of state and private enterprise use to laud them. The form that this aspiration to abolish class takes in Britain is a little peculiar, largely because of the visibility of distinct class mores here (mores that led Henri Cartier-Bresson to say that, when entering this country, he felt as though he was stepping into a theatre in which everybody was playing their roles with a little too much exaggeration); but it is linked to the development of globalised communication and media networks and, especially, to the social model of the United States that is propagated through them.

As against this impulse to a harmonious homogeneity, high art lite contains two contradictory characteristics. The first is its impulse to popularity, to talk openly about what people really care about, to come out from under the cover of elitism, artistic autonomy and specialist discourse. The second is its nihilistic impulse, that settles upon the notion that nothing can be said or decided, that art can only convey its own uselessness, that creativity is an illusion and, in the most extreme cases, that humanity is headed rapidly towards inevitable destruction.

In an argument about the failure of the avant garde that is sometimes overstated – but has the compensating virtue of clarity – Eric Hobsbawm has argued that the outmoded character of the fine art object has condemned the visual avant garde to marginality in the wider culture:

> Such a mode of production belongs typically to a society of patronage or of small groups competing in conspicuous expenditure, and indeed these are still the foundation of the really lucrative art trade. But it is profoundly unsuited to an economy which relies on the demand not of single individuals or a few dozen or scores, but of thousands or even millions; in short, to the mass economy of this century.[19]

That high art lite looks both ways – to the mass market and the elite art market – has produced a deep ambiguity, manifested in its refusal to take a stand, its general lack of depth, and the levity with which it treats its wider audience. Sarah Lucas has said: 'I don't think you need to be exploited to talk about exploitation. And that knowledge is quite important to me.'[20] In her work she does indeed talk about it but, as we have seen, the devices with which the work defends itself mean that it is impossible to know just what she is saying.

Radical purpose

Can high art lite do more than court ambiguity? A useful indicator of artists' social engagement, or lack of it, is their representation of the homeless. This is quite a popular subject in high art lite because homelessness is the most visible and dramatic face of poverty, not shut away in council estates (like Billingham's family) where the cultural elite rarely venture, but encountered all over central London and any other British town or city. Their appearance also has the advantage of comparative novelty – not that homelessness is new, but only since Thatcher's housing and benefit policies got into their stride have the homeless been anything like as numerous, visible and youthful. For a moment, indeed, in copy that dwelt upon the literal surface of their condition, the dress sense of the homeless became a minor media fixation.

In *Snowstorm* (1994) Mat Collishaw took videos of homeless people trying to get to sleep in the street and spliced them with images of snowdome paperweights, the shaken 'snow' drifting upon the restless figures, accompanied by a Yuletide jingle. Collishaw says that in the face of representations that only serve to prettify the problem of homelessness and allow people to ignore it, his work tries to instigate a dilemma in the viewer. He is, however, extremely vague about his overall position and wary about being thought to sympathise with his subjects since that might be condescending (and also not very cool).[21]

There were drawbacks as well as advantages to the subject. Collishaw stepped around them with customary nastiness, pushing liberal sentiment into absurd self-destruction. In using the homeless in works of art, the dual taint of straight documentary and the exploitation of the depicted had to be avoided: the obvious solution for artists to both problems was to use either themselves

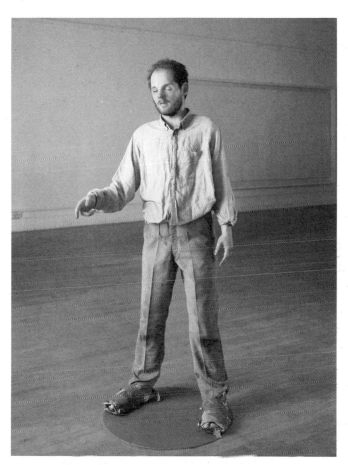

73 Gavin Turk, *Bum*, 1998

or their friends to stand in for the homeless. We have seen that Abigail Lane's *Misfit* (1994, fig. 19) who, given his ragged and soiled appearance is probably meant as a homeless person, has the face of the artist Angus Fairhurst. Gavin Turk's appearance dressed as a tramp at the opening of *Sensation* was followed by his construction of a waxwork of himself in the same guise (entitled *Bum*, 1998), unsteady on his feet, one eye half-closed in injury, and arm outstretched to assail some passer-by. This work should not be seen in isolation from the rest of his output; Gavin Turk the bum is the negative image of Gavin Turk the celebrity.[22]

Permission to reproduce denied

74 Mark Wallinger, *Capital*, 1990

Likewise, Mark Wallinger produced a series of grand, conventionally painted pictures of the homeless, or rather of his friends posing as homeless. He began work on *Capital* after seeing someone sleeping rough under the porch of the Bank of England – as Wallinger commented, 'a pretty ironic image' – and intended them to be a stimulus for a debate on how the homeless are represented:[23]

> It was a challenge to deal with that subject matter. No appropriate fine art language exists for representing the plight of the homeless, so the series is a debate about representation as well as homelessness. It was conceived as a 'public work', a comment on the Thatcher years, a portrait of the underclass painted in the aggrandising style of corporate portraiture.[24]

Capital consists of seven full-length portraits of homeless people standing in front of imposing city doorways, the doors (naturally) being closed. These figures stand blankly before us, holding the attributes of their 'profession' – bottles, cans and carrier bags. The contrast between subject and background,

and the various meanings of the title make plain social comment. Wallinger's style here is detailed but bland, using subdued lighting and colours, deliberately reminiscent of boardroom portraiture. It allows careful attention to detail, both to clothing (soiled coats, odd shoes, string used for belts – a social history in garments) and expressions, which vary from idiotic grins through resignation to resentment. These Dickensian figures comment poignantly enough on Thatcherite 'Victorian values', but there is also a degree of ambiguity and disturbance in these pictures. The boardroom portrait conveys the prestige of its subject through the manifest labour involved in its production and the cultural status of easel painting, so portraying the homeless in this fashion is a half-ironic act of homage.

The point behind using Wallinger's friends for the pictures was not only to avoid the coercion and inequality that can underlie the representation of the disadvantaged:

> I want to counter the Darwinian notion that the homeless are
> intrinsically different. I was almost homeless at the time and it's a
> slippery slope. The underclass are not exotic aliens.[25]

This view, however, is only likely to be appreciated by those in Wallinger's social circle. Further, in the context of the contemporary art gallery, corporate portraiture is derided as kitsch, and we cannot be sure that Wallinger's irony in deploying it does not rebound on his subjects. Despite his laudable intentions, there is something knowing and cold, almost mocking, about these works, which use a neutral style to convey highly emotive subjects, and which confer on their subjects, either the actual people or the roles they play, a status in representation which eludes them in real life.

The strategies pursued by Lane, Turk and Wallinger are grounded in the postmodern critique of documentary representation that charges it with exploiting the subjects it purports to help.[26] Unlike Wearing, who is obviously aware of that critique but who trades in theoretical safety for the gain of public participation by allowing her subjects to appear, the abandonment by other artists of the actual subject in favour of some playful stand-in risks being offensive and exploitative in itself. Tim Jackson, writing of Turk and Wallinger in the magazine run by homeless people, *The Big Issue*, argues that in conceptual

work the homeless can be reduced to a commodity used for the artists' ends, and to metaphors that stand in for something other than themselves: so in Turk's pieces, homelessness is not seen as a misfortune that happens to individuals but is used to stand in for the artist's alienation.[27] Likewise, a spokesperson for the charity Shelter found *Bum* exploitative.[28] We are dealing with the most socially engaged and critical aspect of high art lite, yet even here the irruption of meaning into undesirable and reactionary areas is a problem. In part this is due to the social and cultural environment in which these artists must operate, in part due to the highly circumscribed opportunities left open for art, and in part due to the interpretative structures favoured by high art lite itself.

Other artists have dealt with the issue of how people are discarded by society, most notably Michael Landy, who does not focus upon the homeless but more broadly upon the creation of an underclass. Landy understands that this development is a product of Thatcherite social and economic innovations, and is linked to the decline of job security and to the increase in part-time and casual work.[29] In *Scrapheap Services* (1995), an installation first shown at the exhibition *'Brilliant!'*, then at the Chisenhale Gallery and reinstalled at the Tate Gallery in 1999, dummies dressed in corporate cleaning uniforms sweep up thousands of tiny human figures cut out from drink cans, McDonald's packaging and other detritus.[30] The figures are thus stamped with corporate colours, logos and fragments of writing. Landy has invented his own logo and corporate identity for the fictional 'Scrapheap Services', a company that offers to dispose of surplus people. Large metal signs and a promotional video with jingles and slogans portray the sunny, rural future of a land without a surfeit of humanity, and a tall mechanical shredder at one end of the gallery has ground up a large pile of the figures, their pieces standing in a conical heap.

The video intones:

> Scrapheap Services consider it important that any people who are discarded are swiftly and efficiently cleared away, and this is part of our duty of care. Why put up with unsightly people who are such a burden on your resources when you can turn to the Scrapheap Services people-control range of products?

Although Landy is of the high art lite generation (he showed in *Freeze* and was

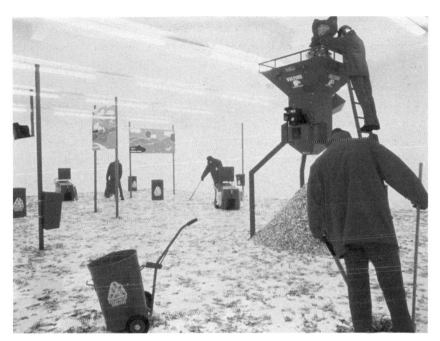

75 Michael Landy, *Scrapheap Services*, 1995

later given a show in Building One by Sellman, Hirst and Freedman), this work plainly stands apart from the mainstream.[31] It makes far too specific and clear-cut a stand on social issues; its irony is directed entirely against a situation the artist objects to, rather than spinning in the air or rebounding on the work. 'I don't think irony in itself is particularly helpful', Landy has said, and that statement marks the difference perfectly.[32] The installation makes viewers uncomfortable and implicates them in the situation depicted – you cannot help but tread on the figures as you walk about, doing your bit in the crushing process – but the artist's stand and what he wants the viewer to think are, with a little attention, clear. Unlike many of the artists we have looked at, Landy does not shy away from political statements:

> Basically the piece poses a question: Are we as a society (I suppose I'm talking about England) going to carry on treating people this way? And if we are, what kind of problems are going to occur in the future unless we find some way of protecting and looking after people?[33]

In similar vein, Landy made five litter bins, each bearing a single word: Disease, Idleness, Ignorance, Squalor, Want – those blights that the welfare state had been set up to end. What, it might be objected, does such a straightforward work of art do that a newspaper article about the threat to the welfare state does not? It helps to make the situation concrete; the cut-out figures in *Scrapheap Services*, no two the same though they are treated as uniform, stand in for individuals, and viewers may find themselves grasping a situation imaginatively that before they had only understood intellectually.

End of an era?

High art lite has been written off rather too often in the past – sometimes in hope, sometimes in more confident tones announcing that it is now out of fashion – to be sure that its demise is now imminent. The recent Saatchi sale of such work was, against the expectations of many commentators who had predicted a catastrophic drop in prices, a reasonable success.[34] Nevertheless, there are one or two clouds on the tendency's horizon.

If high art lite is a product of Thatcherism, the demise of one could spell that of the other. There is a strong connection between the two, though this is not to say that the art is Thatcherite, for it was never quite as radical as that. In both there was an assault on liberal niceties and established institutions. In a fine essay, Raphael Samuel examined the issue of the 'Victorian values' to which Thatcher and a portion of the Conservative Party said that they wished to return. Raphael argues that Thatcherism concealed its radical modernising tendencies behind a rhetoric of tradition and the garments of a mythical past – that it was 'modernism in mufti'.[35] In high art lite there is a similar relation between past and present, but oddly reversed: many of these artists generally want nothing more than to work within the status quo, hiding their essential conservatism and nostalgia behind a veneer of up-to-date pop cultural references, a scattering of demotic material, and constant assurances that they are the expression of the present.

Nevertheless, we have already briefly seen that New Labour's art policy might come into conflict with the character of high art lite. For as long as the Conservatives were in power, the liveliness of the British art scene was

supposed to be a product of market-led innovation, of artists struggling resourcefully and independently, without state subvention, in the harsh but fair environment of the free market. When New Labour took over, and threatened fundamental reform of the welfare system, it was suddenly discovered that the state had all along been directly supporting artists: not so much with Arts Council grants as with social security payments – and without them, how were artists and creative types of all kinds to serve out the long unpaid (or very low-paid) apprenticeships that were expected of them?

Chairman of the Arts Council of England Gerry Robinson, delivering the body's annual lecture in 1998, stressed both that the boundary between high and low culture is illusory, and that the fear of worsening quality by expanding access must not interfere with the core project of widening the audience for the arts:

> Too often artists and performers have continued to ply their trade to the same white, middle-class audiences. In the back of their minds lurks the vague hope that one day enlightenment might descend semi-miraculously upon the rest, that the masses might one day get wise to their brilliance … this is an attitude that just won't do any longer.[36]

It is obvious how high art lite matches this official line. Yet it is also clear where it departs from it: for New Labour, the arts are an integral part of national renewal. They will help society to cohere, the cities to regenerate themselves, people of different races to live in harmony, the long-term unemployed to find work, the ill to get better.[37] This is a vision widely at variance with the outlook typical of high art lite which is to present the worst of what life has to offer with a shrug of the shoulders, to view with enjoyment but definitely not to ameliorate. This is a contradiction that it is hard to see a way around: the celebration of what is cool has turned its back on the liberal and welfare values of old, and indeed with them on most forms of state authority. The attempt to replace high art lite with 'New Neurotic Realism' was a bid to take the sting out of high art lite while retaining its cool and youthful image, to make an art that is more recognisable as art and that also has comforting things to say to those in power. Its failure is symptomatic of the intractable nature of the problem.

Perhaps, though, the attitude of government that praises the creativity of

artists while ignoring what they have to say is a viable outlook, and viewers do not need to take the content of high art lite too seriously. Its nihilism and restless search for novelty, while they sometimes make sponsors nervous, are only the surface traces of a conformity to the market's demands for continual change, for the creation of value in a never-ending stream as material is drawn from periphery to centre.[38] Furthermore, while the state has some control over its own institutions, they by no means dominate the art world or the art market. There is another powerful constituency that will have its say, and the character of high art lite has been formed precisely through successfully appealing to a wider audience and private money at once.

What does darken the prospects for high art lite is the likelihood of another recession. While the tendency was forged by recession in the years following 1989, its artists have since settled into a relatively stable period of modest economic growth. Another sharp downturn would dispose of the established names, and raise something new and oppositional in their place. For the time being a world-wide slump has been avoided but the art market is still in a fragile state, no longer floated by funds from Japan and East Asia (that area being in deeper crisis than in 1989), and tied to the value of stocks that most economists believe to be greatly over-inflated.

High art lite can be viewed as a vehicle of 'endgame capitalism', continuing to make moves but without investment in the principles of the game. The economic crisis has been accompanied by some as yet provisional and uncertain signs of a revival of working-class militancy, particularly in the United States, but also here in Britain.[39] Any further such revival will no doubt remind the bourgeois bohemians of their true loyalties. Possibilities for exploiting weaknesses in the system have recently widened. The long downturn in the economy, punctuated by recession, has caused the engine of appropriation to turn over a little less smoothly. Capitalism has come out from behind the cloak of communism (on which, for as long as it remained a global power, all kinds of evils could be blamed) and is newly revealed as what it always was, a worldwide system, and not a pretty one. In the art world, the conditions in which the engine operates have become so extreme, the time between marginal and mainstream so narrow, the act of commodification so blatant, the trivialisation which accompanies it so apparent, that illusions about it may be eroding even

from the inside. In circumstances of renewed political and social conflict, ironic playing with oneself would no longer seem an interesting option.

Art and its viewers

In a passage related to one that we cited in the introduction, about the older artists jetting to Biennales and being annoyingly half-intellectual, Matthew Collings asks of the new lot:

> Where are you going, young artists? Are you any use? You're always flying around in jets and being in international group shows and staying in hotels. What do you care about what anything means? Wearing your suits in *Vanity Fair*. That's what I was thinking the other day in the Prado in Madrid, in the Velazquez room, with the court dwarves.[40]

Is it expecting too much of these artists to ask that they engage with the broad audience that they have courted? For some commentators, the problem is less with the artists than with the audience itself: Bryan Robertson, certainly no lover of the new art, does concede that it has brought in a larger public, but for him, writing of the viewers of *Sensation*, that should be no cause for automatic celebration:

> Taste has declined inexorably in the past two decades. The same public that can listen day after day to Dimbleby's hushed clichés [about Princess Diana's death] and countenance the spectacle of large, overweight, elderly men and women talking to camera about their masturbation fantasies, can also wander about the bits of sado-kitsch at the RA with equally blank faces.[41]

For Robertson this is also a problem of production – of the cuts in funding to art schools under Thatcher, particularly the shortening of postgraduate courses, which have led students to reach for quick solutions. A more fundamental cause, however, is the degradation of public taste, the decline in education which means that people can no longer understand the paintings in the National Gallery because they do not read classical mythology or Dante or the Bible.[42]

Now this view lays out the matter clearly: should high art lite be celebrated for its connection with people's lives as they are lived – including the long hours spent doing tedious work and watching television – or is that very life so corrupted that art's engagement with it can only be the source of infection with the diseases it should be fighting, and a dissipation of its unique qualities? It is an old problem, brought about by the rise of mass culture, and struggled with by Clement Greenberg, among many others. There is a profound difficulty in art engaging with life while that life, administered and banal, is counterbalanced by spectacular though also highly regulated entertainment.

Given the dark view of ordinary people implicit in high art lite, and based on the obsessions of the mass media that would have its buyers believe that some cannibalistic killer or paedophile is lurking in a semi in every street, it is not surprising that the art cannot come to an understanding of its wider audience as worthy discussants. Some of the artists, however, have a very clear view of the limitations imposed by modern administered life.[43]

76 Angela Bulloch, *Betaville*, 1994

They hint at the system of contemporary life, making works that offer limited freedom to the viewer within a strict set of parameters, or that allow the viewer to alter the work, again within strict limits. Much of Angela Bulloch's work is like this:

> Drawing machines – x/y plotters or a straight line drawn and then erased and drawn again. Lines controlled by sound, movement or the actions of a casual viewer. A network of marks are made directly onto the wall, red diagonals, blue horizontals. A motorised pulley system locates the pen.[44]

Viewers of these plotting systems may come to realise that their actions control the movement of the pens but they can only ever gain very limited control. Bulloch further comments on such systems:

> The work outlines the fact that one's individual choices are more or less meaningless, because the system or structure has already defined the parameters of choice, even if they seem elective.[45]

Likewise Gillian Wearing (an artist who, of all in the tendency, seems to set most store by listening to other people) is equally pessimistic:

> … there's no idea of free will – that's ridiculous. This idea of humanism, which was initially about knowledge giving you power and giving you access to freedom. Now we *feel* we have access to these things, but they're all completely controlled, because they have to be.[46]

Much of Wearing's art takes as its theme the boredom and lack of affect which modern life, lived half in mass media spectacle, half in a banal reality, imposes on people. In the *Boytime* series (1996–98) and in *Sixty Minute Silence* (1996), the boredom and unrest of the boys or adults in police uniforms, required to sit still before a video camera, is matched by the boredom and unease of the viewers. When there is communication in Wearing's work, even of a dramatic kind, the use of masks or dubbing leads to doubt about its source, as if all speech, as in some schizophrenic fantasy, was governed by remote control. In any case, even with all this talk it is doubtful whether there is any communication between people who are increasingly monads, as with the singers in *My*

Favourite Track (1994), all singing along to their Walkmans, turned up so loud that they cannot hear their own voices, let alone those of others.[47]

Is that bleak view extended to the work of art and the artist, or are they privileged exceptions in this world of administered mimicry, or knowing participants in the charade? Is the only form of resistance to point to the existence of a system from which it seems there is no escape?

Bulloch's work gives expression to the idea that the interaction between viewer and work of art is impoverished:

> People still live under existential circumstances that they basically cannot change. I don't like the term interactive which is often used in discussions around the new media. People are obviously fascinated by the prospect of an unlimited possibility of choices and the response of the machine. This is always connected to the idea of complete control and manipulation. In my work there are no big choices. People tend to get really excited about the drawing machines when they first find out that they can manipulate them. They want to draw circles and all kinds of other things; and they are easily disappointed when they find out that they can only influence a simple change of direction.[48]

She sees the realm of reception as being quite as controlled and schematised as that of production. Yet with both Bulloch and Wearing another strain of thought subsists in the work. If choices are rigidly and unchangingly circumscribed, what would be the point of saying so, of building that condition into the heart of the work? To state clearly the limited nature of the available options is to gesture towards elements that lie outside those limits. If artists were truly to believe in the thorough determination of life there would be no point in making art; so such views cannot fully account for either the viewers or the makers of art.

The trajectory and the developing tensions within high art lite are not merely a matter of opportunistic, careerist or amoral artists but reflect a wider crisis in the arts. The distinction between art and life cannot simply be wished away as long as life itself remains so imperfect, impoverished for a significant minority in this country and for a significant majority globally, and degraded by isolation and by the dominance of instrumental and external forces for

almost everyone, even those who are materially well-off. Nor can an art be wished into being that takes its viewers with serious intent as long as those viewers lead an alienated existence, and are regaled by the seductive but manipulative forms of mass culture. In these circumstances, the most positive moves may be the most negative, and for a time high art lite conducted a bracing campaign of criticism against the established art world. Its own positive programme was naturally harder to bring into being, and for the most part it has failed to materialise. Instead, high art lite has aped the forms of mass culture in a manner that allows viewers both to enjoy the acts of expropriation and exploitation and to justify them on the dubious grounds that they raise awareness of cultural degradation. The outline of a more genuinely positive alternative can be seen both in those works that straightforwardly attack the social and aesthetic orthodoxy, and in those that raise awareness of the instrumental web in which the viewers of art remain entangled.

An essential question – and it is an old one, present at the inception of democracy – that should be asked of an art that deals with mass and popular culture, that hails the non-elite audience, is whether it takes as its task to stir 'hearts and to prevent them falling asleep in that false and wholly material happiness which is given by monarchies.'[49] The majority of artists purveying high art lite have been content to play the well-remunerated role of court dwarf.

If we see the art system as governed by evolution, then it is apparent that it can produce a degree of complexity and variety that exceeds the intentions of its agents. Its plumage may not be designed to entice the vast majority but it can nevertheless be put to use by them. Even art that does not aspire to be radical, and even art that believes its viewers to be puppets, can open the door on another world. Artists can assist in this or not as they like. Those who do may come to a conscious understanding of the distinct contribution that their chosen vocation can make. Those who do not are entertainers, condemned to the marginality of a system of cultural production that cannot fully embrace mechanical methods of reproducing its goods. Like the economy, and like all evolutionary systems, it produces knowledge that none of the participants individually grasp, and that may come to fruition only in work done on art by its viewers. Perhaps, then, and despite everything, it is too early to write off art just yet.

Notes

1 Introduction

1 Johnnie Shand Kydd, *Spit Fire: Photographs from the Art World, London 1996/97*, Thames and Hudson, London 1997.

2 Matthew Arnatt, 'Another Lovely Day', in Duncan McCorquodale, Naomi Siderfin and Julian Stallabrass, eds, *Occupational Hazard: Critical Writing on Recent British Art*, Black Dog Publishing, London 1998, p. 46.

3 Liam Gillick, 'When are you Leaving?', *Art and Design*, 1995, special issue *British Art – Defining the 1990s*, p. 81.

4 For an account of the artists' unified social scene, see Gordon Burn, 'Damien Hirst', in Hayward Gallery, *Spellbound: Art and Film*, London 1996.

5 Carl Freedman, 'Living in a Material World', *Frieze*, no. 35, 1997, p. 49.

6 Ibid.

7 For instance, Norman Rosenthal raises this possibility in his introduction to the Royal Academy's *Sensation* catalogue. See 'The Blood Must Continue to Flow', in Royal Academy of Arts, *Sensation: Young British Artists from the Saatchi Collection*, Royal Academy of Arts/Thames and Hudson, London 1997, p. 8.

8 Sotheby's and Christie's takings for contemporary art were not to recover their pre-recession level until 1996. See Colin Gleadell, 'Crisis, What Crisis?', *Art Monthly*, no. 204, March 1997, p. 52. See also, however, Gleadell's article, 'Market Measures', *Art Monthly*, no. 200, October 1996, pp. 74–5, where he discusses the difficulties of arriving at reliable indicators of market activity in the art world. There he also notes that the revival of the British art market, though slow, was more rapid than that in France or the US.

9 An indication of Saatchi's previous collection can be had from the four volumes of *Art of Our Time: The Saatchi Collection*, Lund Humphries, London 1984.

10 Saatchi's activities are discussed further in chapter 7; the Turner Prize in chapter 6.

11 The exhibitions were called *Wonderful Life* (1993) and *Ideal Standard Summertime* (1995).

12 See James Roberts, 'What's the Story …?', in Tochigi Prefectural Museum of Fine Arts, *Real/Life: New British Art*, The Asahi Shimbun, Japan, 1998, p. 13.

13 A similar point is made by Clifford Myerson, 'Michael Landy and the Great Sale', *Art Monthly*, no. 157, June 1992, p. 17.

14 Carl Freedman notes that various changes to the department's location and intake mean that this productive atmosphere has now changed. See 'Space', in Deichtorhallen Hamburg, *Emotion: Young British and American Art from the Goetz Collection*, Cantz, Ostfildern-Ruit 1998, pp. 72–3.

15 On this, see Richard Shone, 'From "Freeze" to *House*: 1988–94', in Royal Academy of Arts, *Sensation*, p. 19.

16 See Sarah Kent, *Shark Infested Waters. The Saatchi Collection of British Art in the 90s*, Zwemmer, London 1994.

17 On the importance of the Karsten Schubert Gallery, see Shone, 'From "Freeze" to *House*: 1988–94', pp. 20–1. In this essay, Shone also provides a clear and detailed account of the development of the high art lite scene, including the role of private galleries.

18 Interview with Gilbert and George in Paola Igliori, *Entrails, Heads and Tails*, Rizzoli, New York 1992, n.p. The ties between Gilbert and George and high art lite have been made clear in shows that have included both. Gilbert and George showed in *Some Went Mad, Some Ran Away ...*, curated by Hirst at the Serpentine Gallery in 1994, and in *Minky Manky*, curated by Carl Freedman at the South London Gallery in 1995. They were also included in the Paris *Live/Life* show in 1996.

19 See Adrian Searle, 'Rachel Doesn't Live Here Any More', *Frieze*, no. 14, January–February 1994, p. 26.

20 On Whiteread's own surprise, see ibid., p. 26.

21 James Lingwood, ed., *Rachel Whiteread: House*, Phaidon, London 1995. The book contains reproductions of press reports about *House*.

22 Matthew Collings, *Blimey! From Bohemia to Britpop: The London Art World from Francis Bacon to Damien Hirst*, 21 Publishing, Cambridge 1997, p. 15.

23 There are two small points I should make about this: the first is that material in the footnotes is almost entirely confined to sources, so the text can be read without reference to them, if readers wish; second, some of the names of artists' organisations and magazines contain non-standard capitalisation – BANK, *everything, frieze, make* and so on – which I have made uniform in the interests of readability.

24 Eddie Chambers, 'Review Publications', *AN Magazine*, June 1998, p. 25. He was reviewing McCorquodale et al., *Occupational Hazard*.

25 I have co-edited a book which does have that intention: see Duncan McCorquodale et al., *Occupational Hazard*. Another attempt to look beyond the artists who get most attention was the special issue of *Contemporary Visual Arts* entitled *Other British Artists: Art Beyond the yBas*, no. 17, 1997. See also Ikon Gallery, *Out of Here: Creative Collaborations Beyond the Gallery*, Birmingham 1998.

26 See Michel Foucault, 'What is an Author?', in *Aesthetics, Method and Epistemology* (Essential Works of Michel Foucault, vol. 2), ed. James Faubion, Allen Lane, London 1998.

2 Famous for being famous

1 On this issue, see the eloquent discussion in Thomas Crow, *Modern Art in the Common Culture*, Yale University Press, New Haven 1996, p. 101.

2 See Roland Barthes, 'The Death of the Author', in Barthes, *Image, Music, Text*, trans. Stephen Heath, Fontana, London 1977.

3 Virginia Button, text in the Tate Gallery booklet, *The Turner Prize 1995*, n.p.; Tate Gallery press release, 'Damien Hirst Wins the Turner Prize', 28 November 1995.

4 Sarah Greenberg and Andrew Wilson, 'Art Gets in Your Face', *Tate Magazine*, no. 2, Spring 1994.

5 Brian Sewell, *An Alphabet of Villains*, Bloomsbury, London 1995. It should be noted that Sewell, unlike many conservative critics, has in a cautious manner praised works by Hirst,

reading them as making serious comment about death and modern medical technology. See Brian Sewell, *The Reviews that Caused the Rumpus and Other Pieces*, Bloomsbury, London 1994, pp. 270–1.

6 Andrew Graham-Dixon, introduction to Serpentine Gallery, *Broken English*, London 1991, n.p.

7 Stuart Morgan, 'Semen's Mission', *Art Monthly*, no. 153, February 1992, p. 7.

8 Will Self, 'A Steady Iron-Hard Jet', *Modern Painters*, Summer 1994, p. 51.

9 Iwona Blazwick, foreword to Institute of Contemporary Arts, *Damien Hirst*, London 1991, n.p.

10 Damien Hirst, *I Want to Spend the Rest of my Life Everywhere, with Everyone, One to One, Always, Forever, Now*, Booth-Clibborn Editions, London 1997, p. 102.

11 Jerry Saltz, 'More Life: The Work of Damien Hirst', *Art in America*, vol. 83, no. 6, 1995, p. 84.

12 Charles Hall, 'A Sign of Life', in Institute of Contemporary Arts, *Damien Hirst*, n.p.

13 Sarah Kent, *Shark Infested Waters: The Saatchi Collection of British Art in the 90s*, Zwemmer, London 1994, pp. 35–6.

14 Ibid., p. 36.

15 Sewell, *An Alphabet of Villains*, p. 104.

16 Richard Shone, essay in Serpentine Gallery, *Some Went Mad, Some Ran Away ...*, London 1994, p. 10.

17 See Serpentine Gallery, *Some Went Mad, Some Ran Away*

18 Gordon Burn, essay in Jablonka Galerie, *Damien Hirst*, Cologne 1994, n.p.

19 Text by Hirst presented in the form of an interview with Sophie Calle, in Institute of Contemporary Arts, *Damien Hirst*, n.p.

20 Hirst: 'I try to say and deny many things to imply meaning, so that when you work out a reading you implicate yourself ... I like all the readings.' Ibid.

21 Greenberg and Wilson, 'Art Gets in Your Face', p. 54.

22 Institute of Contemporary Arts, *Damien Hirst*, n.p.

23 Serpentine Gallery, *Broken English*, n.p.

24 Gordon Burn, 'Is Mr. Death In?', in Hirst, *I Want to Spend the Rest of my Life ...*, p. 10.

25 Hirst in an interview with Carl Freedman, in South London Gallery, *Minky Manky*, London 1995, n.p.

26 Hirst in an interview with David Bowie, '(s)Now', *Modern Painters*, Summer 1996, p. 39.

27 Hirst in South London Gallery, *Minky Manky*, n.p.

28 On Hirst's apparent impasse with making art, see the description of the absurd sub-Surrealist combinations of objects the artist showed at the Bruno Bischofberger Gallery, Zurich, in Juri Steiner, 'Divide et Impera', *Parkett*, nos. 50–1, 1997, pp. 288–90.

29 Cited in Gordon Burn, 'Is Mr. Death In?', in Hirst, *I Want to Spend the Rest of my Life ...*, p. 11.

30 Self, 'A Steady Iron-Hard Jet', p. 52.

31 See William Leith, 'Avoiding the Sharks', *Observer Life Magazine*, 12 February 1999, p. 15.

32 On Pharmacy's travails, see Amelia Gentleman, 'Hirst's Prescription Falls Foul of the Pharmacists', *Guardian*, 9 September 1998.

33 Damien Hirst, *I Want to Spend the Rest of my Life*

34 Robert Garnett, 'Gimme More', *Art Monthly*, no. 211, November 1997, pp. 40–1.

35 Hirst in an interview with Liam Gillick, in Building One, *Gambler*, London 1990, n.p.

36 Interview with Stuart Morgan; cited in Adrian Searle, 'Love in a Cold Climate', *Artscribe*, no. 88, September 1991, p. 84.

37 Text on a page of pictures devoted to the shark, *Frieze*, no. 4, May 1992, p. 48.

38 The sharpest formulation tying the fate of the shark to that of the art was by Kitty Hauser, 'Sensation: Young British Artists from the Saatchi Collection', *New Left Review*, no. 227, January–February 1998, pp. 154–60.

39 Hume cited in Lindsay Baker, 'The Beauty Bomber', *Guardian Weekend*, 2 May 1998, p. 40.

40 Interview with Marcelo Spinelli, in Walker Art Center, *'Brilliant!' New Art from London*, Minneapolis 1995, p. 45.

41 The quote is Gary Hume in South Bank Centre, *The British Art Show 1990*, London 1990, p. 66.

42 See Gregor Muir, 'Lacquer Syringe', *Parkett*, no. 48, 1996, p. 26.

43 Ibid., p. 24.

44 Cited in interview with Adrian Dannatt, 'Gary Hume: The Luxury of Doing Nothing', *Flash Art*, no. 183, Summer 1995, p. 97.

45 Hume cited in Adrian Searle, 'Shut that Door', *Frieze*, no. 11, Summer 1993, p. 48.

46 Baker, 'The Beauty Bomber', p. 40.

47 Hume cited in ibid., p. 43.

48 Adrian Searle, 'Unbound', in Hayward Gallery, *Unbound: Possibilities of Painting*, London 1994, p. 14.

49 Lionel Bovier, 'Definitely Something', *Parkett*, no. 48, 1996, p. 21.

50 Stuart Morgan, 'The Story of I', *Frieze*, no. 34, 1997, p. 60.

51 Ibid., pp. 58–60.

52 Ibid., p. 58.

53 David Bowie, 'It's Art, Jim, But As We Know It' [interview with Tracey Emin], *Modern Painters*, Autumn 1997, p. 29.

54 Mark Gisbourne, 'Life into Art' [interview with Tracey Emin], *Contemporary Visual Arts*, no. 20, 1998, p. 33. The idea that Emin's work is of universal significance is a common theme of the essays by Neal Brown and Sarah Kent in Jay Jopling/White Cube, *Tracey Emin*, London 1998.

55 This was a performance in a Stockholm gallery that was supposed to mark the rebirth of her painting, long abandoned. See Sarah Kent, 'Tracey Emin: Flying High', in Jay Jopling/White Cube, *Tracey Emin*, p. 31.

56 See, for example, Neal Brown on the 'authenticity' of Emin's drawings. 'God, Art and Tracey Emin', in Jay Jopling/White Cube, *Tracey Emin*, p. 6.

57 Bowie, 'It's Art, Jim, But As We Know It', pp. 29–30.

58 Gisbourne, 'Life into Art', p. 34.

59 Matthew Collings, 'Just How Big Are They?', in Jay Jopling/White Cube, *Tracey Emin*, p. 59.

60 Neal Brown, 'God, Art and Tracey Emin', in Jay Jopling/White Cube, *Tracey Emin*, p. 5.

61 See Calvin Tomkins, *Duchamp: A Biography*, Chatto and Windus, London 1997, pp. 255, 431.

62 See Richard Gott, 'Sexual In-tent', *Guardian Weekend*, 5 April 1997, p. 30.

63 *I Need Art Like I Need God* was the title of Emin's exhibition at the South London Gallery in 1997.

64 Emin states that the purpose of her Museum was to communicate directly with the public. See her statement in the galleries' volume of Musée d'Art Moderne de la Ville de Paris, *Life/Live: La scène artistique au Royaume-Uni en 1996*, Paris 1997, p. 122.

65 See 'Gavin Turk', *Frieze*, no. 1, 1991, p. 12.

66 Tony Godfrey, *Conceptual Art*, Phaidon, London 1998, p. 382.

67 Alex Farquharson, 'Tonight, Manzoni, I'm Going to be Gavin Turk', in *Gavin Turk: Collected Works 1994–1998*, Jay Jopling, London 1998, n.p.

68 On this, see Carl Freedman/Gavin Turk, 'Making Omelettes', *Modern Painters*, Autumn 1998, pp. 99–100.

69 Ibid., p. 100.

70 James Roberts, 'Last of England', *Frieze*, no. 13, November–December 1993, p. 30.

71 See ibid., p. 28.

72 Gavin Turk, cited in Kent, *Shark Infested Waters*, p. 94.

73 An example is Daniel Farson, *With Gilbert and George in Moscow*, Bloomsbury, London 1991.

74 On the association of postmodernism with speculation, among a large literature, see Fredric Jameson's clear exposition, 'Culture and Finance Capital', in his book, *The Cultural Turn: Selected Writings on the Postmodern, 1983–1998*, Verso, London 1998.

3 Artist-curators and the 'alternative' scene

1 This was the only passage from Nabokov's novel *Despair* that was left uncrossed-out by artist Matthew Higgs in his display of all its pages. See David Barrett, 'Fiona Banner/Matthew Higgs/Jaki Irvine/Frieda Munro', *Art Monthly*, no. 184, March 1995, p. 27.

2 Matthew Collings, *Blimey! From Bohemia to Britpop: The London Art World from Francis Bacon to Damien Hirst*, 21 Publishing, Cambridge 1997, p. 74.

3 For an account of these conditions of artistic production, see Naomi Siderfin, 'Occupational Hazard', in Duncan McCorquodale/Naomi Siderfin/Julian Stallabrass, eds, *Occupational Hazard: Critical Writing on Recent British Art*, Black Dog Publishing, London 1998.

4 See Carl Freedman's account of this time, 'Space', in Deichtorhallen Hamburg, *Emotion: Young British and American Art from the Goetz Collection*, Cantz, Ostfildern-Ruit 1998, pp. 75–6.

5 This point is regularly made about the show. See, for instance, Gilda Williams, 'Pause … Rewind … Press Play. Reviewing British Art in the 1990s', in Sammlung Goetz, *Art from the UK*, Kunstverlag Ingvild Goetz, Munich 1998, p. 16.

6 *Freeze*, exhibition catalogue, London 1988. Carl Freedman is anxious to play down this professional aspect of *Freeze*, arguing that its budget excluding the catalogue was modest, and that sponsorship of the catalogue was more down to luck than business skills. See 'Space', p. 74.

7 Ingvild Goetz, 'The Work is my Description of the World. Interview with Sarah Lucas', in Sammlung Goetz, *Art from the UK*, p. 135.

8 Angus Fairhurst in, Walker Art Center, *'Brilliant!' New Art from London*, Minneapolis 1995, p. 34.

9 Peter Wollen, 'Thatcher's Artists', *London Review of Books*, 30 October 1997, p. 8.

10 This is noted by Maureen Paley in Andrew Renton and Liam Gillick, eds, *Technique Anglaise: Current Trends in British Art*, Thames and Hudson/One-Off Press, London 1991, p. 23.

11 For details of various precursors to 'alternative' spaces in Britain before the 1990s, see Rebecca Gordon-Nesbitt, 'Surprise Me', in Musée d'Art Moderne de la Ville de Paris, *Life/Live: La scène artistique au Royaume-Uni en 1996*, Paris 1997, galleries' volume, pp. 143.

12 Freedman, 'Space', p. 76.

13 Robert Garnett, 'Beyond the Hype', *Art Monthly*, no. 195, April 1996, pp. 43–4.

14 On body cases see, for instance, the discussion in John Hutchinson, 'Return (the Turning Point)', in John Hutchinson, E.H. Gombrich and Lela B. Njatin, *Antony Gormley*, Phaidon, London 1995, p. 46.

15 See Nicholas Bourriaud, 'Angela Bulloch and the Event', in CCC, *Angela Bulloch*, CCC, Tours 1994, p. 41.

16 See Tim Noble and Sue Webster, *The New Barbarians*, Modern Art Inc., London 1999, p. 4.

17 Stuart Morgan, 'Confessions of a Body Snatcher', *Frieze*, no. 12, October–November 1993, p. 52.

18 See Anthony Caro, *The Trojan War. Sculptures by Anthony Caro*, Lund Humphries, London 1994.

19 Will Self, 'A Steady Iron-Hard Jet', *Modern Painters*, Summer 1994, p. 51.

20 Interview with Marcelo Spinelli posted on the World Wide Web at illumin.co.uk.britishart/artists/dh.

21 Mat Collishaw, 'The Freeze Exhibition', posted on the Web at illumin.co.uk/britshart/artists/mc.

22 Robert Garnett, 'Young British Artists IV', *Art Monthly*, no. 187, June 1995, p. 32.

23 See Walker Art Center, *'Brilliant!'*, p. 31.

24 Sarah Lucas interviewed by Marcelo Spinelli, in ibid., p. 64.

25 For a short account of City Racing and its demise, in part due to the withdrawal of London Arts Board funding, see David Musgrave, 'The Last Show', *Art Monthly*, no. 222, December 1998–January 1999, pp. 26–7. For details of a wide variety of artist-led and 'alternative' spaces, see the galleries' volume of Musée d'Art Moderne de la Ville de Paris, *Life/Live: La scène artistique au Royaume-Uni en 1996*, Paris 1997. See also the essays by Malcolm Dickson and Naomi Siderfin in McCorquodale et al., *Occupational Hazard*. This book is also illustrated with a large amount of material from the archives of artist-led organisations.

26 On Gallacio's work, see Locus+/Tramway, *Chasing Rainbows*, Newcastle-upon-Tyne 1999.

27 For an account of Chodzko's work, see James Roberts, 'Adult Fun', *Frieze*, no. 31, 1996, pp. 62–7.

28 A similar point is made by Iwona Blazwick, 'Douglas Gordon', *Art Monthly*, no. 183, February 1995, p. 35.

29 Part of the catalogue essay I wrote appears in modified form as the final section of this chapter. The catalogue to the show was never produced but an edited version of the full essay was published in *Art Monthly*, no. 182, December 1994–January 1995, pp. 3–6. *Candyman II* was the name of a film sequel that did not then exist (but does now). The Candyman of the films, it is worth noting, is the demonic manifestation of a disgruntled artist.

30 On the radical aspect of this collective practice, see Naomi Siderfin, 'Occupational Hazard', in McCorquodale et al., *Occupational Hazard*, p. 35.

31 For those whom the campaign did not reach, the acronym stands for French Connection United Kingdom.

32 *The Bank*, no. 19, 23 May 1997.

33 Bank, gallery handout for *Stop Short-Changing Us. Popular Culture is for Idiots.We Believe in Art*, 1998.

34 See the front pages of the Bank tabloid, 'Arse Council', *The Bank*, 17 December 1997; and 'LAB-otomy', *The Bank*, 21 December 1997.

35 Bank, press release for *Mask of Gold*, 1997.

36 Bank, gallery handout for *Stop Short-Changing Us*

37 For Brian Griffiths, see the illustrations of his work in The Saatchi Gallery, *The New Neurotic Realism*, London 1998. For artists making pop music, see Martin Sexton and Paul Hitchman, *We Love You*, Booth-Clibborn Editions, London 1998, with its accompanying CD.

38 For feminist worries about Bank's interventions and a final assurance that what they do is not reactionary, see Paula Smithard, 'How Rude Can You Get?', *Make*, no. 74, February–March 1997, p. 27.

39 Robert Garnett, 'The Charge of the Light Brigade/John Timberlake', *Art Monthly*, no. 191, November 1995, p. 27.

40 Wayne Winner, *House of Wax* press release, 1996.

41 See Bank, *Press Release*, Gallerie Poo Poo, London 1998.

42 'Irony Man in R.S.I. Eyebrow and Wink Action', *The Bank*, no. 32, 23 December 1997, n.p.

43 David Barrett, 'Zombie Golf, *Frieze*, no. 24, October 1995, pp. 74–5.

44 'Cottage Industry' was held at Beaconsfield, Vauxhall in November 1995. It was curated by Naomi Siderfin, and included the work of Sonia Boyce, Siobhan Davies, Mikey Cuddihy, Kate Bush, Elsie Mitchell, Clare Palmier and Naomi Siderfin. See Beaconsfield, *Cottage Industry*, London 1995.

45 The piece is illustrated in The Saatchi Gallery, *The New Neurotic Realism*, London 1998, but the photographs are of the Beaconsfield installation.

46 Karl Marx, *Capital*, vol. I, Penguin, London 1990, pp. 163–4.

4 Dumb and dumber?

1 Octopus, 'Practical Uses for Theoretical Essays', *Everything*, vol. 2, no. 1, 1997, pp. 18–19.

2 For a succint and original account of the development of postmodernism, see Perry Anderson, *The Origins of Postmodernity*, Verso, London 1998. For an account of the absurdities that have become accepted as orthodoxy as more nuanced and sophisticated theory is filtered through secondary literature, see Terry Eagleton, *The Illusions of Postmodernism*, Blackwell, Oxford 1996.

3 The intertwining of business, consumerism and culture has been most forcefully brought out by Fredric Jameson. See especially *Postmodernism, or, the Cultural Logic of Late Capitalism*, Verso, London 1991, and in that book particularly ch. 8.

4 I wrote some reviews that made a critique of the relation to art and theory in such work, some of which occasioned debate. See, for instance, 'Lea Andrews', *Art Monthly*, no. 163, February 1993, pp. 24–5; 'Power to the People' (review of work by Judith Cowan, Andrea Fisher and Gillian Wearing), *Art Monthly*, no. 165, April 1993, pp. 15–17; criticisms of this article were published in the next issue (no. 166, May 1993) by Michael Archer (pp. 14–16) and Andrew Wilson (p. 31); my reply to their comments was published in no. 167, June

1993, pp. 28–9; see also my 'Renegotiations: Class, Modernity and Photography', *Art Monthly*, no. 166, May 1993, pp. 21–2; letters criticising this article were published in the July–August issue along with my reply (no. 168, pp. 36–8).

5 On this change, see Perry Anderson, 'Culture in Contraflow'; on the peculiar and partial nature of British intellectual life before this period, see Anderson, 'Components of the National Culture'. Both essays are in his book *English Questions*, Verso, London 1992.

6 Gilbert and George/David Sylvester, 'I Tell You Where There's Irony in Our Work: Nowhere, Nowhere, Nowhere', *Modern Painters*, Winter 1997, p. 19.

7 Ibid., p. 23.

8 Brian Sewell, *The Reviews that Caused the Rumpus and Other Pieces*, Bloomsbury, London 1994, p. 259.

9 Simon Frith and Jon Savage, 'Pearls and Swine: The Intellectuals and the Mass Media', *New Left Review*, no. 198, March–April 1993, p. 111.

10 The classic statement is Jean-François Lyotard, *The Postmodern Condition: A Report on Knowledge*, trans. Geoff Bennington and Brian Massumi, University of Manchester Press, Manchester 1984.

11 See Roland Barthes, 'The Death of the Author', in Barthes, *Image, Music, Text*, trans. Stephen Heath, Fontana, London, 1977.

12 Fiona Rae in the *Time Out* supplement to the *Sensation* exhibition, 18 September 1997, p. 28.

13 Fiona Rae, artist's statement in Museum of Modern Art, Oxford, *About Vision: New British Painting in the 1990s*, Oxford 1996, n.p.

14 See Fiona Rae's statement cited by Sarah Kent in The Saatchi Gallery, *Fiona Rae, Gary Hume*, London 1997, n.p.

15 It should be said here that not all recent British art demonstrates this suspicion of critical thought. Exceptions are examined especially in chapters 3 and 10.

16 Hirst in Will Self, 'A Steady Iron-Hard Jet', *Modern Painters*, Summer 1994, p. 51.

17 Sarah Lucas, '*Guardian* Questionnaire (Unsolicited Version)', in Portikus, *Sarah Lucas*, Frankfurt am Main, 1996, n.p.

18 Sarah Lucas cited in Sarah Kent, *Shark Infested Waters. The Saatchi Collection of British Art in the 90s*, Zwemmer, London 1994, pp. 58–9.

19 For a critical article on Lucas concerned with the ambiguity fostered by her artistic persona, see Ian Hunt, 'Sarah Lucas', *Art Monthly*, no. 207, June 1997, pp. 35–6.

20 Brigitte Kölle in discussion with Sarah Lucas, in Portikus, *Sarah Lucas*, Frankfurt am Main, 1996, n.p.

21 Ibid.

22 Cited in Helen Sumpter, 'Naughty but Nice', *The Big Issue*, 8–14 September 1997.

23 Jane Beckett, 'History (Maybe)', in Ferens Art Gallery, *History: The Mag Collection: Image-Based Art in Britain in the Late Twentieth Century*, Kingston upon Hull City Museums, Art Galleries and Archives, 1997, p. 138.

24 Lucas in interview with Marcelo Spinelli, in Walker Art Center, *'Brilliant!' New Art from London*, Walker Art Center, Minneapolis 1995, p. 65.

25 For one of the rare exceptions, see Nikos Papastergiadis, 'Back to Basics: British Art and the Problems of a Global Frame', in Museum of Contemporary Art, Sydney, *Pictura Britannica: Art from Britain*, Sydney 1997, p. 137.

26 Matthew Collings, *Blimey! From Bohemia to Britpop: The London Art World from Francis Bacon to Damien Hirst*, 21 Publishing, Cambridge 1997, p. 134.

27 Andrew Renton and Liam Gillick, eds, *Technique Anglaise: Current Trends in British Art*, Thames and Hudson/One-Off Press, London 1991, p. 20.

28 See Hayward Gallery, *Spellbound: Art and Film*, London 1996.

29 Adrian Searle, 'Shut that Door', *Frieze*, no. 11, Summer 1993, pp. 48.

30 Gary Hume, statement in South Bank Centre, *The British Art Show 1990*, London 1990, p. 66.

31 *Make: The Magazine of Women's Art* ran an 'anti-theory' issue, no. 79, March–May 1998. In relating the issue's theme to recent British art, Jamie Brassett and Lorraine Gamman made a qualified defence of theory against the artists who would dispose of it. See 'The Art of Mutation', pp. 9–11. There is also an excellent assessment of the contradictions in the anti-theory attitude by Mark Harris, 'Like a Dog Biting its own Tail', pp. 15–16.

32 The works are respectively *Light Switch* (1992), *Light* (1994) and *Projection* (1997).

33 Gordon Burn, 'Sister Sarah', *Guardian Weekend*, 23 November 1996, p. 30.

34 For a review of some of the interpretations of Whiteread's work, see Paul Usherwood, 'The Rise and Rise of Rachel Whiteread', *Art Monthly*, no. 200, October 1996, pp. 11–13.

35 Glenn Brown cited in Kent, *Shark Infested Waters*, p. 12.

36 Georges Bataille, *The Tears of Eros*, City Lights, New York 1989. See Douglas Fogle, 'A Scatological Aesthetics for the Tired of Seeing', in Jake and Dinos Chapman, *Chapmanworld*, Institute of Contemporary Arts, London 1996, n.p. There are other works by the Chapmans that serve almost as illustrations of Bataille; for instance, *Little Death Machine* (1993), where the association between death and orgasm that Bataille explores at great length is given visual incarnation.

37 For David Falconer they are 'quite *literal* translations' of polymorphous perversity. See 'Doctorin' the Retardis', in Jake and Dinos Chapman, *Chapmanworld*, n.p.

38 Klaus Biesenbach and Emma Dexter, 'Foreword', in Jake and Dinos Chapman, *Chapmanworld*, n.p.

39 Douglas Fogle, 'A Scatological Aesthetics for the Tired of Seeing', in Jake and Dinos Chapman, *Chapmanworld*, n.p.

40 Georgie Hopton, 'Interview: Fiona Rae', *Transcript*, vol. 3, no. 2, 1998, p. 73.

41 See Rosemary Betterton, 'The New British Art', in Ferens Art Gallery, *History*, p. 126.

42 Mark Gisbourne, 'Life into Art' (interview with Tracey Emin), *Contemporary Visual Arts*, no. 20, 1998, p. 30.

43 Artist's statement, in Institute of Contemporary Arts, *Die Young Stay Pretty*, London 1998, n.p.

44 Collings, *Blimey!*, pp. 68–9.

45 Matthew Collings, 'Is it Gleaming or is it Abject?', *Modern Painters*, Autumn 1998, p. 82.

46 David Bowie, 'It's Art, Jim, But As We Know It' [interview with Tracey Emin], *Modern Painters*, Autumn 1997, p. 32.

47 For an example of the latter view, see Bryan Robertson, 'Something is Rotten in the State of Art', *Modern Painters*, Winter 1997, pp. 15–16. A passage from this article is cited in chapter 10. For an ambivalent editorial statement on high art lite, see 'An Overwhelming Sensation?', *Modern Painters*, Autumn 1997, p. 27.

48 Neal Brown, 'I Need Art Like I Need God. Interview with Tracey Emin', in Sammlung Goetz, *Art from the UK*, Kunstverlag Ingvild Goetz, Munich 1998, p. 64.

49 For a good example of such mythifying, see Stuart Morgan, 'The Elephant Man', *Frieze*, no. 15, March–April 1994, pp. 40–3.

50 The advertisement appeared in *Frieze*, no. 10, May 1993.

51 For information on *Imprint 93*, see Musée d'Art Moderne de la Ville de Paris, *Life/Live: La scène artistique au Royaume-Uni en 1996*, Paris 1997, galleries' volume, pp. 76–8.

52 See Geoffrey Worsdale, 'Chris Ofili', *Art Monthly*, no. 198, July–August 1996, p. 27.

53 Ofili, interview with Marco Spinelli, *'Brilliant!'*, p. 67.

54 Ibid., p. 67. *Magiciens de la Terre* was an exhibition held at the Musée National d'Art Moderne in Paris in 1989, and was one of the first major attempts to showcase contemporary art of the non-Western world.

55 See Ofili's responses to a *Time Out* questionnaire in 1997; these are reprinted in Kodwo Eshun, 'Plug into Ofili', in Southampton City Art Gallery/Serpentine Gallery, *Chris Ofili*, Southampton 1998, this section unpaginated. Eshun's article also contains Ofili's comments on *The Holy Virgin Mary*.

56 Eshun, 'Plug into Ofili', n.p.

57 Ofili, interview with Marco Spinelli, *'Brilliant!'*, p. 67.

58 Akure Wall, in Museum of Modern Art, Oxford, *About Vision: New British Painting in the 1990s*, Oxford 1996, n.p.

59 See Lisa G. Corrin, 'Confounding the Stereotype', in Southampton City Art Gallery, *Chris Ofili*, pp. 13–14.

60 Chris Ofili, interview with Marcelo Spinelli, *'Brilliant!'*, p. 61.

61 Niru Ratnam, 'Chris Ofili and the Limits of Hybridity', *New Left Review*, no. 235, May–June 1999, p. 155.

62 Shonibare, cited in Kobena Mercer, 'Back to my Routes: A Postscript to the 1980s', in Museum of Contemporary Art, Sydney, *Pictura Britannica*, p. 121.

63 Tom Nairn, *The Enchanted Glass: Britain and its Monarchy*, Vintage, London 1994, p. xxviii.

64 For an effective critique of such theory, see Aijaz Ahmad, *In Theory. Classes, Nations, Literatures*, Verso, London 1992.

65 On this, see Ameena Meer, 'Island Stories: Interview with Keith Piper', *Frieze*, no. 6, September–October 1992, p. 45.

66 Martin Maloney, 'Dung and Glitter', *Modern Painters*, Autumn 1998, p. 42.

67 Ibid.

68 I wrote a study of some of these attitudes in British art and anthropology of the 1920s. See 'The Idea of the Primitive. British Art and Anthropology 1918–1930', *New Left Review*, no. 183, September–October 1990, pp. 95–115.

69 It has been argued that these paintings involve self-mockery and deliberate bad taste, in which case it is easy to see the attraction for Ofili. See Maria Lluisa Borràs, *Picabia*, Thames and Hudson, London 1985, p. 412.

70 For Ofili's comments on Picabia's art and lifestyle, see Kodwo Eshun, 'Plug into Ofili', n.p.

71 Eddie Chambers, 'Whitewash', *Art Monthly*, no. 205, April 1997, pp. 11–12. This essay is reprinted in Eddie Chambers, *Run Through the Jungle: Selected Writings*, INIVA, London 1999.

72 Baudelaire, *The Salon of 1845*, in Charles Baudelaire, *Art in Paris, 1845–1862: Salons and Other Exhibitions*, trans. Jonathan Mayne, Phaidon Press, London 1965, p. 4.

73 Dave Beech, 'Chill Out', *Everything*, no. 20, 1996, p. 6.

74 See John Roberts, 'Mad for It! Bank and the New British Art', *Everything*, no. 18, 1996, pp. 15–19.

75 Ibid., pp. 18–19.

76 John Roberts, 'Mad for It! Philistinism, the Everyday and the New British Art', *Third Text*, no. 35, Summer 1996, p. 29.

77 John Roberts, 'Notes on 90s Art', *Art Monthly*, no. 200, October 1996, p. 3.

78 Dave Beech and John Roberts, 'Spectres of the Aesthetic', *New Left Review*, no. 218, July–August 1996, pp. 102–27. Various articles were published in reply to this article. Two came from thinkers who had been dubbed aesthetes of the New Left: J.M. Bernstein, 'Against Voluptuous Bodies: Of Satiation Without Happiness', *New Left Review*, no. 225, September–October 1997, pp. 89–104; and Andrew Bowie, 'Confessions of a "New Aesthete": A Response to the "New Philistines"', *New Left Review*, no. 225, September–October 1997, pp. 105–26. A coherent and radical essay on the philistine by Malcolm Bull also appeared: 'The Ecstasy of Philistinism', *New Left Review*, no. 219, September–October 1996 This will be discussed in chapter 10.

79 Roberts, in Tate Gallery, *Bill Woodrow: Fool's Gold*, London 1996, p. 32, my emphasis.

80 The classic statement is Matthew Arnold, *Culture and Anarchy*, ed. Samuel Lipman, Yale University Press, New Haven 1994, first published in 1865.

81 Roberts senses the problem at one point, asking 'Is the category of the "philistine", then, just another way of talking about the positional politics of the avant-garde?' See 'Mad for It!', *Third Text*, p. 35. In an essay following their original *New Left Review* article (and written after a version of this critique was originally published in *Art Monthly*, no. 206, May 1997) Beech and Roberts attempted to fill the category of the philistine with historical content; however, since this involved a fundamental revision of their original view, and shed little light on the association of the philistine with the proletarian, this article will not be considered here. See Dave Beech and John Roberts, 'Tolerating Impurities: An Ontology, Genealogy and Defence of Philistinism, *New Left Review*, no. 227, January–February 1998, pp. 45–71.

82 South Bank Centre, *The British Art Show 4*, London 1995.

83 This was a point made effectively in Bernstein, 'Against Voluptuous Bodies', pp. 100f.

84 Roberts, 'Mad for It!', *Third Text*, p. 32.

85 Georges Bataille, 'The Solar Anus' (1931), in *Visions of Excess. Selected Writings, 1927–1939*, edited by Allan Stoekel, Manchester 1985, p. 8.

86 Anderson, *English Questions*, p. 246.

87 Ibid.

88 For a typical example, see Andrew Wilson's musings on the exhibition Hirst curated at the Serpentine Gallery, *Some Went Mad, Some Ran Away ...* in 'Out of Control', *Art Monthly*, no. 177, June 1994, pp. 3–4.

89 Biesenbach and Dexter, 'Foreword', in Jake and Dinos Chapman, *Chapmanworld*, n.p.

5 That's entertainment

1 Damien Hirst, *I Want to Spend the Rest of my Life Everywhere, with Everyone, One to One, Always, Forever, Now*, Booth-Clibborn Editions, London 1997, pp. 198–9.

2 For a brief account of the Major administration and some of the disasters that it weathered, see Larry Elliott and Dan Atkinson, *The Age of Insecurity*, Verso, London 1998, pp. 144f.

3 Andrew Renton and Liam Gillick, eds, *Technique Anglaise: Current Trends in British Art*, Thames and Hudson/One-Off Press, London 1991, p. 40.

4 See Camerawork, *Half-Lit World: Rod Dickinson Selected Works, 1991–1998*, London 1998.

5 Jopling cited in Marianne Macdonald, 'Shark Operator', *Observer Life Magazine*, 31 August 1997. The work referred to is *Isolated Elements Swimming in the Same Direction for the Purposes of Understanding*, 1991.

6 Jopling in the *Evening Standard*, 29 November 1995, cited in Jane Beckett, 'History (Maybe)', in Ferens Art Gallery, *History: The Mag Collection: Image-Based Art in Britain in the Late Twentieth Century*, Kingston upon Hull City Museums, Art Galleries and Archives, 1997, p. 136.

7 Damien Hirst cited in Andrew Wilson, 'Out of Control', *Art Monthly*, no. 177, June 1994, p. 8.

8 See Dan Glaister, 'Saatchi Agency "Stole My Idea"', *Guardian*, 2 March 1999.

9 Henry Bond, *The Cult of the Street*, Emily Tsingou Gallery, London 1998.

10 The point about the identity of Bond's subjects is made by David Barrett, 'Henry Bond', *Art Monthly*, no. 217, June 1998, pp. 33–4.

11 Henry Bond in conversation with Stephan Schmidt-Wulffen, in Bond, *The Cult of the Street*, n.p.

12 David Sylvester in an interview with Carl Freedman, 'About David Sylvester', *Frieze*, no. 30, 1996, p. 49. The reference is to Baudelaire's essay 'Some Modern Caricaturists', 1857.

13 Will Self, 'A Steady Iron-Hard Jet', *Modern Painters*, Summer 1994, p. 52.

14 *Bloody Wallpaper* and its source are reproduced in Institute of Contemporary Arts, *Abigail Lane*, London 1995, cover and p. 9. See also Simon Grant, 'Abigail Lane', *Art Monthly*, April 1995, pp. 33–4.

15 Gordon Burn, *Happy Like Murderers*, Faber, London 1998.

16 See Iwona Blazwick, 'Repeating the Unrepeatable', in Institute of Contemporary Arts, *Abigail Lane*, p. 39.

17 The point is made by Sarah Kent in *Shark Infested Waters. The Saatchi Collection of British Art in the 90s*, Zwemmer, London 1994, p. 34.

18 The phrase is Baudelaire's, used of Horace Vernet. See Charles Baudelaire, *Art in Paris, 1845–1862: Salons and Other Exhibitions*, trans. Jonathan Mayne, Phaidon Press, London 1965, p. 94.

19 Marcus Harvey, artist's statement in Museum of Modern Art, Oxford, *About Vision: New British Painting in the 1990s*, Oxford 1996, n.p.

20 See Ian Hunt, 'Christine Borland', in Musée d'Art Moderne de la Ville de Paris, *Life/Live: La scène artistique au Royaume-Uni en 1996*, Paris 1997, artists' volume, p. 43.

21 Hirst, *I Want to Spend the Rest of my Life ...*, p. 17.

22 Cited in Gordon Burn, 'The Height of the Morbid Manner', *Guardian Weekend*, 6 September 1997.

23 Carl Freedman, 'Space', in Deichtorhallen Hamburg, *Emotion: Young British and American Art from the Goetz Collection*, Cantz, Ostfildern-Ruit 1998, p. 75.

24 Serpentine Gallery, *Barclays Young Artist Award 1991*, London 1991, p. 40.

25 Nancy Spector, 'This is All True, and Contradictory, if Not Hysterical. Interview with Douglas Gordon', in Sammlung Goetz, *Art from the UK*, Kunstverlag Ingvild Goetz, Munich 1998, p. 85.

26 See the discussion in Richard Cork, 'Injury Time', in South Bank Centre, *The British Art Show 4*, London 1995, pp. 31–2.

27 David Gordon, fax message, reproduced in Stedelijk Museum, *Wild Walls*, Amsterdam 1995, p. 128.

28 Cited in David Norris, 'The Royal Academy of Porn', *Daily Mail*, 16 September 1997.

29 Peter Richardson, 'Keith Coventry Interview', *Transcript*, vol. 3, no. 2, 1998, p. 59.

30 John Berger, *A Painter of Our Time* [1958], Penguin, Harmondsworth, Middlesex 1965.

31 Jake Chapman, 'No-one's Mother Sucks Cock in Hell', in Chisenhale Gallery, *Sam Taylor-Wood*, London 1996, n.p.

32 Douglas Fogle, interview with Sam Taylor-Wood, in Walker Art Center, *'Brilliant!' New Art from London*, Walker Art Center, Minneapolis 1995, p. 78.

33 Ibid.

34 See Michael Archer, 'Piss and Tell', *Art Monthly*, no. 172, December 1993–January 1994, pp. 18–19.

35 James Roberts, 'Making a Drama Out of a Crisis', *Frieze*, no. 44, 1999, p. 55.

36 Carl Freedman, 'A Balance Between Neurosis and Psychosis. Interview with Sam Taylor-Wood', in Sammlung Goetz, *Art from the UK*, p. 150.

37 Chapman, 'No-one's Mother ...', n.p.

38 Goya's *Desastres* was first published by the Academy of San Fernando in 1863, in a form that the artist had not intended. The prints themselves were made c. 1810–20.

39 Cited in Martin Maloney, 'The Chapman Bros. When Will I Be Famous', *Flash Art*, vol. xxix, no. 186, January–February 1996, p. 64.

40 Carl Freedman, 'Jake and Dinos Chapman', *Frieze*, no. 11, Summer 1993, p. 50.

41 Maloney, 'The Chapman Bros.', p. 64.

42 Ibid., p. 64.

43 Douglas Fogle, 'A Scatological Aesthetics for the Tired of Seeing', in Jake and Dinos Chapman, *Chapmanworld*, Institute of Contemporary Arts, London 1996, n.p.

44 As reported in David Norris, 'The Royal Academy of Porn', *Daily Mail*, 16 September 1997.

45 Klaus Biesenbach and Emma Dexter, 'Foreword', in Jake and Dinos Chapman, *Chapmanworld*, n.p.

46 The Chapmans, cited in Fogle, 'A Scatological Aesthetics', in Jake and Dinos Chapman, *Chapmanworld*, n.p.

47 See Eric Troncey, in Andrea Schlieker/Henry Bond, eds, *Exhibit A: Eight Artists from Europe and America*, Serpentine Gallery, London 1992, volume 2, pp. 30–1.

48 *Time Out* supplement to the *Sensation* exhibition, 18 September 1997, p. 15.

49 Sarah Kent described this piece as 'one of the most glamorous' images in the *Sensation* exhibition. See 'Rogue's Gallery', *Time Out*, 24 September 1997.

50 Carl Freedman, 'Mat Collishaw', *Frieze*, no. 37, 1997, p. 79.

51 For the latter interpretation, see Stuart Morgan, 'Forbidden Images', *Frieze*, no. 26, January–February 1996, p. 53.

52 Interview with Carl Freedman, in South London Gallery, *Minky Manky*, London 1995, n.p.

53 Cited in Morgan, 'Forbidden Images', p. 54.

54 Chapman, 'No-one's Mother ...', n.p.

55 Maloney in conversation with Gemma de Cruz, in Institute of Contemporary Arts, *Die Young Stay Pretty*, London 1998, n.p.

56 Matthew Collings, '"Sensation". Royal Academy of Arts', *Artforum*, January 1998, p. 95.

57 Hirst, *I Want to Spend the Rest of my Life* ..., pp. 17, 48, 88.

58 Keith Alexander, ed., *Date with an Artist*, BBC Education Production, London 1997, p. 38.

59 George in Gilbert and George/David Sylvester, 'I Tell You Where There's Irony in Our Work: Nowhere, Nowhere, Nowhere', *Modern Painters*, Winter 1997, p. 21. He is referring to their drinking pieces made in 1972–73.

60 Musée d'Art Moderne de la Ville de Paris, *Life/Live*, artists' volume, pp. 164–5.

61 Sarah Lucas cited in Kent, *Shark Infested Waters*, p. 59.

62 David Batchelor, 'Living in a Material World', *Frieze*, no. 35, 1997, p. 48.

63 Shone saw this as a shift against the minimalist-derived work of the generation of Gallacio, Hirst, Landy and Whiteread, but this chapter will contend that such work co-existed with the domestic and nostalgic strand. Among Shone's books is *Bloomsbury Portraits: Vanessa Bell, Duncan Grant and their Circle*, Phaidon, London 1993. He has also written extensively on Walter Sickert.

64 Richard Shone, 'Statement', in Tate Gallery, Liverpool, *New Contemporaries*, Liverpool 1996, p. 15.

65 Sarah Kent in The Saatchi Gallery, *Fiona Rae, Gary Hume*, London 1997, n.p.

66 See Kent, *Shark Infested Waters*, p. 103.

67 Waldemar Januszczak, 'Facing the Scary', *Sunday Times*, 21 September 1997.

68 Sigmund Freud, 'The Uncanny' (1919), in Freud, *Art and Literature*, Penguin Books, London 1985. For a brief account of recent theory on the uncanny, see Martin Jay, 'The Uncanny Nineties', in his book *Cultural Semantics: Keywords of Our Time*, The Athlone Press, London 1998.

69 See Tochigi Prefectural Museum of Fine Arts, *Real/Life: New British Art*, The Asahi Shimbun, Japan, 1998. There were females among the 1980s sculptors, including Alison Wilding but their work was generally considered less important than that of the men. One major exhibition was composed entirely of work by men: *British Sculpture Since 1965: Cragg, Deacon, Flanagan, Long, Nash, Woodrow*, Museum of Contemporary Art, Chicago 1987. See the accompanying publication, Terry A. Neff, ed., *A Quiet Revolution: British Sculpture Since 1965*, Thames and Hudson, London 1987.

70 For the account of Banner's working methods, see Gregor Muir, 'Daddy's Speeding', in British Council, *General Release: Young British Artists at Scuola di San Pasquale*, Venice 1995, pp. 15–17.

71 Fiona Banner, *The Nam*, Frith Street Books, London 1997. On the characteristics of the book, see Stephen Bury, 'The Nam', *Art Monthly*, no. 207, June 1997, p. 46.

72 Martin Maloney, 'Introduction', in Waddington Galleries, *Ian Davenport: New Paintings*, London 1996, n.p.

73 Colin Gleadell, 'Formaldehyde Blues', *Art Monthly*, no. 221, November 1998, p. 48; William Leith, 'Avoiding the Sharks', *Observer Life Magazine*, 12 February 1999, p. 12.

74 On the after-life of painting see Yve-Alain Bois, 'Painting: The Task of Mourning', in his book *Painting as Model*, The MIT Press, Cambridge, Mass. 1990.

75 Stuart Morgan, 'Playing for Time', in Waddington Galleries, *Fiona Rae*, London 1991, n.p.

76 Richard Shone, catalogue essay in Waddington Galleries, *Fiona Rae*, London 1995, n.p.

77 Kent, *Shark Infested Waters*, pp. 39–40.

78 See ibid., p. 42.

79 See Waddington Galleries, *Zebedee Jones: New Paintings*, London 1998.

80 Jason Martin, artist's statement in Museum of Modern Art, Oxford, *About Vision*, n.p.

81 See Davenport's statement in South Bank Centre, *The British Art Show 1990*, London 1990, p. 50.

82 On Davenport's straighforwardness, see Martin Maloney, 'Introduction', in Waddington Galleries, *Ian Davenport: New Paintings*, London 1996.

83 Ian Davenport, artist's statement in Museum of Modern Art, Oxford, *About Vision*, 1996, n.p.

84 See Mark Harris, 'Angus Fairhurst', *Art Monthly*, no. 202, December 1996–January 1997, p. 25.

85 Steven Pippin, 'Introduction', in Institute of Contemporary Arts, *Steven Pippin: The Rigmarole of Photography*, London 1993, p. 7.

86 Kitty Hauser, 'Sensation: Young British Artists from the Saatchi Collection', *New Left Review*, no. 227, January–February 1998, pp. 154–60.

87 James Roberts, 'Last of England' [interview with Gavin Turk], *Frieze*, no. 13, November–December 1993, p. 28.

88 A striking exception is the work of Mariko Mori which, in three-dimensional photographs and films, technologically rivals mass-media productions. The artist is able to fund the making of her work from the family fortune that runs to billions of dollars. See Serpentine Gallery, *Mariko Mori*, London 1998.

89 George Walden, 'Leave your Weapons at the Door. Democracy, State Modernism and the Official Embrace of the Arts', *London Review of Books*, 26 September 1997, p. 10.

90 'Why Bother?', *The Bank*, no. 14, 23 March 1997, n.p.

6 The market and the state

1 Eric Hobsbawm, *Behind the Times: The Decline and Fall of the Twentieth-Century Avant-Gardes*, Thames and Hudson, London 1998, p. 13. His source is the Economist, *Pocket Britain in Figures: 1997 Edition*.

2 Rosemary Betterton, 'The New British Art', in Ferens Art Gallery, *History: The Mag Collection: Image-Based Art in Britain in the Late Twentieth Century*, Kingston upon Hull City Museums, Art Galleries and Archives, 1997, pp. 123, 130, citing *Cultural Trends*, 1995.

3 Pierre Bourdieu and Alain Darbel with Dominique Schnapper, *The Love of Art. European Art Museums and their Public*, trans. Caroline Beattie and Nick Merriman, Polity Press, Cambridge 1991.

4 All this information is posted on the Tate Gallery's website: www.tate.org.uk

5 This information was supplied by the Tate Gallery's press office; figures are rounded to the nearest thousand.

6 Chin-tao Wu, *Privatising Culture: Aspects of Corporate Art Intervention in Contemporary Art and Art Institutions during the Reagan and Thatcher Decade*, PhD thesis, University of London, 1997. Part of this thesis has been published in modified form: 'Embracing the Enterprise Culture: Art Institutions Since the 1980s', *New Left Review*, no. 230, July–August 1998, pp. 28–57. My discussion in this section is much indebted to both texts.

7 On this, see Patrick J. Boylan, 'British Art in the 1980s and 1990s: The Social and Political Background', in Museum of Contemporary Art, Sydney, *Pictura Britannica: Art from Britain*, Sydney 1997, pp. 155f.

8 See ibid., p. 152.

9 There is a forthright discussion of the advantages to companies in sponsoring exhibitions in Pierre Bourdieu and Hans Haacke, *Free Exchange*, Polity Press, Cambridge 1995, pp. 14f.

10 On Beck's campaign to become the lager of choice for the art world, see Chin-tao Wu, 'Embracing the Enterprise Culture', pp. 37–8.

11 Toshiba mission statement in Jake and Dinos Chapman, *Chapmanworld*, Institute of Contemporary Arts, London 1996, n.p.

12 See Chin-tao Wu, 'Embracing the Enterprise Culture', pp. 47–8.

13 See Peter Fuller, 'The Lady's Not for Turner', *Art Monthly*, no. 82, December 1984–January 1985, pp. 2–6.

14 This section of the chapter draws on the clear and frank account of the development of the Prize, given by Virginia Button in her book, *The Turner Prize*, Tate Gallery Publishing, London 1997.

15 Another factor, Button points out, was the suspension in the mid-1980s of another regular showcase for contemporary art, the Hayward Annual; Button, *The Turner Prize*, p. 26. While there are other prize-giving shows and annual group shows of young artists, including East (based in Norwich) and the New Contemporaries exhibition, none has anything like the prominence in the media of the Turner Prize.

16 See Nicholas Serota's statement about these changes, cited in Button, *The Turner Prize*, p. 78.

17 See James Lingwood, ed., *Rachel Whiteread: House*, Phaidon, London 1995.

18 Brian Sewell, *The Reviews that Caused the Rumpus and Other Pieces*, Bloomsbury, London 1994, p. 95.

19 Tom Nairn, *The Enchanted Glass: Britain and its Monarchy*, Vintage, London 1994, pp. vii–x.

20 Bridger also placed his own label over the original, reading 'Mark Bridger, Black Sheep, May 9, 1994'. See 'Sheep Exhibit Attack "An Artistic Statement"', *Daily Telegraph*, 17 August 1994; reprinted in Damien Hirst, *I Want to Spend the Rest of my Life Everywhere, with Everyone, One to One, Always, Forever, Now*, Booth-Clibborn Editions, London 1997, p. 294.

21 'Patterson: One Idea, Eight Years', *The Bank*, no. 3, 22 September 1996, n.p.

22 Adrian Searle, 'Shut that Door', *Frieze*, no. 11, Summer 1993, p. 49.

23 Statement by Davenport in South Bank Centre, *The British Art Show 1990*, London 1990, p. 50.

24 See Colin Gleadell, 'Sotheby's Woos Young Brits', *Art Monthly*, no. 206, May 1997, p. 45.

25 Colin Gleadell, 'Spinning Jenny', *Art Monthly*, no. 233, February 1999, p. 49.

26 Ibid., p. 48.

27 Peter Wollen, 'London Swings', in David Burrows, ed., *Who's Afraid of Red White & Blue? Attitudes to Popular and Mass Culture, Celebrity, Alternative & Critical Practice & Identity Politics in Recent British Art*, University of Central England/ARTicle Press, 1998, p. 24.

28 Cited in Richard Gott, 'Where the Art Is', *Guardian Weekend*, 7 October 1995, p. 42.

29 Joshua Compston, statement in the galleries' volume of Musée d'Art Moderne de la Ville de Paris, *Life/Live: La scène artistique au Royaume-Uni en 1996*, Paris 1997, p. 63.

30 Hirst, *I Want to Spend the Rest …*; Marc Quinn, *Incarnate*, Gagosian Gallery, New York 1998.

31 See Angela Bulloch, *Satellite: Angela Bulloch*, Museum für Gegenwartskunst, Zurich 1998, p. 60.

32 Friedrich Meschede, 'Emotion and Sensation', in Deichtorhallen Hamburg, *Emotion: Young British and American Art from the Goetz Collection*, Cantz, Ostfildern-Ruit 1998, p. 175.

33 Patricia Bickers, 'As Others See Us: Towards a History of Recent Art from Britain', in Museum of Contemporary Art, Sydney, *Pictura Britannica*, p. 65.

34 George Walden, 'Leave your Weapons at the Door. Democracy, State Modernism and the Official Embrace of the Arts', *London Review of Books*, 26 September 1997, p. 10.

35 Ibid., p. 11.

36 Chris Smith, *Creative Britain*, Faber and Faber, London 1998.

37 Ibid., p. 2.

38 Ibid., p. 144.

39 Andrew Brighton, 'Command Performance', *Guardian*, 12 April 1999, pp. 12–13.

40 Contemporary photography had been seen in Newcastle at the Zone Gallery that closed in 1998; Locus+, an artist-led organisation, has no gallery but mounts contemporary art shows, installations and performances in sites throughout the region. See Samantha Wilkinson, ed., *Locus+, 1993–1996*, Locus+, Newcastle-upon-Tyne 1996.

41 The 'Angel' is 65 feet high and has a wing span of 169 feet.

42 Smith, *Creative Britain*, p. 143.

43 For an account of some of the development plans for London and their place in a wider cultural-economic strategy, see Simon Ford and Anthony Davies, 'Art Capital', *Art Monthly*, no. 213, February 1998, pp. 1–4.

44 Smith, *Creative Britain*, p. 45; see also pp. 126–7.

45 Ibid., p. 6.

46 Ibid., p. 119.

47 Ibid., p. 16.

48 Ibid., p. 19.

49 Ibid., pp. 54–5. Indeed there is an organisation, ABSA (Association for Business Sponsorship of the Arts) that is devoted to fostering such creativity in business.

50 Ibid., pp. 21–2.

51 On the links between New Labour and the Australian Labor Party, and on this particular mix of policy, see Boris Frankel, 'Beyond Labourism and Socialism: How the Australian Labor Party Developed the Model of "New Labour"', *New Left Review*, no. 221, January–February 1997, pp. 3–33.

52 Smith, *Creative Britain*, p. 131.

53 Blair cited in the *Sunday Times*, 29 March 1998.

7 Saatchi and *Sensation*

1 For doubts about Saatchi's involvement with an exhibition of Julian Schnabel at the Tate Gallery in 1982, see Virginia Button, *The Turner Prize*, Tate Gallery Publishing, London 1997, p. 17.

2 Richard Wentworth, cited in Gordon Burn, 'I Want it, I Want it All, and I Want it Now', *Guardian*, 7 December 1998, section 2, p. 3.

3 Catherine Milner, 'A Shy Man', *Sunday Telegraph*, 23 July 1997.

4 Patricia Bickers, 'Sense and Sensation', *Art Monthly*, no. 211, November 1997, p. 3.

5 On this, see Andrew Wilson, 'God Not Warhol', *Art Monthly*, no. 217, June 1998, p. 45.

6 For information about the Saatchi collection of the 1980s, see the four-volume catalogue, *Art of Our Time: The Saatchi Collection*, Lund Humphries, London 1984.

7 Mark Honigsbaum and Chris Blackhurst, 'Royal Academy Warned of Acting as a Dealer for Saatchi', *Independent on Sunday*, 14 September 1997.

8 See Anon., 'The Saatchi Collection', *Galleries*, October 1997.

9 Bickers, 'Sense and Sensation', p. 4.

10 Turk cited in 'Gavin Turk: The Stuff Show', *Evening Standard*, 10 October 1998.

11 For this work, see Sarah Kent, *Shark Infested Waters. The Saatchi Collection of British Art in the 90s*, Zwemmer, London 1994.

12 Gemma de Cruz in conversation with Maloney, in Institute of Contemporary Arts, *Die Young Stay Pretty*, London 1998, n.p.

13 Cited in Joanna Pitman, 'Art Breaker', *The Times*, 13 September 1997.

14 On this worry, see Carl Freedman, 'Space', in Deichtorhallen Hamburg, *Emotion: Young British and American Art from the Goetz Collection*, Cantz, Ostfildern-Ruit 1998, p. 77.

15 Carl Freedman/Gavin Turk, 'Making Omelettes', *Modern Painters*, Autumn 1998, p. 100.

16 See Tim Noble and Sue Webster, *British Rubbish*, The Independent Art Space, London 1996, n.p.

17 For an assertion that it is the former, see David Barrett, 'How to be a Young British Artist for Fun and Profit', in Tim Noble and Sue Webster, *The New Barbarians*, Modern Art Inc., London 1999, pp. 5–7.

18 *Sensation: Young British Artists from the Saatchi Collection* was held at the Royal Academy of Arts, 18 September–28 December 1997. There have been some excellent reviews of the exhibition: see, for instance, Patricia Bickers on the background to the show in *Art Monthly*, no. 211, November 1997, pp. 1–6; Naomi Siderfin's analysis of the congruence of new British art and the Royal Academy in her review in *Make*, no. 78, December 1997–February 1998, p. 25; Neil Mulholland's detailed critique of this work's engagement with mass culture in the *Burlington Magazine*, vol. cxxxix, no. 1137, December 1997, pp. 886–8; and Kitty Hauser's account of the art's pale reflection of mass culture in 'Sensation: Young British Artists from the Saatchi Collection', *New Left Review*, no. 227, January–February 1998, pp. 154–60.

19 Burn, 'I Want it', p. 2.

20 Andy Beckett, 'Shock Art to Shop Art', *Guardian*, 28 August 1997.

21 On the debt, see Sarah Greenberg, 'All the Rage', *Tate*, no. 14, Spring 1998, p. 54.

22 See David Lister, 'Hirst Snubs "Fat, Stuffy, Pompous" Royal Academy'; *Independent*, 10 September 1997.

23 As reported in Anthea Guthrie, 'Royal Academy Chief Blasts its Irrelevant, Ageing Artists', *Observer*, 14 September 1997.

24 This point was made at the time by professional publicists. See Graham Goodkind, 'Hirst Criticisms Put the Royal Academy Firmly in the Picture', *PR Week*, 19 September 1997.

25 Will Self, 'The Royal Academy is Casting its Mantle upon Saatchi's Brit Kids. Middle England is Shocked and Enjoying Every Minute of it', *New Statesman*, 19 September 1997, p. 39. The exhibition opened less than a month after Diana's death.

26 The Academicians who resigned over the showing of *Myra* were Craigie Aitchison, Gillian Ayres, Michael Sandle and John Ward.

27 Christopher Elliott, 'Withdraw Portrait of Me, Urges Hindley', *Guardian*, 31 July 1997.

28 Cited in Barbara Ellen, 'Hindley and the Appeal of the Cynical', *Observer*, 14 September 1997.

29 For a more interesting take on the predecessors to *Myra* in terms of subject matter, see Mulholland, 'London "Sensation"', pp. 887–8. It should also be noted that a similar controversy was caused over the showing of a work by Jamie Wagg, *Shopping Mall or Cartoon for a Tragedy*, that used CCTV images related to the murder of the toddler James Bulger. These were exhibited at the *Whitechapel Open* in 1994.

30 'Mother's Fury at Myra "Art"', *Daily Mail*, 26 July 1997.

31 Cited in Gordon Burn, 'The Height of the Morbid Manner', *Guardian Weekend*, 6 September 1997.

32 Cited in Julie Burchill, 'Death of Innocence', *Guardian*, 12 November 1997.

33 Ibid.

34 Sarah Kent, writing it is true for one of the sponsors of the exhibition, thought it 'extremely clever'. See 'Rogue's Gallery', *Time Out*, 24 September 1997.

35 Richard Dorment, 'Sensation? What Sensation?', *Daily Telegraph*, 17 September 1997.

36 Richard Cork, 'The Establishment Clubbed', *The Times*, 16 September 1997.

37 Waldemar Januszczak, 'Facing the Scary', *Sunday Times*, 21 September 1997.

38 Matthew Collings, '"Sensation". Royal Academy of Arts', *Artforum*, January 1998, p. 94.

39 Tom Lubbock, 'Who are they Pointing at?', *Independent*, 18 September 1997.

40 William Packer, 'What Sensation?', *Financial Times*, 20 September 1997.

41 Cited in Jerry Armstrong and Paul Byrne, 'Artless: Fury at Child-Fingerprint Portrait of Monster Myra', *Mirror*, 26 July 1997.

42 Winnie Johnson, as quoted in John Kay, 'It's an Artrage', *Sun*, 26 July 1997.

43 Jeremy Armstrong and Paul Byrne, 'Artless: Fury at Child-Fingerprint [sic] Portrait of Monster Myra', *Mirror*, 26 July 1997; Paul Waugh, 'The Giant Painting of Myra "Designed to Shock"', *Evening Standard*, 25 July 1997.

44 Among a good deal of press reporting of this event, the *Daily Mail* ran it as a front page story. See Bill Mouland, 'Invitation to an Outrage', *Daily Mail*, 17 September 1997.

45 Bryan Robertson, 'Something is Rotten in the State of Art', *Modern Painters*, Winter 1997, p. 16.

46 Michael Sandle, 'The RA is Rotten at the Top', *Daily Telegraph*, 23 September 1997.

47 Mark Wallinger, 'The Pygmalion Paradox', *Art Monthly*, no. 218, July–August 1998, p. 3.

48 Burchill, 'Death of Innocence'. The article provoked correspondence in the *Guardian*, most of it hostile to Burchill's views. See *Guardian*, 14 November 1997.

49 See the front page story of the *Mirror*, 19 September 1997.

50 'Academy is Now Dead, says Craigie', *Evening Standard*, 19 September 1997.

51 'Exhibited by the Royal Academy in the So-called Name of Art, Defaced by the People in the Name of Common Decency', *Mirror*, 19 September 1997.

52 Rosanna de Lisle and Annabelle Auerbach, 'The New Establishment', *Independent*, 31 August 1997.

53 'How Can this Pile of Sh*t be Worth £250,000?', *Sport*, 19 September 1997.

54 Paul Johnson, 'An Obscene Picture and the Question: Will Decency or Decadence Triumph in British Life?', *Daily Mail*, 20 September 1997.

55 In the 1950s, a series of purchases of Moore's work by public bodies were the occasion of much controversy. In the 1970s, the Tate's purchase of André's *Equivalent VIII* caused such a fuss that the gallery started to think out the possibilities for privately funding the acquisition of similar works.

56 Tracey Emin, 'School of Scandal', *The Face*, November 1997.

57 Andrea Rose, 'Foreword', in British Council, *Dimensions Variable: New Works for the British Council Collection*, London 1997, p. 5.

58 *Modern Medicine*, exhibition catalogue, anonymous text, London n.d., n.p.

59 Herbert Marcuse, *One-Dimensional Man* [1964], Routledge, London 1991, p. 57.

60 For an analysis of heritage film which is related to arguments about British economic and political exceptionalism, see Paul Dave, 'The Bourgeois Paradigm and Heritage Cinema', *New Left Review*, no. 224, July–August 1997, pp. 111–26.

61 Louisa Buck, *Moving Targets: A User's Guide to British Art Now*, Tate Gallery Publishing, London 1997, pp. 126–7.

62 Royal Academy of Arts, *Sensation: Young British Artists from the Saatchi Collection*, Royal Academy of Arts/Thames and Hudson, London 1997.

63 Richard Shone, 'From "Freeze" to *House*: 1988–94', in *Sensation*, pp. 12–24.

64 Lisa Jardine, 'Modern Medicis: Art Patronage in the Twentieth Century in Britain', in *Sensation*, pp. 40–8. The essay is the more remarkable since, in a newspaper article, Jardine rehearsed (it is true in rather anodyne fashion) the argument that the dominance of one dealer-collector over the British scene was unhealthy and that *Sensation* looked like a survey but was in fact the exercise of an individual and partial taste. See Lisa Jardine, 'How One Man Decides What is Good for Art', *Daily Telegraph*, 18 September 1997.

65 *Modern Medicine*, n.p.

66 Dick Price, 'Don't Stop 'til you get Enough', in The Saatchi Gallery, *The New Neurotic Realism*, London 1998, n.p.

67 Institute of Contemporary Arts, *Die Young*, n.p.

68 Price, 'Don't Stop 'til you get Enough', n.p.

69 Dexter Dalwood, in Institute of Contemporary Arts, *Die Young*, n.p.

70 Martin Maloney title essay, in Claudia Gian Ferrari Arte Contemporanea, *Martin Maloney: Conversation Pieces*, Milan 1998, p. 11.

71 Ibid., p. 11.

72 Emma Dexter, foreword in Institute of Contemporary Arts, *Die Young*, n.p. The point about art historical references is also made in Price, 'Don't Stop 'til you get Enough', n.p.

73 Maloney in Institute of Contemporary Arts, *Die Young*, n.p.

74 Ibid.

75 Ibid.

76 See, for instance, Robert Garnett, 'Die Young Stay Pretty', *Art Monthly*, no. 22, December 1998–January 1999, pp. 39–40.

77 See Colin Gleadell, 'Spinning Jenny', *Art Monthly*, no. 233, February 1999, pp. 48–9.

78 See 'Saatchi Gives Modern Works to Arts Council', *Guardian*, 10 February 1999.

79 See, for example, Peter Fuller, 'Where was the Art of the Seventies?', in his book *Beyond the Crisis in Art*, Writers and Readers, London 1980.

80 This point is made by Mulholland, 'London "Sensation"', p. 886.

8 The Britishness of British art

1 Sarah Lucas in an interview with Carl Freedman, in South London Gallery, *Minky Manky*, London 1995, n.p.

2 On this, see Tom Nairn, *The Enchanted Glass: Britain and its Monarchy*, Vintage, London 1994, p. xix.

3 I am drawing here on a lecture Eddie Chambers gave on black artists' use of the Union Jack, given at the Ruskin School, Oxford University, in Spring 1999.

4 See David Burrows, 'Ade Adekola/Yinka Shonibare/Mark Wallinger', *Art Monthly*, no. 203, February 1997, p. 32.

5 Rose Jennings, 'Liquid Engineering', *Frieze*, no. 2, 1991, p. 31.

6 Alex Farquharson, 'Tonight, Manzoni, I'm Going to be Gavin Turk', in *Gavin Turk: Collected Works 1994–1998*, Jay Jopling, London 1998, n.p.

7 On the pre-war period, see Charles Harrison, *English Art and Modernism, 1900–1939*, Allen

Lane, London 1981; on the post-war period, see Margaret Garlake, *New Art New World: British Art in Postwar Society*, Yale University Press, New Haven 1998, especially ch. 4.

8　See David Burrows, 'Exquisite Corpses', *Art Monthly*, no. 221, November 1998, pp. 24–5.

9　James Roberts, 'Last of England', *Frieze*, no. 13, November–December 1993, p. 30.

10　Ibid.

11　Patricia Bickers, 'As Others See Us: Towards a History of Recent Art from Britain', in Museum of Contemporary Art, Sydney, *Pictura Britannica: Art from Britain*, Sydney 1997, pp. 71f.

12　Ibid., pp. 80–2.

13　For an account of the reception of recent British art in the US, see Brooks Adams, 'Thinking of You: An American's Growing, Imperfect Awareness', in Royal Academy of Arts, *Sensation: Young British Artists from the Saatchi Collection*, Royal Academy of Arts/ Thames and Hudson, London 1997, pp. 35–9.

14　Peter Schjeldhal, 'Twelve British Artists', *Frieze*, no. 7, December 1992, p. 45.

15　See Tony Godfrey, *Conceptual Art*, Phaidon, London 1998, p. 383.

16　Cited in Martin Maloney, 'The Chapman Bros. When Will I Be Famous', *Flash Art*, vol. xxix, no. 186, January–February 1996, p. 64.

17　Alexandra Anderson-Spivy, 'The Freeze Generation and Beyond', *Art Journal*, vol. 57, no. 3, Fall 1998, p. 89. The word 'vanquish' is Anderson-Spivy's and Rosenthal actually puts the matter as an open question. See Norman Rosenthal, 'The Blood Must Continue to Flow', in Royal Academy of Arts, *Sensation*, p. 8.

18　Anderson-Spivy, 'The Freeze Generation and Beyond', p. 89.

19　George Barber gave the lecture in January 1999 for the Ruskin School's series on video art.

20　David Frankel, 'Steve McQueen', *Artforum*, November 1997, p. 102.

21　McQueen plays down the importance of race in his work. See, for instance, Patricia Bickers, 'Let's Get Physical' [interview with Steve McQueen], *Art Monthly*, no. 202, December 1996–January 1997, pp. 1–5.

22　Robert Storr, 'Going Places', in Institute of Contemporary Arts, *Steve McQueen*, London 1999, p. 12.

23　On art history, film history and modernism, see ibid., pp. 8–9, 12, 14, 18.

24　For this line of argument, see Jon Thompson, 'Steve McQueen', in Musée d'Art Moderne de la Ville de Paris, *Life/Live: La scène artistique au Royaume-Uni en 1996*, Paris 1997, artists' volume, p. 93.

25　Peter Wollen, 'Thatcher's Artists', *London Review of Books*, 30 October 1997, pp. 7–9.

26　See Peter Wollen's analysis 'Vectors of Melancholy', in Ralph Rugoff, with Anthony Vidler and Peter Wollen, *Scene of the Crime*, The MIT Press, Cambridge, Mass. 1997. As there are British exceptions to this general trend, so there are on the West Coast, including the socially engaged work of Anthony Hernandez and David Hammons.

27　Michael Corris, 'The Triumphant Moment: A Research Program for the Future, Now that "Young British Art" is Dead as a Theoretical Concept or as a Means of Developing Frameworks Influencing How we Make and Think about Art', *Magazyn Sztuki*, no. 18, February 1998, p. 111.

28　Wollen, 'Thatcher's Artists', p. 8.

29　This argument is made in Peter Wollen, 'London Swings', in David Burrows, ed., *Who's Afraid of Red White & Blue: Attitudes to Popular and Mass Culture, Celebrity, Alternative & Critical Practice & Identity Politics in Recent British Art*, University of Central England/ARTicle Press, 1998.

30 See, for example, Portikus, *Sarah Lucas*, Frankfurt am Main, 1996.
31 Jake Chapman in interview with Douglas Fogle, 'Stop the Chatter', in Walker Art Center, *'Brilliant!' New Art from London*, Minneapolis 1995, p. 22; Gary Hume in interview with Marcelo Spinelli, 'Gary Hume', in ibid., p. 45.
32 Eric Underwood, *A Short History of English Painting*, Faber & Faber, London 1933, p. 6.
33 See Garlake, *New Art New World*, p. 64.
34 Nikolaus Pevsner, *The Englishness of English Art*, Penguin Books, London 1964, p. 199.
35 Ibid., pp. 15–16.
36 Ibid., p. 196.
37 On the incompatibility of Hogarth and the interests of modernism, see Garlake, *New Art New World*, pp. 64–5.
38 Tim Head in an interview with Liam Gillick, in Building One, *Gambler*, London n.d. [1990], n.p.
39 See Museum Ludwig, *Sarah Lucas: Car Park*, Oktagon Verlag, Cologne 1997.
40 Anne Hamlyn, 'Tracing Blind Spots: Art and the Criminal Element', in Tate Gallery, Liverpool, *New Contemporaries*, Liverpool 1996, p. 61.
41 Thomas Crow, *Modern Art in the Common Culture*, Yale University Press, New Haven 1996, ch. 10. The essay in the form it appears here was first published in *October* in 1993.
42 Clement Greenberg, 'Review of Exhibitions of Hyman Bloom, David Smith, and Robert Motherwell', *The Nation*, 26 January 1946, in *The Collected Essays and Criticism. Volume 2, Arrogant Purpose, 1945–1949*, edited by John O'Brian, University of Chicago Press, Chicago 1986, pp. 51–2.
43 For the classical roots of pastoral, see David Rosand, 'Giorgione, Venice, and the Pastoral Vision', in The Phillips Collection, *The Pastoral Landscape: The Legacy of Venice and the Modern Vision*, Washington, DC 1988, p. 26.
44 William Empson, *Some Versions of Pastoral*, Penguin, London 1995, p. 17.
45 Ibid., p. 13.
46 Ibid., p. 19.
47 Ibid., p. 25.
48 Ibid., p. 19.
49 Ibid., p. 20.
50 For Crow, this is also one of the fundamental virtues of pastoral. See *Modern Art in the Common Culture*, p. 211.
51 Carl Freedman, 'Keith Coventry', *Frieze*, no. 35, 1997, p. 96.
52 Ibid., p. 95.
53 See Rut Blees Luxemburg, *London: A Modern Project*, Black Dog Publishing, London 1997.
54 See Izi Glover, 'Rut Blees Luxemburg Talks about her Photographs *Vertiginous Exhilaration* and *A Modern Project*', *The Slade Journal*, vol. 1, Summer 1997, p. 18.
55 Peter Richardson, 'Keith Coventry Interview', *Transcript*, vol. 3, no. 2, 1998, p. 62.
56 This point is made by Simon Morrissey, 'Insomniac Lens: Rut Blees Luxemburg's Urban Vision', *Portfolio*, no. 26, December 1997, p. 49.
57 New York is one of the exceptions to the general US model of urban development in which the centre is abandoned to the poor, while the suburbs are inhabited by the rich.
58 On crime and its control in Japan, see S.N. Eisendstadt, *Japanese Civilization: A Comparative View*, University of Chicago Press, Chicago 1995, ch. 5.
59 Empson, *Some Versions of Pastoral*, p. 14.

60 Gilbert and George/David Sylvester, 'I Tell You Where There's Irony in Our Work: Nowhere, Nowhere, Nowhere', *Modern Painters*, Winter 1997, p. 18.

61 On these issues, see Perry Anderson, *English Questions*, Verso, London 1992; E.P. Thompson, 'The Peculiarities of the English', in *The Poverty of Theory and Other Essays*, Merlin, London 1978; Ellen Meiksins Wood, *The Pristine Culture of Capitalism: A Historical Essay on Old Regimes and Modern States*, Verso, London 1991.

62 For a succinct discussion of gentrification, based on the work of David Harvey and others, see Rosalyn Deutsche, *Evictions: Art and Spatial Politics*, The MIT Press, Cambridge, Mass. 1996, pp. 14–16.

63 These have been published in a book: Gillian Wearing, *Signs that say what you want them to say and not Signs that say what someone else wants you to say*, Interim Art, London 1997.

64 August Sander, *Citizens of the Twentieth Century: Portrait Photographs, 1892–1952*, ed. Gunter Sander, The MIT Press, Cambridge, Mass. 1986.

65 Some of Wearing's *Signs* were reproduced in an 'exhibition' mounted in the pages of the homeless people's paper, *The Big Issue*. Since the pastoral effect is much dependent on the context of showing, there they probably had a more straightforward effect.

66 Richard Billingham, *Ray's a Laugh*, Scalo, Zurich 1996.

67 James Lingwood, 'Family Values' [interview with Richard Billingham], *Tate*, no. 15, Summer 1998, p. 54.

68 In Billingham's film, *Fishtank*, there is a similar contrast set up using a shot of wind blowing through trees. This, like the bird pictures, says Billingham, acts as a self portrait. See James Lingwood, 'Inside the Fishtank' [interview with Richard Billingham], *Tate*, no. 16, Winter 1998, p. 58.

69 Cited in Jojo Moyes, 'Son's Stark Portrait of Family at War', *Independent*, 28 August 1997.

70 Lingwood, 'Family Values', p. 56.

71 Lingwood, 'Inside the Fishtank', p. 58. Adrian Searle also draws attention to the unchanging character of the Billingham's family life. See 'Family Fortunes', *Frieze*, no. 44, 1999, p. 37.

72 See Will Hutton, *The State We're In*, Jonathan Cape, London 1995, pp. 105f.

73 For an analysis of the 'responsible' version of pastoral favoured in Britain in which hard agrarian labour was pictured as 'a form of relaxation', see David Solkin's text in Tate Gallery, *Richard Wilson: The Landscape of Reaction*, London 1982.

74 See, for instance, John Roberts, 'Pop Art, the Popular and British Art of the 1990s', in Duncan McCorquodale, Naomi Siderfin and Julian Stallabrass, eds, *Occupational Hazard: Critical Writing on Recent British Art*, Black Dog Publishing, London 1998.

75 Raphael Samuel, *Theatres of Memory. Volume II: Island Stories: Unravelling Britain*, ed. Alison Light, Verso, London 1998, p. 256.

76 T.J. Clark, *The Painting of Modern Life: Paris in the Art of Manet and his Followers*, Alfred A. Knopf, New York 1985, p. 237.

77 Ibid., p. 258.

78 Adrian Searle, 'Fools and Horses', *Frieze*, no. 8, January–February 1993, p. 17.

79 Crow, *Modern Art in the Common Culture*, p. 211.

80 Empson, *Some Versions of Pastoral*, p. 23.

81 See George Walden, 'Leave your Weapons at the Door. Democracy, State Modernism and the Official Embrace of the Arts', *London Review of Books*, 26 September 1997, p. 11.

82 Wyndham Lewis, 'Manifesto', *Blast*, no. 1, 29 June 1914, p. 11; Michael Corris, 'British? Young? Invisible? w/Attitude?', *Artforum*, vol. xxx, no. 9, May 1992, p. 106.

83 Empson, *Some Versions of Pastoral*, p. 17.

84 Richardson, 'Keith Coventry Interview', pp. 59–60, 62.

85 Peter Bürger, *Theory of the Avant-Garde*, trans. Michael Shaw, Manchester University Press, Manchester 1984.

9 The decline and fall of art criticism

 1 See, for instance, Maurice Berger, ed., *The Crisis of Criticism*, New York 1998. The contributions to this book look at the situation in the US and usefully cover criticism of film, literature, music and fashion as well as the visual arts. As in this essay, the view is frequently expressed that to confront the current crisis, criticism must broadly address the system in which art and criticism is produced. It also highlights the plight of critics who work with those arts that are also well-developed and powerful industries: film companies and fashion houses have no compunction about simply excluding disobedient critics from their events, thus ending their careers.

 2 Among the contributions that do attempt a wider view are articles by Simon Ford, Robert Garnett and Kitty Hauser. Details can be found in the list of references.

 3 See Matthew Collings, *Blimey! From Bohemia to Britpop: The London Artworld from Francis Bacon to Damien Hirst*, 21 Publishing, Cambridge 1997; Louisa Buck, *Moving Targets: A User's Guide to British Art Now*, Tate Gallery Publishing, London 1997. Collings's book has been discussed above in chapter 4.

 4 Jeffrey Kastner, 'Where's the Scene?', *Art Monthly*, no. 172, December 1993–January 1994, pp. 14–17.

 5 Iwona Blazwick, 'An Anatomy of the Interview', *Art Monthly*, no. 200, October 1996, p. 16.

 6 Stuart Morgan, 'Forbidden Images', *Frieze*, February 1996, p. 55.

 7 David Bowie, 'Super-Banalism and the Innocent Salesman', *Modern Painters*, Spring 1998, p. 27.

 8 David Barrett, 'Art Ain't Wot It Used To Be', *Art Monthly*, no. 200, October 1996, pp. 32–3.

 9 Karsten Schubert in Andrew Renton and Liam Gillick, eds, *Technique Anglaise: Current Trends in British Art*, Thames and Hudson/One-Off Press, London 1991, p. 15.

10 Lindsay Baker, 'The Beauty Bomber', *Guardian Weekend*, 2 May 1998, pp. 40–3.

11 For a recent examination of the role of art in business and the promotion of a commercially successful national culture, see Simon Ford and Anthony Davies, 'Art Capital', *Art Monthly*, no. 213, February 1998, pp. 1–4.

12 This passage follows the interpretation of David Harvey in *The Condition of Postmodernity: An Enquiry into the Origins of Cultural Change*, Blackwell, Oxford 1990.

13 See Gail Johnson, 'Pepsi Blue', *Adbusters*, no. 20, Winter 1998, pp. 13–14.

14 Brian Sewell, in an essay about the degraded condition of art criticism, makes the same point, noting that magazine illustrations are also paid for by dealers and promoters. See Brian Sewell, *The Reviews that Caused the Rumpus and Other Pieces*, Bloomsbury, London 1994, p. 4.

15 Ibid., p. 3.

16 Martin Maloney, 'The Chapman Bros. When Will I Be Famous', *Flash Art*, vol. xxix, no. 186, January–February 1996, p. 67.

17 The Chapman Bros., 'When Will I Be Infamous', advertisement, *Flash Art*, vol. xxix, no. 187, March–April 1996, p. 35.

18 Damien Hirst, *I Want to Spend the Rest of my Life Everywhere, with Everyone, One to One, Always, Forever, Now*, Booth-Clibborn Editions, London 1997, pp. 154–5. *Hanging Around* was shown at the Hayward Gallery's *Spellbound* exhibition in 1996.

19 On this long-term development see Ben H. Bagdikian, *The Media Monopoly*, Beacon Press, Boston 1992.

20 Memo reprinted in the *Matador Records Newsletter*, 6 March 1996.

21 The *Listener* ceased publication in 1991; the *New Statesman* is now a reliable mouthpiece of New Labour.

22 See Terry Eagleton, *The Function of Criticism: From the* Spectator *to Post-Structuralism*, Verso, London 1996, passim but especially ch. 4.

23 Sarah Kent, *Shark Infested Waters. The Saatchi Collection of British Art in the 90s*, Zwemmer, London 1994, p. 6. The reference is to Thomas McEvilley, 'Father the Void', in *Tyne International: A New Necessity*, Tyne International, Newcastle-upon-Tyne 1990, p. 134.

10 The future for high art lite

1 This is the concluding quotation from Sarah Lucas in Gordon Burn's article, 'Sister Sarah', *Guardian Weekend*, 23 November 1996, p. 33.

2 Stephen Jay Gould, *Wonderful Life*, Penguin, London 1991. The exhibition *Wonderful Life* was shown at the Lisson Gallery in 1993. See the review by James Odling Smee in *Art Monthly*, no. 170, October 1993, pp. 26–7.

3 Roger Caillois, 'Mimetisme et psychasthénie légendaire', *Minotaure*, no. 7, 1935, pp. 4–10; translated as 'Mimicry and Legendary Psychasthesia', *October*, no. 31, Winter 1984, pp. 17–32.

4 For this and other objections, see Stephen Jay Gould, 'Evolution: The Pleasures of Pluralism', *New York Review of Books*, 26 June 1997, pp. 47–52.

5 Charles Darwin, *The Origin of Species* [1859], Oxford University Press, Oxford 1996, p. 396.

6 Ibid., p. 66.

7 For various views of the end of art, see Fredric Jameson, '"End of Art" or 'End of History'?", in *The Cultural Turn: Selected Writings on the Postmodern, 1983–1998*, Verso, London 1997; Arthur C. Danto, *After the End of Art. Contemporary Art and the Pale of History*, Princeton University Press, New Jersey 1997; Jean Baudrillard, 'Aesthetic Illusion and Virtual Reality', in Baudrillard, *Art and Artefact*, edited by Nicholas Zurbrugg, Sage, London 1997.

8 Gavin Turk, cited in Sarah Kent, *Shark Infested Waters. The Saatchi Collection of British Art in the 90s*, Zwemmer, London 1994, p. 94. See also Carl Freedman/Gavin Turk, 'Making Omelettes', *Modern Painters*, Autumn 1998, p. 101.

9 Sarah Kent, *Shark Infested Waters*, p. 35.

10 Alan Sinfield, *Literature, Politics and Culture in Postwar Britain*, The Athlone Press, London 1997, pp. xiv–xvii; Irvine Welsh, *Trainspotting*, Minerva, London 1994.

11 Clement Greenberg, 'Avant Garde and Kitsch', in *Art and Culture: Critical Essays*, Beacon Press, Boston 1965, p. 8.

12 Malcolm Bull, 'The Ecstasy of Philistinism', *New Left Review*, no. 219, September–October 1996, pp. 22–41. Beech and Roberts' views were discussed in chapter 4.

13 See Bull, 'The Ecstasy of Philistinism', p. 39.

14 Susan Sontag, 'Notes on "Camp"', in *Against Interpretation* [1961], Vintage, London 1994, p. 277. Sontag also mentions in passing that there is a connection between 'Camp' and Empson's 'urban pastoral' (p. 279).

15 Ibid., p. 287.

16 Ibid., pp. 288–9.

17 Matthew Collings, *Blimey! From Bohemia to Britpop:The London Art World from Francis Bacon to Damien Hirst*, 21 Publishing, Cambridge 1997, p. 17.

18 Arnold, *Culture and Anarchy*, London 1998, p. 77; as cited in Perry Anderson, *English Questions*, Verso, London 1992, p. 126.

19 Eric Hobsbawm, *Behind the Times: The Decline and Fall of the Twentieth-Century Avant-Gardes*, Thames and Hudson, London 1998, p. 17.

20 Sarah Lucas, interview with Marco Spinelli, in Walker Art Center, *'Brilliant!' New Art from London*, Minneapolis 1995, p. 65.

21 Mat Collishaw, statement in Musée d'Art Moderne de la Ville de Paris, *Life/Live: La scène artistique au Royaume-Uni en 1996*, Paris 1997, artists' volume, p. 61.

22 See David Burrows, 'Exquisite Corpses', *Art Monthly*, no. 221, November 1998, p. 24.

23 See Paul Bonaventura, 'Turf Accounting' [interview with Mark Wallinger], *Art Monthly*, no. 175, April 1994, p. 3.

24 Mark Wallinger cited in Kent, *Shark Infested Waters*, p. 99.

25 Mark Wallinger cited ibid., p. 99.

26 For an eloquent example of this line of thinking, see Martha Rosler, 'In, Around, and Afterthoughts (On Documentary Photography)', in Richard Bolton, ed., *The Contest of Meaning. Critical Histories of Photography*, Cambridge, Mass. 1989.

27 Tim Jackson, 'Is this Real or is it Art?', *The Big Issue*, 31 August–7 September 1998.

28 Robert Yates, 'Diary', *Observer Review*, 6 September 1998.

29 See Landy interviewed by Douglas Fogle, in Walker Art Center, *'Brilliant!'*, p. 59.

30 For an account of this process, see Alison Jacques's essay in Waddington Galleries, *Michael Landy:The Making of Scrapheap Services*, London 1996.

31 Carl Freedman says that it was Landy's exhibition, *Market*, that lost so much money that it closed the company down. 'Space', in Deichtorhallen Hamburg, *Emotion:Young British and American Art from the Goetz Collection*, Cantz, Ostfildern-Ruit 1998, p. 76.

32 Landy interviewed by Douglas Fogle, in Walker Art Center, *'Brilliant!'*, p. 60.

33 Ibid., p. 59.

34 See Colin Gleadell, 'Spinning Jenny', *Art Monthly*, no. 233, February 1999, pp. 48–9

35 Raphael Samuel, 'Mrs Thatcher and Victorian Values', in Raphael Samuel, *Theatres of Memory. Volume II: Island Stories: Unravelling Britain*, ed. Alison Light, Verso, London 1998, p. 346.

36 As cited in Dan Glaister, 'Royal Opera "Giving Arts a Bad Name"', *Guardian*, 15 October 1998.

37 See the account of Robinson's speech in the *Guardian* leader, 'Arts Uplifted. Gerry Robinson has Vision', 15 October 1998.

38 On the difficulties of getting sponsorship for a US showing of *Sensation*, see Carol Vogel, 'British Outrage Heads for Brooklyn', *New York Times*, 8 April 1999.

39 See Kim Moody, *Workers in a Lean World: Unions in the International Economy*, Verso, London 1997.

40 Collings, *Blimey!*, p. 206.

41 Bryan Robertson, 'Something is Rotten in the State of Art', *Modern Painters*, Winter 1997, p. 16.

42 Ibid., p. 16.

43 For an account of the dilemma that Weberian administered life poses for aesthetic theory,

see J.M. Bernstein, 'Against Voluptuous Bodies: Of Satiation Without Happiness', *New Left Review*, no. 225, September–October 1997, pp. 90f.

44 CCC, *Angela Bulloch*, CCC, Tours 1994, p. 14.
45 David Bussel, 'Who Controls What? Interview with Angela Bulloch', in Sammlung Goetz, *Art from the UK*, Kunstverlag Ingvild Goetz, Munich 1998, p. 31.
46 Ben Judd, 'Gillian Wearing' [interview], *Untitled*, no. 12, Winter 1996–97, p. 5; reprinted in Russell Ferguson, Donna de Salvo and John Slyce, *Gillian Wearing*, Phaidon, London 1999, p. 125.
47 For a general account of Wearing's art, see Russell Ferguson, 'Survey', in Russell Ferguson et al., *Gillian Wearing*.
48 Angela Bulloch, *Satellite: Angela Bulloch*, Museum für Gegenwartskunst, Zurich 1998, p. 60.
49 Stendhal, *The Charterhouse of Parma* [1839], trans. C.K. Scott Moncrieff, Chatto and Windus, London 1931, p. 447.

References

Books and exhibition catalogues

Theodor W. Adorno, *The Culture Industry: Selected Essays on Mass Culture*, ed. J.M. Bernstein, Routledge, London 1991.

Aijaz Ahmad, *In Theory: Classes, Nations, Literatures*, Verso, London 1992.

Keith Alexander, ed., *Date with an Artist*, BBC Education Production, London 1997.

Perry Anderson, *English Questions*, Verso, London 1992.

Perry Anderson, *The Origins of Postmodernity*, Verso, London 1998.

Matthew Arnold, *Culture and Anarchy* [1865], ed. Samuel Lipman, Yale University Press, New Haven 1994.

Ben H. Bagdikian, *The Media Monopoly*, Beacon Press, Boston 1992.

Bank, *Press Release*, Gallerie Poo Poo, London 1998.

Fiona Banner, *The Nam*, Frith Street Books, London 1997.

Roland Barthes, *Image, Music, Text*, trans. Stephen Heath, Fontana, London 1977.

Georges Bataille, *The Tears of Eros*, City Lights, New York 1989.

Georges Bataille, *Visions of Excess. Selected Writings, 1927–1939*, ed. by Allan Stoekel, Manchester 1985.

Charles Baudelaire, *Art in Paris, 1845–1862: Salons and Other Exhibitions*, trans. Jonathan Mayne, Phaidon, London 1965.

Jean Baudrillard, *Art and Artefact*, ed. by Nicholas Zurbrugg, Sage, London 1997

Beaconsfield, *Cottage Industry*, London 1995.

John Berger, *A Painter of Our Time* [1958], Penguin, Harmondsworth, Middlesex 1965.

Maurice Berger, ed., *The Crisis of Criticism*, The New Press, New York 1998.

Patricia Bickers, *The Brit Pack: Contemporary British Art, the View from Abroad*, Cornerhouse, Manchester 1995.

Richard Billingham, *Ray's a Laugh*, Scalo, Zurich 1996.

Rut Blees Luxemburg, *London: A Modern Project*, text by Michael Bracewell, Black Dog Publishing, London 1997.

Richard Bolton, ed., *The Contest of Meaning. Critical Histories of Photography*, Cambridge, Mass. 1989.

Yve-Alain Bois, *Painting as Model*, The MIT Press, Cambridge, Mass. 1990.

Henry Bond, *The Cult of the Street*, Emily Tsingou Gallery, London 1998.

Maria Lluisa Borràs, *Picabia*, Thames and Hudson, London 1985.

Pierre Bourdieu, *Distinction. A Social Critique of the Judgement of Taste*, trans. Richard Nice, Routledge, London 1984.

Pierre Bourdieu and Alain Darbel with Dominique Schnapper, *The Love of Art. European Art Museums and their Public*, trans. Caroline Beattie and Nick Merriman, Polity Press, Cambridge 1991.

Pierre Bourdieu and Hans Haacke, *Free Exchange*, Polity Press, Cambridge 1995.

British Council, *Dimensions Variable: New Works for the British Council Collection*, London 1997.

British Council, *General Release:Young British Artists at Scuola di San Pasquale*,Venice 1995.

Louisa Buck, *MovingTargets:A User's Guide to British Art Now*,Tate Gallery Publishing, London 1997.

Louisa Buck and Philip Dodd, *Relative Values, or, What's Art Worth?*, BBC Books, London 1991.

Building One, *Gambler*, London n.d. [1990].

Building One, *Modern Medicine*, London n.d. [1990].

Angela Bulloch, *Satellite:Angela Bulloch*, Museum für Gegenwartskunst, Zurich 1998.

Peter Bürger, *Theory of the Avant-Garde*, trans. Michael Shaw, Manchester University Press, Manchester 1984.

Gordon Burn, *Happy Like Murderers*, Faber, London 1998.

David Burrows, ed., *Who's Afraid of Red White & Blue:Attitudes to Popular and Mass Culture, Celebrity,Alternative & Critical Practice & Identity Politics in Recent British Art*, University of Central England/ARTicle Press, 1998

Virginia Button, *The Turner Prize*,Tate Gallery Publishing, London 1997.

Camerawork, *Half-Lit World: Rod Dickinson Selected Works, 1991–1998*, London 1998.

CCC, *Angela Bulloch*, CCC,Tours 1994.

Anthony Caro, *The Trojan War. Sculptures by Anthony Caro*, Lund Humphries, London 1994.

Eddie Chambers, *Run Through the Jungle: Selected Writings*, INIVA, London 1999.

Jake and Dinos Chapman, *Chapmanworld*, Institute of Contemporary Arts, London 1996.

Chisenhale Gallery, *Sam Taylor-Wood*, London 1996.

Chisenhale Gallery, *Simon Patterson*, London 1994.

T.J. Clark, *The Painting of Modern Life: Paris in the Art of Manet and his Followers*, Alfred A. Knopf, New York 1985.

Claudia Gian Ferrari Arte Contemporanea, *Martin Maloney: Conversation Pieces*, Milan 1998.

Matthew Collings, *Blimey! From Bohemia to Britpop:The London Art World from Francis Bacon to Damien Hirst*, 21 Publishing, Cambridge 1997.

Contemporary Visual Arts, special issue, *Other British Artists:Art Beyond the yBas*, no. 17, 1997.

Thomas Crow, *Modern Art in the Common Culture*,Yale University Press, New Haven 1996.

Arthur C. Danto, *After the End of Art. Contemporary Art and the Pale of History*, Princeton University Press, New Jersey 1997.

Charles Darwin, *The Origin of Species* [1859], Oxford University Press, Oxford 1996.

Deichtorhallen Hamburg, *Emotion:Young British and American Art from the Goetz Collection*, Cantz, Ostfildern–Ruit 1998.

Rosalyn Deutsche, *Evictions:Art and Spatial Politics*,The MIT Press, Cambridge, Mass. 1996.

Terry Eagleton, *The Function of Criticism: From the Spectator to Post-Structuralism*, Verso, London 1996.

Terry Eagleton, *The Illusions of Postmodernism*, Blackwell, Oxford 1996.

S.N. Eisendstadt, *Japanese Civilization: A Comparative View*, University of Chicago Press, Chicago 1995.

Larry Elliott and Dan Atkinson, *The Age of Insecurity*,Verso, London 1998.

William Empson, *Some Versions of Pastoral*, Penguin, London 1995.

Daniel Farson, *With Gilbert and George in Moscow*, Bloomsbury, London 1991.

Ferens Art Gallery, *History: The Mag Collection: Image-Based Art in Britain in the Late Twentieth Century*, Kingston upon Hull City Museums, Art Galleries and Archives, 1997.

Russell Ferguson, Donna de Salvo and John Slyce, *Gillian Wearing*, Phaidon, London 1999.

Michel Foucault, *Aesthetics, Method and Epistemology* (Essential Works of Michel Foucault, vol. 2), ed. James Faubion, Allen Lane, London 1998.

Freeze, exhibition catalogue, London 1988.

Sigmund Freud, *Art and Literature*, Penguin Books, London 1985.

Peter Fuller, *Beyond the Crisis in Art*, Writers and Readers, London 1980.

Margaret Garlake, *New Art New World: British Art in Postwar Society*, Yale University Press, New Haven 1998.

Tony Godfrey, *Conceptual Art*, Phaidon, London 1998.

Stephen Jay Gould, *Wonderful Life*, Penguin, London 1991.

Clement Greenberg, *Art and Culture: Critical Essays*, Beacon Press, Boston 1965.

Clement Greenberg, *The Collected Essays and Criticism. Volume 2, Arrogant Purpose, 1945–1949*, edited by John O'Brian, University of Chicago Press, Chicago 1986.

Charles Harrison, *English Art and Modernism, 1900–1939*, Allen Lane, London 1981.

David Harvey, *The Condition of Postmodernity: An Enquiry into the Origins of Cultural Change*, Blackwell, Oxford 1990.

Hayward Gallery, *Unbound: Possibilities of Painting*, London 1994.

Hayward Gallery, *Spellbound: Art and Film*, London 1996.

Damien Hirst, *I Want to Spend the Rest of my Life Everywhere, with Everyone, One to One, Always, Forever, Now*, Booth-Clibborn Editions, London 1997.

Eric Hobsbawm, *Behind the Times: The Decline and Fall of the Twentieth-Century Avant-Gardes*, Thames and Hudson, London 1998.

John Hutchinson, E.H. Gombrich and Lela B. Njatin, *Antony Gormley*, Phaidon, London 1995.

Will Hutton, *The State We're In*, Jonathan Cape, London 1995.

Paola Igliori, *Entrails, Heads and Tails*, Rizzoli, New York 1992.

Ikon Gallery, *Mark Wallinger*, Birmingham 1995.

Ikon Gallery, *Out of Here: Creative Collaborations Beyond the Gallery*, Birmingham 1998.

Institute of Contemporary Arts, *Abigail Lane*, London 1995.

Institute of Contemporary Arts, *Damien Hirst*, London 1991.

Institute of Contemporary Arts, *Die Young Stay Pretty*, London 1998.

Institute of Contemporary Arts, *Steve McQueen*, London 1999.

Institute of Contemporary Arts, *Steven Pippin: The Rigmarole of Photography*, London 1993.

Institute of Contemporary Arts/Jay Jopling, *Damien Hirst*, London 1991.

Jablonka Galerie, *Damien Hirst*, Cologne 1994.

Fredric Jameson, *The Cultural Turn: Selected Writings on the Postmodern, 1983–1998*, Verso, London 1998.

Fredric Jameson, *Postmodernism, or, the Cultural Logic of Late Capitalism*, Verso, London 1991.

Martin Jay, *Cultural Semantics: Keywords of Our Time*, The Athlone Press, London 1998.

Jay Jopling/White Cube, *Tracey Emin*, London 1998.

Sarah Kent, *Shark Infested Waters. The Saatchi Collection of British Art in the 90s*, Zwemmer, London 1994.

James Lingwood, ed., *Rachel Whiteread: House*, Phaidon, London 1995.

Jean-François Lyotard, *The Postmodern Condition: A Report on Knowledge*, trans. Geoff Bennington and Brian Massumi, University of Manchester Press, Manchester 1984.

Herbert Marcuse, *One-Dimensional Man* [1964], Routledge, London 1991.

Karl Marx, *Capital: A Critique of Political Economy, Volume I*, Penguin, London 1990.

Duncan McCorquodale, Naomi Siderfin and Julian Stallabrass, eds, *Occupational Hazard: Critical Writing on Recent British Art*, Black Dog Publishing, London 1998.

Kim Moody, *Workers in a Lean World: Unions in the International Economy*, Verso, London 1997.

Musée d'Art Moderne de la Ville de Paris, *Life/Live: La scène artistique au Royaume-Uni en 1996*, Paris 1997, 2 vols.

Musée National d'Art Moderne, *Magiciens de la Terre*, Paris 1989.

Museum of Contemporary Art, Sydney, *Pictura Britannica: Art from Britain*, Sydney 1997.

Museum Ludwig, *Sarah Lucas: Car Park*, Oktagon Verlag, Cologne 1997.

Museum of Modern Art, Oxford, *About Vision: New British Painting in the 1990s*, Oxford 1996.

Tom Nairn, *The Enchanted Glass: Britain and its Monarchy*, Vintage, London 1994.

Terry A. Neff, ed., *A Quiet Revolution: British Sculpture Since 1965*, Thames and Hudson, London 1987.

Tim Noble and Sue Webster, *British Rubbish*, The Independent Art Space, London 1996.

Tim Noble and Sue Webster, *The New Barbarians*, Modern Art Inc., London 1999.

Nikolaus Pevsner, *The Englishness of English Art*, Penguin Books, London 1964.

The Phillips Collection, *The Pastoral Landscape: The Legacy of Venice and the Modern Vision*, Washington, DC 1988.

Portikus, *Sarah Lucas*, Frankfurt am Main 1996.

Marc Quinn, *Incarnate*, Gagosian Gallery, New York 1998.

Andrew Renton and Liam Gillick, eds, *Technique Anglaise: Current Trends in British Art*, Thames and Hudson/One-Off Press, London 1991.

Royal Academy of Arts, *Sensation: Young British Artists from the Saatchi Collection*, Royal Academy of Arts/Thames and Hudson, London 1997.

Ralph Rugoff, with Anthony Vidler and Peter Wollen, *Scene of the Crime*, The MIT Press, Cambridge, Mass. 1997.

The Saatchi Gallery, *Art of Our Time: The Saatchi Collection*, Lund Humphries, London 1984.

The Saatchi Gallery, *Fiona Rae, Gary Hume*, London 1997.

The Saatchi Gallery, *The New Neurotic Realism*, London 1998.

Sammlung Goetz, *Art from the UK*, Kunstverlag Ingvild Goetz, Munich 1998.

Raphael Samuel, *Theatres of Memory. Volume II: Island Stories: Unravelling Britain*, ed. Alison Light, Verso, London 1998.

August Sander, *Citizens of the Twentieth Century: Portrait Photographs, 1892–1952*, ed. Gunter Sander, The MIT Press, Cambridge, Mass. 1986.

Andrea Schlieker and Henry Bond, eds, *Exhibit A: Eight Artists from Europe and America*, Serpentine Gallery, London 1992, vol. 2.

Serpentine Gallery, *Barclays Young Artist Award 1991*, London 1991.

Serpentine Gallery, *Broken English*, London 1991.

Serpentine Gallery, *Mariko Mori*, London 1998.

Serpentine Gallery, *Some Went Mad, Some Ran Away ...*, London 1994.

Brian Sewell, *An Alphabet of Villains*, Bloomsbury, London 1995.

Brian Sewell, *The Reviews that Caused the Rumpus and Other Pieces*, Bloomsbury, London 1994.

Martin Sexton and Paul Hitchman, *We Love You*, Booth-Clibborn Editions, London 1998.

Johnnie Shand Kydd, *Spit Fire: Photographs from the Art World, London 1996/97*, Thames and Hudson, London 1997.

Richard Shone, *Bloomsbury Portraits: Vanessa Bell, Duncan Grant and their Circle*, Phaidon, London 1993.

Alan Sinfield, *Literature, Politics and Culture in Postwar Britain*, The Athlone Press, London 1997.

Chris Smith, *Creative Britain*, Faber and Faber, London 1998.

Susan Sontag, *Against Interpretation* [1961], Vintage, London 1994.

South Bank Centre, *The British Art Show 1990*, London 1990.

South Bank Centre, *The British Art Show 4*, London 1995.

South Bank Centre, *Material Culture: The Object in British Art in the 1980s and '90s*, London 1997.

South London Gallery, *Minky Manky*, London 1995.

Southampton City Art Gallery/Serpentine Gallery, *Chris Ofili*, Southampton 1998.

Southampton City Art Gallery, *Real Art. A 'New Modernism'. British Reflexive Painters in the 1990s*, Southampton 1995.

Stedelijk Museum, *Wild Walls*, Amsterdam 1995.

Stendhal, *The Charterhouse of Parma* [1839], trans. C.K. Scott Moncrieff, Chatto and Windus, London 1931.

Tate Gallery, *Bill Woodrow: Fool's Gold*, London 1996.

Tate Gallery, *Richard Wilson: The Landscape of Reaction*, London 1982.

Tate Gallery, *The Turner Prize 1995*, booklet, London 1995.

Tate Gallery, Liverpool, *New Contemporaries*, Liverpool 1996.

E.P. Thompson, *The Poverty of Theory and Other Essays*, Merlin, London 1978.

Tochigi Prefectural Museum of Fine Arts, *Real/Life: New British Art*, The Asahi Shimbun, Japan 1998.

Calvin Tomkins, *Duchamp: A Biography*, Chatto and Windus, London 1997.

Gavin Turk, *Gavin Turk: Collected Works 1994–1998*, Jay Jopling, London 1998.

Eric Underwood, *A Short History of English Painting*, Faber & Faber, London 1933.

Waddington Galleries, *Fiona Rae*, London 1991.

Waddington Galleries, *Fiona Rae*, London 1995.

Waddington Galleries, *Ian Davenport: New Paintings*, London 1996.

Waddington Galleries, *Michael Landy: The Making of Scrapheap Services*, London 1996.

Waddington Galleries, *Zebedee Jones: New Paintings*, London 1998.

Walker Art Center, *'Brilliant!' New Art from London*, Walker Art Center, Minneapolis 1995.

Gillian Wearing, *Signs that say what you want them to say and not Signs that say what someone else wants you to say*, Interim Art, London 1997.

Irvine Welsh, *Trainspotting*, Minerva, London 1994.

Samantha Wilkinson, ed., *Locus+, 1993–1996*, Locus+, Newcastle-upon-Tyne 1996.

Ellen Meiksins Wood, *The Pristine Culture of Capitalism: A Historical Essay on Old Regimes and Modern States*, Verso, London 1991.

Chin-tao Wu, *Privatising Culture: Aspects of Corporate Art Intervention in Contemporary Art and Art Institutions during the Reagan and Thatcher Decade*, PhD thesis, University of London, 1997.

Essays, reviews and newspaper articles

Anon., 'Academy is Now Dead, says Craigie', *Evening Standard*, 19 September 1997.

Anon., 'Arse Council', *The Bank*, 17 December 1997.

Anon., 'Arts Uplifted. Gerry Robinson has Vision', *Guardian*, 15 October 1998.

Anon., 'Exhibited by the Royal Academy in the So-called Name of Art, Defaced by the People in the Name of Common Decency', *Mirror*, 19 September 1997.

Anon., 'Gavin Turk', *Frieze*, no. 1, 1991, p. 12.

Anon., 'Gavin Turk: The Stuff Show', *Evening Standard*, 10 October 1998.

Anon., 'How Can this Pile of Sh*t be Worth £25,000?', *Sport*, 19 September 1997.

Anon., 'Irony Man in R.S.I. Eyebrow and Wink Action', *The Bank*, no. 32, 23 December 1997, n.p.

Anon., 'LAB-otomy', *The Bank*, 21 December 1997.

Anon., McCann Erickson memo reprinted in the *Matador Records Newsletter*, 6 March 1996.

Anon., 'Mother's Fury at Myra "Art"', *Daily Mail*, 26 July 1997.

Anon. (editorial statement), 'An Overwhelming Sensation?', *Modern Painters*, Autumn 1997, p. 27.

Anon., 'Patterson: One Idea, Eight Years', *The Bank*, no. 3, 22 September 1996, n.p.

Anon., 'Saatchi Gives Modern Works to Arts Council', *Guardian*, 10 February 1999.

Anon., 'The Saatchi Collection', *Galleries*, October 1997.

Anon., 'Why Bother?', *The Bank*, no. 14, 23 March 1997, n.p.

Alexandra Anderson-Spivy, 'The Freeze Generation and Beyond', *Art Journal*, vol. 57, no. 3, Fall 1998, pp. 88–91.

Michael Archer, 'Piss and Tell', *Art Monthly*, no. 172, December 1993–January 1994, pp. 18–19.

Jerry Armstrong and Paul Byrne, 'Artless: Fury at Child-Fingerprint Portrait of Monster Myra', *Mirror*, 26 July 1997.

Lindsay Baker, 'The Beauty Bomber', *Guardian Weekend*, 2 May 1998, pp. 40–3.

David Barrett, 'Art Ain't Wot It Used To Be', *Art Monthly*, no. 200, October 1996, pp. 32–3.

David Barrett, 'Fiona Banner/Matthew Higgs/Jaki Irvine/Frieda Munro', *Art Monthly*, no. 184, March 1995, p. 27–8.

David Barrett, 'Henry Bond', *Art Monthly*, no. 217, June 1998, pp. 33–4.

David Barrett, 'Zombie Golf', *Frieze*, no. 24, October 1995, pp. 74–5.

David Batchelor, 'Living in a Material World', *Frieze*, no. 35, 1997, pp. 47–8.

Andy Beckett, 'Shock Art to Shop Art', *Guardian*, 28 August 1997.

Dave Beech, 'Chill Out', *Everything*, no. 20, 1996, pp. 5–7.

Dave Beech and John Roberts, 'Spectres of the Aesthetic', *New Left Review*, no. 218, July–August 1996, pp. 102–27.

Dave Beech and John Roberts, 'Tolerating Impurities: An Ontology, Genealogy and Defence of Philistinism, *New Left Review*, no. 227, January–February 1998, pp. 45–71.

J.M. Bernstein, 'Against Voluptuous Bodies: Of Satiation Without Happiness', *New Left Review*, no. 225, September–October 1997, pp. 89–104.

Patricia Bickers, 'Sense and Sensation', *Art Monthly*, no. 211, November 1997, pp. 1–6.

Patricia Bickers, 'Let's Get Physical' [interview with Steve McQueen], *Art Monthly*, no. 202, December 1996–January 1997, pp. 1–5.

Iwona Blazwick, 'An Anatomy of the Interview', *Art Monthly*, no. 200, October 1996, pp. 15–16.

Iwona Blazwick, 'Douglas Gordon', *Art Monthly*, no. 183, February 1995, pp. 34–6.

Paul Bonaventura, 'Turf Accounting' [interview with Mark Wallinger], *Art Monthly*, no. 175, April 1994, pp. 3–7.

Lionel Bovier, 'Definitely Something' [Gary Hume], *Parkett*, no. 48, 1996, pp. 19–21.

Andrew Bowie, 'Confessions of a "New Aesthete": A Response to the "New Philistines"', *New Left Review*, no. 225, September–October 1997, pp. 105–26.

David Bowie, 'It's Art, Jim, But As We Know It' [interview with Tracey Emin], *Modern Painters*, Autumn 1997, pp. 24–32.

David Bowie, '(s)Now' [interview with Damien Hirst], *Modern Painters*, Summer 1996, pp. 36–9.

David Bowie, 'Super-Banalism and the Innocent Salesman', *Modern Painters*, Spring 1998, pp. 27–34.

Jamie Brassett and Lorraine Gamman, 'The Art of Mutation', *Make*, no. 79, March–May 1998, pp. 9–11.

Andrew Brighton, 'Command Performance', *Guardian*, 12 April 1999, pp. 12–13.

Neal Brown, 'Tim Noble and Sue Webster', *Frieze*, no. 30, 1996, pp. 84–5.

Malcolm Bull, 'The Ecstasy of Philistinism', *New Left Review*, no. 219, September–October 1996, pp. 22–41.

Julie Burchill, 'Death of Innocence', *Guardian*, 12 November 1997.

Gordon Burn, 'The Height of the Morbid Manner', *Guardian Weekend*, 6 September 1997.

Gordon Burn, 'I Want it, I Want it All, and I Want it Now', *Guardian*, 7 December 1998, section 2, pp. 2–3.

Gordon Burn, 'Sister Sarah', *Guardian Weekend*, 23 November 1996, pp. 26–33.

David Burrows, 'Ade Adekola/Yinka Shonibare/Mark Wallinger', *Art Monthly*, no. 203, February 1997, pp. 31–2.

David Burrows, 'Exquisite Corpses' [Gavin Turk], *Art Monthly*, no. 221, November 1998, pp. 24–5.

Stephen Bury, 'The Nam', *Art Monthly*, no. 207, June 1997, p. 46.

Roger Caillois, 'Mimetisme et psychasthénie légendaire', *Minotaure*, no. 7, 1935, pp. 4–10; translated as 'Mimicry and Legendary Psychasthesia', *October*, no. 31, Winter 1984, pp. 17–32.

Eddie Chambers, 'Review Publications', *AN Magazine*, June 1998, pp. 23–5.

Eddie Chambers, 'Whitewash', *Art Monthly*, no. 205, April 1997, pp. 11–12.

The Chapman Bros., 'When Will I Be Infamous', advertisement, *Flash Art*, vol. xxix, no. 187, March–April 1996, p. 35.

Matthew Collings, 'Is it Gleaming or is it Abject?', *Modern Painters*, Autumn 1998, pp. 82–4.

Matthew Collings, '"Sensation". Royal Academy of Arts', *Artforum*, January 1998, pp. 94–5.

Richard Cork, 'The Establishment Clubbed', *The Times*, 16 September 1997.

Michael Corris, 'British? Young? Invisible? w/Attitude?', *Artforum*, vol. xxx, no. 9, May 1992, p. 106.

Michael Corris, 'The Triumphant Moment: A Research Program for the Future, Now that "Young British Art" is Dead as a Theoretical Concept or as a Means of Developing Frameworks Influencing How We Make and Think about Art', *Magazyn Sztuki*, no. 18, February 1998, pp. 102–33.

Adrian Dannatt, 'Gary Hume: The Luxury of Doing Nothing', *Flash Art*, no. 183, Summer 1995, pp. 96–9.

Paul Dave, 'The Bourgeois Paradigm and Heritage Cinema', *New Left Review*, no. 224, July–August 1997, pp. 111–26.

Richard Dorment, 'Sensation? What Sensation?', *Daily Telegraph*, 17 September 1997.

Barbara Ellen, 'Hindley and the Appeal of the Cynical', *Observer*, 14 September 1997.

Christopher Elliott, 'Withdraw Portrait of Me, Urges Hindley', *Guardian*, 31 July 1997.

Tracey Emin, 'School of Scandal', *The Face*, November 1997.

Simon Ford, 'Myth Making', *Art Monthly*, no. 194, March 1996, pp. 3–9.

Simon Ford and Anthony Davies, 'Art Capital', *Art Monthly*, no. 213, February 1998, pp. 1–4.

Boris Frankel, 'Beyond Labourism and Socialism: How the Australian Labor Party Developed the Model of "New Labour"', *New Left Review*, no. 221, January–February 1997, pp. 3–33.

David Frankel, 'Steve McQueen', *Artforum*, November 1997, pp. 102–3.

Carl Freedman, 'About David Sylvester', *Frieze*, no. 30, 1996, pp. 46–9.

Carl Freedman, 'Keith Coventry', *Frieze*, no. 35, 1997, pp. 95–6.

Carl Freedman, 'Jake and Dinos Chapman', *Frieze*, no. 11, Summer 1993, pp. 50–1.

Carl Freedman, 'Living in a Material World', *Frieze*, no. 35, 1997, pp. 47, 49.

Carl Freedman, 'Mat Collishaw', *Frieze*, no. 37, 1997, p. 79.

Carl Freedman/Gavin Turk, 'Making Omelettes', *Modern Painters*, Autumn 1998, pp. 99–101.

Simon Frith and Jon Savage, 'Pearls and Swine: The Intellectuals and the Mass Media', *New Left Review*, no. 198, March–April 1993, pp. 107–16.

Peter Fuller, 'The Lady's Not for Turner', *Art Monthly*, no. 82, December 1984–January 1985, pp. 2–6.

Robert Garnett, 'Beyond the Hype', *Art Monthly*, no. 195, April 1996, pp. 43–4.

Robert Garnett, 'The Charge of the Light Brigade/John Timberlake', *Art Monthly*, no. 191, November 1995, pp. 26–8.

Robert Garnett, 'Die Young Stay Pretty', *Art Monthly*, no. 22, December 1998–January 1999, pp. 39–40.

Robert Garnett, 'Gimme More', *Art Monthly*, no. 211 November 1997, pp. 40–1.

Robert Garnett, 'Young British Artists IV', *Art Monthly*, no. 187, June 1995, pp. 31–3.

Amelia Gentleman, 'Hirst's Prescription Falls Foul of the Pharmacists', *Guardian*, 9 September 1998.

Gilbert and George/David Sylvester, 'I Tell You Where There's Irony in Our Work: Nowhere, Nowhere, Nowhere', *Modern Painters*, Winter 1997, pp. 18–25.

Liam Gillick, 'When are you Leaving?', *Art and Design*, 1995, special issue *British Art – Defining the 1990s*, pp. 77–81.

Mark Gisbourne, 'Life into Art' [interview with Tracey Emin], *Contemporary Visual Arts*, no. 20, 1998, pp. 28–34.

Dan Glaister, Royal Opera "Giving Arts a Bad Name"', *Guardian*, 15 October 1998.

Dan Glaister, 'Saatchi Agency "Stole My Idea"', *Guardian*, 2 March 1999.

Colin Gleadell, 'Crisis, What Crisis?', Art Monthly, no. 204, March 1997, pp. 52–3.

Colin Gleadell, 'Formaldehyde Blues', *Art Monthly*, no. 221, November 1998, pp. 48–9.

Colin Gleadell, 'Market Measures', *Art Monthly*, no. 200, October 1996, pp. 74–5.

Colin Gleadell, 'Sotheby's Woos Young Brits', *Art Monthly*, no. 206, May 1997, p. 45.

Colin Gleadell, 'Spinning Jenny', *Art Monthly*, no. 233, February 1999, pp. 48–9.

Izi Glover, 'Rut Blees Luxemburg Talks about her Photographs *Vertiginous Exhilaration* and *A Modern Project*', *The Slade Journal*, vol. 1, Summer 1997, pp. 14–20.

Graham Goodkind, 'Hirst Criticisms Put the Royal Academy Firmly in the Picture', *PR Week*, 19 September 1997.

Richard Gott, 'Sexual In-tent' [Tracey Emin], *Guardian Weekend*, 5 April 1997, pp. 26–33.

Richard Gott, 'Where the Art is', *Guardian Weekend*, 7 October 1995, pp. 36–47.

Stephen Jay Gould, 'Evolution: The Pleasures of Pluralism', *New York Review of Books*, 26 June 1997, pp. 47–52.

Simon Grant, 'Abigail Lane', *Art Monthly*, April 1995, pp. 33–4.

Sarah Greenberg, 'All the Rage', *Tate*, no. 14, Spring 1998, pp. 54, 57–8.

Sarah Greenberg and Andrew Wilson, 'Art Gets in Your Face', *Tate*, no. 2, Spring 1994, 54–7.

Anthea Guthrie, 'Royal Academy Chief Blasts its Irrelevant, Ageing Artists', *The Observer*, 14 September 1997.

Mark Harris, 'Angus Fairhurst', *Art Monthly*, no. 202, December 1996–January 1997, pp. 24–5.

Mark Harris, 'Like a Dog Biting its own Tail', *Make*, no. 79, March–May 1998, pp. 15–16.

Kitty Hauser, 'Sensation. Young British Artists from the Saatchi Collection', *New Left Review*, no. 227, January–February 1998, pp. 154–60.

Mark Honigsbaum and Chris Blackhurst, 'Royal Academy Warned of Acting as a Dealer for Saatchi', *Independent on Sunday*, 14 September 1997.

Georgie Hopton, 'Interview: Fiona Rae', *Transcript*, vol. 3, no. 2, 1998, pp. 67–76.

Ian Hunt, 'Sarah Lucas', *Art Monthly*, no. 207, June 1997, pp. 35–6.

Tim Jackson, 'Is this Real or is it Art?', *The Big Issue*, 31 August–7 September 1998.

Waldemar Januszczak, 'Facing the Scary', *Sunday Times*, 21 September 1997.

Lisa Jardine, 'How One Man Decides What is Good for Art', *Daily Telegraph*, 18 September 1997.

Rose Jennings, 'Liquid Engineering', *Frieze*, no. 2, 1991, pp. 30–1.

Gail Johnson, 'Pepsi Blue', *Adbusters*, no. 20, Winter 1998, pp. 13–14.

Paul Johnson, 'An Obscene Picture and the Question: Will Decency or Decadence Triumph in British Life?', *Daily Mail*, 20 September 1997.

Jeffrey Kastner, 'Where's the Scene?', *Art Monthly*, no. 172, December 1993–January 1994, pp. 14–17.

John Kay, 'It's an Artrage', *Sun*, 26 July 1997.

Sarah Kent, 'Rogue's Gallery', *Time Out*, 24 September 1997.

William Leith, 'Avoiding the Sharks' [Damien Hirst], *Observer Life Magazine*, 12 February 1999, pp. 12–16.

Wyndham Lewis, 'Manifesto', *Blast*, no. 1, 29 June 1914, pp. 11–28.

Rosanna de Lisle and Annabelle Auerbach, 'The New Establishment', *Independent*, 31 August 1997.

James Lingwood, 'Family Values' [interview with Richard Billingham], *Tate*, no. 15, Summer 1998, pp. 54–8.

See James Lingwood, 'Inside the Fishtank' [interview with Richard Billingham], *Tate*, no. 16, Winter 1998, pp. 54–8.

David Lister, 'Hirst Snubs "Fat, Stuffy, Pompous" Royal Academy'; *Independent*, 10 September 1997.

Tom Lubbock, 'Who are they Pointing at?', *Independent*, 18 September 1997.

Marianne Macdonald, 'Shark Operator', *Observer Life Magazine*, 31 August 1997.

Martin Maloney, 'The Chapman Bros. When Will I Be Famous', *Flash Art*, vol. xxix, no. 186, January–February 1996, pp. 64–7.

Martin Maloney, 'Dung and Glitter', *Modern Painters*, Autumn 1998, pp. 41–2.

Ameena Meer, 'Island Stories: Interview with Keith Piper', *Frieze*, no. 6, September–October 1992, pp. 42–5.

Kobena Mercer, 'Art That is Ethnic in Inverted Commas' [Yinka Shonibare], *Frieze*, no. 25, November–December 1995, pp. 39–41.

Catherine Milner, 'A Shy Man' [Charles Saatchi], *Sunday Telegraph*, 23 July 1997.

Stuart Morgan, 'Confessions of a Body Snatcher' [Glenn Brown], *Frieze*, no. 12, October–November 1993, pp. 52–5.

Stuart Morgan, 'The Elephant Man' [Chris Ofili], *Frieze*, no. 15, March–April 1994, pp. 40–3.

Stuart Morgan, 'Forbidden Images' [Mat Collishaw], *Frieze*, no. 26, January-February 1996, pp. 52–6.

Stuart Morgan, 'Semen's Mission', *Art Monthly*, no. 153, February 1992, pp. 5–7.

Stuart Morgan, 'The Story of I' [Tracey Emin], *Frieze*, no. 34, 1997, pp. 56–61.

Simon Morrissey, 'Insomniac Lens: Rut Blees Luxemburg's Urban Vision', *Portfolio*, no. 26, December 1997, pp. 48–9.

Bill Mouland, 'Invitation to an Outrage', *Daily Mail*, 17 September 1997.

Jojo Moyes, 'Son's Stark Portrait of Family at War' [Richard Billingham], *Independent*, 28 August 1997.

Gregor Muir, 'Lacquer Syringe' [Gary Hume], *Parkett*, no. 48, 1996, pp. 22–6.

Gregor Muir, 'Sam Taylor-Wood', *Frieze*, no. 27, March–April 1996, pp. 79–80.

Neil Mulholland, 'London "Sensation"', *Burlington Magazine*, vol. cxxxix, no. 1137, December 1997, pp. 886–8.

David Musgrave, 'The Last Show', *Art Monthly*, no. 222, December 1998–January 1999, pp. 26–7.

Clifford Myerson, 'Michael Landy and the Great Sale', *Art Monthly*, no. 157, June 1992, p. 17.

David Norris, 'The Royal Academy of Porn', *Daily Mail*, 16 September 1997.

Octopus, 'Practical Uses for Theoretical Essays', *Everything*, vol. 2, no. 1, 1997, pp. 18–19.

James Odling Smee, 'Wonderful Life', *Art Monthly*, no. 170, October 1993, pp. 26–7.

William Packer, 'What Sensation?', *Financial Times*, 20 September 1997.

Joanna Pitman, 'Art Breaker', *The Times*, 13 September 1997.

Niru Ratnam, 'Chris Ofili and the Limits of Hybridity', *New Left Review*, no. 235, May–June 1999, pp. 153–9.

Peter Richardson, 'Keith Coventry Interview', *Transcript*, vol. 3, no. 2, 1998, pp. 58–66.

James Roberts, 'Adult Fun' [Adam Chodzko], *Frieze*, no. 31, 1996, pp. 62–7.

James Roberts, 'Last of England' [interview with Gavin Turk], *Frieze*, no. 13, November–December 1993, pp. 28–31.

James Roberts, 'Making a Drama Out of a Crisis' [Sam Taylor-Wood], *Frieze*, no. 44, 1999, pp. 50–5.

John Roberts, 'Mad for It! Bank and the New British Art', *Everything*, no. 18, 1996, pp. 15–19.

John Roberts, 'Mad for It! Philistinism, the Everyday and the New British Art', *Third Text*, no. 35, Summer 1996, pp. 29–42.

John Roberts, 'Notes on 90s Art', *Art Monthly*, no. 200, October 1996, pp. 3–4.

Bryan Robertson, 'Something is Rotten in the State of Art', *Modern Painters*, Winter 1997, pp. 15–16.

Jerry Saltz, 'More Life: The Work of Damien Hirst', *Art in America*, vol. 83, no. 6, 1995, pp. 82–7.

Michael Sandle, 'The RA is Rotten at the Top', *Daily Telegraph*, 23 September 1997.

Peter Schjeldahl, 'Twelve British Artists', *Frieze*, no. 7, December 1992, p. 45.

Adrian Searle, 'Family Fortunes' [Richard Billingham], *Frieze*, no. 44, 1999, pp. 35–7.

Adrian Searle, 'Fools and Horses' [Mark Wallinger], *Frieze*, no. 8, January–February 1993, pp. 17–20.

Adrian Searle, 'Love in a Cold Climate', *Artscribe*, no. 88, September 1991, p. 84.

Adrian Searle, 'Rachel Doesn't Live Here Any More' [Rachel Whiteread], *Frieze*, no. 14, January–February 1994, pp. 26–9.

Adrian Searle, 'Shut that Door' [Gary Hume], *Frieze*, no. 11, Summer 1993, pp. 46–9.

Will Self, 'A Steady Iron-Hard Jet', *Modern Painters*, Summer 1994, pp. 50–2.

Will Self, 'The Royal Academy is Casting its Mantle upon Saatchi's Brit Kids. Middle England is Shocked and Enjoying Every Minute of it', *New Statesman*, 19 September 1997, pp. 38–9.

Naomi Siderfin, 'The Title Gives Nothing Away', [*Sensation*], *Make*, no. 78, December 1997–February 1998, p. 25.

Paula Smithard, 'How Rude Can You Get?' [Bank], *Make*, no. 74, February–March 1997, p. 27.

Julian Stallabrass, 'The Idea of the Primitive. British Art and Anthropology 1918–1930', *New Left Review*, no. 183, September–October 1990, pp. 95–115.

Julian Stallabrass, 'Lea Andrews', *Art Monthly*, no. 163, February 1993, pp. 24–5.

Julian Stallabrass, 'On the Margins', *Art Monthly*, no. 182, December 1994–January 1995, pp. 3–6.

Julian Stallabrass, 'Phoney War', *Art Monthly*, no. 206, May 1997, pp. 15–16.

Julian Stallabrass, 'Power to the People' [review of work by Judith Cowan, Andrea Fisher and Gillian Wearing], *Art Monthly*, no. 165, April 1993, pp. 15–17.

Julian Stallabrass, 'Renegotiations: Class, Modernity and Photography', *Art Monthly*, no. 166, May 1993, pp. 21–2.

Juri Steiner, 'Divide et Impera', *Parkett*, nos. 50–1, 1997, pp. 288–90.

Helen Sumpter, 'Naughty but Nice' [Sarah Lucas], *The Big Issue*, 8–14 September 1997.

Time Out supplement to the *Sensation* exhibition, 18 September 1997.

Paul Usherwood, 'The Rise and Rise of Rachel Whiteread', *Art Monthly*, no. 200, October 1996, pp. 11–13.

Carol Vogel, 'British Outrage Heads for Brooklyn', *The New York Times*, 8 April 1999.

George Walden, 'Leave your Weapons at the Door. Democracy, State Modernism and the Official Embrace of the Arts', *London Review of Books*, 26 September 1997, pp. 10–11.

Mark Wallinger, 'The Pygmalion Paradox', *Art Monthly*, no. 218, July–August 1998, pp. 1–4.

Paul Waugh, 'The Giant Painting of Myra "Designed to Shock"', *Evening Standard*, 25 July 1997.

Irvine Welsh, *Trainspotting*, Minerva, London 1994.

Andrew Wilson, 'God Not Warhol', *Art Monthly*, no., 217, June 1998, pp. 44–5.

Andrew Wilson, 'Out of Control', *Art Monthly*, no. 177, June 1994, pp. 3–9.

Peter Wollen, 'Thatcher's Artists', *London Review of Books*, 30 October 1997, pp. 7–9.

Geoffrey Worsdale, 'Chris Ofili', *Art Monthly*, no. 198, July–August 1996, pp. 27–8.

Chin-tao Wu, 'Embracing the Enterprise Culture: Art Institutions Since the 1980s', *New Left Review*, no. 230, July–August 1998, pp. 28–57.

Robert Yates, 'Diary', *Observer Review*, 6 September 1998.

Index